PETERSBURG PERSPECTIVES

Petersburg Perspectives

Edited by Frank Althaus and Mark Sutcliffe

Photographs by Yury Molodkovets

Fontanka with Booth-Clibborn Editions

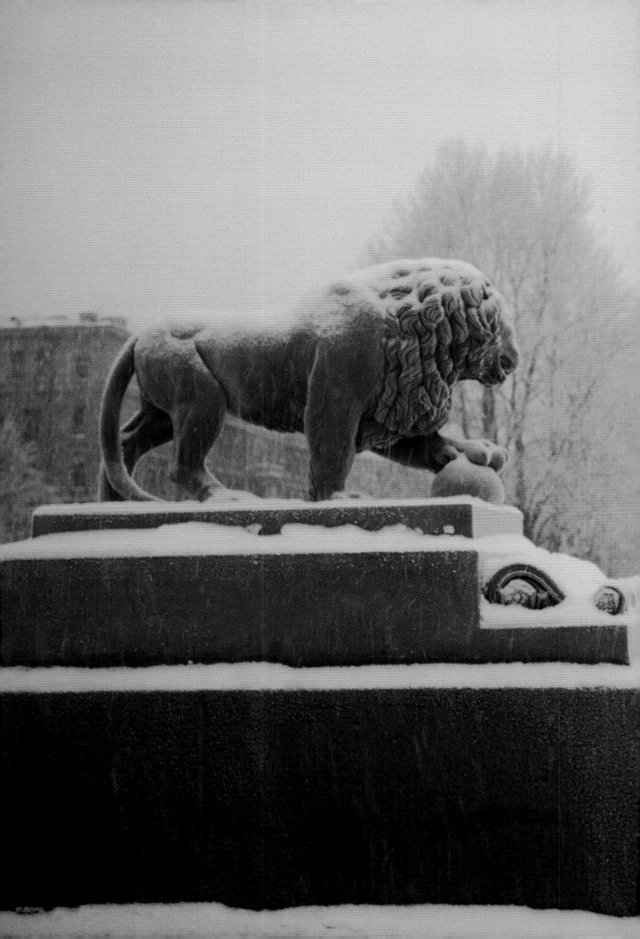

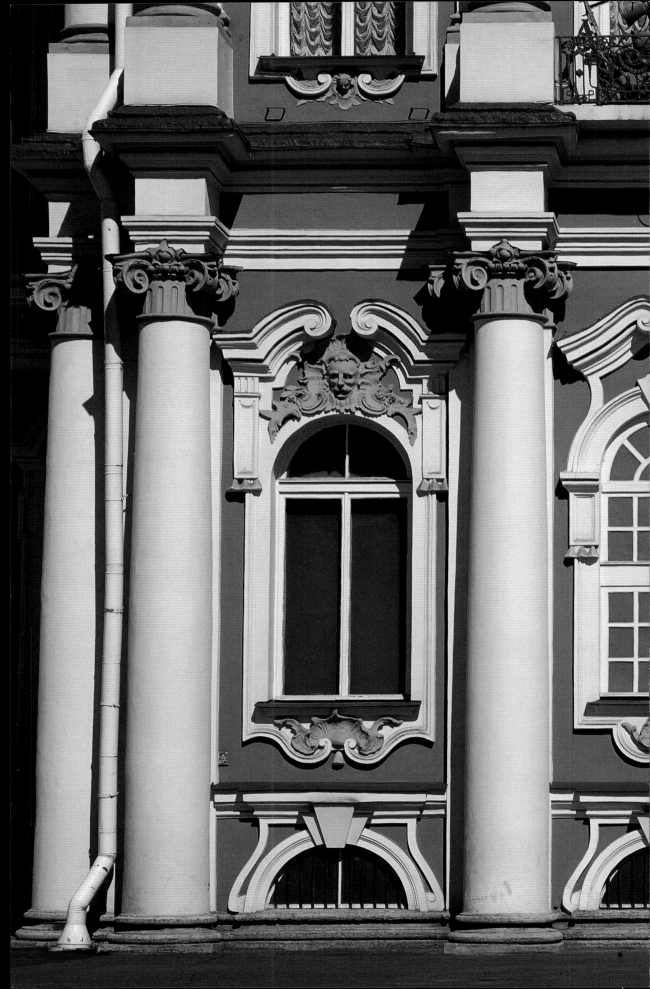

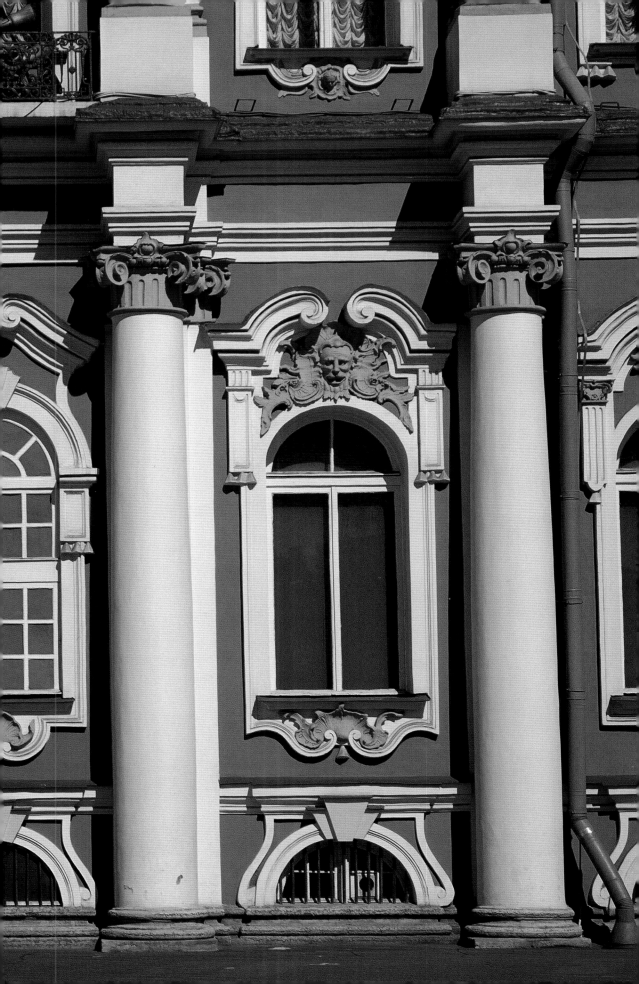

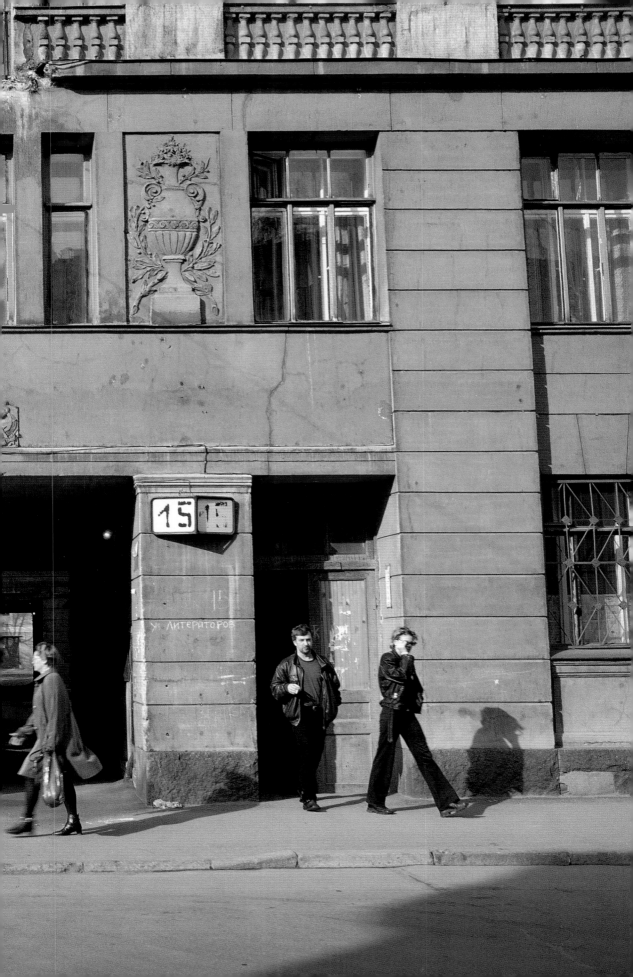

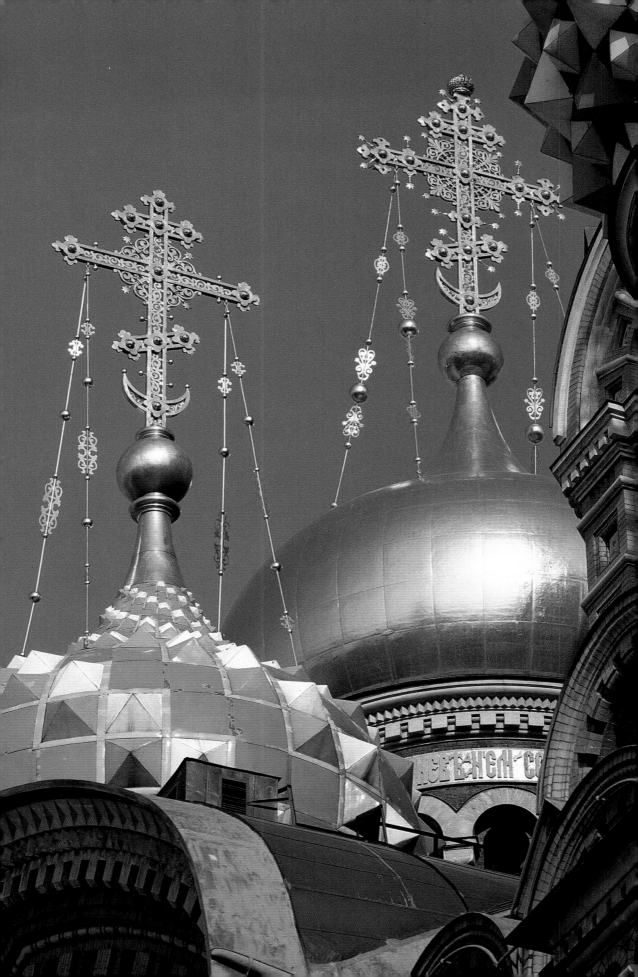

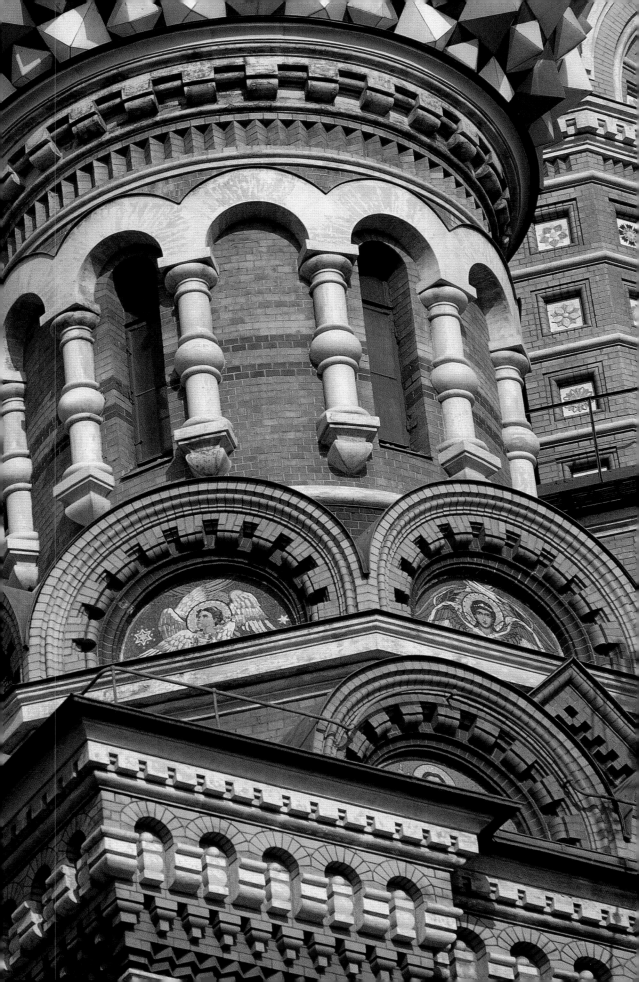

Editors: Frank Althaus, Mark Sutcliffe

Photography: Yury Molodkovets

Design: John Morgan studio

Translation, *An Architecture of Intentions*:
Andrew Bromfield

Editorial assistance: Elena Kulagina,
Cary Rudolph, Lucy Bailey

Index: Hilary Bird

First published in 2003 by
Fontanka
11 Coldbath Square
London EC1R 5HL
info@fontanka.co.uk

Distributed by
Booth-Clibborn Editions
12 Percy Street
London W1T 1DW
www.booth-clibborn.com

ISBN: 1 86154 260 7

Printed in Hong Kong

Menshikov Palace wall (detail) (p. 2)
Lions on Admiralty Embankment (pp. 4–5)
Winter Palace façade (detail) (pp. 6–7)
Courtyard entrance, 15 Literatorov Street (pp. 8–9)
Cathedral of the Resurrection of Christ,
'The Saviour on the Blood' (detail) (pp. 10–11)

With thanks to Dmitry Chekalov, Julia Dvinskaya, Katya Gruzdeva, Yulia Kovas, Irina Nelyubova, Elena Nemirovskaya, Yury Senokosov, Vitaly Tretyakov, Oleg Urazmetov, Rupert Dean, Dawn Holland, Henrietta Wallace

Editorial note

The transliteration system used throughout the book is the Library of Congress System, with the following modifications for readability and ease of pronunciation:

the common Russian endings ый and ий have been rendered *y*; thus Dmitry and Bely

the Russian e has been rendered *e* except at the beginning of a word or after another e, when it is rendered *ye*; thus Felten, but Yekaterina and Andreyev

the Russian ё has been rendered *yo*, except after *ch* when it is *e*; thus Potyomkin, but Chernaya Rechka

soft and hard signs have been omitted; thus Ilich

commonly accepted spellings have been used where such exist; thus Tchaikovsky and Alexei

Contents

ALEXANDER KUSHNER In Petersburg We'll Meet Again 19

YURY ARABOV The Petersburger's Psychology: A Moscow View 37

ORLANDO FIGES Tales of Petersburg 91

YURY PIRYUTKO An Architecture of Intentions 108

M. KIRBY TALLEY, JR The Beautiful and the Damned:
Preserving Peter the Great's Dream on the Neva 171

JOHN NICOLSON Inside the Noah's Ark 187

VLADIMIR SHINKARYOV The Flat 242

CHARLOTTE HOBSON Pushkin's Letter 261

Index 312

Authors' Biographies 319

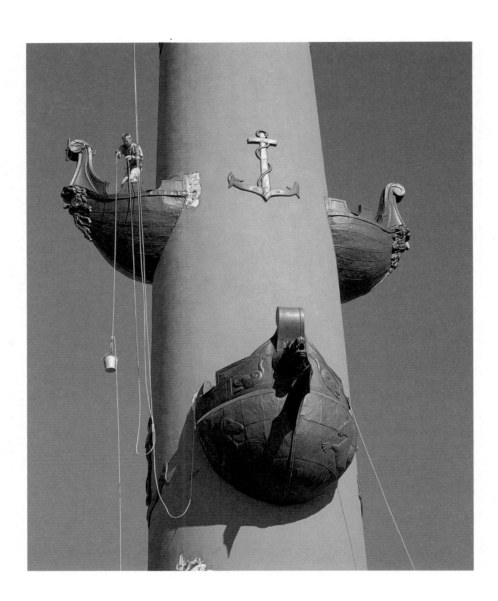

The two rostral columns on the spit
of Vasilevsky Island were originally
designed as lighthouses by Thomas de
Thomon in 1810; their gas torches are
still lit on ceremonial occasions

In Petersburg We'll Meet Again

St Petersburg ceased to be the capital of Russia after the revolution: in 1918 the Bolsheviks restored that honour to Moscow. Nonetheless, the city has retained the aura of a second capital. Along with Russia's numerous other anomalies, here, it seems, is yet one more: a country with two capitals, two hearts – one in the centre, the other shunted north-west, beating not in the chest but somewhere up around the throat.

When, very quietly and modestly, the city marked its 250th anniversary, it seemed to a lad like me an entirely venerable age. Now, from the perspective of my sixty-five years, I feel that I am catching the city up: and anyway – does three hundred years really amount to that much?

Petersburg, it is true, looks older than its years. The city is at once adorned and aged by its cathedrals, colonnades, spires, towers, statues and railings, all based upon classical and Western-European models. And it is aged by its climate, with the long winters, the snow and rain hastening this decline. The Stock Exchange building, for example, built by the Frenchman Thomas de Thomon on the spit of Vasilevsky Island in imitation of an Ancient Greek temple, is restored and re-painted almost every four years: any longer and the paint starts to flake off. Set facing into the Neva and the north wind, the building sparkles like a new toy for a few seasons; then, from a distance, it starts to resemble the ruins of the Parthenon. This is probably caused not just by the climate but by the paint, which is clearly of poor quality and no doubt diluted with water (in Russia people steal and dilute just about everything that comes their way). Nonetheless, the principal enemy of the city's architecture is the autumn and winter weather. Here in the north, three years is the equivalent of almost three centuries under an Hellenic sun.

But there is another foe, yet more terrible: historical cataclysm, whether revolution, economic disintegration, war, siege, or, not least, socialist appropriation of property. Buildings, especially residential buildings, cannot be well maintained unless owned by private individuals with some interest in their preservation. Today, more than ten years after the painful and imperfect return to the principle of private ownership, the city is being transformed before our eyes, with dazzling new hotels and boutiques, window displays and shop-signs. Nevsky Prospect, for example, has been so smartened up as to be almost unrecognisable. Turn off Nevsky, however, and venture down one of the streets that bisect it (Liteiny or Vladimirsky, Mayakovskaya or Vosstaniya), and you will see dilapidated façades, crumbling plasterwork, murky doorways and courtyard entrances. As for the courtyards themselves, better to avoid them

altogether: rather than 150 or 200 years old, they look as if they have been around for a couple of millennia. I suspect that the foreign tourist in Petersburg feels like an explorer wandering through ancient ruins, only instead of stepping on Carthaginian lizards, he stumbles across stray cats.

Let me venture a tentative suggestion: perhaps Petersburg was always like this, from the very beginning. Perhaps it is only in old coloured prints that the city shines out in all its newness; perhaps an eighteenth-century dandy in his velvet caftan had only to turn off Nevsky Prospect or the Admiralty Embankment to find himself amidst dust and disintegration. 'A country of façades' was how the itinerant Marquis de Custine described Russia as early as the 1830s. And the poet Nekrasov, describing a Petersburg street, wrote 'The stucco breaks off, hitting the people below'. It was Nekrasov's journal that printed *Poor Folk*, the first novel of his contemporary, Dostoevsky. In the later *Crime and Punishment* Dostoevsky describes how the hero walks through Petersburg amongst the construction lime, building timbers, bricks, dust and repellent stench, and is possessed by 'a feeling of profound disgust'.

There is something masochistic about the desire to quote such descriptions, but they are the sad truth, which cannot be avoided in these reflections. Happily, though, they are not the whole truth. 'The staircase of almost every Petersburg house was permeated with the scent of visiting ladies and the smell of gentlemen's cigars', wrote Akhmatova in her reminiscences of Petersburg in the 1910s (although she qualified this by saying that she was referring to front staircases: 'back staircases, unfortunately, smelt mostly of cats'). It is hard to avoid the feeling that there were two Petersburgs: formal, magnificent, elegant, European Petersburg – the Petersburg of Pushkin and Akhmatova; and bureaucratic, mercantile, 'backstairs' Petersburg – the Petersburg of Dostoevsky and Nekrasov. And today these two cities continue to co-exist and overlap, despite all the changes that have taken place over the past hundred years. It sometimes seems as though the city adjusts to our view of the world, to whether we embrace or recoil from life – and allows us to make the choice: 'Either the Elysian door creaks gently open, or the door to hell slams shut behind'. As for art, it is wonderfully accommodated in both cities, and uses both beauty and horror as it sees fit. When I think of my own poems, I realise that both these themes are interwoven. Next to a stroll along the Moika in Sunday best, for example, the Yekateringofka tributary lies 'like a patient on her side' in the shadow of monstrous factories, amidst roads with names like 'Turbine Street' and 'Chemical Lane'. Maybe it is this duality which is the very stuff of poetry, mirroring the split personality and contradictions inherent in Russia for at least the last three hundred years.

Of course one can hardly expect an enormous city situated on a latitude with Seward in Alaska to be the model of pristine order. On the other hand, Helsinki is even further north, its winters even more severe, yet somehow it avoids Petersburg's grimy, dishevelled appearance. In my early childhood (I was born in 1936), I remember the city as relatively clean and ordered, which is evidently how it looked when Akhmatova described it at the beginning of the twentieth century. 57 Bolshoi Prospect, on the Petrogradskaya side, was built between 1910 and 1913 in the Art Nouveau style, and still retained traces of its recent grandeur: the stained-glass windows on the stairs, the marble fireplace in the hall, the sumptuous main staircase with cast-iron decorative flowers on the banisters and wide, shallow steps, and the lift with its elaborate cage decorated with the same cast-iron fantastical flowers. In a little

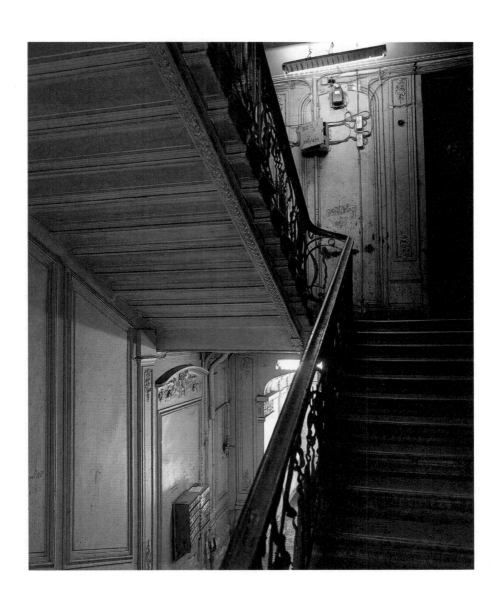

*Staircase in a residential building in the
centre of St Petersburg*

cubby-hole under the stairs sat the doorman (or was he by then merely the caretaker?) who looked after the building. My first memories are linked to this house, which was one of many on Bolshoi Prospect built in the 'Petersburg *moderne*' style during a period of industrial growth in Russia – growth that was predicated on future economic expansion and progress. The house belonged, I think, to an investment company. Its huge apartments, which were rented out to well-to-do people, comprised seven or more rooms each. After the revolution all the apartments were 'compressed', each being inhabited by five, six, even seven families – on average one family per room. This is not the place for a detailed description of communal life, with up to twenty people sharing a single kitchen, bathroom and two lavatories (the best account is by Mikhail Zoshchenko, a wonderful prose writer who, along with Akhmatova, was the victim of Zhdanov's furious denunciation in a party edict of 1946). But I still shudder at the recollection of the morning queue for the lavatory: men standing alongside women alongside children. What did it matter to the children? We knew nothing else and thought that this was how it should be; it wasn't a problem. But I recall with a mixture of horror and sympathy how Yadviga Konstantinovna, a woman of about forty and the wife of the artist Yankov, would enter the closet with her hand over her nose – an image that is seared on my memory. How many times since have I thought of western liberals and those on the 'left', such as the French communists with their dreams of socialism and their Maoist sympathies, and have dreamt of taking them – taking Sartre, for example – to my childhood flat.

The children would trundle down the long corridor of this flat on tricycles with wooden seats and backs, painted all over with bright flowers like the sledges of Russian folklore. Enormous framed and unframed paintings leant face up against the walls (Yankov specialised in painting either seascapes or battle scenes – hence the vast dimensions of his canvases). Between these pictures and the wall was a narrow space, just wide enough for us little ones to get behind and creep along on our hands and knees like mice. We would whisper to each other in the darkness, giggle, recount frightening stories, and emerge covered in cobwebs and dust. Yankov himself was a drunkard. During one of his regular bouts he appeared in the corridor wearing a dressing-gown and turban and declared to the entire flat: 'I am Anna Karenina!' He evidently knew of Anna Karenina from his educated wife. He was also a generous man, who drank his considerable commissions (his paintings were in great demand from the military establishment) in the café in our building, with its broad view of Bolshoi Prospect – always making a point of treating the staff and regulars.

My father, a young construction engineer, my mother, who had qualified as a secretary, and I, their son, lived in one seventeen-square-metre room with a tall Petersburg window overlooking the yard, and a white tiled stove with a bright brass fireplace cover. The room was light (we lived on the fifth floor, in flat number 7). In the next-door room lived my father's elder sister who studied at the College of Paediatrics. Also accommodated there, with my aunt's permission, was our housekeeper (and my nanny) Zina, who came from somewhere near Pskov. The adults went to work, studied, came home late; my nanny took me on walks, fed me, no doubt told me fairytales, but mainly – being literate – read me children's books. I don't remember the fairytales, but every full-throated, popular lyric or military Soviet song from those years I know off by heart. For these were the marches and songs blasted out by brass bands

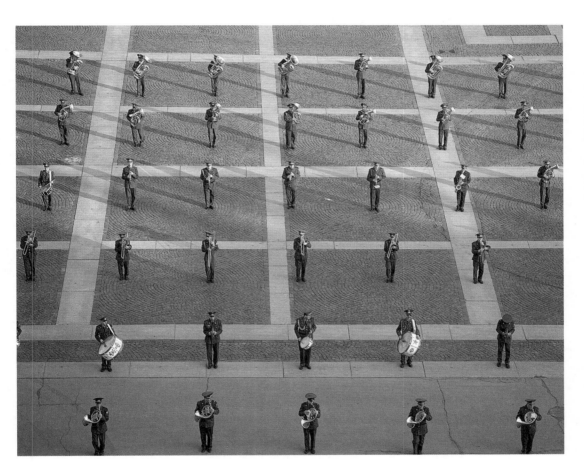

Military band on Palace Square in front
of the Winter Palace

during official holidays and parades, and for a child this many-headed hydra that appeared every First of May and Seventh of November with its red flags and banners was a significant and joyful event. I suspect that the wealth of talent of my generation, which has produced so many extraordinary contributors to literature, music, ballet, painting and so forth, owes something to these 'spirit-rousing' experiences. I don't know what impact they had on adults, but they had children completely under their spell. No medieval Italian carnival could have compared with this fervour, this orchestral jubilation. Pessimism was out of the question. And even now, for no apparent reason, some stirring tune from that time will suddenly come to me, all-pervading, all-eclipsing, obsessive... At the point of death people often recall their childhood. When my father was dying in a Leningrad hospital in 1980, he would complain to me about the persistence of these childhood memories. My fear is that as I breathe my last it will be these songs ('I know no other country, where the human spirit roams so free') which will engulf me.

Without the October Revolution we would have lived near Vitebsk, in a place called Orsh, beyond the Pale of Settlement, and my nanny Zina would have remained near Pskov. I wonder if that is really so. Wouldn't the so-called Bourgeois Revolution of February 1917, which was relatively bloodless, have been quite enough to transform our lives? Anywhere else, perhaps, but not in Russia. Later that same year the Bolshevik Revolution built the happiness of 'the humiliated and degraded' upon the humiliation and degradation of the wealthy and the educated. 'He who was nothing shall become everything': the words of a revolutionary song that were only too effectively put into practice, replacing one injustice with another, still more cruel and bloody.

I'm not entirely happy with the direction my words have taken me: in writing about my home city, I did not intend to settle into the well-worn ruts of historical and social debate. But surely any account of Petersburg is also an account of Leningrad? After all, I was born in Leningrad and have spent most of my life there; and an account of my childhood and our first flat is as important a part of my account of my beloved city as any other. Here is just one, very short, story about the joys of that new life, about those who 'became everything'. In one of the rooms of flat number 7 lived the Nikolaev family, comprising a husband and wife, and their young daughter, Hella – my early childhood friend. The husband, a military specialist, anticipating his imminent arrest, waited until his wife and daughter were out, and then shot himself in their room. A few years later, during the blockade, the wife died from hunger – her body lay all winter in the cold bathroom (those who were left in the flat, including my aunt, hadn't the strength to carry the corpse down from the fifth floor and take it to the cemetery). Their five-year-old daughter, now an orphan, was evacuated with the rest of her orphanage across the wintry Lake Ladoga, along the so-called 'road of life'. She suffered frostbite in her feet, survived, but lost both legs. She was never seen in Leningrad again. If God exists (and it's my hope that He does), how can His existence be reconciled with this horror?

Lev Tolstoy could recall his infancy; he remembered being bathed in a wash-tub at the age of one. I can make no such claim. One of my first memories is linked to the city – and I was probably three at the time. I am standing in a square on Bolshoi Prospect (on the even-numbered side of the street there are several squares with poplars and lime trees, though today they are crammed with little shopping kiosks and built up almost to extinction) on a

bright sunlit day, with the sound of the wind blowing through the leaves... that, essentially, is all I remember. Which adults were with me, I cannot say. Just bright sunlight and the rustle of leaves. Maybe at that moment He whom I have just tried to invoke breathed into my soul. Perhaps children who grow up in the south remember the overcast days, or the snow. For children of the north it is the summer brightness that is imprinted on their hearts. I still love the sunny days, so rare in my city: life is easier when the sun shines, and better for writing poetry. 'Sunless, dismal gardens', wrote Akhmatova, and indeed Petersburg's gardens (like the avenues in Moscow) are damp, shaded and gloomy... But in the squares on Bolshoi Prospect that day the sun was shining brightly!

How I would have lived and what I would have been, had I been born in another city, I do not know. If I had written poems elsewhere, they would have been different. The boy who day in day out for ten years takes the tram two stops to school and back along Bolshoi Prospect (in those days trams still ran here; how they fitted into this confined space is no longer clear), which passed like a narrow mountain ravine through the granite, cliff-like buildings of early twentieth-century Petersburg Art Nouveau – that boy is very different from his coevals growing up in Chelyabinsk or Vyshny Volochek. The strange thing is the way he imagines this to be exactly how every city must be. It is only when he grows up and travels the world that he realises it isn't so. And even the Muscovite Pasternak, responding to the question, 'which city is most representative of a real city?', cited Petersburg, even though by then he had already seen Berlin, Frankfurt, Florence and Venice. In Russia, at least, the automatic response to the word 'fruit' is 'apple'; to the word 'poet' – Pushkin; to 'city' – 'Petersburg'.

To the Peter and Paul Fortress with its faceted spire, blindingly bright in the crack at the end of so many little streets and lanes on the Petrogradskaya side – I give thanks. It's as if the angel which crowns the spire is watching over every one of these streets: 'Every quiet lane has its own Peter and Paul'. To all of Petersburg's rivers – the Nevas and Nevkas, the Moika, Fontanka, Smolenka and Pryazhka; and to the Griboedov, Obvodny and Kryukov canals – I also give thanks... It seems as though the Styx, Cocytus and Acheron are also somewhere round the corner, part of the shifting network of damply breathing, gently lapping rivers that criss-cross the city like blood vessels, making it a truly living creature. One of the rivers is called Chernaya Rechka, or Black River – a name that became self-fulfilling: it was on this river's frozen shore on a February day in 1837 that Pushkin was fatally wounded. 'The sun of our poetry has set!': words from the poet's obituary which earned the editor of the journal that printed them a severe reprimand from the authorities.

The title of my essay is taken from a poem by Mandelshtam: 'In Petersburg we'll meet again, as if we had buried the sun in it'. I wanted to emphasise the link between city and verse, the way Petersburg is permeated by poetry. In the winter months, those black December and January days, it would be impossible to live through the gloom without this secret radiance.

>
Detail from the railing around the garden of the Mikhailovsky Castle, showing the head of Medusa

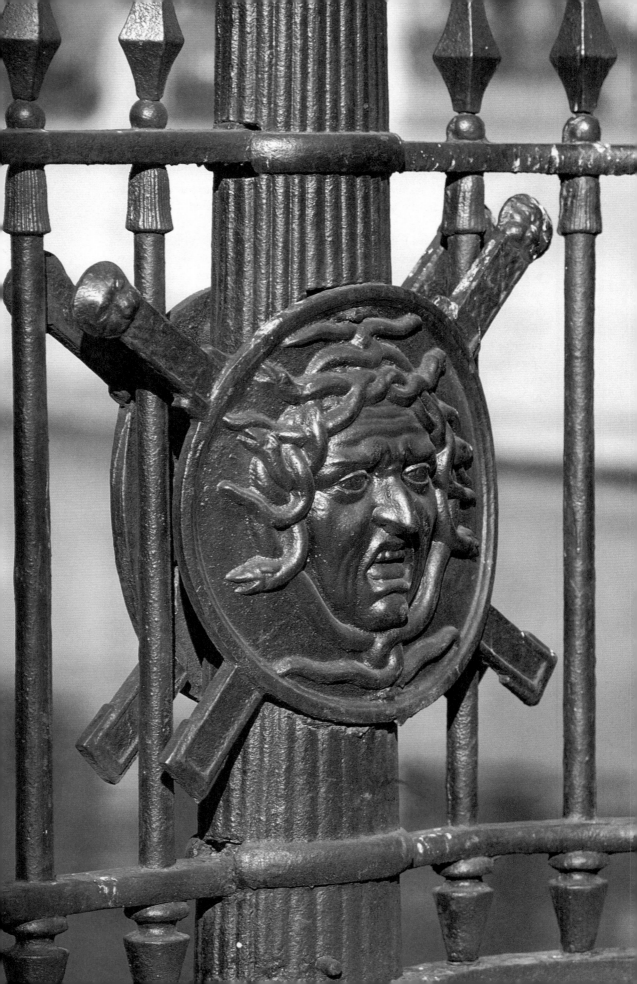

What would I recommend the visitor to see? If he knew nothing of Russian poetry, I would advise him not to visit Petersburg in winter, but only in summer, during the white nights. As well as a stroll through the streets and along the Neva, Moika and Fontanka, I would invite him down onto the gangplanks somewhere by Anichkov Bridge to take a boat trip, and sail beneath the echoing bridges to see the city from this strange, almost inverted perspective – from below. 'Thus souls look down from on high upon their discarded bodies' is a line from an old Russian poem. Petersburg provides an opportunity to look at the 'discarded body' from below as well. For the inhabitants of the city these 'subterranean' river excursions half-opened a door to Venice and Amsterdam – forbidden destinations for many of us, including the author of this essay, in the Soviet period. The granite embankments, the cast-iron fences with their black flowers, seahorses, shields and spears are a purely Petersburg whim and fantasy – they do not exist in Amsterdam or Venice. The artist Dobuzhinsky, one of those who, caught up in a Pushkin-inspired enthusiasm for Petersburg, helped to rediscover the city's secret delights at the beginning of the twentieth century (after the gloomy and negative invective of mid-nineteenth-century writers), recalled how as a boy, when walking with his father past the less formal railings at the back of the Summer Garden near Mikhailovsky Castle, he loved to stroke the nose of the frightening Gorgon Medusa, and sometimes even bravely insert his finger into her gaping mouth.

This is not a guide to the city. But if asked to name my favourite Petersburg building, I would probably cite the Kazan Cathedral with its ancient semicircular colonnade built from the grey-green-yellowish Pudost stone (its texture and colour wonderfully reminiscent of the dilapidated temples and palaces of classical antiquity). The cathedral bears a passing resemblance to St Peter's in Rome, but it is also quite different, being on an altogether more human, intimate, even homely scale. When you stand in the shadow of its narrow colonnade, just a few yards from Nevsky Prospect, you feel in complete seclusion, as if in a small grove hewn from stone.

> As maple and rowan tree grew by your doorstep,
> Rastrelli and Rossi grew next to mine.
> While I could distinguish Rococo from Empire
> You, at that age, could tell ash tree from pine.

In these lines from one of my poems, where the names of Petersburg's Italian architects are interweaved with types of Russian tree, perhaps I came near to putting my finger on what makes a Petersburg or Leningrad childhood different from any other – certainly in Russia. Here too, in the innate link with classical architecture, is what sets Petersburg's poetry apart from Moscow's. 'I love your stern, harmonious look', Pushkin wrote of Petersburg; the same, it would seem, could be said of Petersburg's poetry.

Every place on earth has its own mythology. Without fail someone somewhere will have thrown themselves into the river, heartbroken by a failed love-affair, and you will be shown the stone in the middle of the river or the scarred cliff-face, and so on and so forth. But Petersburg's metaphysics and mythology bear no relation to folklore; they have been created by literature (both poetry and prose), before the reader's very eyes. This is not the place to list all the varieties and sub-branches of the Petersburg myth, nor all its authors. I will name only Pushkin and his *Bronze Horseman*, with the 'clattering' gallop of the horse

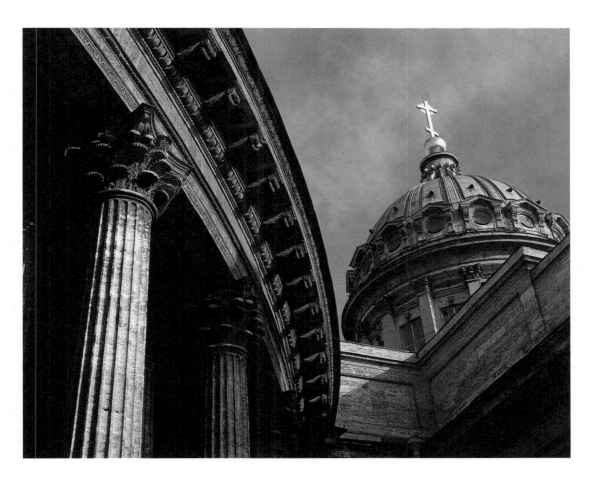

Kazan Cathedral, built by Andrei
Voronikhin between 1801 and 1811

along the cobbled pavement in pursuit of the unfortunate Yevgeny, the petty functionary who dared to threaten Tsar Peter. And also Gogol, who took up the theme in his story 'The Overcoat'; Gogol, who was so filled with sympathy for 'the little man', condemned to suffer and perish in the cold imperial capital. And, of course, Dostoevsky, who imagined the disappearance of 'this most intentioned city on earth', swallowed up by its fluvial, marshy surroundings: 'A hundred times amid the fog I had a strange but persistent dream: "What if, when this fog scatters and flies upward, the whole rotten, slimy city goes with it, rises with the fog and vanishes like smoke, leaving behind the old Finnish swamp, and in the middle of it, I suppose, for beauty's sake, the Bronze Horseman on his panting, whipped horse?".'

Virtually everyone who has written about Petersburg, including Merezhkovsky, Blok and Andrei Bely, has their own myth centred on the city, or a variation of an already existing myth. It would seem that for any serious Petersburg writer this mythology is unavoidable. My work, too, contains a variant of the myth. In the introduction to the book *Apollo in the Snow* I recounted how, walking one winter in Pavlovsk Park near Petersburg, I passed the colonnade of Apollo and was struck by the sight of this god, the leader of the muses, buried in snow and with a hat of snow on his head. How far north he had come! Could one say that here – in Russia – was the final, distant outpost of his influence, that from here he could glimpse into the metaphysical darkness? Surely, in the midst of this wintry silence, he must dream of 'other shores, other waves'? And does not Russian poetry contain such passion so that its word can sound through the frost, so that it can be invoked to warm the human heart and melt the surrounding ice? Apollo in the snow is a metaphor for all Russian culture, for the cruel experience of its existence in the wintry conditions of a despotic regime. The poem 'Apollo in the Snow' describes it thus:

> The soul gleams in the white spikes of a wreath;
> ice and twilight have lodged in its cracks.
> This frost-breathing stone deity bequeaths
> us the victory palm for our task.
> This palm, probably twisted from fir,
> has been dusted all over with rime.
> Here is courage. And here snowstorms swirl.
> Here, enveloped in shivers, are these lines.

In the mid-1970s I found myself in serious trouble as a result of this collection of poems. Comrade Romanov, First Secretary of the Leningrad Regional Committee and a member of the Politburo, quoted from them during a speech to a meeting of the city's writers and artists, and announced (mangling my surname): 'If the poet Alexander *Kushnir* does not like it here, then he should leave.' I was saved by the fact that the poems had yet to be published; some obliging literary assessors had passed them to their boss, having withdrawn them from material being prepared for the next issue of the journal *Aurora*. It turned out, therefore, that the authorities were quoting at the podium from unpublished poems: in such a way were the strings of the party's secret control over literature laid bare. The poems, of course, did not get published in the journal, and it was only under Gorbachev that I was able to see them in print.

As for emigrating, I had no desire to leave the country whatsoever. My life and fate were too closely tied to my native language and country, to the city

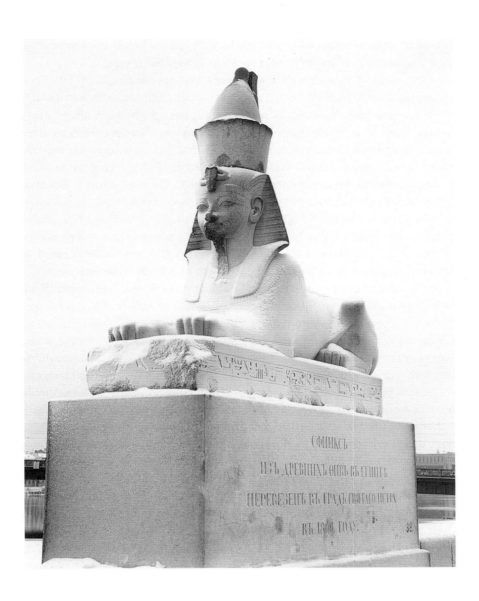

СФИНКСЪ
ИЗЪ ДРЕВНИХЪ ФИВЪ ВЪ ЕГИПТѢ
ПЕРЕВЕЗЕНЪ ВЪ ГРАДЪ СВЯТАГО ПЕТРА
ВЪ 1832 ГОДУ.

Purchased by the Russian government in 1852, the two sphinxes outside the Academy of Arts on University Embankment are said to date from the reign of Amenhotep III (1455–1419 BC), and to bear his features

where I was born and had spent my entire life. Even a move to Moscow, where living conditions were easier and where the state's hand weighed less heavily on artistic life than in Leningrad, would have been fatal for me. I seem to belong to those rare species of mammal which can only exist in their primordial environment, like the Nilotic crocodile or the Ussuri tiger.

In terms of Petersburg's metaphysics and mythology, I confess that, although I love Greek mythology, I am no great adherent of myths, particularly contemporary ones, and would prefer to dispense with them altogether – including my own 'Apollo in the Snow'. Of course any attempt to sidestep life's tragic struggle or exclude elemental forces from life and history would be ruinous to life itself, which would be thus deprived of its ontological roots, including the subterranean currents that nourish the arts. But it is essential to contain this latent strength within civilised borders, to construct a kind of dam or barrier, like the Neva's granite walls and parapets. This unassailable defence I see incarnated in human rights, which oppose dogma and prejudice in race, class and creed. I have always preferred the lyric state of mind to the epic, and have never written an epic poem in my life – only lyric verse.

I sense that Petersburg has had enough of these myths. Who needs them, when the horror of revolution, repression and siege far exceeds any human fantasy? When as a seven-year-old child I returned with my mother to Leningrad from evacuation (we spent the three war years in Syzran on the Volga while my father was at the front), I was struck by the deserted, seemingly desolate city with its lifeless masses of bombed-out houses, gaping black eye-sockets of blown-out windows, empty gardens now swollen with vegetable beds and communal graves. I remember especially the faces and bodies – either emaciated or horribly swollen from metabolic malfunction – of those who had lived through the blockade, their eyes completely dulled or else unnaturally bright. Relatives and friends who had died from hunger weighed on the conscience of the survivors: they had made it, while their mothers, husbands, wives or children had perished – what's more, had perished (so it seemed to them) because they hadn't been able to break off a small crust from their daily ration of 250 grams of bread to save the life of a loved one. My aunt, who worked throughout the blockade as a doctor in a children's home, slowly starving and shivering in bomb shelters, like everyone else, told of her joy on finding a large bottle of fish oil which I – detesting the stuff, like every child – had at some point secretly rolled under the dresser, out of adult view.

How can myths compare with the memories of a Soviet schoolboy in the Stalin years? 'Fear and trembling' is the best way to describe it. Ksenia Konstantinovna, our elephantine director of studies, demanded 'iron discipline', and the discipline was indeed unyielding. We didn't dare make a sound, didn't dare smile – never mind laugh out loud – during her lessons or when standing in line. The brutality of public-school life in the classic English novel pales into insignificance against this terror. I feel sorry for those eight- and nine-year-old boys (girls were taught in a separate school), persecuted by her thunderous voice and her manner – unassailable, monumental, ramrod straight. I feel sorry for Ksenia Konstantinovna, too, left to look after her small daughter after the death of her husband, who was arrested in 1935 during the 'Kirov Affair' (which I only found out about much later, of course – probably in high school). Surely it was this nightmare, and her gratitude to the authorities for allowing her to work in a school at directorial level, which prompted the terror that she, herself crushed and vulnerable, strove to inspire in her pupils?

Nor could this mythology hold any fears for a small schoolboy, who, with the rest of his class, had been on the obligatory excursion to the museum of S.M. Kirov, which was housed in the former mansion of the ballerina Kshesinskaya. It was the last room of the tour that did it, with its deathly white plaster mask of the leader of the Leningrad party machine, murdered by enemies of the people (followers of Trotsky and Bukharin). (Incidentally, a poem written by the poet Tikhonov, which was played constantly at school concerts and on the radio at that time, contained the ominous refrain: 'On Leningrad's iron nights, Kirov walks through the city' – another Leningrad myth, if you will, in which the deceased party leader wanders the city at night in the manner of Puskhin's Commendatore, or Napoleon in an early nineteenth-century German romantic poem.) The red velvet, the crimson banners with black borders, the semi-gloom and mournfully overpowering music gave the room a certain Egyptian tomb-like languor, a sense of nightmarish entrapment. The mansion of merry ballerina and royal mistress had been transformed, so it seemed, into an Egyptian pyramid.

And then, ten, twenty years later... What invented myths could ever compare to the accounts of those who returned from the concentration camps in the mid-1950s? I knew at least four such people, including the playwright Alexander Konstantinovich Gladkov, who wrote in his memoirs of Pasternak and the great director Meyerhold, who was killed in the torture-chamber.

What need of myths has the man whose telephone was tapped throughout the sixties, seventies and eighties? You pick up the receiver, hear the caller's voice and at the same time you sense the presence of others – those subterranean labyrinths with their heavily breathing Minotaur. And what use are myths when one of your friends, whom you trusted unreservedly, turns out to be a paid informer for the KGB? Just as in Ovid's *Metamorphoses*, it feels as if that person has turned into a tree or animal before your very eyes. Nor could any myth compete with the huge building on Liteiny Prospect, situated directly opposite the House of Writers, which housed the Leningrad branch of the secret police. Here people were beaten and tortured, blinded by the light of a table-lamp, subjected to sleep deprivation, tied naked to an iron bedstead (terrifyingly recorded by the Leningrad poet Nikolai Zabolotsky, who miraculously survived being reduced to a bloody mess), and hosed down with ice-cold water.

This is why, despite all the mythologising (including my own 'Apollo in the Snow'), I embrace the dream of a normal life, with none of these unbearable trials that bring the heart to breaking point. This is why all my life, from my very first book, I have written of the value of a simple existence, of such undervalued pleasures as a tablecloth on the table, clean bedlinen and central heating:

> And if you sleep between clean sheets,
> And if the cover is crisp and fresh,
> And if you're sound asleep, and all is silent
> And dark, and you are master of all,
> And if, as they say, tender is the night,
> And if you're sound asleep, and you've locked
> The door to the room, and if
> No other voice can be heard...

And so on... The twentieth century has taught the Russian people (and Russian poetry) to value love, books, trips to the warm sea, carefree walks through

favourite cities – and has, to some extent, cooled the hitherto irresistible ardour for the metaphysical.

The summer, as I have said, is the best time to visit Petersburg, although there will always be the eccentrics in search of adversity and extreme experiences who prefer to visit us in winter (did Odysseus not descend to the underworld from the far north – the land of the Hyperboreans?). Such people are probably motivated by a similar passion to that which drew Amundsen or Nansen to the polar ice. Cold, rain mixed with snow, piercing wind, darkness that descends upon the city at three or four o'clock in the afternoon: the December gloom is our payment for the white nights. In summer the city is transformed; it loses its sombre, harsher features. Take a look at University Embankment: with its green, yellow and red façades and dazzling azure blue Neva at its granite pediment, it resembles the Mediterranean! How delightful the girls look in their summer dresses or cropped T-shirts. How attractive the lines of cars of every imaginable European make ('Along the northern river's embankment speed the fire-flies of cars' – Mandelshtam). I mention European-made cars because in my childhood there were none, only locally manufactured ones which scurried around the streets, presenting a cheerless spectacle. Street cafés, colourful tables beneath bright umbrellas – as children my friends and I could only dream of such things. Was it because we were so in thrall to western films in which the hero and heroine would sit with a glass of wine, somewhere on Oxford Street or on some piazza? To us even their unhappy love affair appeared blissful. What's more, today, on every side you hear people speaking not only Russian, but English, German, French: Petersburg has indeed returned to Europe. And in May we have the lilac. Somehow, whether white, violet or pink, it suits Petersburg more than any other city. Why? Probably because it is as transparent and transient as the white nights. In June the wild, thorny, dark-red and light-pink dogrose comes into flower – and stays until September. I should have written a poem entitled 'Apollo in the Blossom'; in fact, I did write something on those lines: 'Apollo in the grass' ('Like large hail, lie in the grass'), with not a hint of mythology.

Would I want to change places with a Londoner or Parisian of my age? Despite everything – no. No, because my Russian experience means so much to me, because I love Russian poetry, because I love this city. Because I have the feeling that the time and place we are allotted by fate is not entirely a matter of chance. And also because had I not been born in this city at a particular moment, I would not have met those I have loved, and the one I love. We have now lived together some twenty years, but the first half of our lives was spent apart, although as children we lived in the same street: Bolshoi Prospect, just a few yards from one another. No doubt this little girl and boy (he was a few years older) must have run past each other a few times, never suspecting their shared future. And maybe at some point, in another world, we will be presented with an earthly snapshot showing these two children, still unaware of each other's existence, running through the crowded street.

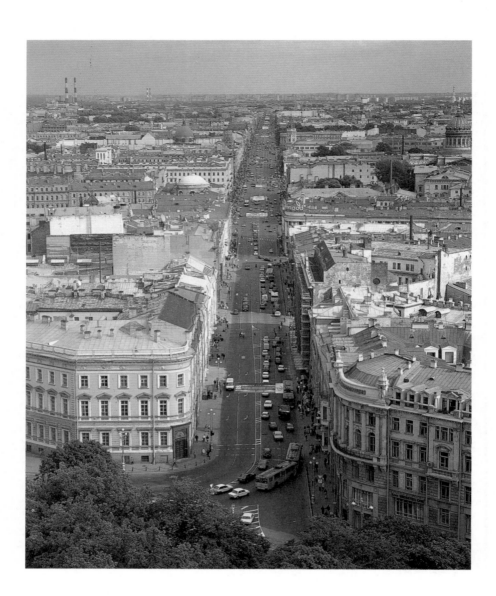

View from the Admiralty down
Nevsky Prospect, originally called
the Great Perspective Road

The Petersburger's Psychology:
A Moscow View

I first visited Petersburg in June 1980, when I was twenty-six. Brezhnev had a couple of years left in him, Soviet power another ten, but I don't suppose any of us had a sense of imminent historical collapse. Nobody could have imagined that the sun was setting on Soviet life, that everything around us was already history, soon to go on display in a museum. The fabric of the city would disintegrate, as if consumed by some voracious moth; water pipes would rust through; and stone would crumble like sand. Only the psychology of the people living here would remain intact – that way of thinking and being which is formed over centuries, passing from generation to generation, and which does not disappear overnight.

I came to Petersburg as a young scriptwriter, ready to conquer Lenfilm, the local film studio renowned for its liberalism. I arrived from Moscow, a city which I had always found impersonal, devoid of feature and landscape. Red Square, the Kremlin – what else stands out amidst Moscow's monoliths? Hardly the monumental Stalinist classicism of the Exhibition of National Economic Achievements, which even then was disintegrating as the plaster peeled from its exhibition halls to reveal the wooden bones beneath.

It was the views in Petersburg which struck me first. For while in the centre of Moscow the eye constantly strikes against the outline of a hill or the dead-end of a little side-street, the first view of Petersburg is of Nevsky Prospect, stretching away from Moscow Station somewhere into the stony distance, as grand as the sea or the steppe. There were fewer cars then, and their exhaust could not disguise the closeness of the water and its smell of washed linen – a smell which has always created in me an illusion of freedom.

Here was nature, caged. I would stand for hours on a bridge, stamping my feet in the cold, and watch mysterious bubbles bursting from the black waters of the Fontanka or the Moika. It was as if some mighty, imprisoned genie was breathing in the depths, gathering his strength for one final assault in autumn. For October was usually the time of floods, when nature took revenge for its humiliation, and the vast stone barrier that surrounded the city was overrun by mutinous waters.

It was at about the time I arrived that a dam started to be constructed in the Gulf of Finland, in an attempt to save Leningrad from watery rebellion once and for all. Sceptics warned that the whole gulf would become overgrown with algae, and that the water would turn as stagnant as a marsh. Nowadays we see they were not altogether wrong.

No other town in Russia has committed so flagrant an assault on the natural world; none has bound nature's body in so rigid a strait-jacket. And when, having crossed a bridge with some mighty classical statue, you turn the corner and suddenly find an ancient Egyptian sphinx, you realise that this city is a kind of inventory of world civilisation. It is a model constructed for the enlightenment of Russia, a country where civilisation of any kind has never been an entirely welcome guest...

As I write these lines I suddenly wonder whether someone else has already beaten me to them. And there you have one of Petersburg's problems. The city is so different from everything else built in our glorious fatherland that it has unwittingly caught the attention of any old scribbler with the slightest literary pretensions. So I shall leave philosophical musings behind, and turn instead to the psychology of the Petersburger himself – a subject surprisingly little studied but full of paradox and contradiction.

There can be little doubt about the key to the psychology of the Petersburger: the suddenness of the city's emergence as Russia's new capital at the beginning of the eighteenth century, and its equally sudden destruction, or rather, its transformation into a provincial town, at the beginning of the twentieth. Imagine for a moment that you are a private in the army, and then suddenly one fine morning you wake up a general. Not a sergeant – a general. What on earth have you done to deserve your promotion? Goodness knows. Then you spend a couple of weeks in your new post, begin to get used to bossing others around, when suddenly – whoosh! – you've been demoted back to a batman. An experience like that would be enough to dull anyone's senses. Little wonder, then, that Petersburgers suffered some psychological damage. After all, their city spent two hundred years as the capital. But then what is two centuries in the thousand-year history of the Russian Empire? Just long enough for the people to get used to their status as chosen ones.

On my regular visits to Petersburg during the eighties and nineties, I noticed one strange truth about its inhabitants: while in public they are all extremely proud of their unique city, in secret they would all much rather move to Moscow. The reason for this curious internal muddle is not just the city's demotion to provincial status. There is, it seems to me, another subconscious force at play here: quite simply, you cannot live all your life in a museum. A museum is a place you go on a Sunday, with all the family, so that on a Monday you can put great statues and monuments behind you, like a bad dream. But when the Heavens have decreed that you are to live in a museum, sleep in a museum, bring up your children in a museum – well, the instinct is to shut the museum down and smash its exhibits to pieces. This, it seems to me, is the cause of the destructiveness and cannibalistic wit of the Petersburger's attitude towards his place of birth. Longed-for Moscow, meanwhile, which everyone curses in public, is not a museum at all; it is a capital city, where money flows and big decisions are taken.

If you walk down Kamennoostrovsky Prospect from the islands towards the Peter and Paul Fortress, you may pass a little courtyard with a granite statue of Lenin. In the eighties there was some kind of educational establishment here, and Lenin sat on his stone pediment, eyes narrowed in a pose of Socratic wisdom, watching the passers-by from his motionless world.

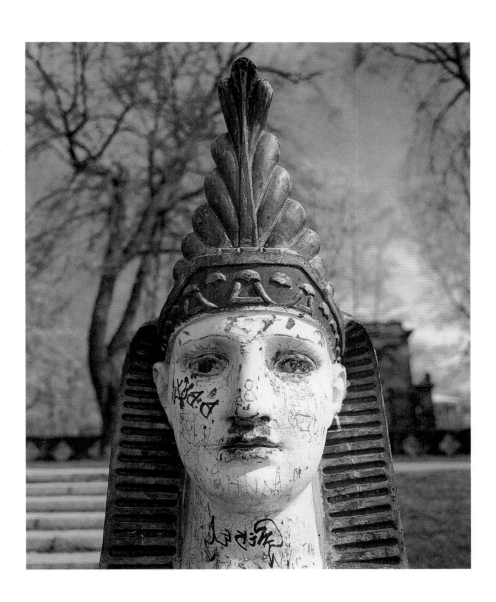

Sphinx on Kamenny Island

He seemed to be uttering that popular inscription on Soviet gravestones: 'You are but a guest here; I am at home.' For some reason the locals took against the old fellow. First his left eye was removed, then his right. How they managed to get the stone out was a mystery; a catapult would hardly have been up to the job, so someone must have climbed up during the night and taken a chisel to his face. After this, Vladimir Ilich looked like a thug who'd had an extremely rough encounter the night before. Anyway, the city authorities replaced his eyes, but a few days later the same thing happened again – and neither the KGB nor the might of the Soviet state could put a stop to these popular avengers. Finally the authorities gave the great leader a new head. But something wasn't quite right. The head was a little smaller than before; suddenly his shoulders and torso seemed quite monstrous, while his head was micro-cephalic. You might have thought the miserable state of the poor chap would have had people reaching in their pockets for charity. But no: soon the whole thing started again, this time with the right eye first.

There is little intrinsically Petersburgian about the broken noses of the numerous Dianas and Venuses in the Summer Garden. The antique marble nose seems to possess just as great an attraction for the Muscovite. I suppose there is a certain necrophiliac eroticism about the removal process, and in this respect, at least, the two cities are in close agreement. Not far from my flat in Moscow stands the former estate of Count Sheremetev, with, of course, its garden full of statues. Just recently these proud demi-gods and goddesses have been struck down with syphilis – their noses broken off, and their snow-white lips given a bloody punching. The Summer Garden in Petersburg is no different. In my imagination I see a little office somewhere in the city dedicated to nose restoration, where ready-prepared, delicate noses are lined up in their dozens in the sculptor's workshop, awaiting their moment of truth. (Disappearing noses are nothing new in Russian culture: Gogol devoted a whole story to the theme. In *The Nose*, Major Kovalyov's proboscis drops off and decides to leave its owner for a career in the Department of Science.)

It is said that such vandalism was the fault of Romanov, the Party Chief with the royal surname, who governed Leningrad in the 1970s and 1980s. He threw the city gates wide open to inhabitants of nearby villages, who, in return for accommodation, agreed to work in Leningrad's numerous factories. At the time these people were called *limitchiks*, since they lived on the city limits. Like all new arrivals, they couldn't care less about their new home, didn't give two hoots for tradition, never read Pushkin, and at the mention of the word 'culture' would call the police. But I'm not sure this tells the whole story. People's sense of belonging, of place, came under assault throughout Soviet Russia. With a flourish of the pen, the authorities resettled entire populations in new parts of the country, while Soviet youth was sent out to construct communism – only for it to become apparent that, due to an error in the accounts, construction would take a little longer than anticipated. Sadly, the process of 'dumbing-down' during the Soviet period affected everyone, not just Petersburgers.

Nevertheless, there remains to this day a certain sense of lordliness about the inhabitants of Petersburg. This is not, I think, the result of aristocratic roots, long since dug up or washed away. Rather, it arises from the city's museum status and in particular from the unique living space that this museum provides. If a Petersburger weeps on your shoulder and tells you that he is freezing in his communal flat, don't believe him. Or at least, he probably

does live in a communal flat, but it will be bigger and better than many individual flats in Moscow. Try reading the essay *A Room and a Half* by Nobel prize-winner Joseph Brodsky, in which the poet describes his childhood in a Leningrad communal flat, and how he used book shelves to give himself some privacy from his parents. Well, I've seen that 'room and a half'. Different people live there nowadays, but the flat itself is the same: magnificent ceilings over three metres high, solid brick walls, air and space...what hardship! Try telling that to me, a grubby little Muscovite, whose childhood was spent in a two-storey wooden barrack, in a room four metres square, where there was me, my mother and my cheerful crook of a father, who every time he came home had to bend down so as not to hit his head on the ceiling. Even today, in the daring dawn of Russian capitalism, the Petersburger is still better off than the Muscovite in terms of accommodation. Property prices in the city on the Neva are lower than those in the capital, so that the Muscovite may look with a certain envy on his gentrified cousin in Petersburg, for whom three-metre ceilings are the norm and 'a room and a half' a frankly unacceptable infringement of his civil rights.

Pursuing further this comparison between the psychology of the inhabitants of Russia's two largest cities, we uncover certain inaccuracies in the myths surrounding them. Or, more precisely, we discover that the myths of the nineteenth century are sadly contradicted by the realities of life in the twenty-first. For example, the view persists that the Petersburger is necessarily a westerniser and a democrat. He may be coughing blood, may even be in the last stages of consumption, but this will not stop him from exposing the hidebound meanness of despotic power or from dragging the country (as usual, digging its heels in like a mule) towards the West. This myth was, inevitably, a nineteenth-century creation which arose when the liberal critic Belinsky took the 'reactionary' Gogol to task for his advocacy of Orthodoxy in *Extracts from a Correspondence with Friends*. Belinsky subsequently went into battle with Slavophiles in Moscow about the future of Russia, and soon the conflict between the two cities was defined: the democrat-cosmopolitan from Petersburg against the patriot-Slavophile from Moscow.

According to this myth, the Muscovite is a ruddy, salt-of-the-earth type. He is a staunch defender of the monarchy, who spends all day sitting by his samovar. He doesn't wear a frock-coat, like the west-leaning Petersburger, preferring instead traditional coarse overcoats and sandals. This conflict was not limited purely to pre-Soviet times. Where, for example, was the Soviet Union's first and most famous rock-and-roll club, that quintessence of westernisation and democracy? In Leningrad, of course. And where could you buy the finest cakes in the land, comparable to Vienna's best? Why, in the Café Nord on Nevsky (although it is true that the ever-vigilant communists changed the name of this popular bakery to 'Sever', the Russian for 'north').

But such examples seem to me the mere tip of the iceberg – an iceberg which reveals an altogether different story in the murky depths beneath the surface. Drawing on my own personal experience of Petersburg, I have reached the conclusion that the patriotic salt-of-the-earth type – or perhaps salt-of-the-water would be more appropriate – is in fact the Petersburger. The proof lies in the city's legends and folklore. Ask a member of the Muscovite intelligentsia about the capital's legends, and he'll shrug his shoulders and tell you some half-hearted tale about Stalin: how he loved the Moscow Arts Theatre, perhaps, or how he remained in heroic isolation in Moscow as Hitler's forces advanced.

But the native Petersburger is another thing altogether: he'll tell you stories to make your eyes pop out of your head.

For example, there is a place in the city where to this day you can meet the ghost of Peter the Great. If the city authorities had any business sense, they would long ago have fenced it off and charged an admission fee. It is the square by the cathedral inside the Peter and Paul Fortress. Here, for the last two centuries, a sorrowful shadow of enormous height has appeared. Come to Petersburg in the autumn, and wait for a particularly miserable night, when the grey waters of the Neva beat against the embankments and a slimy drizzle pours from the cold night sky, and go to the fortress. It is more than likely that you will meet the ghost. (Only do be careful: a stroll with the deceased Peter traditionally promises the living nothing but trouble.)

The first time the dead tsar appeared – if my memory serves – was to Paul I in 1790, when the ghost warned his heir to expect a violent death. Then, at the beginning of the nineteenth century, Alexander I met the same spectre, who told him something about a forthcoming invasion of Russia by the French. In the 1850s the phantom also warned Nicholas I about failure in the Crimean War. And as for the Soviet period – well, the ghost had a phantasmagorical field day. There is a famous statue in front of the Finland Station in Petersburg. It portrays the leader of the world proletariat, V.I. Lenin, who has mounted an armoured car and is pointing towards the Winter Palace, signifying that it is time to seize the building. Anyway, one winter's night in 1943, when Leningrad, besieged by fascist forces, was dying from hunger, it seems that Lenin mysteriously got down from his armoured car, and in his place in similar pose appeared Peter – only this time he was pointing not at the Winter Palace, but in the general direction of Moscow, from where deliverance did indeed come.

Who could think up such stories? Clearly only a true city-patriot. And the more fantastic the legend, the stronger the patriot's belief in it. Nor do these stories end with the ghost of Peter the Great. The same cathedral in the Peter and Paul Fortress contains the remains of the monarchs who ruled the country from Petersburg. Legend has it that the tomb of Alexander I is empty. It is said that, having driven Napoleon from Russia and entered Paris with the allies, the tsar did not in fact die in 1825, but merely faked his own burial. An empty tomb was lowered into the ground of the Peter and Paul Cathedral, and Alexander himself, wearing his traditional overcoat and calling himself Fyodor Kuzmich, became a vagrant amongst the people. Lev Tolstoy believed this, as did the great twentieth-century Russian mystic Daniil Andreyev, who described the tsar's posthumous travels in great detail in his book *Roza Mira*. To top it all, this same Daniil Andreyev claimed that Petersburg had a double under the earth, in one of the circles of Hell. This infernal Petersburg contained copies of many of the real city's monuments, including St Isaac's Cathedral and the Bronze Horseman, although, apart from ghosts of humans, the only inhabitants were giant extinct reptiles.

Moscow has no such apocrypha. In this sense the modern Muscovite is more cosmopolitan, practical and level-headed than his Petersburg counterpart, if by level-headedness we mean a desire not to mythologise the place where we live. The Muscovite has a relaxed attitude towards the authorities, perhaps because he is relatively sated and well provided-for. The Petersburger is more given to extremes. At the end of the 1970s, for example, some thick lettering in white oil paint appeared on the wall of the Peter and Paul Fortress:

'DOLOI KPSS!' ('Down with the Communist Party of the Soviet Union!') The anti-soviet slogan was quickly painted over, but it was talked about in Russia for several years after.

A good friend of mine from Altai, in Siberia, likes to relate an episode from his distant youth. He found himself in Leningrad for the first and last time in his life and, naturally enough, got lost. He was amazed at the way people led him by the hand and explained to him in great detail how to find the street he was looking for, telling him various stories from the city's history along the way. This is one of Petersburg's immutable laws. Try this experiment for yourself: look as though you are lost in Moscow, and ask a Muscovite for directions. He is more likely to show you two fingers than to show you the way. A Muscovite knows nothing and can't see beyond the end of his nose. This is not because he is completely without soul, but simply because he doesn't see the need. He loves his city insofar as it gives him money and the status of inhabitant of the capital. But in Petersburg it is entirely different. Any adult will offer you all the geographical help they possibly can. (Don't try this experiment with young people: in both Moscow and Petersburg they are only virtual, which is to say tangential to reality – but that is really more of a problem for the Ministry of Health.)

How does one explain the Petersburger's concern for his fellow man – if concern is what it is? I am not sure that we are talking here simply about nobility of the soul; I suspect there is another subconscious psychological factor at play. As we know, the Petersburger lives in one giant museum; it follows, therefore, that in the depths of every citizen of Petersburg lurks a secret museum guide. Only the presence of this secret guide can explain the torrent of tiresome stories about the city's history, which would be enough to drive you mad were they not actually rather interesting for people who have spent their whole lives hemmed in by Lenin Avenue and Communist Street (I am referring, of course, to Muscovites, who until recently were drowning in a morass of Soviet street names). And I suppose an American – whose streets, after all, bear numbers rather than names – might be interested to know why 'such and such a street' used to be called 'old such and such a street', and the precise historical significance that should be attached to this remarkable change.

In my dealings with Petersburgers over two decades I have noticed one other mysterious feature: a distorted sense of time where, in the mind, day merges into night, and night passes smoothly into day again. In comparison to Muscovites, people from Petersburg are quite bohemian, in the sense that they appear unable to distinguish between morning and evening. It is extremely rare to find a Muscovite sitting at a laden table late into the night, whereas a Petersburger wouldn't think twice about setting off to visit his friends at midnight. I think this is not so much the result of some inborn artistic nature, but rather the effect of the white nights, which are well known to have damaged the psyche of Petersburg's inhabitants. The pinkish glow of the unsetting sun in June and July creates an illusion of relativity in the daily cycle. And suddenly every Petersburger has to grapple with the question: is it really necessary to sleep at night, and is it really necessary to go to work in the day? I don't know... perhaps not...

>

Sunbathers on the beach beneath the Peter and Paul Fortress, early spring

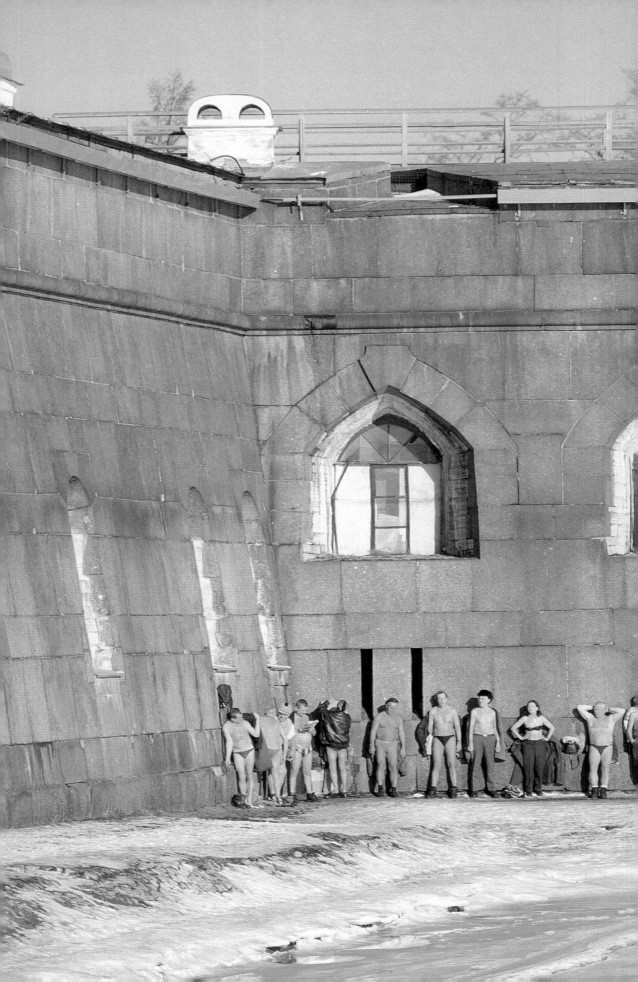

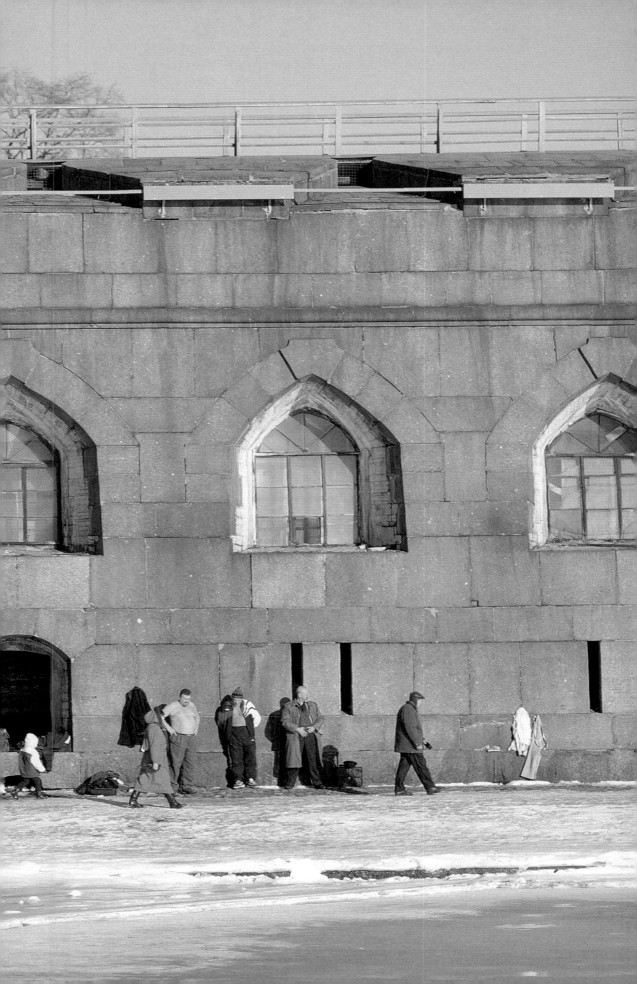

And, of course, the Petersburger is a great lover of water and of dubious dips. Dubious because no one knows about the quality of the water in the Neva, and everyone leaps before they look. In other outposts of the former Russian Empire I have always been amazed by the indifference of the native to the watery mass nearby. This is particularly perplexing in seaside resorts. A stone's throw away, the sparkling sea smiles its welcome, while a warm breeze brings back thoughts of paradise lost – and the native will tell you with a sigh that the last time he swam was back in 1958. 'But why on earth...?!' you exclaim. 'Why should I? You call that sea? Ah, now, in the old days we *used* to have sea...'. And he will proceed to tell you how the quality of the water is not what it was, and that the fish have been poached practically to extinction. But the Petersburger is different. He will slip into the water when he needs to, and he'll slip into the water when he doesn't – which is to say when it is minus fifteen degrees Celsius outside and the shores are covered in snow. This is what Russians call 'walrussing', and the Petersburg walrus shares many features with the walruses of other regions: he has a stout figure and a bright red face (not so much from the icy wind as from the vodka which he has to pour down his neck to warm himself up after the icy water). In Russia we call this strange process 'tempering the soul' or a 'healthy way of life'.

The headquarters of Petersburg swimming is the sandy beach beneath the Peter and Paul Fortress. As soon as the sun peeps out from behind the clouds the grey walls of this former prison become dotted with naked bodies; people stand leaning against the stony surface, their arms thrown open wide like signallers on some great aircraft carrier. This explains why in summer the Petersburger is rather more tanned than the Muscovite, despite both of them being slaves to vast cities fundamentally ill-suited to recreation. But the Petersburger doesn't like to admit this, and so when the sun comes out the city on the Neva takes on all the features of a resort town. The tables and chairs from endless cafes litter the pavements; the citizens, taking a swig on their beer, could be on a beach; the canal water sparkles like the sea. Where shall we go and have a dip? Oh, anywhere will do.

Let us take a walk up towards the islands. We leave Kamennoostrovsky Prospect behind us, and before crossing the Bolshaya Nevka to Chernaya Rechka (where Pushkin once had a fatal duel) we turn left. We soon find ourselves walking through parks with numerous canals and relatively clean air. Glimmering darkly behind forbidding fences stand the comfortable dachas of former party leaders and today's equivalent – close friends of the mayor. But mere mortals are also allowed to come here, because as well as the dachas there are sanatoriums for those with respiratory diseases. On weekdays you won't find anyone in these green glades, and you can spend half a day wandering along the shady alleys, alone almost in the city centre. This area is particularly strange in April. On several occasions in spring I have witnessed the same climatic scene: over a couple of days the sub-zero wintry temperatures suddenly soar into the twenties. The head spins from the sudden change in pressure and temperature. And on the islands a dream-like atmosphere reigns: clods of melting snow lie all around, while the occasional individual who has wandered off this way removes his T-shirt and suns himself on a bench in the sudden warmth of the northern sun.

But I too have wandered off course. Anyway, on the islands there are various ponds where Petersburg's citizens go swimming in summer. I don't know what they are like now, but in the 1980s they were relatively clean, which

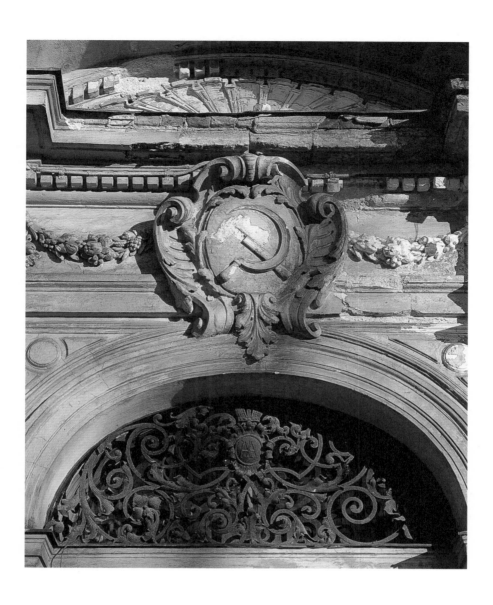

Door architrave detail from the Palace of Grand Duke Alexei Alexandrovich on Moika Embankment; the Grand Duke's double-A monogram is dwarfed by the later addition of the Soviet hammer and sickle emblem

is to say that the water was more or less clear, and there was no broken glass under your feet. These ponds can be found in the so called 'zone of rest', alongside tennis courts and ping-pong tables. You can take a dip, rub yourself dry, and then go and play ping-pong until it's too dark to see. The Muscovite cannot even dream of such pleasures. Obviously, swimming in the ponds is not entirely legal – it is officially forbidden – but, as we have noticed, the Petersburger is prone to extremes, and where it is a question of dipping, nothing will stop him. And if the quality of the water isn't good enough for you, you can always go out of town, to Gatchina for example, the former palace of Emperor Paul I. Here the water in the artificial lakes and canals, which were dug out in the eighteenth century, is especially cold, black and transparent. This strange combination of transparency and blackness is the result of the peat that lies up to ten metres down: you can see the outline quite clearly from the surface. And if you don't like Gatchina, then go back into the centre of town and swim in the icy Neva. The inhabitant of the Northern Palmyra is particularly proud of this river, and always considers it far superior to the Moscow River. And indeed the capital's waterway is little more than a village stream, albeit a rather heavily soiled one, while to this day the Neva continues to provide water for the city's drinking system. Once, on a hot summer's day, I resolved to dive into its steel-blue depths. How can I describe this dangerous experiment? I felt as though I had fallen headlong into some grimy cellar. The water, bitter to the taste, and harsh like sand-paper, burnt my body. I never tried swimming in the Neva again.

Today the Petersburger harbours a secret hope: a return to lost glories. It excites him, and prevents both sleep and creative activities. For a new force has come to power in the country – the so-called 'Petersburg team'. President Putin, as we know, is from Leningrad, and in the long-established Russian tradition he has summoned his fellow townsmen to the capital. It is an entirely natural process, for who can one trust if not those with whom one has grown up? In normal Petersburgers, however, it has encouraged the illusion of hated Moscow's imminent demotion. Soon the capital will be turned into some provincial backwater on which the Petersburger can look down from on high, his inner loathing barely concealed. Petersburg's three hundredth anniversary has only added fuel to the fire: huge sums of money have been spent on the celebrations, and money – regardless of where it comes from – raises the sweet, tantalising question: what if? What if it were suddenly to come true? What if Russia once more were to regain its former capital, 'The City of the Bronze Horseman', 'The Window on Europe', and so on, and so on?

But I think I know how to bring the dreaming Petersburger back down from his cloud to this sinful earth. You just need to ask him a simple question: 'So what is your city actually called?' And here you will be met with an agonised pause. For the city has been renamed so many times that no one really knows what its name is. Saint Petersburg, Petersburg, Petrograd, Piter, Petropolis, Leningrad, Northern Palmyra, Venice of the North, City on the Neva, Cradle of the Revolution... which of these is it? No one knows.

A regrettable fact, of course. All the same I love Petersburg. I love it because this city makes me laugh. Even more than Odessa (which, as every Russian will tell you, is a highly amusing sort of place). And as for dull, indifferent Moscow – well, there's simply no comparison.

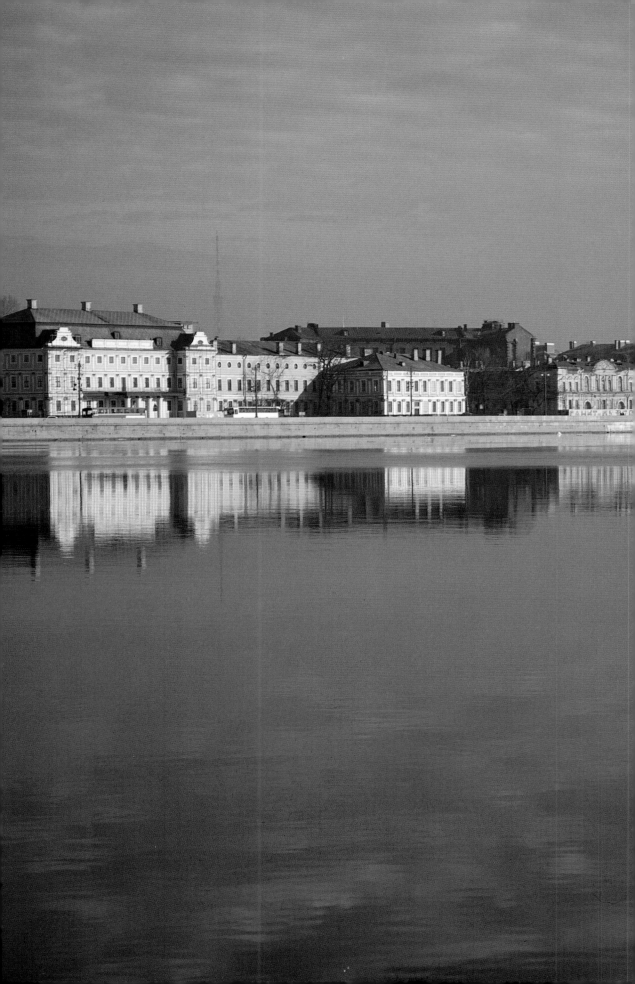

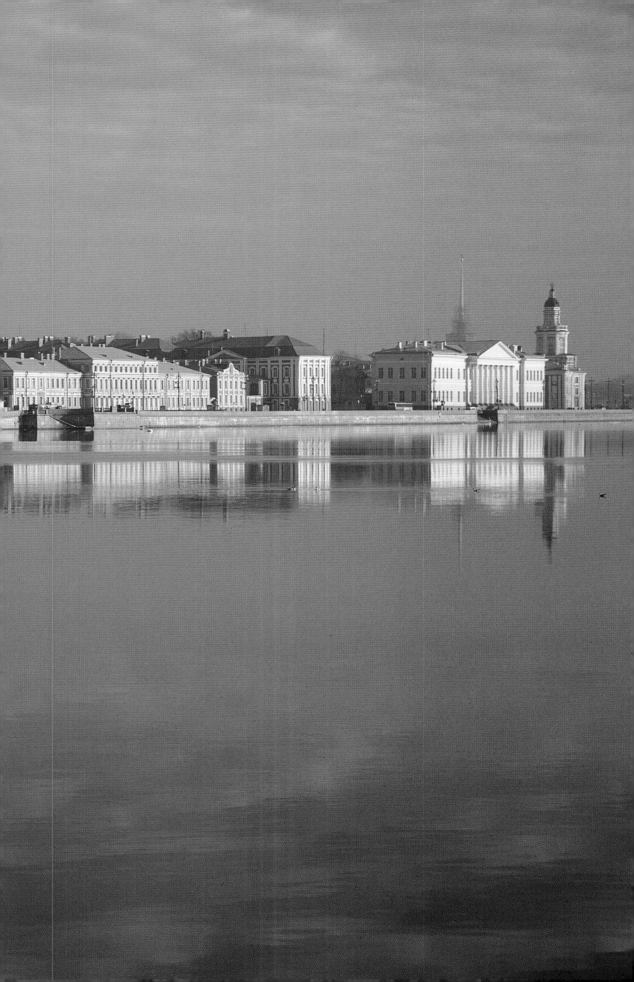

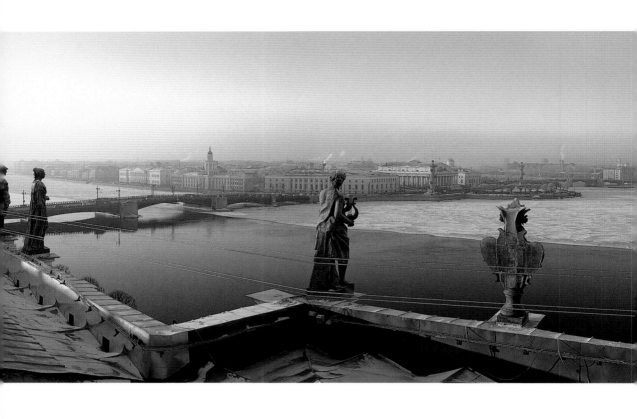

View across the Neva River
from the roof of the Winter Palace

<

University Embankment, Vasilevsky Island

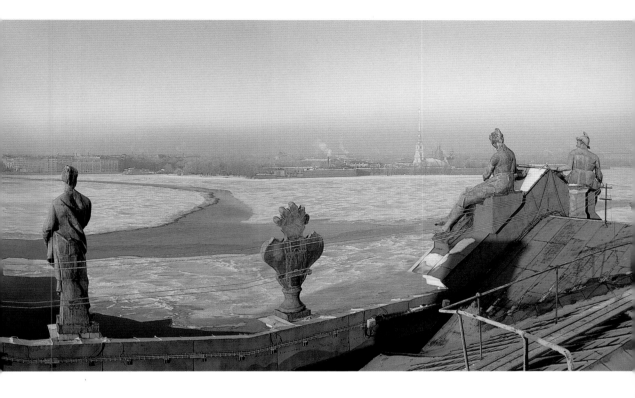

'In the final analysis, the rapid growth of the city and of its splendour should be attributed first of all to the ubiquitous presence of water. The twelve-mile-long Neva branching right in the centre of the town, with its twenty-five large and small coiling canals, provides this city with such a quantity of mirrors that narcissism becomes inevitable. Reflected every second by thousands of square feet of running silver amalgam, it's as if the city were constantly being filmed by its river, which discharges its footage into the Gulf of Finland, which, on a sunny day, looks like a depository of these blinding images. No wonder that sometimes this city gives the impression of an utter egoist preoccupied solely with its own appearance. It is true that in such places you pay more attention to façades than to faces; but the stone is incapable of self-procreation. The inexhaustible, maddening multiplication of all these pilasters, colonnades, porticoes hints at the nature of this urban narcissism, hints at the possibility that at least in the inanimate world water may be regarded as a condensed form of time.'
Joseph Brodsky, 'A Guide to a Renamed City'

Peter and Paul Fortress

The Peter and Paul Fortress is the historical centre of St Petersburg: 16 May 1703, when construction of the fortress began on Zayachy Island, is generally taken as the date of the founding of the city. To the north of the island a separate earthwork rampart, known as the Kronwerk, provided defence against attack on land. In the 1850s the Kronwerk was replaced by a military museum.

Although the Peter and Paul Fortress was designed to keep Russia's external enemies out, it quickly became rather more useful as a place to keep Russia's internal enemies in. Among its early prisoners was Peter the Great's son, the Tsarevich Alexei, who had become the focus for opponents to his father's reforms. Brought up by his mother, Alexei spent much of his life abroad in an attempt to further his education and avoid his father. In 1717, however, he was persuaded to return to Russia, where he was promptly arrested, incarcerated in the Peter and Paul Fortress and sentenced to death. The sentence was never carried out: after torture and interrogations, some personally administered by his own father, Alexei died on 26 June 1718.

In 1772 a woman appeared in Paris claiming to be the daughter of Empress Elizabeth (and hence a more direct claimant to the throne than Catherine the Great). Catherine sent Count Orlov to seduce the impostor into coming back to Petersburg, where she was locked away in the Peter and Paul Fortress. According to legend Countess Tarakanova, as she came to be known, drowned in her cell during the flood of 1777, her demise portrayed in a famous painting by the romantic artist Konstantin Flavitsky. In fact the Countess died in prison of consumption two years before the flood.

In 1924 the Soviet authorities turned the Peter and Paul Fortress and its prison into a museum. For it was here that the leaders of the 1825 Decembrist uprising were imprisoned and executed, while throughout the second half of the nineteenth century various political prisoners (including Lenin's brother Alexander) were held here. One of the Decembrists, Alexander Muravyov, described the revolutionaries' view of the place: 'The Peter and Paul Fortress – a vile monument to autocracy against the background of an imperial palace – stands as a sinister symbol to illustrate that one cannot exist without the other'.

Peter and Paul Fortress, curtain wall (detail)

>

Aerial view of Zayachy Island and the Peter and Paul Fortress

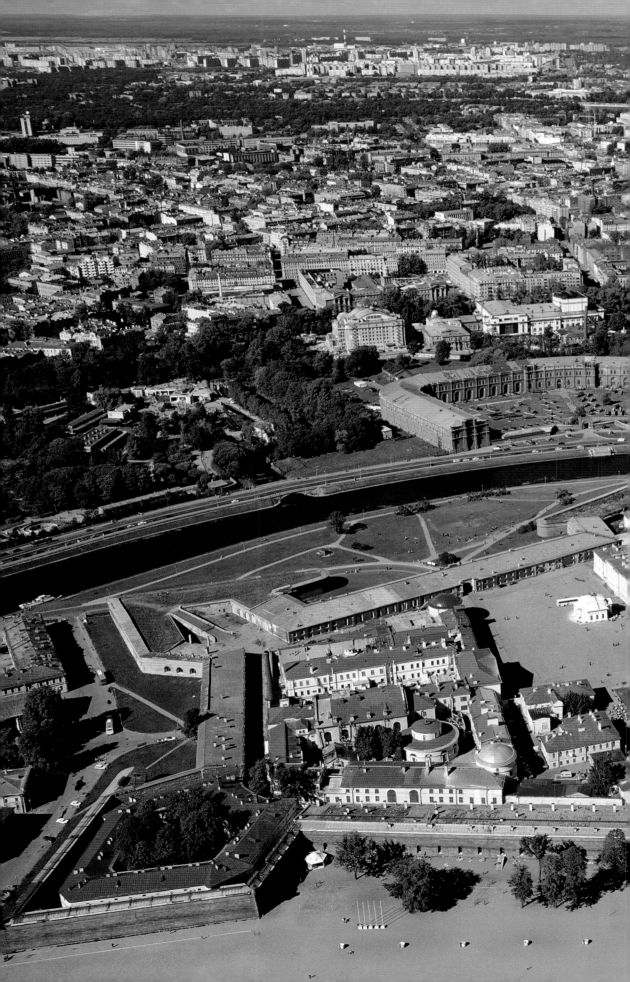

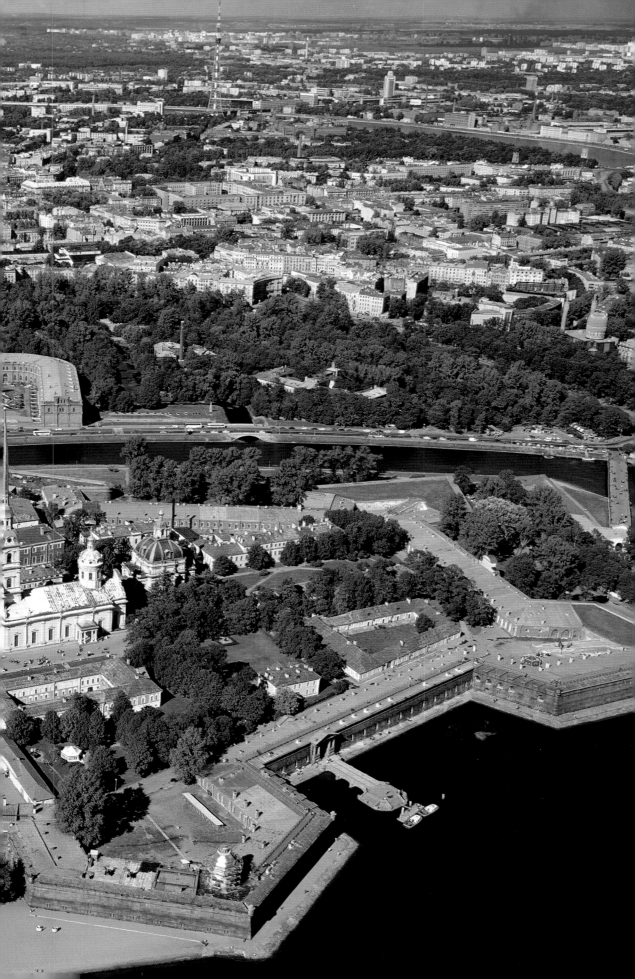

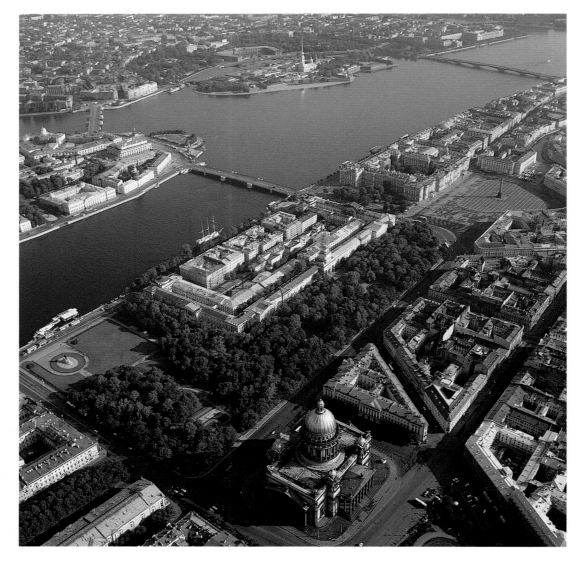

Voznesensky Prospect

Gorokhovaya Street

Nevsky Prospect

Admiralty

After fire destroyed much of the area surrounding the Admiralty in 1735–6, the St Petersburg Construction Commission was established under Field Marshal Burkhard Khristofor Minikh. In an echo of traditional Russian radial town-planning, the Commission placed the Admiralty as the focus of three equally-spaced avenues, now Voznesensky Prospect, Gorokhovaya Street and Nevsky Prospect. (The aerial photograph above shows the Admiralty in the centre, surrounded by trees, with the three avenues branching out to the right.) The views of the Admiralty Spire from each of the avenues are among Petersburg's most recognisable, and do much to define the remarkable harmony of the centre of the city.

>
Admiralty Embankment

> >
Cruise ship moored in front of the Rumyantsev Palace on the English Embankment

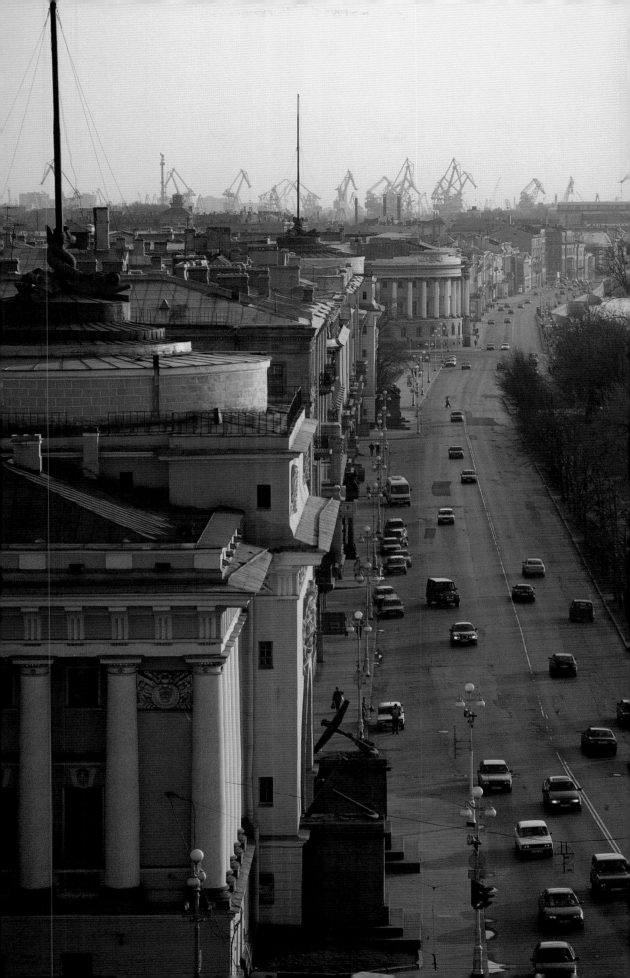

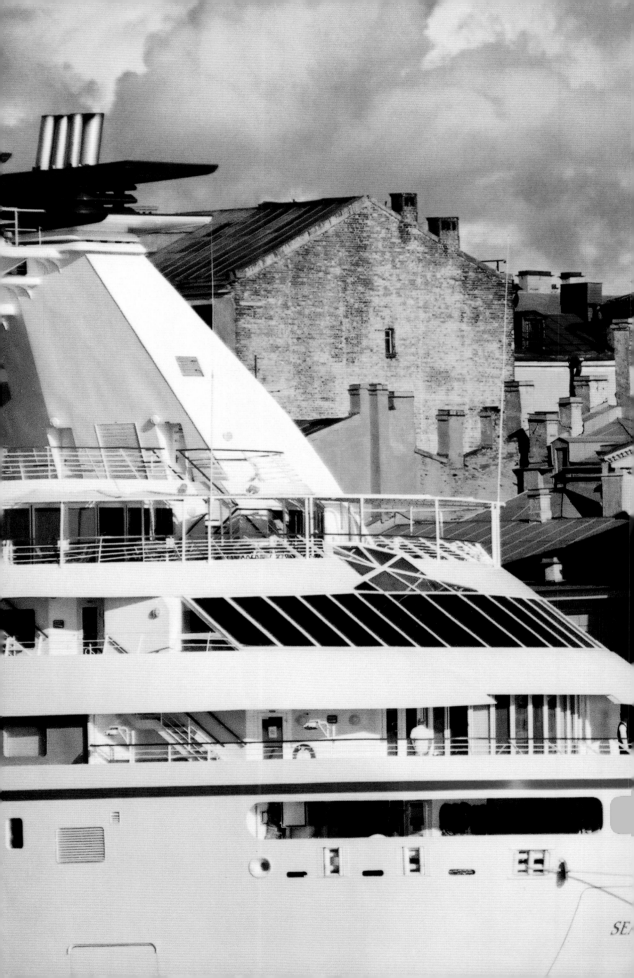

No. 14

Tolstoy stayed here in February 1897
on his last visit to St Petersburg. He
was actively involved at the time in
supporting the Dukhobors, a religious
sect outlawed by the government, and
during his stay he was followed by the
secret police – a task no doubt made
easier by the fact that he famously
wore peasant clothes and attracted
large crowds wherever he went.

No. 16

Fontanka 16 was the headquarters
of the tsarist secret police from the
1830s until 1917. By 1914 over a million
entries on organisations and individ-
uals were kept at this address, each of
them on colour coded cards: yellow for
students, green for anarchists. In the
words of one commentator writing in
1917, there was 'a card on almost any
intelligent man who at any time in his
life thought about politics'.

Fontanka Embankment

St Petersburg's literary associations
stretch far beyond the apartment-
museums and memorial plaques
dedicated to writers like Pushkin,
Dostoevsky, Blok or Nabokov. Walk
down almost any street in the centre
of the city and it is likely that you
will pass a building once inhabited
or frequented by a well-known poet,
playwright or novelist; if not, then cer-
tainly by a famous musician or artist.
This short stretch of the Fontanka
Embankment opposite Mikhailovsky
Castle is no exception.

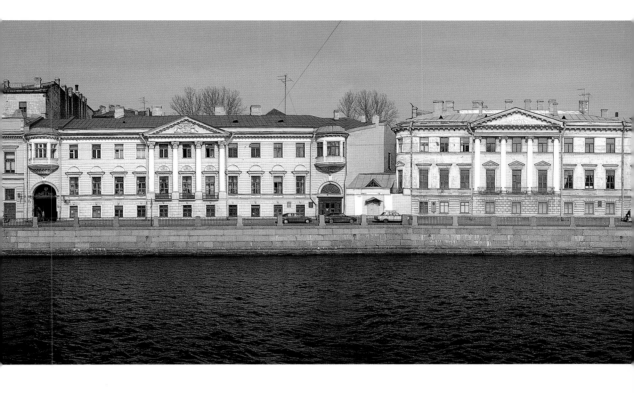

No. 18

In the early 1920s the poet Anna Akhmatova lived here with her friends Olga Sudeikina and Artur Lourié, the composer. Forty years later Lourié described this time: 'I recall how I tried to drag [Akhmatova] away from there long ago; she was stubborn and did not want to come to Paris... We lived together, the three of us, on the Fontanka and the *Poema* [Akhmatova's *Poem without a Hero*] tells of this in a coded way.'

No. 20

Around 1815 the top-floor flat was occupied by two brothers, Alexander and Nikolai Turgenev. Alexander was a founder-member of a literary society called Arzamas, whose meetings were attended by many of Petersburg's leading figures, including Pushkin. Pushkin's poem 'Liberty', about the murder of Paul I in the Mikhailovsky Castle, is said to have been inspired by the flat's view of the castle across the river.

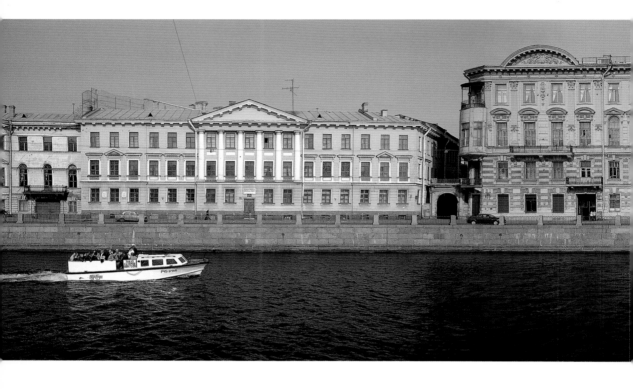

No. 22
The historian Mikhail Pylyaev
lived here. In his small flat filled
with books, engravings and old manu-
scripts he wrote what has become a
classic work on the city: *Old Petersburg*,
published in 1889. Describing the
city's early years under Empress
Elizabeth, Pylyaev tells how the forest
beyond the Fontanka (then considered
the city boundary) was full of brig-
ands; those who owned residences
along the river were ordered by the
police to fell their trees so that the
robbers should have no refuge.

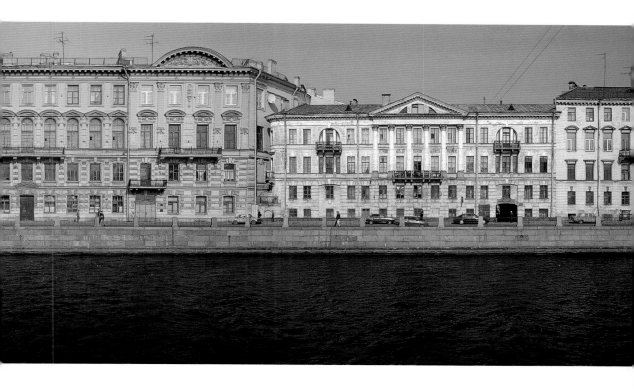

No. 24

Dostoevsky, Turgenev and the composer Rubinshtein were among the regular visitors to the famous 'Fridays' – literary, artistic and musical evenings – held by the poet Yakov Polonsky, which from the 1880s took place in this building. Such circles played an important role in the city's intellectual life in the nineteenth and early twentieth century, providing a link between different generations of writers, artists and musicians.

No. 26

The writer and historian Nikolai Karamzin spent the last three years of his life here, completing his famous twelve-volume *History of the Russian State*. Pushkin later recalled its publication in St Petersburg: 'Everyone, even society women, rushed to read the history of their country... Ancient Russia, it seemed, had been discovered by Karamzin as America by Columbus.'

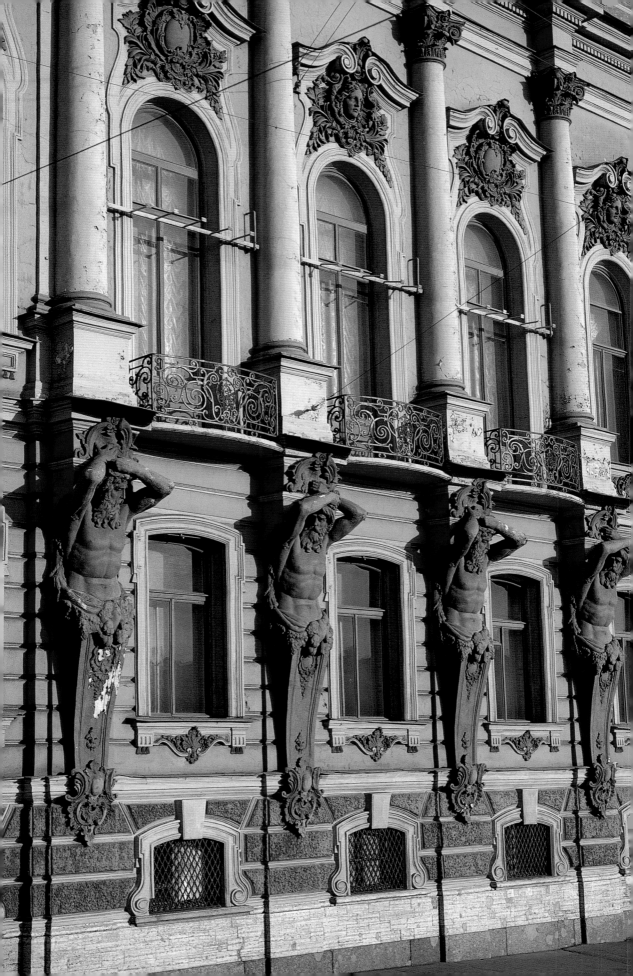

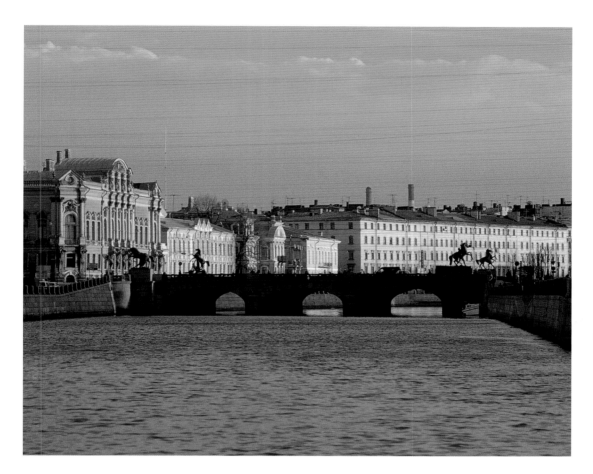

Beloselsky-Belozersky Palace

Built between 1846 and 1848 on the corner of the Fontanka Embankment and Nevsky Prospect, the Beloselsky-Belozersky Palace was designed by Andrei Shtakenshneider in imitation of the eighteenth-century Russian baroque, described by the British writer and diplomat Fitzroy Maclean as 'a rather painful mixture of styles'. The palace's tongue-twister of a name stems from a family that could trace its history back to the great tenth-century Kievan prince, Vladimir Monomachus. In the late nineteenth century, however, it was better known as the 'Sergievsky Palace' after Grand Duke Sergei Alexandrovich, youngest son of Alexander II and uncle of Nicholas II. Sergei was by no means a popular figure, even within his own family. His cousin Grand Duke Alexander Mikhailovich wrote of him, 'Try as I might, I simply cannot find one redeeming feature in his character...Stubborn, rude and unpleasant, he defied his own shortcomings, throwing complaints from anyone back in their faces.' Appointed to the governorship of Moscow by Nicholas, in 1905 Sergei suffered a similar fate to his father, Alexander II, and was blown up by a terrorist bomb. By a certain circularity that would no doubt have appealed to those early revolutionaries, after 1917 the Beloselsky-Belozersky Palace became the headquarters of the local branch of the Communist Party.

Anichkov Bridge over the Fontanka

The Fontanka River arcs through the centre of St Petersburg, flowing from the Neva just east of the Summer Garden and out into the Bolshaya Neva in the south-west of the city. Its name originates from the fact that it used to supply the water for the fountains in the Summer Garden. In the eighteenth century the Fontanka River formed the southern border of the city, creating a dividing line that separated aristocrats, government officials and merchants from the labourers, shipyard workers and street-sellers who lived beyond it. Those wishing to enter or leave the city had to pay a levy and present their documents to sentries at a barrier across the Anichkov Bridge.

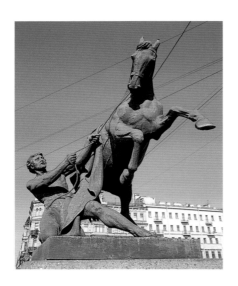

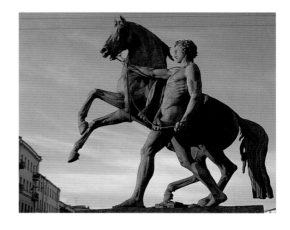

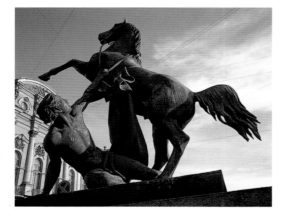

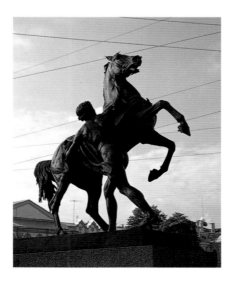

Horses on Anichkov Bridge

The four horses being broken in stand at each corner of Anichkov Bridge; they were erected in 1849–50, the work of Pyotr Klodt. Klodt was something of an equine specialist, responsible for the six horses surmounting the Narva Gate as well as the equestrian monument to Nicholas I in St Isaac's Square.

Restoration work to the Anichkov horses and their tamers took place in 2001 (*right*), the first time that the sculptures had been removed from their positions since the Second World War. During the war Anichkov Bridge itself sustained severe artillery bombardment, but the group of four horses were buried nearby in the grounds of Anichkov Palace and survived undamaged.

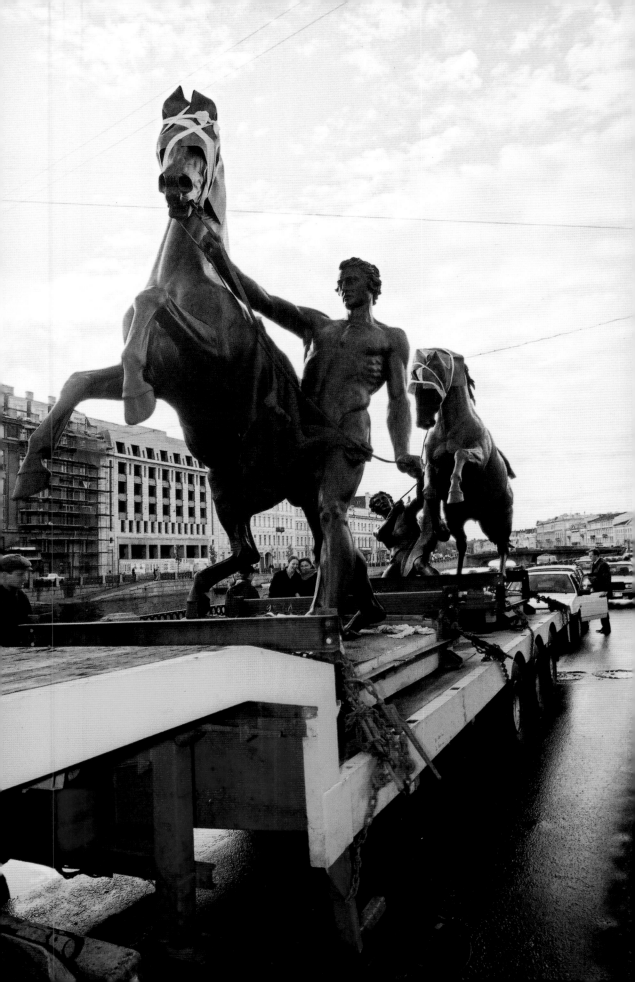

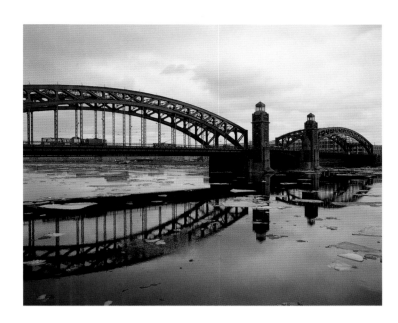

Bolsheokhtinsky Bridge

The Bolsheokhtinsky Bridge spans the
Neva near the Smolny Institute, con-
necting the island of Malaya Okhta
with the main part of the city. Plans
for a bridge on this stretch of the Neva
were in existence as early as 1829,
although by the turn of the twentieth
century ferries still provided the only
means of crossing here. In 1907 one of
these ferries, the *Arkhangelsk*, sank; a
large number of those on board
drowned. Tsar Nicholas II gave the
order that plans for the construction
of the bridge were not to be delayed,
and in 1909 the foundations were laid.
The bridge was originally called the
Peter the Great Bridge, since con-
struction began on the eve of the
bicentenary of Peter's victory in the
Battle of Poltava. The bridge consists
of two outer arced spans 136 metres in
length, and a central span 48 metres
long. Two towers, designed in imita-
tion of lighthouses, stand at each end
of the central span, which lifts to
allow the passage of river traffic.

>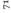

New Holland

St Petersburg's first 'Holland' was an
area next to the Admiralty where ship-
building timbers were kept. The name
referred to the Dutch method of stor-
ing timbers vertically (the old Russian
way had been to lay them flat). When
the Kryukov and Admiralty Canals
were dug out between 1717 and 1720,
a small island emerged which was
an ideal place to store flammable
materials. This became known as
Novaya Gollandiya, or New Holland.
The vertical storage method accounts
for the great height of the warehouses
on the island, whose walls tower over
the buildings around.

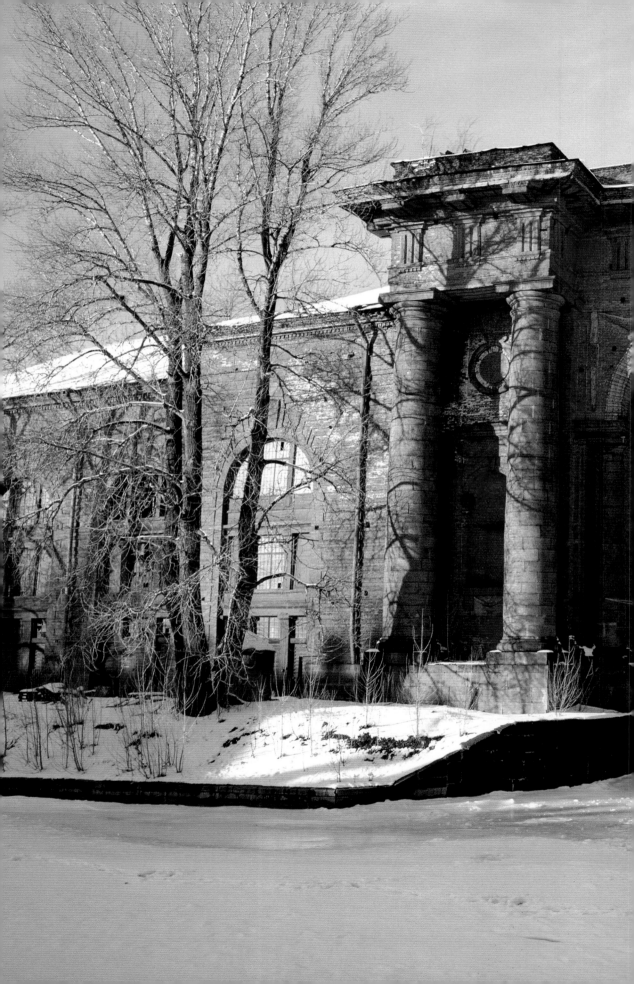

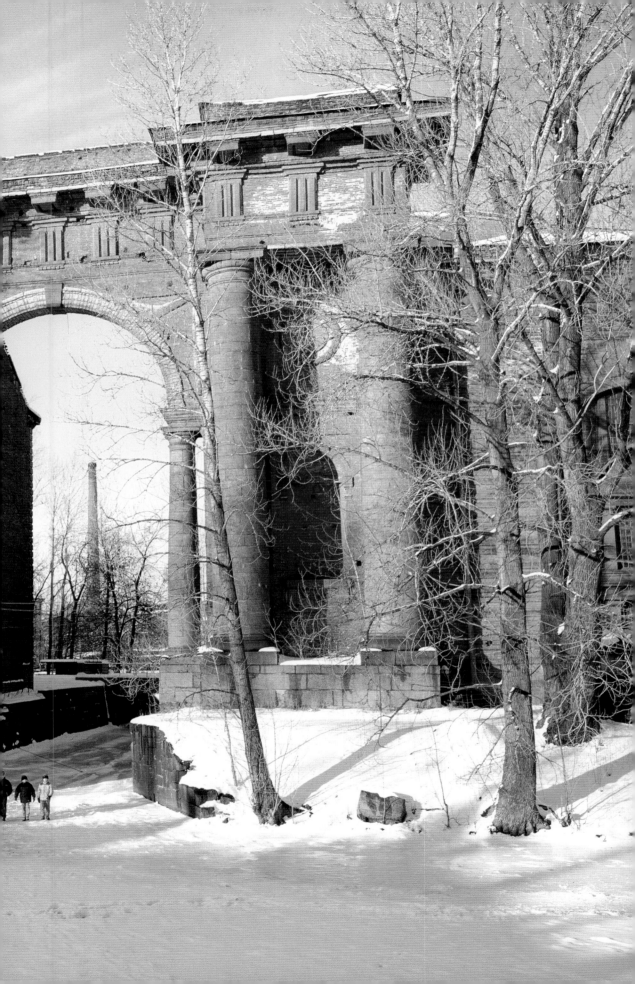

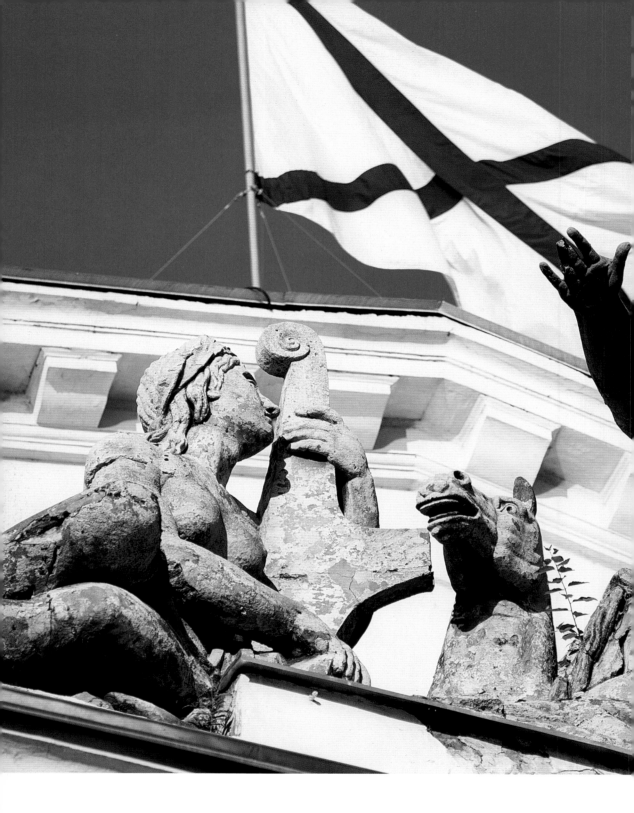

Statue of Neptune, Naval Museum

From its elevated position on the former Stock Exchange building on the spit (known as the Strelka) of Vasilevsky Island, the allegorical statue of Neptune looks out over the widest reach of the Neva river. The Stock Exchange was built between 1805 and 1810 by the French architect Thomas de Thomon, who modelled it on the Temple of Hera at Paestum, near Naples. Having dominated the Russian Empire's trade in securities and commodities around the turn of the twentieth century, the Stock Exchange became redundant after the Revolution and in 1940 was given over to the collection of naval memorabilia originally started by Peter the Great. Its prize exhibit is Peter's *botik* – the small vessel on which the future tsar learned to sail.

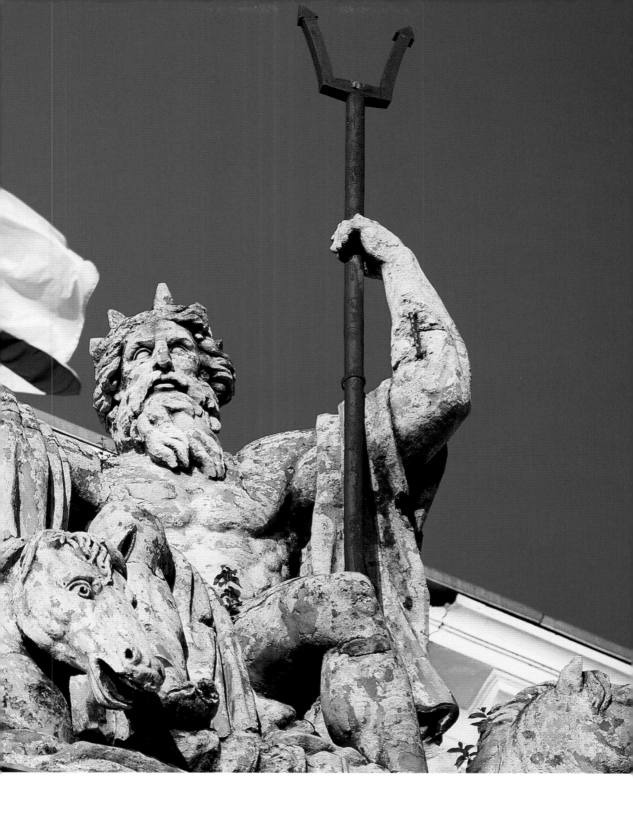

The Cruiser Aurora

The *Aurora*, now anchored on the Bolshaya Nevka near the Nakhimov Naval Academy, was one of the few ships to survive Japan's humiliating defeat of the Russian fleet at Tsushima Bay in May 1905, an event which precipitated the 1905 upheavals often referred to as the first Russian revolution. The *Aurora* is of course better known for the part it played in the 1917 Revolution and the overthrow of Russia's Provisional Government. At 9.40 p.m. on 25 October 1917 the *Aurora*, then anchored alongside the English Embankment, fired one blank round in the direction of the Winter Palace where Kerensky and his ministers were gathered. After a short break to allow those who wished to do so to evacuate the palace, the order was given for the real firing to begin from the Peter and Paul Fortress, the *Aurora* and from Palace Square. Damage inflicted by shells from the fortress and the cruiser was minimal. The following morning the ship's radio was used to broadcast Lenin's address 'To the Citizens of Russia!' proclaiming the victory of the proletarian revolution. At the start of the Siege of Leningrad in 1941 the *Aurora* was sunk in shallow water near Oranienbaum to protect it from German forces, and raised 950 days later, in 1944. It has been a museum since 1956.

Navy Day Celebrations

Navy Day is celebrated on the last Sunday in July, when thousands of striped T-shirts and rakish caps descend on the city's parks and bars. Joseph Brodsky emphasises St Petersburg's unique maritime status within Russia: '... the idea of the sea is still somewhat alien to the general population... The notions of freedom, open space, of getting the hell out of here, are instinctively suppressed and consequently surface in the reverse forms of fear of water, fear of drowning. In these terms alone, the city in the Neva delta is a challenge to the national psyche and justly bears the name of "foreigner in his own fatherland" given to it by Nikolai Gogol.'

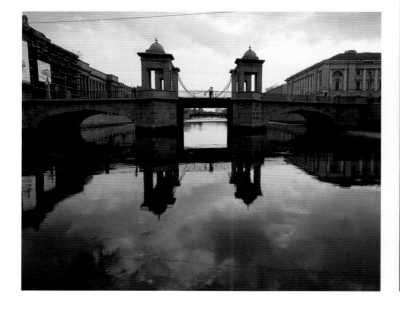

Lomonosov Bridge
Granite embankments were con-
structed along the Fontanka River
in the 1780s. At the same time seven
identical bridges were built across the
river, with granite towers containing
winches to haul the chains that
opened the central drawbridge. Over
the years most of these narrow bridges
were replaced with wider, more acces-
sible metal bridges, and only two have
retained their original design: Staro-
Kalinkin and Lomonosov.

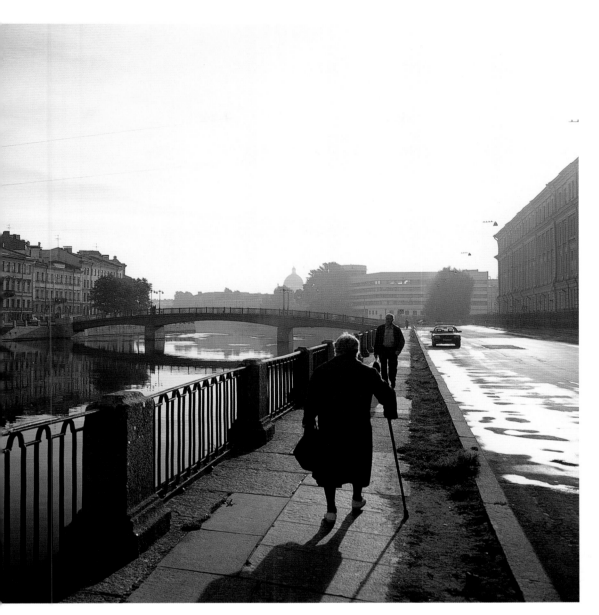

Fontanka Embankment

Further down towards the western end of the Fontanka River, in a district known as Kolomna, the buildings are a little shabbier, a little less formal and elegant than their counterparts up towards the Summer Garden. Dostoevsky described the area in his novel, *Poor Folk*: 'On every bridge were old women selling damp gingerbread or withered apples, and every woman looked as damp and dirty as her wares. In short, the Fontanka is a saddening spot for a walk, for there is wet granite under one's feet, and tall, dingy buildings on either side of one, and wet mist below and wet mist above.'

>

Griboedov Canal under ice

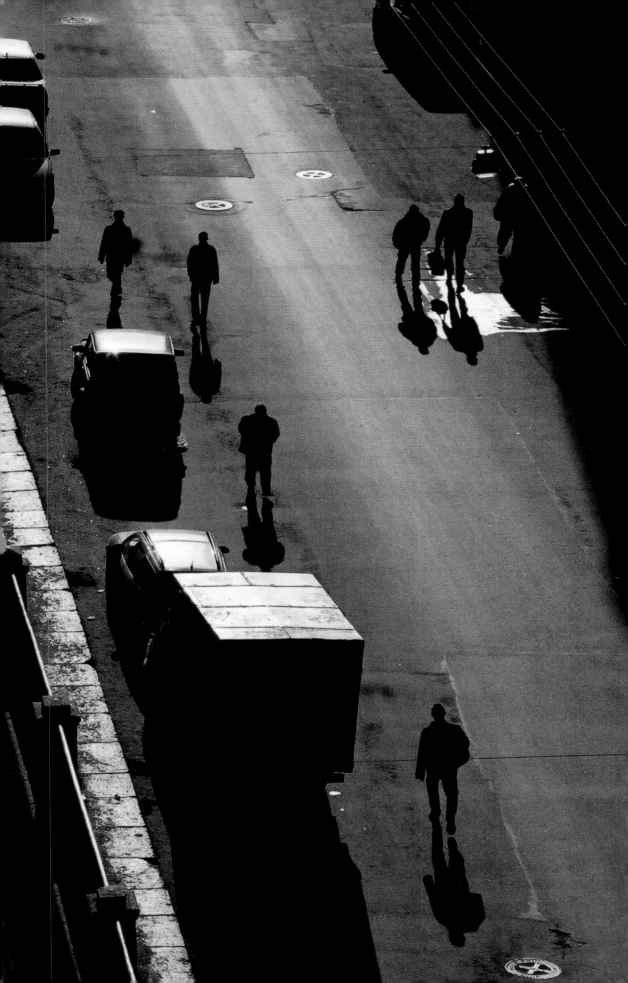

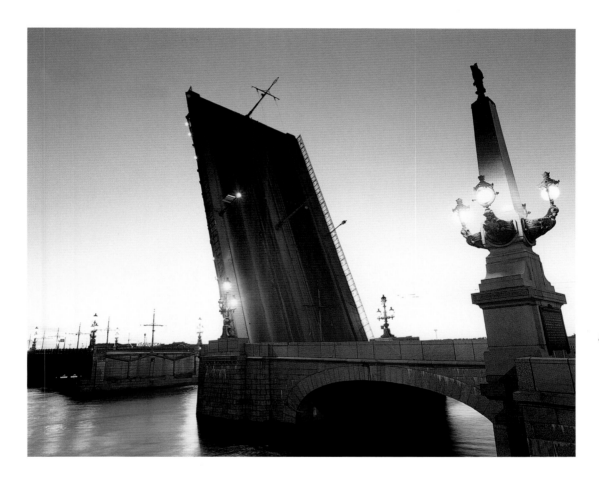

Troitsky Bridge

The Neva River ices over in November, and remains frozen until April. The thaw is marked by the *ledokhod*, or ice-flow, which normally takes place in two phases. First, the river's surface-ice breaks up and flows out to sea; then, about two weeks later, mighty chunks of ice drift down the Neva towards the Gulf of Finland from Lake Ladoga. When the river has once again become navigable, St Petersburg's bridges open nightly to allow the free passage of river traffic. All the bridges open at some stage between 1.25 a.m. and 5.05 a.m. Precise opening times, however, vary from bridge to bridge, often leading to chaos for the city's nocturnal inhabitants and visitors:

queues at one bridge, a frantic dash for the disappointed along the city's embankments to the next, and sometimes a two-hour wait on the wrong side of the river. Troitsky Bridge opened in 1903 to commemorate the city's bicentenary. A number of foreign engineers entered the competition to design the bridge, including the Frenchman, Gustave Eiffel; the final contract, however, was awarded to another French company, Batignolle. Originally a swing bridge, with the central two spans rotating open, Troitsky Bridge was redesigned in 1965 and converted into a lifting bridge, with its distinctive single lifting span.

<

Troitsky Bridge, detail showing the join between the bridge's spans when closed

Высота воды
7 Ноября 1824 года

Flood Water Marker

On 7 November 1824 St Petersburg suffered the worst flood in its history; the water rose 421 centimetres above normal levels. This plaque, on the corner of the Summer Palace in the Summer Garden, marks the flood level on that day. The flood is described in Pushkin's most famous poem *The Bronze Horseman*. Numerous contemporary accounts also exist, including the letters of Konstantin Bulgakov, director of the city's postal service at the time, to his brother Alexander in Moscow.

'*St Petersburg, 7 November 1824*
All night a strong wind has blown in from the sea, and is still blowing. The ditches are full to the brim and probably in Kolomna the streets are already flooded. It doesn't look good...

11.05 a.m.
Since I started this letter the water has risen sharply and we are now surrounded; the Moika has burst its banks... In the house opposite water has started to flood the cellars.

12.10 p.m.
Our street is like a fast-flowing river, the courtyard is full of water. My God, how will this end? How many poor people will perish?

St Petersburg, 8 November 1824
My dear friend, the flood has caused utter catastrophe: bridges swept away, barges marooned on the streets, old trees decimated in the Summer Garden... And many people have died.'

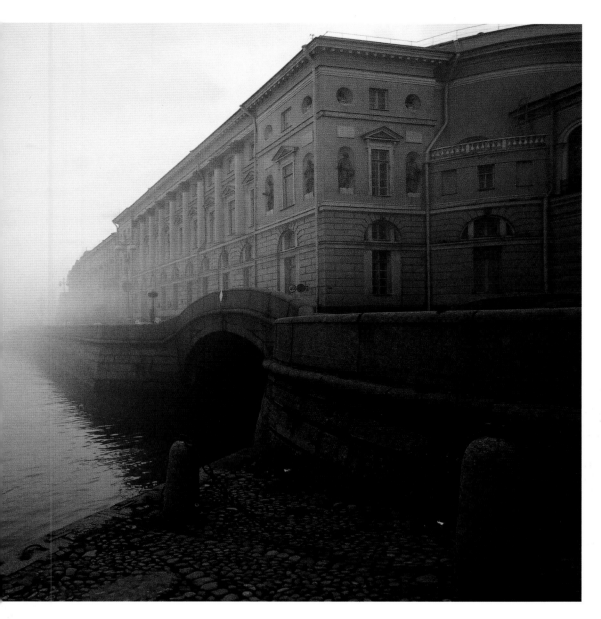

**Hermitage Theatre and Hermitage
Bridge over the Winter Canal**

The Hermitage Theatre was built in
1775–84 by Giacomo Quarenghi as a
private theatre for Catherine the
Great. The Comte de Ségur, French
ambassador at the time and part-time
playwright, described one particular
performance: 'One fine Thursday I
was asked to the Gala at the Hermitage
before the whole Court and the
Diplomatic Corps. I arrived; the
Empress called me and made me sit
below her, actually at her feet. The
curtain rose, the actors appeared and
to my astonishment I saw that it was
my tragedy that they were declaiming.
Never in my whole life was I so embar-
rassed... the Empress who was behind
and above me suddenly took my right
hand in hers, my left hand in the other
and forced me to applaud myself.'

>
Winter Canal

One of Russian opera's most dramatic
moments takes place on the bridge
over the Winter Canal. In Tchaikovsky's
The Queen of Spades Lisa, the heroine,
plunges to her death after Hermann
has rejected her in favour of a visit to
the casino. Pushkin, on whose story
Tchaikovsky based his opera, is a little
more restrained: Lisa goes off and
marries 'a pleasant young man'.

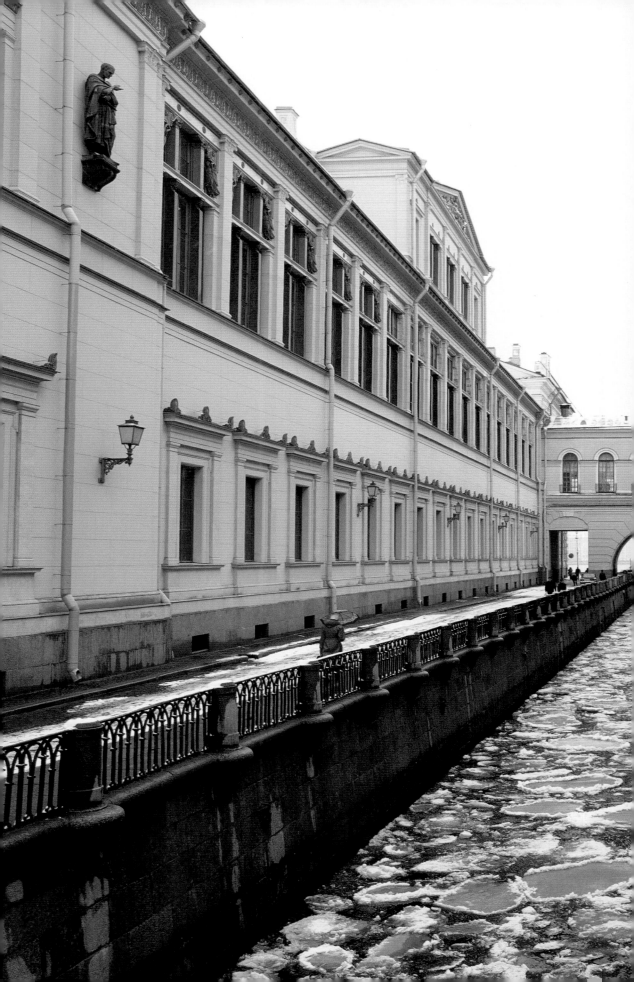

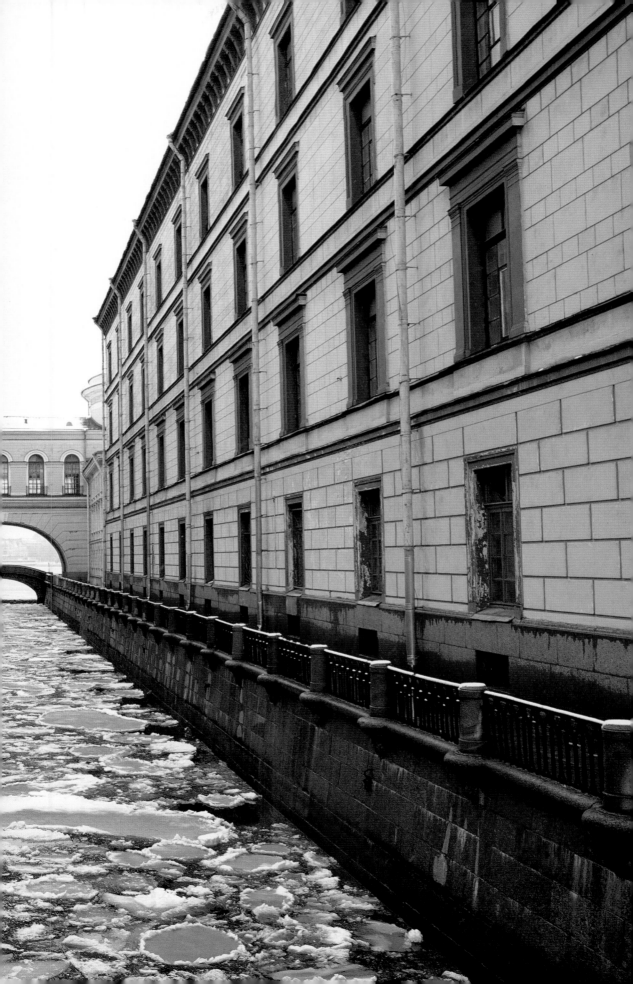

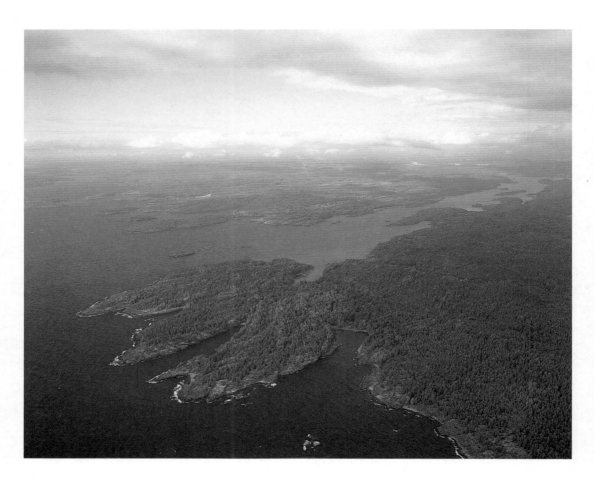

Shore of Lake Ladoga,
north of St Petersburg

Tales of Petersburg

St Petersburg defies the natural order: a city built on water with imported stone. Like the magic city of a Russian fairy tale, it seems to be suspended between sea and air.

The history of the city is enshrined in myth. Even in his lifetime there was a folk legend that Peter the Great had constructed the city in the sky and then found a site for it on the earth below. It was the only way Russians could explain the miraculous appearance of their new capital on the barren, flooded marshlands where the Neva River runs into the Baltic Sea.

An imperial capital without foundations in the Russian soil. What a contrast to the bedrock solidity of landlocked Moscow, where the Kremlin's walls were so firmly rooted to the ground that they seemed to grow from it.

Here was the basis of the myth of Petersburg – the unreal, artificial, abstract, foreign city – which animated so much literature and art in that crucial period of Russian culture, from Pushkin in the nineteenth century to Pasternak in the twentieth, when the national identity was formed.

Peter could hardly have chosen a less suitable site for the capital of Europe's largest state. Swept by mists from melting snow in spring, and overblown by winds that led to frequent floods, it was scarcely a place for human habitation. Only a handful of Swedish fishermen had ever tried to settle there.

Until the end of the first millennium the area lay beneath the sea. When Peter's soldiers dug into the ground they found water just a foot or two below. To the north of the estuary lay a small island, where the land was slightly raised. This was the only place where they could build, and even here a huge amount of rubble had to be brought in for the foundations of the Peter and Paul Fortress, the first major building of the capital. A vast army of conscripts dug out the boggy peat with their bare hands, cleared away the forests, and dragged in stones from quarries on the Tosna River, dozens of kilometres away.

Within a few years the estuary was transformed into a frenzied building site. Workers were conscripted from all over Russia, even from the Caucasus and Siberia; Finnish peasants and Swedish prisoners of war were also drafted in. In 1714, Peter passed a law forbidding stonemasons to work outside St Petersburg, so building work on palaces and churches ceased elsewhere, as all the country's craftsmen converged on the capital. Foreign architects (Domenico Trezzini from Italy, Jean Leblond from France and Georg

Mattarnovi from Germany) oversaw the building of the streets, canals and palaces. By the 1720s, perhaps a quarter of a million labourers were working on the site, sleeping in the makeshift wooden shacks that filled every empty space. With foul water everywhere, disease was bound to take a heavy toll. Precise rates of death are hard to ascertain, with estimates by historians varying violently, from a few thousand to 300,000 deaths. Such uncertainty, however, was itself the breeding-ground of urban myths – not least the founding legend of Petersburg: a city raised on the bones of the serfs who died in its construction.

Most of the city's earliest buildings were made of wood, but after a series of devastating fires (in 1710, 1711 and 1718) Peter decided to build only out of brick and stone. Factories churned out 20 million bricks per year (a colossal figure for the 1720s): whole forests were cut down to keep them fuelled. Peter passed a law obliging every cart or boat arriving in the capital to bring a set amount of rocks to pave the city's streets. Stone was imported from abroad: the famous granite of Petersburg's embankments came from Finland and Karelia; the marble of its palaces from Italy, the Urals and the Middle East; gabbro and porphyry were brought in from Sweden; sandstone from Poland and Germany; tiles from the Low Countries and Lübeck.

Peter was eclectic in his architectural tastes and borrowed what he liked from his trips to London, Stockholm, Riga and Vienna between 1696 and 1698. During his Grand Embassy he never reached Venice, in many ways the model for St Petersburg, but he took what he wanted of it from books and paintings. In this way St Petersburg developed as a sort of composite of eighteenth-century European styles.

The view of Petersburg as an artificial copy of the ideal western city became commonplace in the nineteenth century, when Russian intellectuals began to search for a distinctive national style. The writer Alexander Herzen once wrote that Petersburg 'differs from all other European towns by being like them all.'[1] Yet the city also had its own special character, which derived from the grandeur and harmonic unity of its architectural ensembles. As the artist Alexander Benois wrote: 'If it is beautiful then it is so as a whole, or rather in huge chunks.'[2]

The first real plan for the layout of the city dates from 1737, twelve years after Peter's death. It placed the Admiralty at the centre of the city, with three straight avenues (now Nevsky, Gorokhovaya and Voznesensky) radiating out from it in a fan shape. But even before that, in 1712, Peter had set up a special Office of Construction to oversee all aspects of the building work; and he himself became involved in all the architectural plans. Uniformity was Peter's over-arching principle. He insisted that palaces had façades constructed in accordance with his own designs, with a regular roof-line and iron railings on their balconies. The strictest rules were applied to the larger palaces along the Neva's banks; for this was the point of entry for foreigners arriving in the capital by ship, and these were the buildings with which Peter most wanted to impress his visitors.

From the 1760s the classical contours of St Petersburg became more pronounced, as the planning of the city came under the sole control of the newly-established Commission for the Masonry Construction of St Petersburg. The city was developed as a series of architectural ensembles geometrically inter-connected by rivers, parks, canals and squares; while the avenues, those straight lines stretching unbroken to the sky, gave the city's structures space

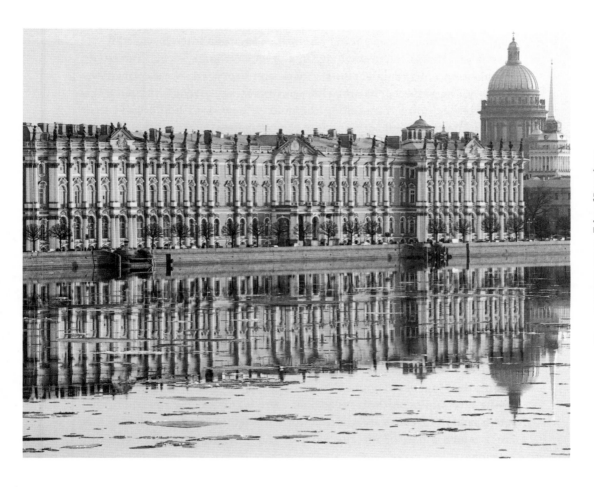

*Façade of the Winter Palace with
the Admiralty spire and the dome
of St Isaac's in the background*

to breathe. Water was the key to this architectural harmony. It added lightness and classical proportion to the heavy baroque style of the palaces constructed on the water's edge. The Winter Palace is a supreme example: despite its colossal size it seems almost to float on the embankment – and the syncopated rhythm of the white columns on its blue-green façade gives a sense of motion echoed by the Neva River flowing past.

The principle of regularity was applied to far more than the city's architecture. For Petersburg was conceived as a cultural space to regiment the Russians and reshape their way of life on rational European lines. That is perhaps what Dostoevsky meant in *Notes from Underground* when he called it 'the most abstract and intentional city in the whole round world'.[3] Petersburg would bring enlightenment to the dark and backward world of medieval Muscovy. Every aspect of its urban life was strictly regulated to bring about this end. Peter set down rules telling the nobility how they should build their palaces, how they should dress and cut their hair, how they should eat and conduct themselves at court, and how they should entertain polite society.

The sudden imposition of these foreign conventions soon gave rise to a popular conception of the imperial capital as an alienating and un-Russian place. Folklore cast the city as a kingdom of oppression and apocalypse. Among the Old Believers, the clergy and the Cossacks who held on to the customs of medieval Muscovy, there was a busy trade of urban myths that portrayed Petersburg as the capital of the Antichrist. Well into the nineteenth century, they continued to tell tales of Peter's ghost walking through the streets at night, of monsters hopping over churches, or of floods washing up the skeletons of people who had died in the construction of the city.

This oral genre worked its way into the salons of St Petersburg, where such writers as Pushkin and Prince Odoevsky used it as the basis of their own 'ghost stories' from the capital. Thus the myth of Petersburg took shape – the unreal city that was alien to Russia, the supernatural realm of fantasies and ghosts, the kingdom of oppression and apocalypse – which found expression in the tales of Gogol, Dostoevsky, Blok. Here is the shadow Petersburg that looms behind its classical façades: a world of literary and artistic myths that are as much a part of the city today as the mists and fog that frequently envelop it.

The founding text of the literary myth of Petersburg was Pushkin's *The Bronze Horseman*, subtitled 'A Tale of Petersburg' (1833). The poem was inspired by Falconet's equestrian statue of Peter the Great, which stands on Senate Square as the city's *genius loci*. Like the poem that made it so famous, the statue symbolises the dangerous underpinning of the capital's imperial grandeur. Outwardly, the statue seems to herald Peter's dazzling achievement with the construction of Petersburg against all the forces of Nature; yet at the same time it is left unclear to what extent he actually controls the horse (which became the great poetic metaphor of Russia's destiny in the literary and artistic imagination). The horseman appears to teeter on the edge of an abyss, held back only by the taut reins of his steed. The huge granite rock – so wild in appearance – on which the statue stands is itself an emblem of the tragic struggle between man and nature: the city hewn in stone is never entirely safe from the incursions of the watery chaos from which it was claimed.

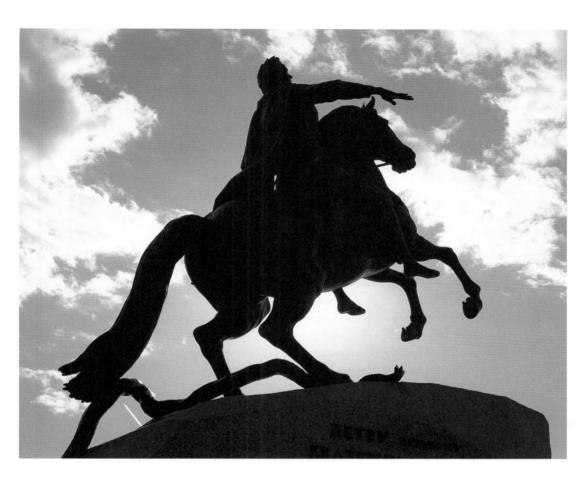

The Bronze Horseman, Etienne Falconet's
statue of Peter the Great, completed in 1782,
was commissioned by Catherine the Great
as her tribute to the city's founder

In 1909, a technical commission carried out an inspection of the statue. Engineers bored holes into the bronze. From inside the statue they pumped out 1500 litres of water.[4] Without protective dikes, flooding was a constant threat to Petersburg. One of the worst floods in the city's history took place in 1824. *The Bronze Horseman* tells the story of this flood and how a sad clerk called Yevgeny discovers that the house of his beloved Parasha has been washed away. Almost insane from grief, Yevgeny wanders aimlessly through the deserted streets and squares. Eventually he finds himself in front of Falconet's horseman and, delirious with rage, castigates the tsar for having built a city at the mercy of the elements. The statue stirs in anger and pursues the poor clerk, who runs all night in terror of its thundering brass hooves. Yevgeny is drowned, his body washed up on the island where Parasha's house had stood.

The literary and artistic myth that took its cue from Pushkin's poem envisaged Petersburg in four main themes. The first is the notion of an unreal city – a supernatural space of fantasies and ghosts. More than anyone it was Gogol who developed this phantasmagoria. As a young Ukrainian writer struggling to survive in the capital, Gogol lived among the petty clerks whose literary *alter egos* fill his *Tales of Petersburg* (1842). These are lonely and alienated figures, crushed by the city's oppressive atmosphere and doomed, for the most part, to die untimely deaths. Gogol's Petersburg is a city of deceit: in the first of his *Tales of Petersburg*, he warns, 'It lies all the time, that Nevsky Prospect does, but especially at night, when the devil himself lights the street lamps for the sole purpose of showing everything as it really is not.'[5] Away from the glittering parade of St Petersburg's main street, Gogol's 'little men' inhabit the dark shadows of the imposing citadel. They scuttle between menacingly vast ministerial buildings and the equally inhuman tenement apartments where they live – alone, of course. Gogol's Petersburg is not a real city. It is a ghostly shadow of the real Petersburg, which, like a blurred reflection in the mirror, is close enough to reality to haunt the city to this day.

In 'The Overcoat', the last of the *Tales*, Gogol tells the story of Akaky Akakievich, a humble civil servant who scrimps and saves to replace his threadbare overcoat that has long been the subject of ridicule in the ministry where he works. The new coat restores his sense of pride, becoming a symbol of his acceptance by his peers who throw a champagne party in celebration. But as he returns home across a dark and 'endless square', Akaky is set upon by thieves and robbed of his precious fur. His efforts to retrieve it by appealing to an Important Personage come to nothing. He falls ill and dies, a tragic figure destroyed by a materialistic and uncaring society. Akaky's ghost, however, continues to walk the streets of Petersburg. One night it haunts the Important Personage and, in turn, robs him of his coat.

Dostoevsky, it is commonly supposed, once said that the whole of Russian literature 'came out from underneath Gogol's overcoat'.[6] Dostoevsky's early tales, especially *The Double* (1846), are very Gogolesque, although in his later works, such as *Crime and Punishment* (1865–6), he adds an important psychological dimension to the capital's topography. Dostoevsky conjures up his unreal city through the diseased mental world of his characters, so that it becomes 'fantastically real'.[7] Dostoevsky himself was not immune to this. In 1861 he recalled a vision of the Neva which he had experienced around 1840 and had included in the short story *A Weak Heart* (1841). Dostoevsky later claimed that this had been the precise moment of his artistic self-discovery.

I remember once on a wintry January evening I was hurrying home from the Vyborg side... The taut air quivered at the slightest sound, and columns of smoke like giants rose from all the roofs on both embankments and rushed upward through the cold sky, twining and untwining on the way, so that it seemed new buildings were rising above the old ones, a new city was forming in the air...It seemed as if all that world, with all its inhabitants, strong and weak, with all their habitations, the refuges of the poor, or the gilded palaces for the comfort of the powerful of this world, was at that twilight hour like a fantastic vision of fairyland, like a dream which in its turn would vanish and pass away like vapour in the dark blue sky.[8]

The premonition of apocalypse, which Dostoevsky seemed to sense, is the second theme in the myth of Petersburg. The flood was a constant motif in the city's tales of doom. Built in defiance of the natural order, on land stolen from the sea, Peter's stone creation was an invitation to Nature's revenge. Pushkin was only one of many writers to pick up on these tales in *The Bronze Horseman*. Odoevsky, too, used them as the basis of his story 'A Joker from the Dead' in *Russian Nights* (1844). It is the story of a beautiful princess who abandons her young lover to marry a middle-aged official. One stormy autumn night they attend a ball in St Petersburg, where she has a fainting fit. In her dreams the Neva breaks its banks. Its waters flood the ballroom, bringing in a coffin whose lid flies open to reveal her dead lover. The palace walls come crashing down, and Petersburg is swept into the sea.

The notion of the flood had become so integral to the city's own imagined destiny that even Karl Bryullov's famous painting, *The Last Day of Pompeii* (1833), was viewed as a warning to St Petersburg. Slavophiles like Gogol, a close friend of Bryullov, saw it as a prophecy of divine retribution against western decadence. 'The lightning poured out and flooded everything', commented Gogol, as if to underline that the city on the Neva lived in constant danger of a similar catastrophe.[9] But Westerners, like Herzen, drew the parallel as well: 'Pompeii is the Muse of Petersburg!'[10]

As the year of 1917 approached, the flood became a revolutionary storm. The apocalypse was a central theme for the Symbolists, who embraced creative destruction as an agency of spiritual renewal. Chief among the Symbolists was Andrei Bely, whose novel *Petersburg* (written between 1905 and 1917) maps out a city living on the edge: a thin veneer of western civilisation precariously balanced on top of the savage 'eastern' culture of the Russian peasantry. Set in the revolutionary autumn of 1905, *Petersburg* is full of howling winds from the Asiatic steppe that almost blow the city back into the sea. The novel builds on the myth of the unreal city, with numerous allusions to the literary creations that have shaped its self-image. In Bely's vision Petersburg is the city of apocalypse; Peter the Great – again in the form of the Bronze Horseman – is recast as the Antichrist, the apocalyptic rider spiralling towards the End of Time and dragging Russia into his vortex. The bomb which structures the thin plot (a student is persuaded by the revolutionaries to assassinate his father, a high-ranking bureaucrat) is a symbol of this imminent catastrophe.

>
Petersburgers crossing the frozen Neva River in late spring

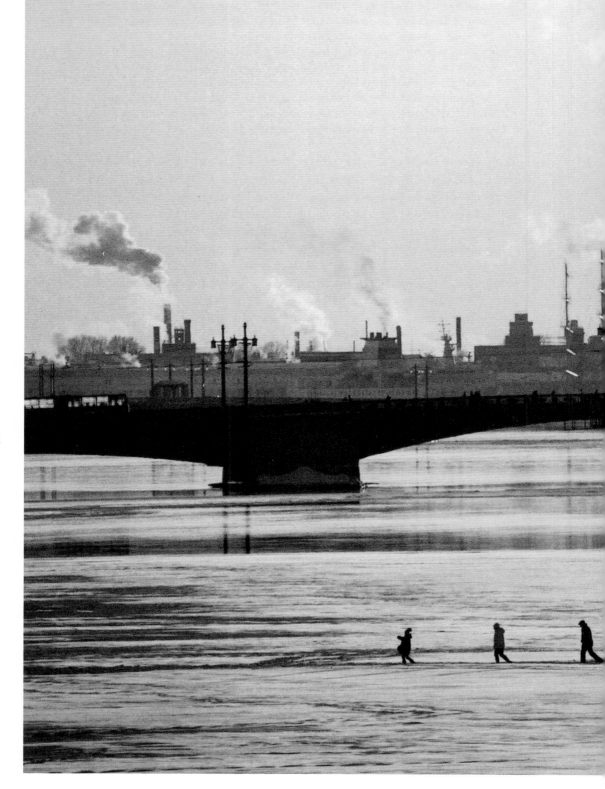

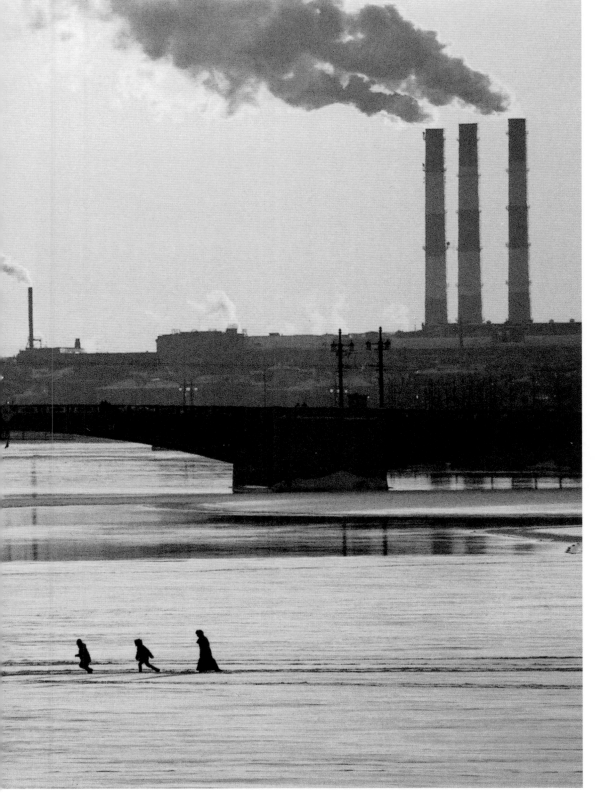

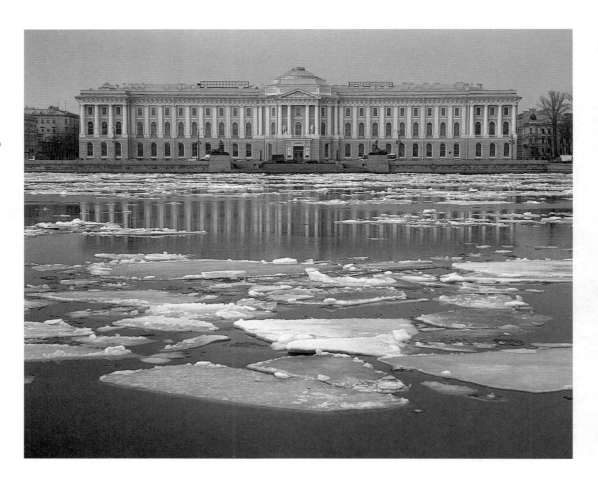

The Academy of Arts on University
Embankment, founded by Catherine the
Great to teach 'the three most exalted arts',
was built between 1764 and 1788 by
Alexander Kokorinov and Jean-Baptiste
Vallin de la Mothe

In apparent opposition to such eschatological preoccupations was the idea of Petersburg as a place of universal beauty, a classical empire that reflected the lasting achievements of human endeavour. This notion – the third theme in the myth of Petersburg – is beautifully evoked at the beginning of *The Bronze Horseman*. In a lyrical tribute written in the eighteenth-century panegyric style, Pushkin presents the city as a resplendent monument of Nature tamed and fashioned to the glory of one man:

> I love you, Peter's creation,
> I love your stern and harmonious look,
> The Neva's stately flow,
> Her granite banks,
> The iron tracery of your railings,
> Your pensive nights...

For much of the nineteenth century, however, the prevailing mood of cultural nationalism led to the downgrading of the classical ideals epitomised by the new capital. Artists looked instead towards Moscow, with its ancient crafts, like icon-painting and Palekh lacqueur work, and its Russian customs that set it apart from the West. Petersburg was viewed as an emblem of the foreign element. It was only at the end of the nineteenth century that the city's classical conception came into its own again.

The artists grouped around the journal *Mir iskusstva* ('World of Art') led the way: Benois, Dobuzhinsky, the critic Filosofov and the impresario Sergei Diaghilev. These pioneers of the Ballets Russes defined themselves as Petersburg cosmopolites (they called themselves the 'Nevsky Pickwickians'). As Benois put it, they championed 'the idea of some sort of united humanity'[11] which they saw embodied in the universal culture of St Petersburg. At the centre of their artistic philosophy was the cult of eighteenth-century Petersburg. Benois and his nephew Eugène Lanceray each produced a series of prints and lithographs depicting city scenes in the reigns of Peter and Catherine the Great. Their aim was to remind Russians that they too, like the Europeans, had a classical inheritance.

There was a distinctly aristocratic spirit to this retrospective aesthetic, an ethos of art for art's sake that shunned the utilitarian and didactic principles of nineteenth-century realist or democratic art. The same spirit lay behind the group's impassioned advocacy of ballet, and in particular their championing of Tchaikovsky, whose more European style of music had never been much favoured by the nationalists grouped around Stasov and Balakirev.

Tchaikovsky was the last of the great European court composers; his Russia was the last of the great European eighteenth-century states. Staunchly monarchist, Tchaikovsky was a member of Tsar Alexander III's inner circle. His music, which epitomised the 'Imperial style',[12] was strongly preferred by the court to the more obviously Russian harmonies of Mussorgsky, Borodin and Rimsky-Korsakov. His opera *The Queen of Spades* (1890), based on the story by Pushkin, evoked the bygone Petersburg of Catherine the Great, an era when the capital was fully integrated, and played a major role, in the culture of Europe.

'Tchaikovsky's music', Benois wrote in his old age, 'was what I had seemed to be waiting for since my earliest childhood.'[13] The 'aristocratic spirit'[14] of the ballet, as Benois described it, was only part of the group's

attraction to Tchaikovsky. More important still was its nostalgia for a civilisation which, the World of Art group seemed to sense, was about to pass away. In 1905, a year of revolutions throughout the Empire, Diaghilev organized an exhibition of eighteenth-century Russian portraits in the Taurida Palace (shortly to become the home of the Duma and the Soviet). He introduced the portraits as 'a grandiose summing-up of a brilliant, but, alas, dying period in our history'.[15]

After the revolution and the removal of the seat of Soviet government to Moscow in 1918, St Petersburg remained a symbol of the nation's basic European values. Nostalgia for the Petersburg inheritance was now even more pronounced. Among the émigrés, in particular, there was a conscious effort to relocate themselves in its classical empire. This was reflected in the neo-classical style of Prokofiev and Stravinsky, in the Ballets Russes revival of *The Sleeping Beauty* in 1921, and in Stravinsky's comic opera, *Mavra* (1922), dedicated to the memory of Pushkin, Glinka and Tchaikovsky. This engagement with the past was a natural search for order by the émigrés after all the chaos and destruction of the revolutionary period. But a similar nostalgia was also felt by the so-called 'internal émigrés': European Russians who had found a home in the international culture of St Petersburg but who struggled to survive in the new dark age of Soviet Moscow. One can hear this longing for the Classical Empire in the poetry of Mandelshtam:

> We shall meet again in Petersburg
> as though we had interred the sun in it
> and shall pronounce for the first time
> that blessed, senseless word.
> In the black velvet of the Soviet night,
> in the velvet of the universal void
> the familiar eyes of blessed women sing
> and still the deathless flowers bloom.[16]

Mandelshtam did not survive Stalin's Terror. Anna Akhmatova, however, lived through both the Terror and the Siege of Leningrad. For Akhmatova, Leningrad was defined by a classical tradition: it was an intellectual community connecting the present with the past, herself with Pushkin. But Akhmatova's city was more than the classical ideal of the World of Art group: it became a symbol of spiritual endurance and rebirth. In her poem 'The Way of all the Earth' (1940), she compared Leningrad with the invisible city of Kitezh, whose legend was the subject of an opera by Rimsky-Korsakov. Like Peter's capital, Kitezh also emerged from out of the water. According to the legend, the city's reflection on the surface of Lake Svetloyar (near Nizhny Novgorod) misled the invading Tartar infidels to ride into the lake and drown. Kitezh was conceived as a sacred sphere: only its true (i.e. Christian) citizens could gain access to it beneath the lake. Thus both cities – Leningrad in the era of Stalin and Kitezh at another, earlier, Christ-less time – were symbols of the endurance of sacred Russian ideals.

This tale of spiritual endurance is the final element in the myth of Petersburg. It is a story told by the poetry of Akhmatova and the 'Leningrad Symphony' of Shostakovich. Akhmatova gave powerful voice to the city's tragic suffering in *Requiem* (1935–43), a poem about the Terror, in which the dead of Leningrad are a haunting presence in a city made of ghostly shadows from the past. But Akhmatova's Leningrad was ultimately a city of triumph. It survived

these terrible years, including the loss of more than half its population during the siege, because of its spiritual strength. This was the Heroic City of Akhmatova's greatest masterpiece: *Poem Without a Hero* (1940–62).

Akhmatova dedicated the poem 'to the memory of its first audience – my friends and fellow citizens who perished in Leningrad during the siege. I hear their voices and remember them when I read the poem aloud, and for me this invisible chorus is an everlasting justification of the work'.[17] Isaiah Berlin, to whom she read the poem at the Sheremetev Palace (Fountain House) in 1945, described it as a 'kind of final memorial to her life as a poet and the past of the city – St Petersburg – which was part of her being'.[18] There is a deliberately self-conscious effort to situate the poem in the mythical tradition of St Petersburg. She calls it (like Pushkin and Gogol before her) a 'Tale of Petersburg', and saturates the poem with allusions to her literary forbears, as well as memories from her own past in the city. The poem conjures up, in the form of a carnival procession of masked figures which appears before the author at the Fountain House, a whole generation of vanished friends and figures from the Petersburg which history left behind in 1913. Through this creative act of memory her poetry redeems that history.

Shostakovich was equally a product of St Petersburg. It comes through in all his music and in his character. The composer's famous caution and reserve were not just a reaction to the climate of the Terror but formed part of his 'refined St Petersburg manner'.[19] He loved the city's literature, especially the works of Gogol, whose sarcastic anger and taste for the grotesque was close to his own heart, and he could cite long passages of Gogol's novel *Dead Souls* by heart. His operatic version of *The Nose* is a comic masterpiece in the best traditions of fantastic Petersburg. But perhaps it was to Akhmatova that Shostakovich felt himself closest. The two were brought together by the suffering of their city during Stalin's Terror and the siege, and each, in their own way, expressed that suffering. Akhmatova did not miss a single première of Shostakovich's work. In 1957, after the first performance of the Eleventh Symphony ('The Year 1905'), she compared its hopeful revolutionary songs, dismissed by critics as devoid of interest, to 'white birds flying against a terrible black sky'.[20] The two did meet on one occasion: 'We sat in silence for twenty minutes. It was wonderful', recalled Akhmatova.[21]

As the German armies circled in on Leningrad in 1941, the communist authorities appealed to Akhmatova and Shostakovich to address the city in a radio broadcast. For years Akhmatova's poetry had been effectively forbidden; yet her very name was so synonymous with the spirit of the city that even communists were prepared to bow to it in this hour of need. Her courageous broadcast appealed to the city's entire legacy – not just to Lenin but to Pushkin, Blok and Dostoevsky. Shostakovich, as befits his character, was more circumspect, merely mentioning that he was about to finish his Seventh Symphony. Life was going on.

Later that same day the Germans broke through to the gates of Leningrad. Akhmatova was evacuated to Moscow and then Tashkent, Shostakovich to the Volga city of Kuibyshev, where the symphony, 'The Leningrad', was finally completed. In order to achieve its symbolic goal, it was vital that the symphony be performed in Leningrad (a city which both Stalin and Hitler loathed). The Leningrad Philharmonic had been evacuated and the Radio Orchestra was the only remaining ensemble in the city. The first winter of the siege had reduced it to a mere fourteen players, and extra musicians had

*Memorial plaque on Literatorov Street to
the artist Pavel Filonov, who died during
the Siege of Leningrad*

to be brought out of retirement or borrowed from the army defending Leningrad. When the symphony was performed, on 9 August 1942, it was as if the city had been saved. 'People who no longer knew how to shed tears of sorrow and misery', recalled the playwright Alexander Kron, 'now cried from sheer joy.'[22]

At its darkest hour Russia was redeemed by its artistic creativity. Like no other nation, Russia is embodied in its culture, its sense of nationhood reflected in the values of its literature and arts. Peter the Great, Lenin and Stalin might have ruled, but Pushkin, Tolstoy and Akhmatova were Russia's unofficial legislators. Their world – the literary myth of St Petersburg – has played as important a role in shaping perceptions of the city as tsars and communists alike. Petersburg's inhabitants (and tourist guides) will show you to the grey tenement building in Stolyarny Lane and count out the thirteen steps Raskolnikov descended in *Crime and Punishment*, as if Dostoevsky's fictional creation actually lived there. They will show you the cellar door 'from which he took the axe' and the exact spot 'where he killed the old woman'. The poet Joseph Brodsky called this the 'second Petersburg – the one made of verses and of Russian prose'.[23] Like the legendary city of Kitezh, it only appears to exist. But there is a sense in which it is the real Russian capital – the capital of Russian wonderland.

1 A.I. Gertsen, 'Moskva i Peterburg', *Sobranie sochinenii v tridtsati tomakh*, Moscow, 1954, vol. 2, p. 36.

2 A. Benois, 'Zhivopisnyi Peterburg', *Mir iskusstva*, vol. 7, 1902, no. 2 (1–6), p. 1.

3 F. Dostoevsky, *Notes From the Underground, The Double*, trans. J. Coulson, Harmondsworth, 1972, p. 17.

4 R.D. Timenchuk, '"Medny Vsadnik" v literaturnom soznanii nachala XX veka', *Problemy pushkinovedeniia*, Riga, 1938, p. 83.

5 N.V. Gogol, 'Nevskii Prospekt', *Peterburgskie povesti*, Leningrad, 1976, pp. 54–5.

6 J. Frank, *Dostoevsky: The Seeds of Revolt 1821–1849*, Princeton, 1977, p. 332.

7 D. Fanger, *Dostoevsky and Romantic Realism*, Cambridge, Mass., 1965, p. 132.

8 F.M. Dostoevsky, *Polnoe sobranie sochinenii*, 30 vols, Leningrad, 1972–88, vol. 19, p. 69.

9 Cited in *Istoricheskii vestnik*, 1881, no. 1, p. 137.

10 Cited in N.P. Antsiferov, *Dusha Peterburga*, Petrograd, 1922, p. 100.

11 A. Benois, *Reminiscences of the Russian Ballet*, London, 1941, p. 93.

12 S. Volkov, *Balanchine's Tchaikovsky: Interviews with George Balanchine*, New York, 1985, p. 127.

13 Benois, *Reminiscences*, p. 124.

14 Ibid., p. 130.

15 A. Haskell, *Diaghileff. His Artistic and Private Life*, London, 1935, p. 160.

16 O. Mandelshtam, *Selected Poems*, trans. D. McDuff, London, 1983, p. 69.

17 *The Complete Poems of Anna Akhmatova*, trans. J. Hemschemeyer, Boston, 1983, p. 543.

18 I. Berlin, 'Meetings with Russian Writers in 1945 and 1956', in *Personal Impressions*, Oxford, 1982, p. 194.

19 Flora Litvinova cited in E. Wilson, *Shostakovich: A Life Remembered*, London, 1994, p. 156.

20 Wilson, *Shostakovich*, p. 319.

21 Ibid., p. 321.

22 Ibid., p. 149.

23 J. Brodsky, 'A Guide to a Renamed City', *Less Than One: Selected Essays*, New York, 1986, p. 93.

An Architecture of Intentions

What images are conjured up by mention of St Petersburg? The broad stream of the Neva imprisoned within its granite banks, perhaps; or endless panoramas, magnificent in their uniformity, punctuated by an occasional golden spire piercing heavy skies. The city works its magic on spectators like a two-dimensional stage set, in which each element is less important for its own sake than for its relationship to the whole. For St Petersburg was built with the spectator in mind; such is both the origin of its magical allure and its fatal limitation.

Pushkin celebrated St Petersburg's 'austere, harmonious aspect', but he was not alone in mistaking architectural harmony for the product of deliberate design. It has long been accepted wisdom that St Petersburg is the embodiment of the ideas of its brilliant founder, Peter the Great. This myth is just one of many which have usurped the true history of the city. Thus, misty-eyed, we refer to it as the Russian Amsterdam or Venice, or the Northern Palmyra, when even the most superficial acquaintance with the city is enough to debunk such high-flown comparisons.

St Petersburg's 'Russianness' is constantly questioned, especially in relation to Moscow. In one sense, however, the city represents the very essence of the Russian self-image: that unbridgeable gap between the way things are and the way Russians perceive them to be. Today's aesthetes gaze lovingly at the potholed roads of Kolomna's slum districts, or the columns of industrial smoke rising on the northern banks of the Neva, and derive a peculiar satisfaction from the thought that their artistic forebears would have looked upon exactly the same scene a hundred years ago. But one wonders of what use to the rest of the population are that piercing melancholy, that literary elision of the human figure between the immense expanse of the river and the infinite space of the sky; and whether the premeditated and fantastic city beloved of Dostoevsky specialists can somehow compensate for the lack of so many essential comforts.

Absurd, perhaps – but then the absurd is quite natural in the context of the history of St Petersburg. How could it be otherwise in a city whose founder selected the one spot in the whole surrounding area that was least suited to human habitation? For it was not as if the land on which St Petersburg was built was entirely wild and unexplored. The Novgorodians, who owned the territory in the twelfth century, were perfectly familiar with the behaviour of the river Neva, which broke its banks every autumn and flooded the islands in its estuary. That was why the first large Novgorodian settlement, Spasskoe,

was located about seven kilometres upstream, at a point where the risk of flooding was minimal. And when in 1301 the Swedes established their first fortified base in the area, they chose a site opposite Spasskoe on the right bank of the Neva.

Four hundred years later, however, Peter the Great decided he had little to learn from the Novgorodians and the Swedes. The 'miracle-working builder', as Pushkin called him, chose to found his city much nearer the mouth of the river delta on Zayachy Island – one of the very islands which every year disappeared below the water.

Perhaps there were strategic reasons for Peter's choice of site? After all, Russia was three years into the Great Northern War against Sweden, and construction of the new capital began with the Peter and Paul Fortress, built by craftsmen expert in the latest advances in the science of fortification. It is true, also, that the fortress's bastions could command lines of fire covering the Lesser and Greater Neva rivers. However, any defensive use the fortress might have had was completely undermined by Peter's decision to locate the administrative centre of his city on Vasilevsky Island, to the *west* of the Peter and Paul Fortress – and thus entirely open to attack from the seaward side. Unable to understand why, in these circumstances, such a fortress was required, Peter's contemporaries assumed that he simply wanted to use it for training his subjects in the art of fortifications. A rather expensive teaching aid.

As for Vasilevsky Island itself, its suitability as home to the government institutions of the Russian Empire may be judged by the fact that even a century and a half after Peter's death the island still had no permanent connection with the mainland; when the river was freezing over or the ice melting, it was actually cut off from the city altogether. Furthermore, a third of the island remained entirely uninhabitable right up until the early twentieth century, when a series of complicated, large-scale earthworks were finally completed.

A year after construction began on the Peter and Paul Fortress, the foundations of a second structure were laid on the opposite bank of the Neva. This was the Admiralty, and with its ramparts, moats and bastions it was to serve as both fortress and shipbuilding wharf. Again, however, Peter's intentions seem to have borne little relation to reality: on the river side of the Admiralty a sand-bank prohibited the launching of large ships, while on the other side the space for a wharf was restricted by the fortifications. And so, even as the Admiralty fortress was being built, construction began on a New Admiralty further downstream, on a site where ships continue to be built to this day. It is hard to avoid the conclusion that, like the Peter and Paul Fortress on the northern bank of the Neva, the Admiralty was just another of Peter the Great's playthings.

Surely, it might be objected, some things were built as intended; not everything could have been the result of misguided planning? But there is no evidence of this. There was no far-seeing plan. Building work was carried out haphazardly, trusting to luck Russian-style, demolishing what might have been useful later, reworking things along the way, abandoning what had been

>
Aerial view of St Petersburg and the Neva River looking west towards the Gulf of Finland

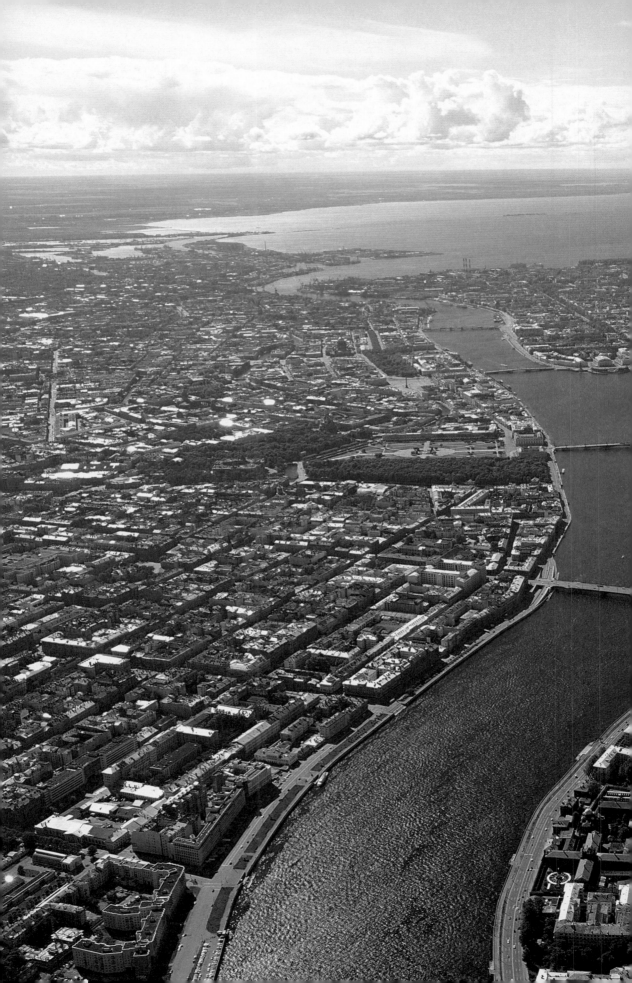

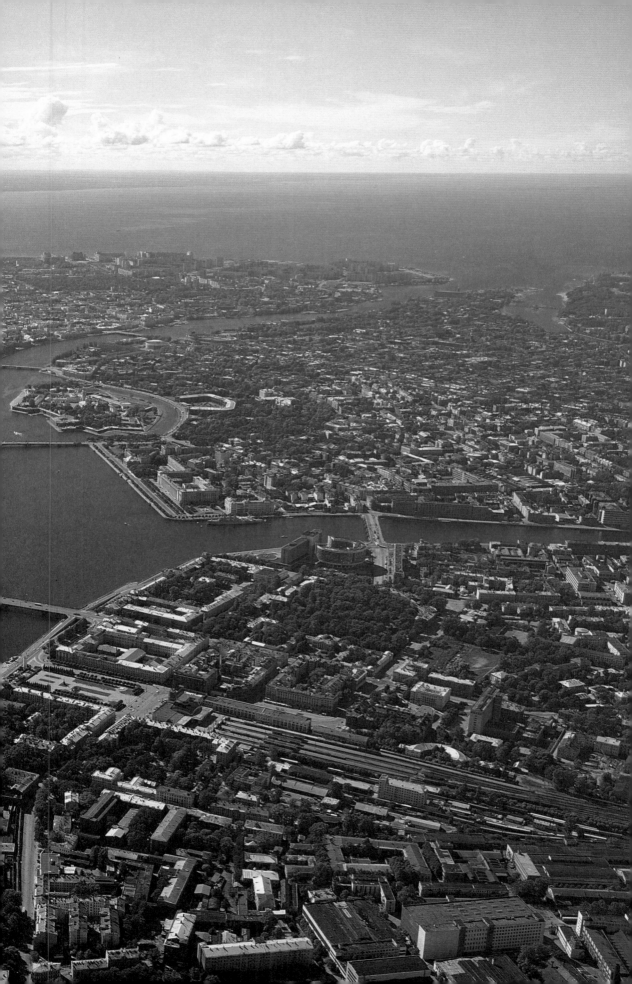

*Inscription on the Catherine Bastion
of the Peter and Paul Fortress, which
reads: 'Bastion of Empress Yekaterina
Alexeyevna. Faced in stone under
Empress Yekaterina II, 1780'*

begun with no thought for the money or lives wasted. Johann Gottlieb Georgi, the academician and learned author of the first proper description of the 'imperial Russian capital city', published in 1794, was quite correct in asserting that 'the first plans for St Petersburg were changed so often that it seemed as though everyone was building exactly as he wished'.[1]

The same spontaneity that marked the initiation of these illogically conceived projects sometimes led, without any form of interconnected system, to the development of settlements which long predated the foundation of St Petersburg. Thus, for example, the Alexander Nevsky Monastery was founded on the old inhabited site of the village of Vihtula. The monastery was an important ideological component of the image of St Petersburg, which, by virtue of its status as the new capital, had inherited the mantle of the 'Third Rome' from Moscow (a title dating to the early sixteenth century when, after the fall of Constantinople and Rome, Moscow had come to see itself as the centre of Christendom).

A fortress with nothing to defend, a shipyard incapable of launching ships, a centre for the Russian Orthodox Church on the site of a Finnish settlement: these constitute Peter's great legacy, the reference points to which the plan of St Petersburg has remained permanently linked. The facts surrounding their construction are indisputable, and yet faith in Peter the Great's visionary genius remains ineradicable.

Peter died in 1725. Just how well his heirs understood his intentions for the city is eloquently expressed by where they chose to lay him to rest. The tsar was interred in the unfinished cathedral inside the Peter and Paul fortress, despite the fact that Peter himself had made unambiguous preparations for an imperial vault in the Alexander Nevsky Monastery by burying his relatives there. The result was the creation of a unique synthesis: the fortress, which had no strategic use, was transformed into a secure prison which doubled as the Mint, while the rulers of the empire were buried there alongside the torture chamber.

Georgi wrote that 'the construction of the city only acquired substantial arrangement in 1737'.[2] In 1735–6 devastating fires laid waste the ramshackle wooden housing of the seamen's settlements on the Admiralty side. This prompted the establishment of the St Petersburg Construction Commission, headed by Fieldmarshal Burkhard Khristofor Minikh, which finally gave serious attention to formulating a city plan. (Following the brief reign of Peter II (1725–7), during which the court was moved back to Moscow and the new capital reduced to a state of desolation before it had even come of age, it was Minikh who had persuaded Empress Anna Ioannovna to restore the status of capital city to St Petersburg.)

Minikh, however, did not wish to interfere with Peter's autocratic concept and abandon the ongoing construction of the Peter and Paul Fortress in the centre of the city. Instead, the fortress was substantially reinforced in the 1730s, by which time any incursion by the Swedes into the Russian capital was effectively impossible. The whimsical nature of the fortress's construction continued into the second half of the eighteenth century: it was Catherine the Great who ordered the addition of granite bastions, their only purpose being to ennoble the view from the windows of the Winter Palace.

Under the new plan the strict Roman grid of Vasilevsky Island was combined with a medieval radial and ring-road plan on the south bank of the Neva. The Admiralty Fortress was adopted as the conventional nucleus, with three equally-spaced streets radiating out from it: Voznesensky Prospect, Gorokhovaya Street and Nevsky Prospect. The equivalent of the encircling medieval walls were the three waterways: the Moika, the Catherine (now Griboedov) Canal and the Fontanka.

Seen on the map the effect is highly elegant, and the views of the Admiralty spire from each of the three radial streets are certainly amongst Petersburg's finest. For all its symmetry, however – and Gorokhovaya, the middle of the three, was constructed purely for the sake of symmetry (initially being referred to as 'the middle perspective') – the plan raises one fundamental question: how effective is a radial plan when three roads converge on the centre from one side of the city (the south-east), and not a single radial road leads out of the city on the other?

But then beauty, which in Petersburg's case may best be understood to mean a strictly hierarchical system of proportion, has invariably taken precedence over functionality in the planning and construction of Russia's imperial capital. This principle found its most extreme expression in the urban development activity of the architect Carlo Rossi. His 1819 plan for the area around the Winter Palace involved the creation of a magnificent sequence of three linked public spaces: Palace Square, Senate Square and, between them, a new square in front of the Admiralty, made possible by the removal of the building's needless fortifications. At the heart of Rossi's plan was a desire to expose to full view the Admiralty's 407-metre southern façade. However, the citizens of St Petersburg were only able to admire it for about sixty years: in the 1870s the Alexandrovsky Garden was laid out in front of the Admiralty, since when the building has been completely concealed by the spreading branches of the trees.

In the 1820s and 1830s an area of the city further down Nevsky Prospect was also fundamentally redesigned by Rossi. The territory extended along the west bank of the Fontanka, from the Summer Garden and the Field of Mars in the north, down to the Alexandrinsky Theatre and the street that now bears Rossi's name. Much of the plan was a triumph of form over function: essential ancillary buildings were sacrificed for the sake of strict symmetry and clear lines. The implications of this unyielding design are still felt today. The Alexandrinsky Theatre, for example, lacks its own storage area, so the scenery for each performance has to be carted over every day from a separate store. Behind the theatre, the proportions of Architect Rossi Street are famously balanced (25 metres wide and high, 250 metres long). Venture behind the street's elegant columns, however, and you will discover that these ministerial buildings do not have three storeys, as suggested by their façade, but five. Added to which, Architect Rossi Street actually leads nowhere; it simply drains away into the aimless jumble of lanes around Apraksin Dvor market.

The need to modernise Paris and Vienna during the second half of the nineteenth century (and Moscow during the 1930s) was entirely understandable: these were medieval cities that had expanded in uncontrolled fashion over centuries. But it seems strange that St Petersburg should have been faced with similar problems at the beginning of the twentieth century, given the regulated manner of its construction from Minikh to Rossi. Indeed, right up until 1894 when Nicholas II came to the throne,[2] plans for the

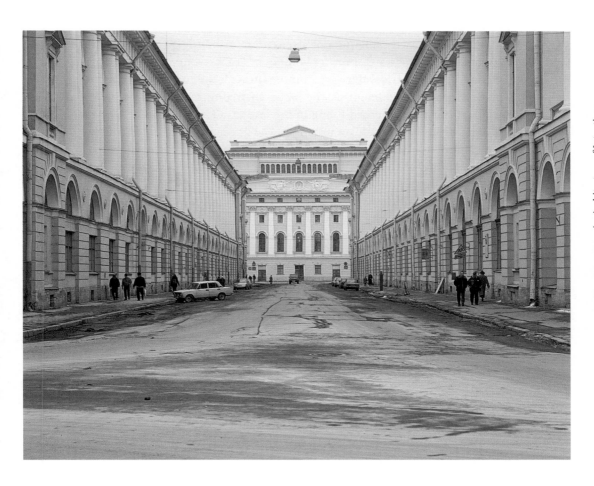

The back of the Alexandrinsky Theatre
is framed by the perfect proportions of
Architect Rossi Street

erection of any building in the city had to be submitted to the scrutiny of the sovereign himself.

In 1908 the venerable architect and professor of the Academy of Arts, Leonty Benois, raised the question of 'the need to draw a complete project for the arrangement of St Petersburg', on the assumption that 'the transformation and development of a city is a natural and inevitable consequence of the changing requirements and circumstances of life'.[3] Four years later the public of St Petersburg was presented with a plan developed by Benois together with the engineer Fyodor Yenakiev and the architect Marian Peretyatkovich.

The plan caused something of a sensation, primarily on account of its sober analysis of the state of town planning in St Petersburg, and its suggestion that the concentric waterways running through the city were as much of a hindrance to development as the walls encircling medieval towns. The authors of the plan proposed filling in the Catherine (now Griboedov) Canal and building along its route an urban railway line supported on trestles like the Berlin metro. Benois's other radical proposal was to construct a broad highway leading south along the route of the Kryukov Canal to a new railway terminus for arrivals from the west of the country.

The filling-in of the Kryukov Canal would certainly have deprived us of a most charming view of the Cathedral of St Nicholas, its bell tower reflected in the rippling waters of the canal (which, incidentally, was dug after the cathedral was built). Gone, too, would have been one of the most romantic corners of old St Petersburg, where seven bridges are visible at the intersection of the Griboedov and Kryukov canals. The delightful little two- and three-storey houses along the banks would have been replaced by pompous office buildings in the style of the 1910s. Perhaps the price of bourgeois comfort would have been too high, but when, day in day out, you find yourself stuck in the impenetrable tailbacks created by the collision of six streams of traffic between the Mariinsky Theatre and Potseluev Bridge, the charms of the architecture somehow fail to soften the heart.

Benois's and Yenakiev's pragmatic project was based upon the future development of the city to the north and north-east, since the south and southwest were cut off by a factory belt and a web of railway lines beyond the Obvodny Canal. A highway would connect these new districts to the old centre of the city, where it would join the final element of the plan – a new main road running parallel to Nevsky Prospect.

It would be naïve to reproach Leonty Benois, a member of one of the most cultured families in Russia, with vandalism and a nihilistic attitude to the beauties of the 'Palmyra of the North'. He was simply making a professional architect's assessment of the city's immediate requirements. At that time, with St Petersburg supposedly developing into a major capital city, it was still possible to dream of such things.

Benois's plan of 1912 was never implemented: approaching war and revolutionary rumblings left the authorities with other things on their minds. And when the Bolsheviks came to power, far from transforming the capital, they simply decided to move it to Moscow.

The preservation of St Petersburg as a historical monument is an exclusively twentieth-century phenomenon, which may well have arisen because after the revolution no other function could be found for this city built over two centuries. The military and educational institutions were certainly put to good use under the new order, while the spacious 'bourgeois' apartments were

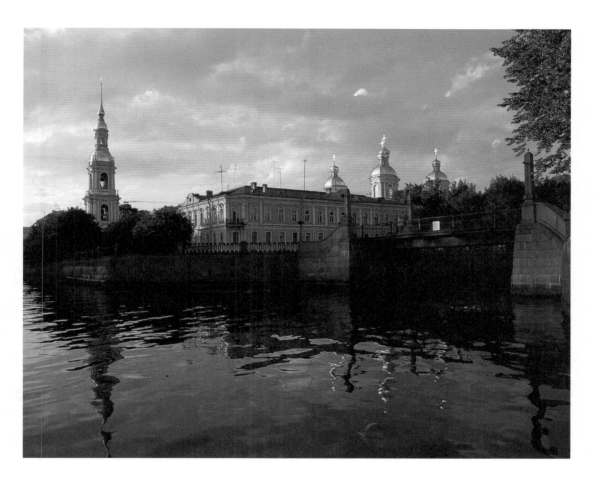

View of the bell tower and domes of
the Cathedral of St Nicholas from the
Kryukov Canal

*The Kunstkamera on University
Embankment was commissioned by Peter
the Great in 1718 to house his collection
of fossils and human and animal freaks*

transformed into crowded communal flats. Practically every other substantial building was eventually occupied by the city's proliferating regional bureaucracy. Palaces were declared 'architectural monuments', but now harboured numerous offices behind their neo-classical and baroque façades. Floor space was fully occupied, but a lack of funds meant that it was easier to let a monument sink into a state of total decay than to reconstruct it – or demolish it and so clear the site for a new, contemporary building. (The only exception made was for churches, which were demolished without regard for their architectural significance, and without the slightest need in terms of urban planning. Nothing of merit replaced them and the city merely became less interesting.)

Despite the relative peace in which St Petersburg (now renamed Leningrad) found itself, the problems essentially remained the same. The city centre, developed as a formal façade for a nineteenth-century imperial power, was unable to support either the pressure of a growing population or even the elementary requirements of public health.

An attempt to transform the city was made in the 1930s. Avoiding the risks involved in tackling the problems of the historical city centre, chief municipal architect Lev Ilin chose the entirely logical goal of creating a new Leningrad with an administrative centre ten kilometres to the south of the old one. The problem of breaking through the industrial belt on the south side of the city remained, but given the turbulent situation in Central and Eastern Europe in the 1930s, and the fact that the state border ran only thirty kilometres to the north of Leningrad, there was no alternative. The plan was put into effect with the speed typical of a Bolshevik concerted effort, and was only halted by the war, when German forces advanced to a point just eight kilometres from the newly built House of the Soviets.

After the war the 'push to the south' continued, although this was more the result of inertia than sound planning, since, with the Soviet Union's northern border now secure, the main argument against expanding to the north had ceased to exist. But the administrative centre remained in the old city, which became hemmed in on all sides by new, developing regions. And so the pressures on the centre, which had seemed insupportable a hundred years before, merely increased. Moreover, despite the five general plans approved one after another during the years of Soviet power (the last of which was due to run until 2005), there is still no bypass capable of handling the flow of traffic that presently passes through the city centre. The routes leading from the centre to residential districts are still obstructed by narrow roads entirely inadequate for heavy traffic. Half a million people living in the southern region of Kupchino take the daily risk of returning to their home district over the rickety Tsimbalinsky railway viaduct, which is fit to serve only as a monument to pre-war notions of technology. Meanwhile the inhabitants of the northern districts, who number more than a million, make their way back to the open spaces of Ozerki, Grazhdanka and Porokhovye by picking their way through a labyrinth of streets no wider than the lanes of Petersburg's predecessor, the seventeenth-century fortress town of Nienshants.

Nonetheless, as the citizens of St Petersburg converge and collide on Nevsky Prospect (which has retained its dimensions entirely unchanged for three hundred years) and roundly curse the municipal authorities, it never occurs to them to sacrifice any part of the city centre that is crumbling before their very eyes. Venice, even though it is sinking and falling apart (at least to the eye of the superficial tourist), manages to make serious money from

its fungus-infected marble, black-incrusted statues and stagnant canals. St Petersburg is different: its decrepitude is nothing more than the result of slovenliness. What right have these buildings to look old, compared with examples of European Gothic and Renaissance architecture, when a dab of plaster and a lick of paint are all that is required to restore them to a state of pristine order?

The campaign launched by the present city boss, Vladimir Yakovlev, to repair all of St Petersburg's dilapidated roads provokes universal rumblings of discontent, even though – as far as it goes – it is absolutely essential. But again the underlying problem remains. It is possible to pave the sidewalks of Nevsky Prospect with slabs of granite and even rid city-centre streets of the tramlines rendered rather pointless by the collapse of public transport. These palliative measures will not, however, alter the rigid framework of city blocks in a centre that was constructed to demonstrate the might of Empire rather than meet the requirements of daily life.

The sharply drawn silhouette of the real St Petersburg can still sometimes be glimpsed in the hours before a summer dawn, in those secluded corners where no cars hurtle by. It is better to avoid the Neva's embankments during the white nights – that time when St Petersburg is still by old tradition regarded as being at its most attractive, despite the bustling crowds and endless stream of tour buses.

According to contemporary testimony, St Petersburg looked its most beautiful in 1921 and 1942 – the most terrible years in its history, when the city was literally dying. Its entirely empty streets and avenues created a sensation of eerie harmony. It was in 1921 that Nikolai Antsiferov, the researcher of 'St Petersburg's soul', commented that 'Petropolis has become Necropolis'.[4] The peculiar beauty of St Petersburg when it is empty of people is a quality which by no means every city possesses, and it provides a key to deciphering its true nature: this was a place not intended for real people to live in, but to affirm the suprahuman principles of harmony and world order.

In the early 1990s there were vigorous public protests against the alteration of a façade in the Art Nouveau style located opposite Vladimirskaya Church (down in Dostoevsky territory). In a typically Petersburgian solution the façade has been preserved, but the building behind it is gone and a new one is being built behind the old mask. So, too, with the rest of the city: Russia was an empire, St Petersburg its formal façade. But the building has collapsed, and the façade that remains has been stripped of meaning.

1 Georgi, J.G., *Description of the Russian imperial capital of St Petersburg and of its surrounding monuments* (introduction by Yu.M. Piryutko), St Petersburg, 1996.

2 Ibid.

3 *Plans for the transformation of St Petersburg. Research of F.E. Yenakiev, communications engineer*, St Petersburg, 1912.

4 N.P. Antsiferov, *The Soul of Petersburg*, Petrograd, 1922, p. 224.

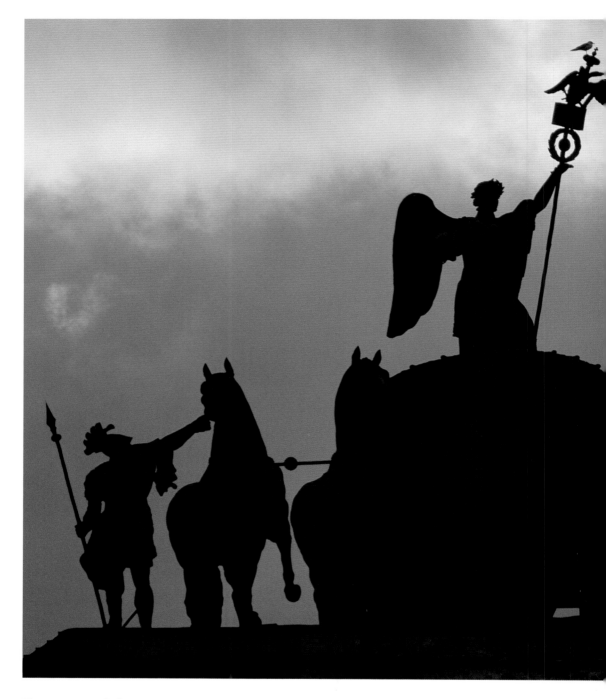

'As we crossed the vast squares, various architectural phantoms arose with silent suddenness right before us. We felt a cold thrill, generally associated not with height but with depth – with an abyss opening at one's feet – when great, monolithic pillars of polished granite (polished by slaves, repolished by the moon, and rotating smoothly in the polished vacuum of the night) zoomed above us to support the mysterious rotundities of St Isaac's cathedral. We stopped on the brink, as it were, of these perilous motifs of stone and metal, and with linked hands, in Lilliputian awe, craned our heads to watch new colossal visions rise in our way – the ten glossy-gray atlantes of a palace portico, or a giant vase of porphyry near the iron gate of a garden, or that enormous column with a black angel on its summit that obsessed, rather than adorned, the moon-flooded Palace Square.' Vladimir Nabokov, *Speak, Memory*

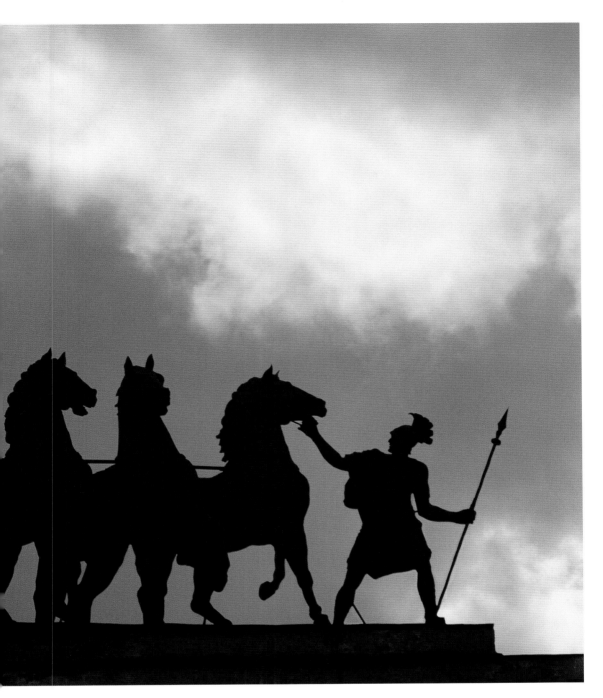

Statue of Nike on the Triumphal Arch of the General Staff Building, Palace Square

>

Palace Square (detail)

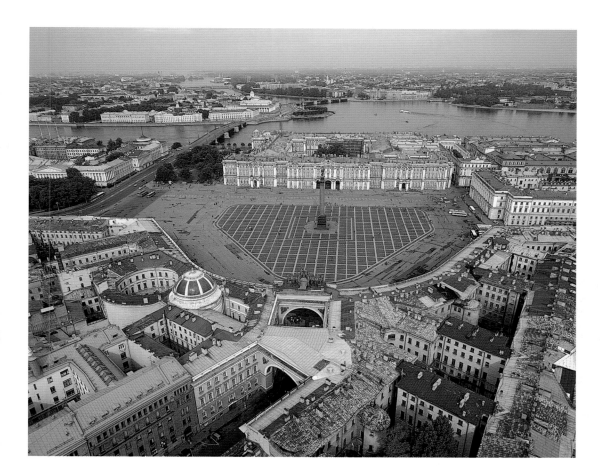

View of the Winter Palace and Palace
Square from behind the General Staff

<

Angel on the Alexander Column (detail)

Palace Square

The Winter Palace was completed in 1762, establishing Palace Square as the heart of imperial Russia; for the next fifty years, however, the south-eastern side of the square was populated with private town houses. In 1819 Alexander I purchased these properties and commissioned Carlo Rossi to build a government office building: the *Glavny Shtab*, or General Staff. Sir Samuel Hoare, a British diplomat, described working in the General Staff building at the beginning of the First World War: 'Our rooms looked out

upon the Winter Palace and the great Square in front of it... Beneath our windows were constantly drilling platoons of Russian recruits who, whatever the weather and however deep the mud, would charge across the square and lie on their faces, as though they were advancing to take German trenches... True to Russian type, the façade was the best part of the building. At the back of the General Staff was a network of smelly yards and muddy passages that made entrance difficult and health precarious.'

The Alexander Column was erected in 1834 to commemorate Alexander I's victory over Napoleon. It is said that Boris Orlovsky, the sculptor, was ordered to portray Alexander in the face of the angel (*left*) and Napoleon in the face of the serpent crushed beneath the angel's cross; close inspection, however, suggests the story is apocryphal. The column was not the final addition to Palace Square: the cobbled grid surrounding its base dates from 1977.

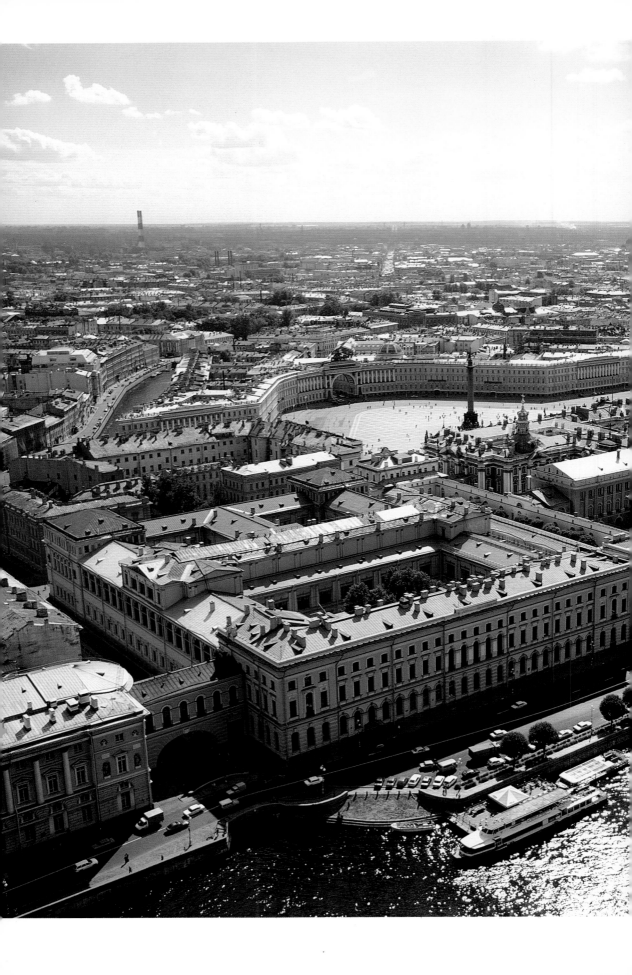

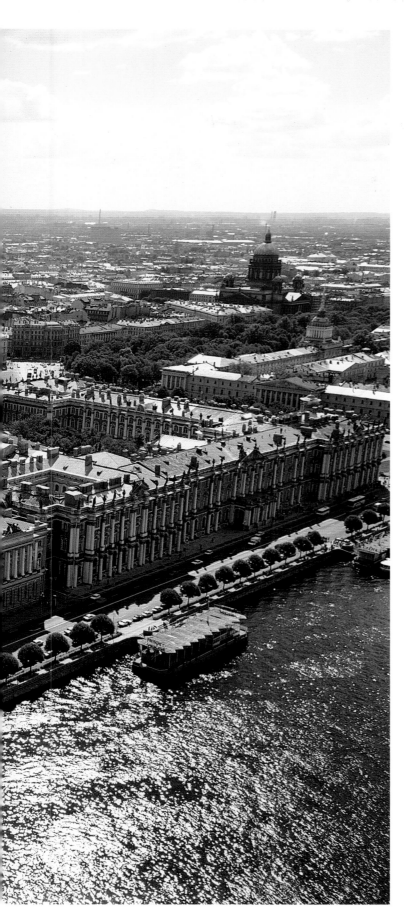

Hermitage Museum

The buildings of the Hermitage Museum overlook the Neva River on one side and Palace Square on the other. The main building in the ensemble is the Winter Palace (*near right*); next to it stand the two pavilions of the Small Hermitage, one facing the Neva, the other facing Palace Square; they are joined by a long narrow Hanging Garden. The large building adjoining the Small Hermitage consists of two parts: the Large and New Hermitages. The Large Hermitage, built around a single courtyard, overlooks the Neva, while the New Hermitage, with two internal courtyards, was added behind it sixty years later. The Winter Canal runs down the side of the Large and New Hermitages, and a covered bridge leads over the canal to the final building in the ensemble, the Hermitage Theatre (*bottom left*).

The Winter Palace, which remained the royal residence of the Romanovs until 1917, was commissioned by Empress Elizabeth from her favourite architect, Bartolomeo Rastrelli. It was the fifth winter palace on the site (the first having been built for Peter the Great in 1711). Elizabeth died in 1761, the year before her palace was ready, and so the first occupant of the new building was Catherine the Great. The two buildings that make up the Small Hermitage were commissioned by Catherine between 1765 and 1769 from Yury Felten and Jean-Baptiste Vallin de la Mothe, and named after Catherine's 'small hermitages' – evenings of games and plays that were held there.

In 1764 Catherine purchased a collection of paintings from the Berlin merchant Johann Gotzkowski, the first of many acquisitions. To house her ever-expanding collection, Catherine commissioned the Large Hermitage from Felten, completed in 1787. At the same time she invited Giacomo Quarenghi to build the Hermitage Theatre on the other side of the Winter Canal. Quarenghi also built an extension to the Large Hermitage for the Raphael Loggias (eighteenth-century copies of the frescoes in the Vatican), before uniting the whole ensemble with a bridge over the Winter Canal.

The Hermitage collection continued to grow in the early nineteenth century, and in 1839 Nicholas I commissioned the German architect Leo von Klenze to build the New Hermitage behind the Large Hermitage. Klenze's design was adapted by two Russian architects, Vasily Stasov and Nikolai Yefimov, and the new building opened in 1852. No further additions have since been made to the Hermitage ensemble, although the museum continues to expand: its collections now occupy part of the General Staff on the southern side of Palace Square.

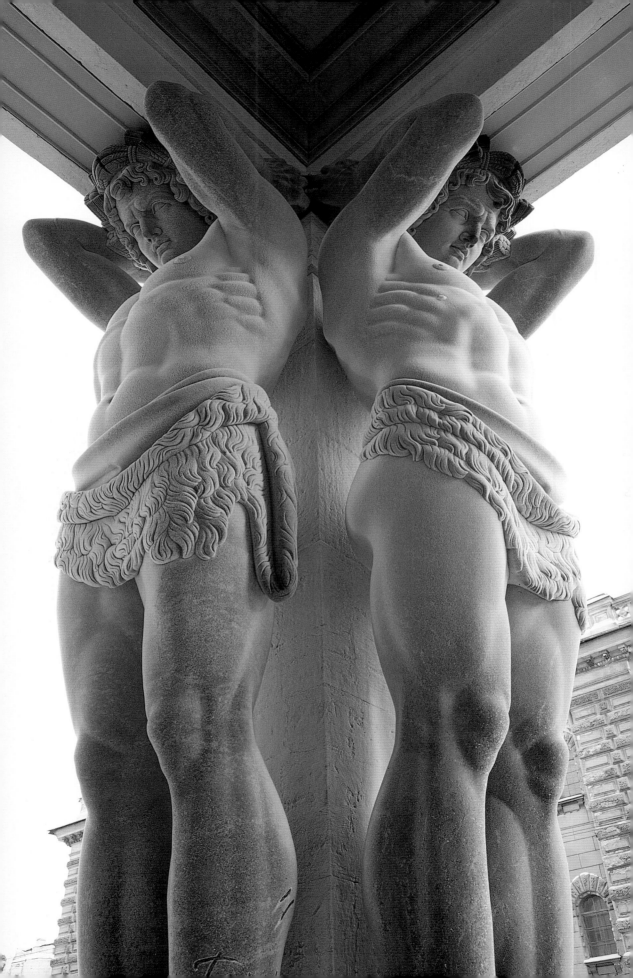

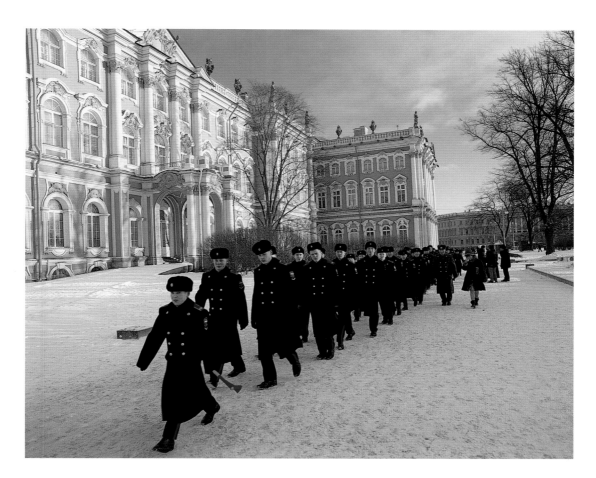

Naval cadets in front of the west façade of the Winter Palace

Atlantes

Alexander Terebenev's ten atlantes, which support the monumental portico over the entrance to the New Hermitage, echo the collections of Greek and Roman antiquities housed within. Terebenev received the commission in 1844 and supervised a team of more than 150 stonemasons, who worked on the sculptures for over three years. Their achievement was summed up at the time by the secretary of the Academy of Arts, Viktor Grigorovich, who wrote:

'Nowhere in Europe can any sculptor produce from granite what the Ancient Egyptians and Greeks produced. But now this Egyptian art has become Russian, and enormous sphinxes are no longer a great marvel alongside the colossal caryatids [*sic*]... so excellently sculpted from stone by Terebenev.' The atlantes were Alexander Terebenev's greatest achievement and passing glory: his life ended at the age of forty-eight in a hospital ward for the destitute.

>

Putti on the rotunda of the Hermitage Church

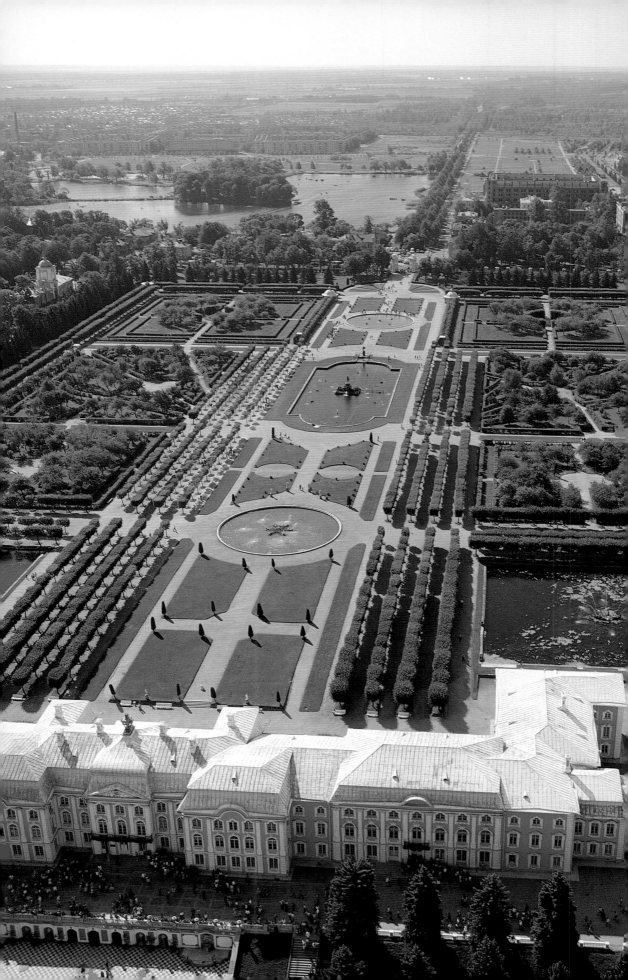

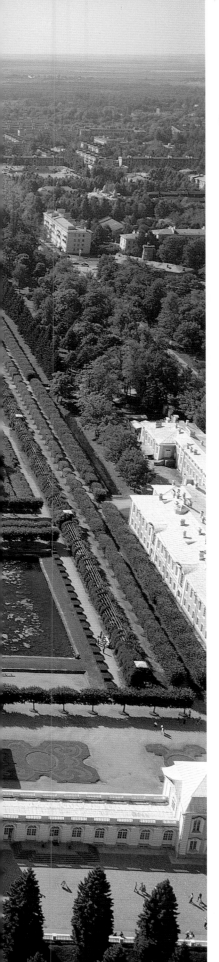

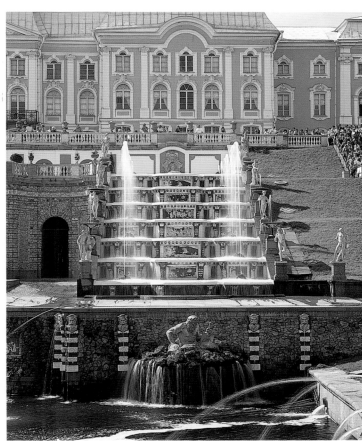

Peterhof

The park at Peterhof is the fountain *aficionado's* dream, with everything from formal cascades to the so-called 'Umbrella' fountain which rains on those who venture too near. But Peterhof was not conceived as a simple pleasure park: it was both Peter the Great's answer to Versailles, and a glorious victory celebration. Peter's defeat of the Swedes at Poltava in 1709 had finally secured the area around St Petersburg, and the new palace, raised on a natural high terrace and approached directly from the sea along the Marine Canal, was Peter's way of confirming his newly secured authority. The Grand Cascade, with its sequence of 37 gilded bronze sculptures and 64 fountains spurting from 142 water jets, was designed to celebrate and symbolise this victory in the Northern War, and the centrepiece was Mikhail Kozlovsky's sculpture of Samson rending the jaws of a lion (the victory at Poltava on 27 June 1709 being the same date the Orthodox Church marks the day of St Samson the Hospitable).

Over two hundred years later another war resulted in the destruction of the palace and the disappearance of Samson, abducted by the Germans in their occupation of the surrounding area. But just as the palace at Peterhof was recreated by the skill of Russian craftsmen, so, on 14 September 1947, a perfect replica of the original Samson and the lion was erected in the central pool, and that day declared a holiday for all the citizens of Leningrad who had survived the blockade. Despite the reconstruction of the palace, Peterhof was left with some lethal reminders of the war: 35,000 mines buried within its grounds. The mine-clearers were faced with a difficult task because of the intricate system of metal pipes supplying the fountains which set off the detectors, so they used dogs to seek out the mines which were then disabled. One particular collie called Jim was responsible for detecting several thousand mines.

>

Statue of Samson and the Grand Cascade

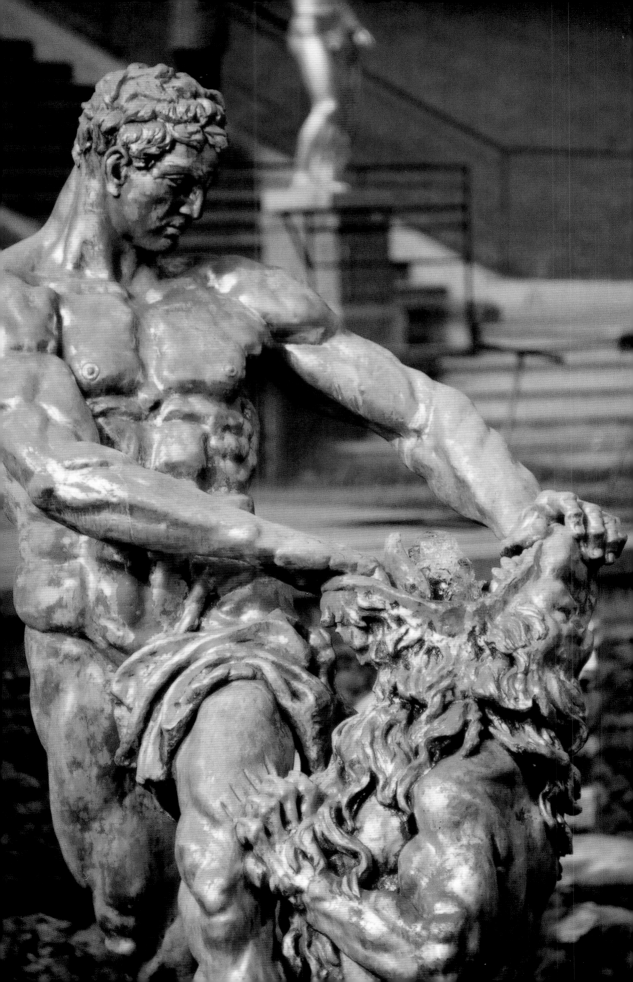

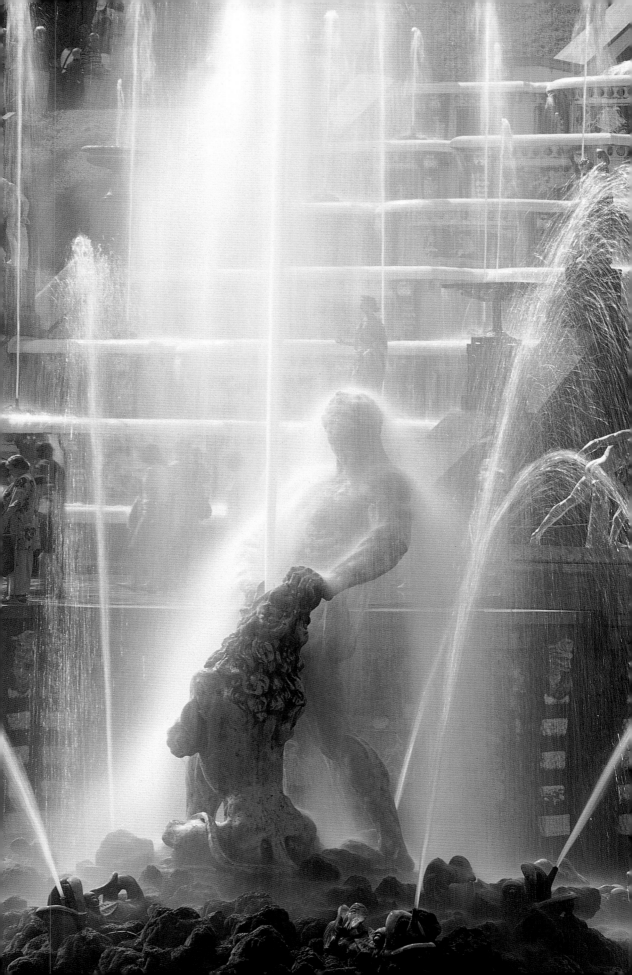

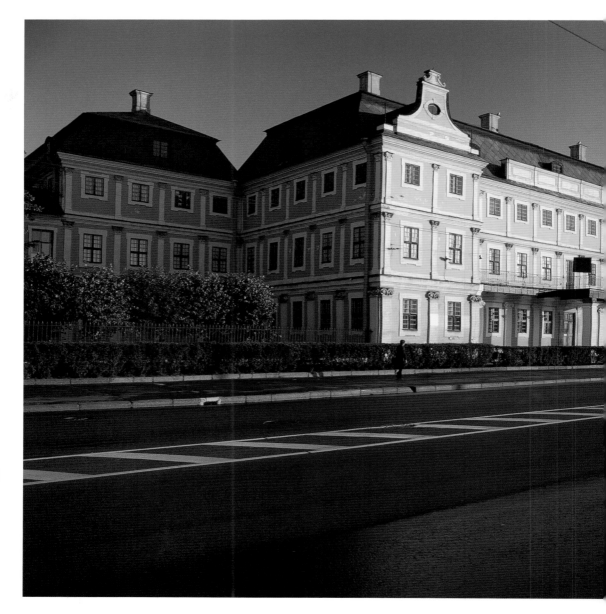

Menshikov Palace

Soon after the founding of the city in 1703, Peter the Great presented Alexander Menshikov, his closest friend and first governor of St Petersburg, with the whole of Vasilevsky Island. (Peter reclaimed the island in 1714 as part of his unsuccessful plan to make it the centre of his new capital.) In 1704 Menshikov started to lay out a garden, but it was only in 1710 that he chose a site for his first palace – a wooden building set back from the embankment. Between 1710 and 1714 the central part of the existing palace on University Embankment was built by Giovanni Maria Fontana and Gottfried Schädel; a private quay and landing stage gave onto the Bolshaya Neva opposite the front door, and the European-style garden behind the palace, with its fountains, sculptures and orangeries, extended as far back as the Malaya Neva to the north. Today the Menshikov Palace is a branch of the Hermitage Museum, housing its collection of early eighteenth-century Russian artefacts.

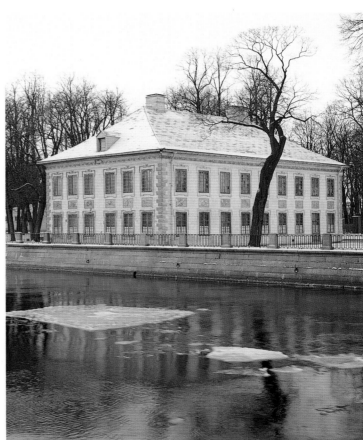

139

Summer Palace

The Summer Palace was Peter the Great's second St Petersburg residence (the first being the wooden *domik* which still stands on the north bank of the Neva River). Built between 1710 and 1714 by Domenico Trezzini, it was one of the city's first bricks-and-mortar structures, though it retained the essential simplicity of the earlier wooden building, and was considerably more modest than Alexander Menshikov's palace across the river. Indeed, rather than entertain at home, Peter preferred to commandeer his favourite's residence for bouts of serious carousing. By contrast, on the door of the Summer Palace (where Peter occupied the ground floor while his wife Catherine inhabited the floor above) was a sign which read: 'No one without orders or who has not been called inside may enter, be he stranger or a servant of this house, so that at least here the master may have a quiet place. Peter.'

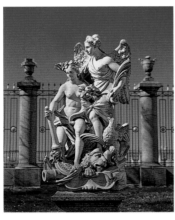

Statues in the Summer Garden

In 1704 Peter the Great commissioned a Summer Garden in the formal French style, to include a dazzling display of gilded statues and fountains. Peter's choice of allegorical and mythological statues is said to have been prompted by a conversation between the tsar and his garden designer: "'I want people walking in the garden to find something instructive. How can this be done?' 'I don't know,' replied the gardener. "Unless your highness should order books to be placed about the garden, covered from the rain, so that people can sit down and read them." The sovereign laughed and said: "It would be difficult to read books in a public garden. I have a better idea. I think we should place statues of Aesop's fables here."' The flood of 1777 destroyed all the fountains and more than half the statues. The 91 that survived – unremarkable examples of eighteenth-century sculpture, predominantly Italian – also include busts of Alexander the Great and various Roman emperors, as well as the Roman philosopher and statesman Seneca. In 1855 the connection with Aesop was re-established with the erection of a statue to Ivan Krylov, Russia's most famous fabulist.

>
Bust of Seneca by Orazio Marinali,
early eighteenth century

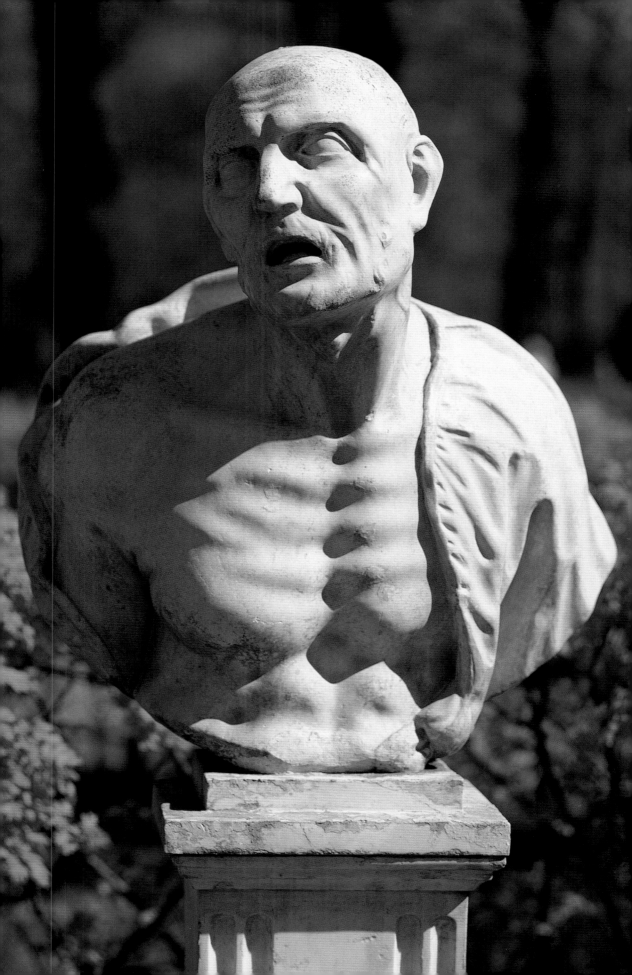

Summer Garden in Winter
'The summer statues were each hidden under boards; the grey boards looked like coffins stood on end; and the coffins stood on either side of the paths; in these coffins light nymphs and satyrs had taken shelter, so that the tooth of time should not gnaw them away with snow, rain and frost, because time sharpens its iron tooth on everything; and the iron tooth will uniformly gnaw away both body and soul, even the very stones.'
Andrei Bely, *Petersburg*

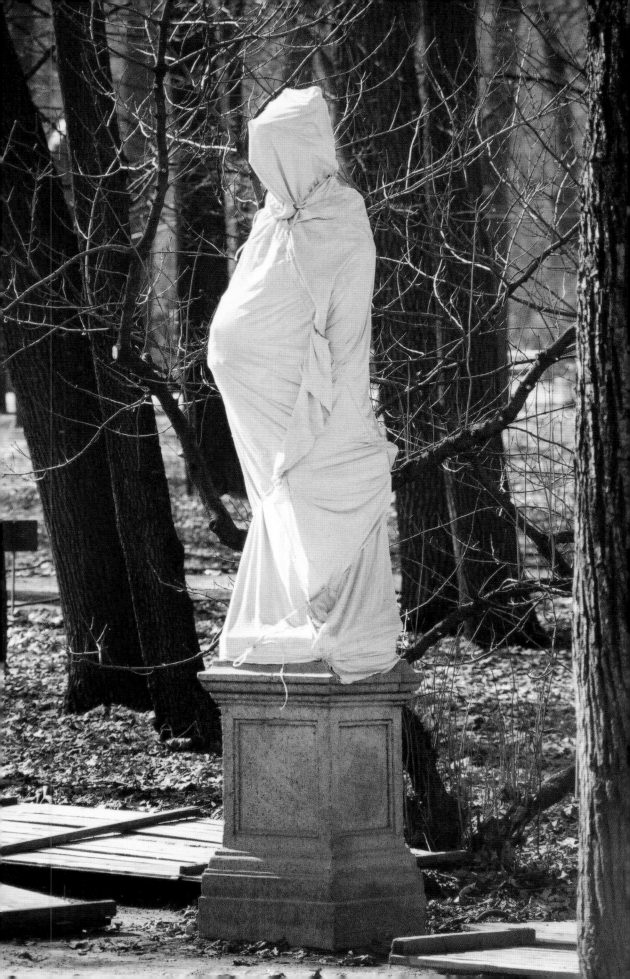

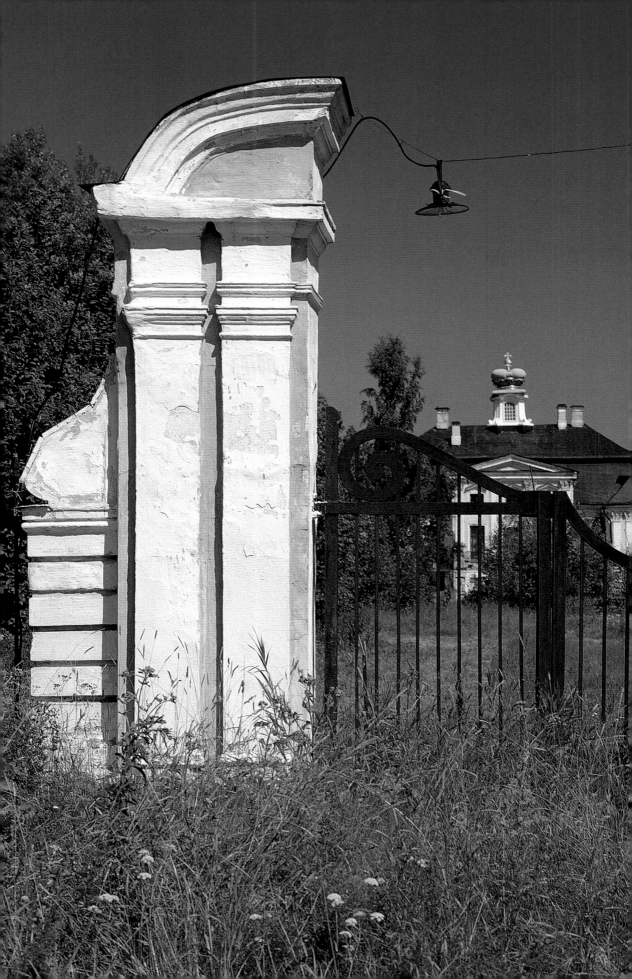

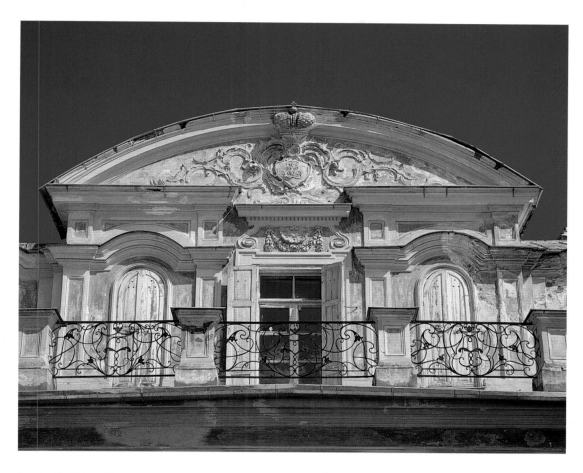

Façade of the Chinese Palace

<
Gates to the Grand Palace

Oranienbaum

Oranienbaum (from the German for 'orange tree') originally belonged to Alexander Menshikov. The name is thought to derive from the orangeries that Menshikov had built in the palace's grounds, and which were the ultimate status symbol of the time. The Grand Palace was built between 1710 and 1725 by the same architects – Schädel and Fontana – who designed Menshikov's palace on Vasilevsky Island, and in its extravagance it far surpassed Peter the Great's neighbouring palace at Peterhof. In fact its exorbitant cost probably contributed to the downfall of a man who at one point owned 3,000 villages and more

than 300,000 serfs throughout Russia. In 1727, after the deaths of Peter and his successor Catherine I (Menshikov's former mistress), Menshikov was exiled to Siberia by the young Peter II, and Oranienbaum passed to the state. In 1743 Elizabeth I presented it to her fifteen-year-old nephew and heir, the future Peter III. Peter's greatest pleasure was playing at soldiers, and here he built himself a miniature fortress and parade ground where he drilled his troops. Peter's wife, later Catherine the Great, was less enamoured of a place she associated with her detested husband ('I felt totally isolated, cried all day and spat blood', she wrote in

her memoirs). In 1762 she conspired with her lover Grigory Orlov, and his brother Alexei, to get rid of Peter. The tsar was taken from Oranienbaum to Peterhof where he meekly abdicated in favour of his wife. A week later he was killed by the Orlov brothers at Ropsha near Peterhof. Catherine subsequently commissioned Rinaldi to build her a 'personal dacha' at Oranienbaum – the Chinese Palace.

>
Detail of staircase to the Grand Palace

>>
Bust at the Chinese Palace

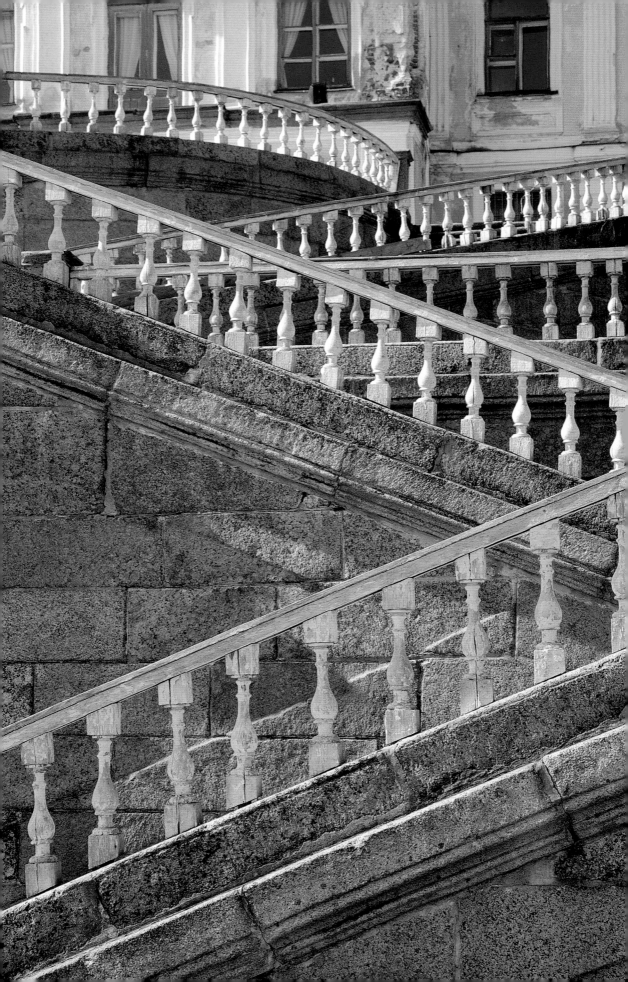

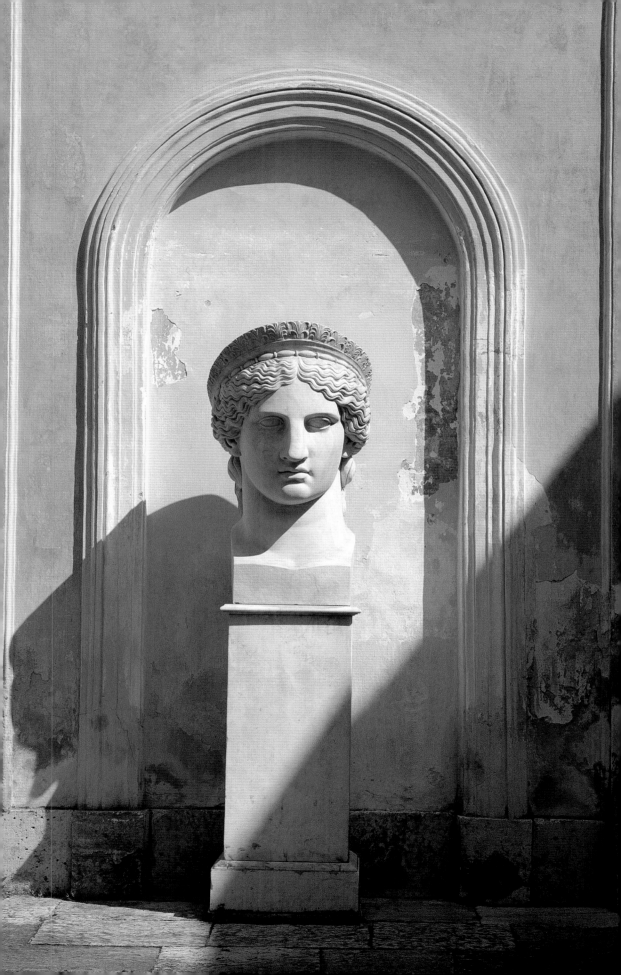

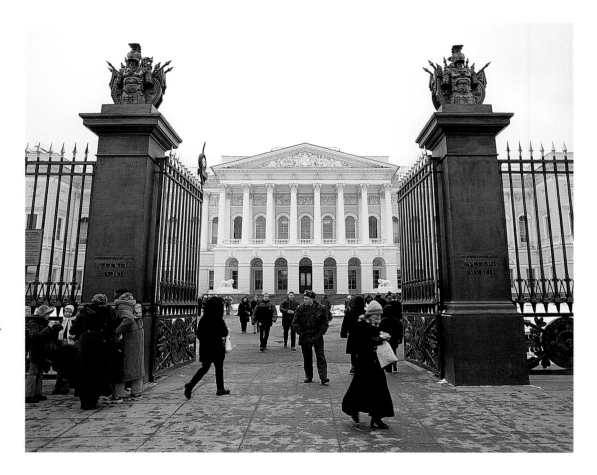

Russian Museum

Every aspect of Russian art, from icons to the work of contemporary artists, is represented behind the neo-classical façade of the former Mikhailovsky Palace, now the Russian Museum.

The history of the collection often mirrors the political history of the country. The museum was founded in 1895 by Alexander III, who wanted to promote a strongly national artistic tradition (reflected in the monumental history paintings by such artists as Surikov and Repin). The early twentieth century saw an extraordinary period of artistic experimentation and innovation, though often still rooted in iconic or Russian folk traditions. In the years leading up to 1917 Russia led the way in European modern art, through the work of Malevich,

Kandinsky, Goncharova, Larionov and other members of the Russian avant-garde. For a short period following the Revolution, art and politics were united in a utopian desire to bring art to the masses through street art and so-called Institutes of Artistic Culture. Tatlin's famous model for the *Monument to the Third International*, designed to straddle the Neva River and house the world government of planet earth, with revolving rooms that moved in time with the circuits of the sun, moon and stars, was one of the more ambitious schemes. This intellectually stimulating period was brought to an abrupt end in the early 1930s by Zhdanov's codification of Socialist Realism as a literary and artistic method. The glorification of

the Soviet system was paramount; modernism was outlawed. The Hermitage canvases by Matisse and Picasso were put into storage; similarly, at the Russian Museum, Malevich and co were consigned to the cellars, where they remained for fifty years until the political thaw of Gorbachev's *glasnost*.

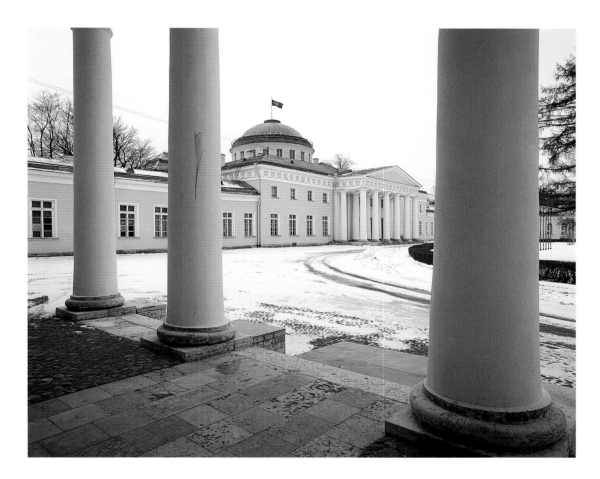

Taurida Palace

In a speech marking the opening of an exhibition of Russian historical portraits at the Taurida Palace in 1905, Sergei Diaghilev, the exhibition's organiser and future impresario, made a telling prediction: 'We are witnesses of the greatest moment of summing up in history, in the name of a new and unknown culture, which will be created by us, and which also will sweep us away.' The Taurida Palace itself was a symbol of the imperial St Petersburg that was soon to be swept away. Built by Ivan Starov between 1783 and 1789, it was a gift from Catherine the Great to her lover and mentor, Prince Potyomkin. Catherine had awarded Potyomkin the title Prince of Taurida after his successful annexation of the Crimea

(Tauris being the ancient name of the Crimea) in 1783.

The Taurida Palace was the setting for one of the most famous parties in Russian history. On 28 April 1791, just a few months before his death, Potyomkin gave a masquerade ball to mark Russia's triumph over the Turks, Prussians and English. Five thousand members of the public were treated to free food and drink, while inside the largest hall in Europe – the Colonnade Hall – three thousand guests, including Catherine and her son Paul, were lavishly entertained. The cost was rumoured to have approached half a million roubles. Catherine wrote the following day to her confidant, the philosopher Friedrich Melchior Grimm: 'That Marshal Prince

Potyomkin gave us a superb party yesterday at which I stayed from seven in the evening until two in the morning... Now I am writing to you to improve my headache.'

As Diaghilev's words neared their prophetic resolution, the Taurida Palace played a central role in the transition from imperial to Bolshevik rule. In 1906 Russia's first parliament, the State Duma, was convened there; after the February Revolution of 1917 the palace became the seat of the Provisional Government headed by Kerensky, and subsequently the meeting place for the Petrograd Soviet of Workers' and Soldiers' Deputies. It remains a government building today, and its gardens one of the city's most popular parks.

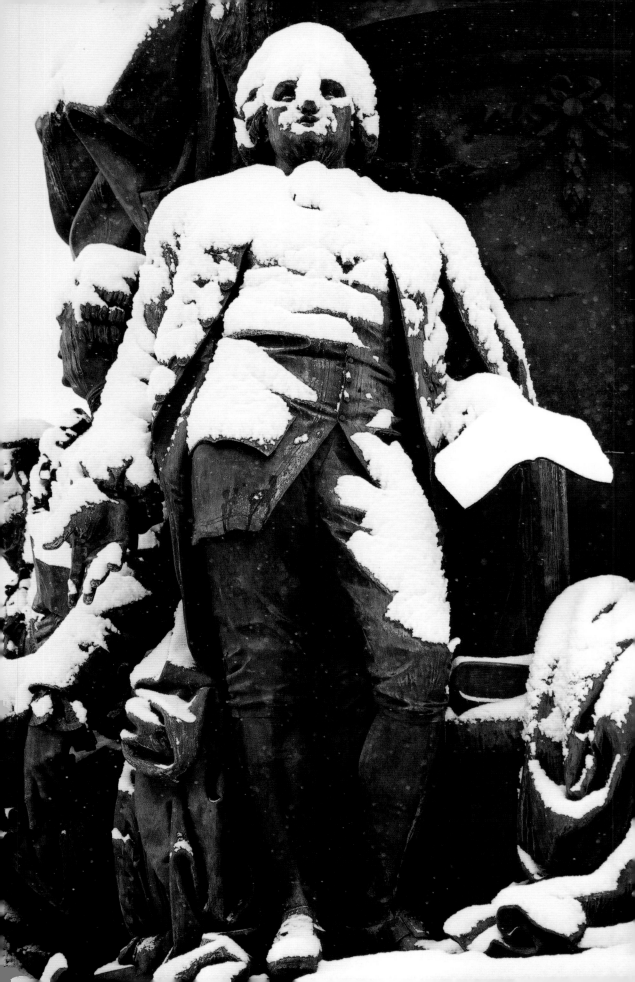

<

Statue of Derzhavin at the base of the
monument to Catherine the Great

Monument to Catherine the Great

This monument, designed by Mikhail
Mikeshin and erected in front of the
Alexandrinsky Theatre in 1873, is,
somewhat surprisingly, the city's
only statue of Catherine the Great.
Surprising, because – for all its associa-
tions with Peter the Great (whose
image now proliferates on everything
from monolithic memorials to ciga-
rette packets) – St Petersburg's devel-
opment as an imperial capital in its
first hundred years owed as much to
the vision of two of Peter's successors:
the empresses Elizabeth and
Catherine the Great. The monument
shows Catherine surrounded by

statesmen and other favourites,
including her lover Prince Grigory
Potyomkin, Princess Yekaterina
Dashkova (the first woman president
of the Academy of Sciences), and the
poet and statesman Gavrila Derzhavin
(*left*). Derzhavin first attracted
Catherine's attention in 1783 with his
eulogy to the empress entitled 'Ode to
Princess Felitsa'. He enjoyed a brief
period of favour at court, being pro-
moted to the rank of state secretary;
however, he was altogether too honest
and conscientious for court life, and
Catherine soon dismissed him with
the words, 'Let him write verse'.

Alexandrinsky Theatre

The Alexandrinsky Theatre, designed
by Carlo Rossi, provides a backdrop to
the monument to Catherine the Great
on Ostrovsky Square. Completed in
1832, the theatre has witnessed several
historic premières, including Gogol's
The Inspector General and Chekhov's *The
Seagull*. But perhaps its most historically
poignant production was Meyerhold's
staging of Lermontov's *Masquerade*,
which took place amidst increasing
revolutionary fervour in February 1917.
The choir's mournful liturgy in the
final scene seemed to many like a wake
for the regime and its imperial capital.
Anna Akhmatova described returning
home from the play: 'There were shots
on Nevsky Prospect and horsemen
with bared swords attacked passers-by.
Machine guns were set up on roof tops
and in attics.'

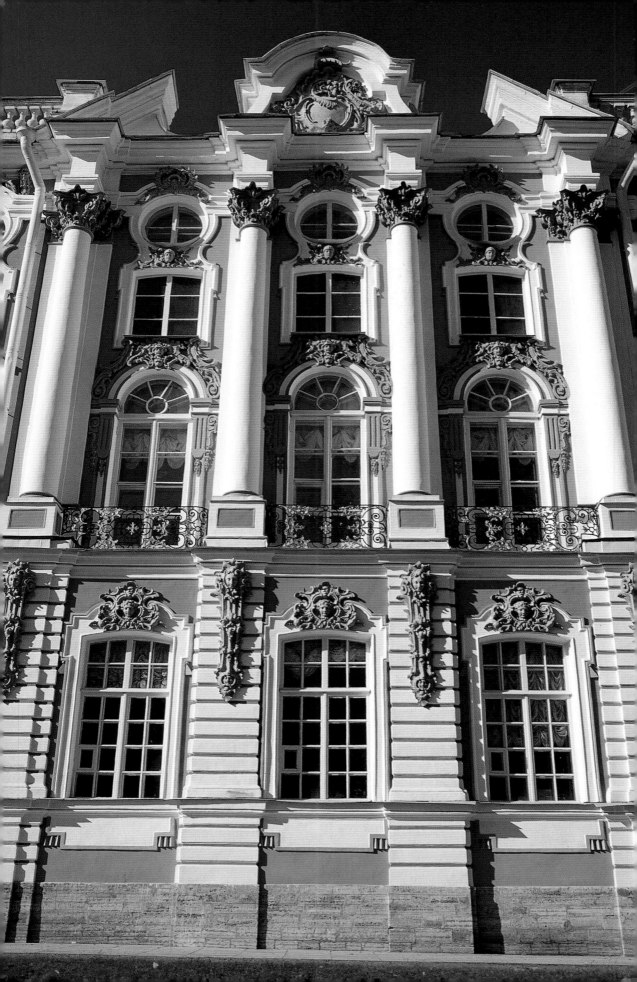

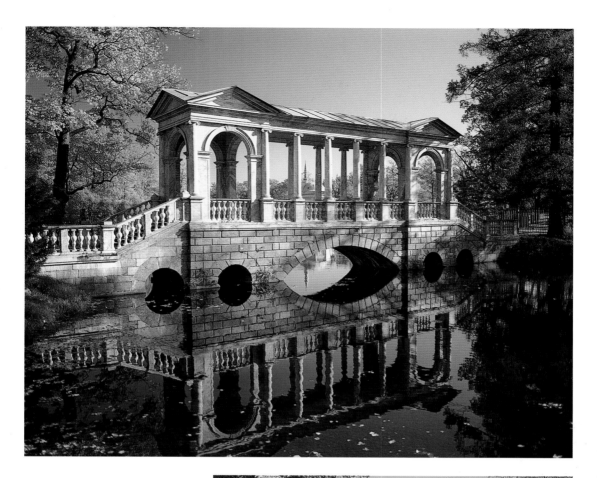

Siberian Bridge on the Large Lake

<
Catherine Palace

Tsarskoe Selo

The Catherine Palace at Tsarskoe Selo was designed by Rastrelli in 1752 for Empress Elizabeth, who named it after her mother Catherine I. Catherine II (the Great) left the baroque façade virtually unchanged, but commissioned the Scottish architect Charles Cameron to redesign the interiors to her more neo-classical taste.

'I adore English gardens', Catherine wrote to Voltaire in 1772, and it was at Tsarskoe Selo that the first proper landscape garden, known in Russia as an 'English garden', was developed. Gardeners were invited over from England, and architects such as Vasily Neyelov, who modelled the Siberian Bridge on the Palladian Bridge at Wilton, were sent over to visit Kew, Hampton Court and other famous English gardens. Neyelov was also responsible for the oriental Cross Bridge in the Alexander Park, which reflected European, and particularly English, enthusiasm for 'Chinese taste' at the time.

>
Cross Bridge in the Alexander Park

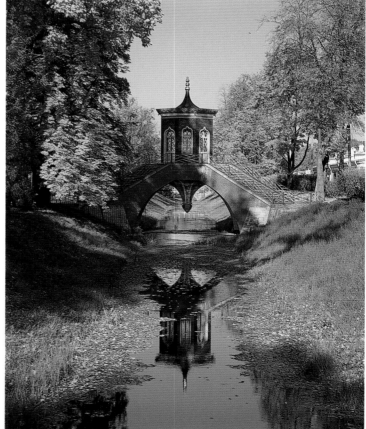

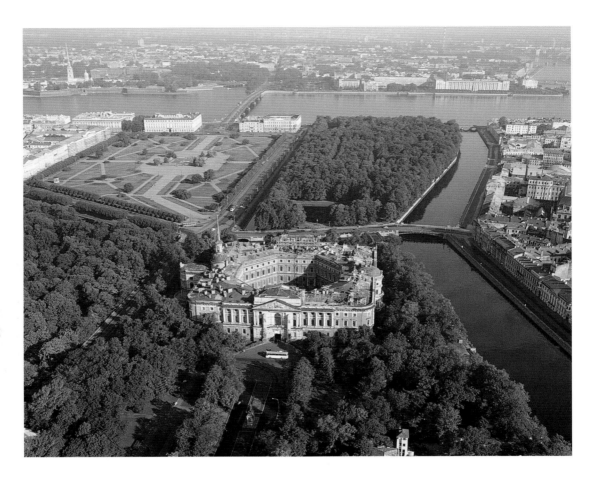

Mikhailovsky Castle

The Mikhailovsky Castle was built for Paul I on the site of Empress Elizabeth's Summer Palace, where Paul himself had been born. Paul was anointed tsar in 1796 on the death of his mother, Catherine the Great, and work quickly began on the fortress that was to protect this paranoid ruler from his enemies. Two canals were dug which, along with the Fontanka and Moika rivers, effectively formed a moat around the castle; access was by draw-bridge alone.

One of Petersburg's more charming legends explains the castle's distinctive brick-red colour. Anna Lopukhina, a future favourite of Paul's, dropped her glove while standing next to the tsar at a court ball. When Paul bent to pick it up he was so taken with the glove's colour that he

asked to keep it, and promptly sent it off to Brenna, the castle's architect and designer.

Paul moved into the Mikhailovsky Castle in February 1801, the paint still drying and the building poorly ventilated; within forty days he was dead – killed by plotters including his own guards, courtiers and ministers. The events of the night of 10 March 1801 were recorded by one of the conspirators, General Bennigsen: 'In this state of stupor [the emperor] was found by seven or eight of the conspirators who, intoxicated with wine, had lost their way and were now pushing in with great noise... General Bennigsen alone avoided joining in this terrible mêlée... on re-entering after scarcely a moment's absence he saw Paul already strangled with a sash. His murderers

later maintained that he had put up little resistance; he had only pushed his hand between the sash and his neck, and said in French: "Messieurs au nom de ciel, épargnez-moi! Laissez-moi le temps de prier à Dieu! [Sirs, in heaven's name spare me! Leave me the time to pray to God!]" These were his last words.'

The Mikhailovsky Castle was the shortest-lived of all of St Petersburg's imperial palaces: by 1823 it had become home to the Engineering Institute, since when it has been known as the Engineer's Castle.

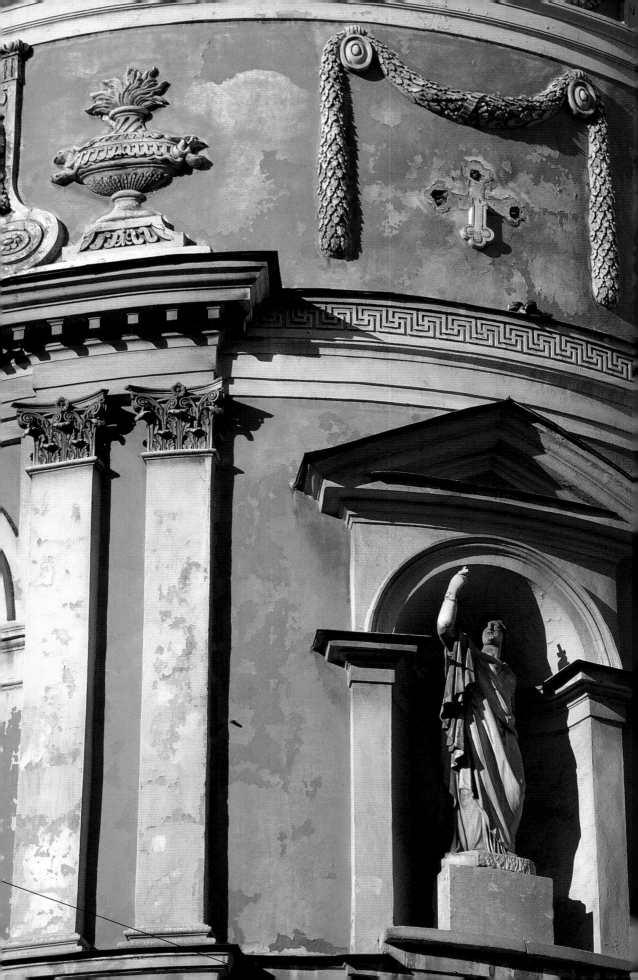

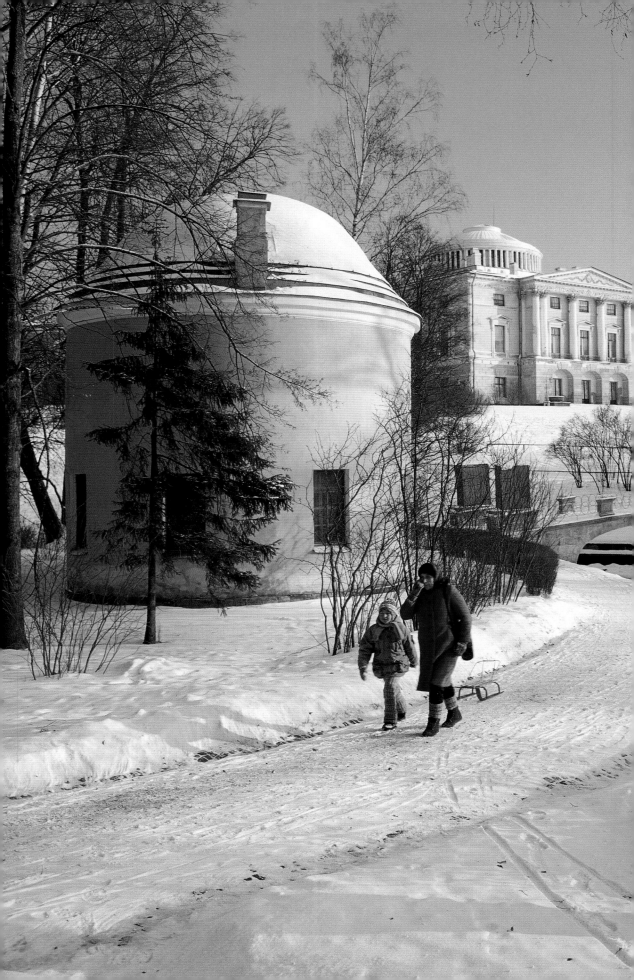

Pavlovsk

The land on which Pavlovsk was built was presented by Catherine the Great to her son Paul (Pavel, hence Pavlovsk) on the birth of his eldest son Alexander in 1777. Originally designed by the Scot Charles Cameron, who eventually fell out with Paul and his wife Maria Fyodorovna, the Great Palace was later extended by Cameron's assistant, Vincenzo Brenna. The park, which was landscaped by Cameron and Pietro di Gonzago with numerous pavilions and 'architectural diversions', has long been one of the most popular destinations for inhabitants of St Petersburg – initially for a very practical reason. In 1835 the German engineer Anton Ritter von Gerstner, who had built Austria's first railway line, sent Nicholas I a proposal to construct Russia's first rail link between Moscow and St Petersburg. The tsar decided to test out this new-fangled mode of transport with a more modest scheme, linking Petersburg with Tsarskoe Selo and ending at Pavlovsk. Within two years the capital's newspapers were writing of the 'deafening roar of the fiery stallion which runs to Pavlovsk in 35 minutes'. An elegant terminus building was constructed at Pavlovsk by Andrei Shtakenshneider, with a restaurant, billiard rooms and winter gardens. The building was called 'Vauxhall' after the restaurant in the Vauxhall Gardens in London; its Russian transliteration 'voksal' has subsequently come to be used for all such buildings, meaning simply 'station'. Concerts were held at the Vauxhall, attracting some of the most famous musicians and composers of the time. Glinka composed a waltz that became known as the Pavlovsk Waltz; for ten seasons from 1856 Johann Strauss was musical director there; later still Shalyapin sang, Glazunov and Prokofiev played, and, in 1914, Anna Pavlova danced there. After the Revolution the railway meant that Pavlovsk and its concerts, which had once been the preserve of the aristocratic rich, became accessible to all. In 1941, however, the area was occupied by the Germans, and when they were finally expelled from Pavlovsk on 24 January 1944, the palace had been reduced to a burnt-out shell and the Vauxhall completely destroyed. Iosif Orbeli, then director of the Hermitage, commented that humanity was the poorer for the loss of Pavlovsk, and photographs of the devastation were used as prosecution evidence at Nuremburg. With the decision to rebuild Pavlovsk after the war, the palace and park became once more a popular weekend destination.

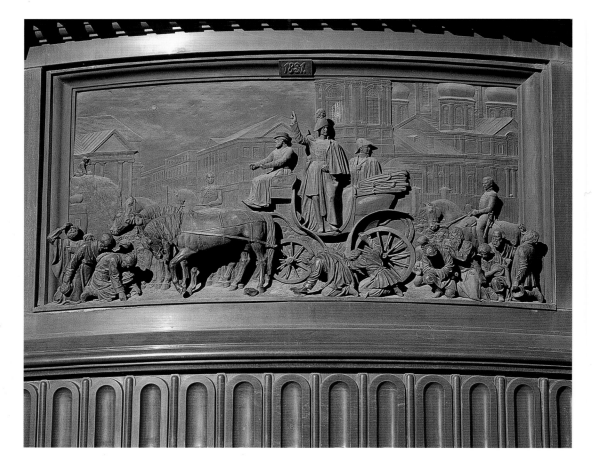

*Bas relief around the base of the Statue
of Nicholas I (detail)*

Statue of Nicholas I

The equestrian statue of Nicholas I
stands in the centre of St Isaac's
Square, part of Auguste de Mont-
ferrand's overall design for St Isaac's
Cathedral and Square. The statue itself
is the work of Pyotr Klodt, who also
created the four horses on Anichkov
Bridge. Four bas-reliefs around the
base of the statue depict scenes from
Nicholas I's reign, including his
quelling of the Cholera Uprising on
Sennaya Square (*above*).

 In 1831 Russia was struck by an
outbreak of cholera. The large number
of deaths, allied to the inefficacy of
the medical services and police
brutality, gave rise to rumours that
water and medicine in the city were
being deliberately poisoned. On 21
June 1831 a crowd stopped a cart
carrying infected people and set them
free. The next day police were attacked
and doctors thrown from hospital
windows, before regiments of guards
eventually brought the uprising
under control. According to legend,
however, it was Nicholas I himself
who came out onto Sennaya Square
and single-handedly brought the
uprising to an end by drinking a flask
of medicine and crying, 'What are you
doing, you fools? What has made you
think you are being poisoned? It is a
punishment from God. On your knees,
fools! Pray to God!'

>
*Shadow of the Statue of Nicholas I
on St Isaac's Square*

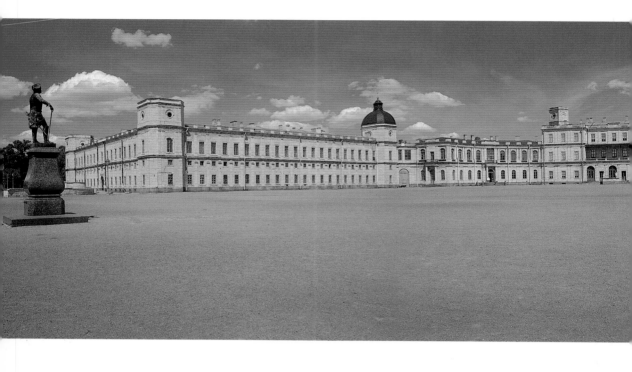

Gatchina Palace

Catherine the Great presented the land at Gatchina to her favourite, Count Grigory Orlov, in 1765. The palace's severe, castellated design by the Italian Antonio Rinaldi – including turrets and an underground tunnel – set the tone for Gatchina's somewhat gloomy role in Russian imperial history.

After Orlov's death Catherine bought Gatchina back from his family. She gave it to her son, the future Emperor Paul I, who was apparently untroubled by moving into a palace built for his father's murderer. Paul set about turning the palace into even more of a fortress: in the 1790s the meadow in front of the palace was

converted into a parade ground, sentry boxes were built, a moat was dug and draw-bridges installed, and grilles were placed over the windows.

In the 1840s Gatchina became the principal residence of Nicholas I, but later in the century it returned to a use more suited to its forbidding exterior: it was here that Alexander III

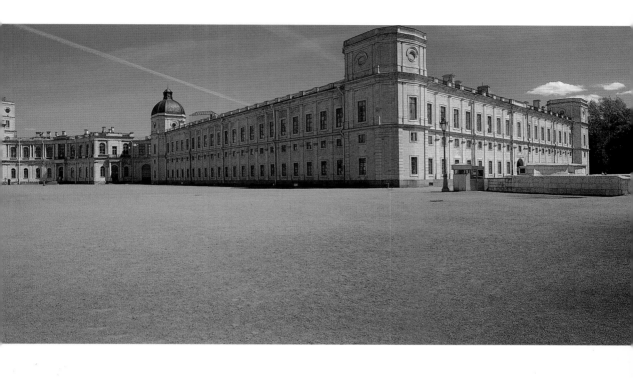

took refuge after his father had been assassinated in 1881 – or, as the preface to the 1882 edition of Marx and Engels' *Communist Manifesto* put it, 'Today [Alexander III] is a prisoner of war of the revolution in Gatchina, and Russia forms the vanguard of revolutionary action in Europe.'

It was also at Gatchina that Alexander Kerensky, head of the Provisional Government, sought refuge after the Bolsheviks took over the Winter Palace in October 1917, and where he met up with a troop of Cossacks under General Krasnov. The Kerensky-Krasnov Rebellion, as Soviet historians rather grandly titled it, was short-lived: on the night of 30 October revolutionaries took back Gatchina. Krasnov and his forces were arrested, while Kerensky escaped once more.

Situated forty-five kilometres south of St Petersburg, today Gatchina is a museum. The interiors were almost completely destroyed by the retreating Germans in 1944, and the palace remains only partially restored.

Wall Surrounding the Bobrinsky Palace Garden

The Bobrinsky Palace stands at the confluence of the Admiralty and New Admiralty Canals. Designed by Luigi Rusca in the 1790s, it spent much of the Soviet era housing the Psychology Faculty of Leningrad State University.

\>

Follenveider Mansion

This mansion on Krestovsky Island was built in 1904 by Roman Meltzer, one of the leading architects working in Style Moderne at the turn of the twentieth century.

\>

Marble Palace

Built by Antonio Rinaldi between 1768 and 1785, the Marble Palace was also known familiarly as the Konstantin Palace, since for eighty years leading up to 1915 its three inhabitants were all called Grand Duke Konstantin.

\>

Yelagin Palace

The Yelagin Palace, commissioned in 1817 by Alexander I for his mother, Maria Fyodorovna, was Carlo Rossi's first major project in the city.

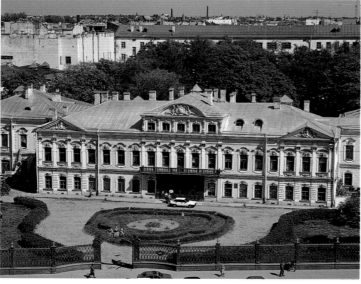

Sheremetev Palace

Although the existing baroque palace was built between 1750 and 1755 by Savva Chevakinsky, the Sheremetev family had lived on this site by the Fontanka River from 1712, when Peter the Great awarded the land to Field Marshal Boris Sheremetev for his military exploits against Sweden. For much of the nineteenth century the palace was frequented by writers, artists and musicians, but it was under communism that it acquired its most famous literary association: the poet Anna Akhmatova lived in one of the service apartments from 1933 to 1941 and again from 1944 to 1954. Today the palace houses the Museum of Musical Instruments, while the Anna Akhmatova Museum occupies the poet's former apartment.

Konstantinovsky Palace

Situated at Strelna some twenty kilometres from St Petersburg, Konstantinovsky Palace is the third (with Peterhof and Oranienbaum) of the great palace complexes built on the southern shore of the Gulf of Finland. A palace and surrounding park were originally commissioned by Peter the Great as early as 1707, but work on the Great Palace began only in 1719 under the architect Niccolò Michetti, and continued for several decades under different architects (including Bartolomeo Rastrelli from 1747 to 1761, Andrei Voronikhin at the beginning of the nineteenth century after two fires destroyed much of the palace, and Andrei Shtakenshneider in the 1850s). In 1847 the entire palace ensemble at Strelna became the summer residence of Nicholas I's son, Konstantin, from whom the Great Palace acquired its sobriquet. Left a virtual ruin by the occupying German forces in the Second World War, the palace was subsequently partially restored and taken over by the Arctic Sailors' College. Compared to neighbouring Peterhof, however, Konstantinovsky Palace suffered many years of neglect until the recent decision of Vladimir Putin to support the reconstruction of the palace as a centre for international summits and conferences (as well as occasional presidential residence). An estimated 200 million US dollars is being spent to restore not just the palace but also the network of canals, cascades and bridges in the surrounding estate.

>
Statue of Peter the Great

Mikhail Shemyakin's statue in the Peter and Paul Fortress was unveiled in 1990; it was not greeted with universal acclaim. An article in *Pravda* described Peter as 'bald, swollen and monstrously ugly', and concluded that Petersburgers 'have ended up shrugging and passing by on the other side'. Shemyakin's Peter, however, was better received than a vast statue portraying the tsar standing at the prow of a ship, erected on the banks of the river in Moscow. The local member of parliament announced at a press-conference that his constituents had warned him, 'If they put it up, we'll blow it up'.

>>
Statue of Lenin

Unveiled on Moscow Square in 1970 to commemorate the centenary of Lenin's birth, Mikhail Anikushin's statue was intended to express 'the concentration of will and energy, the embodiment of humanity, unwavering conviction and unstinting pursuit of a great aim'.

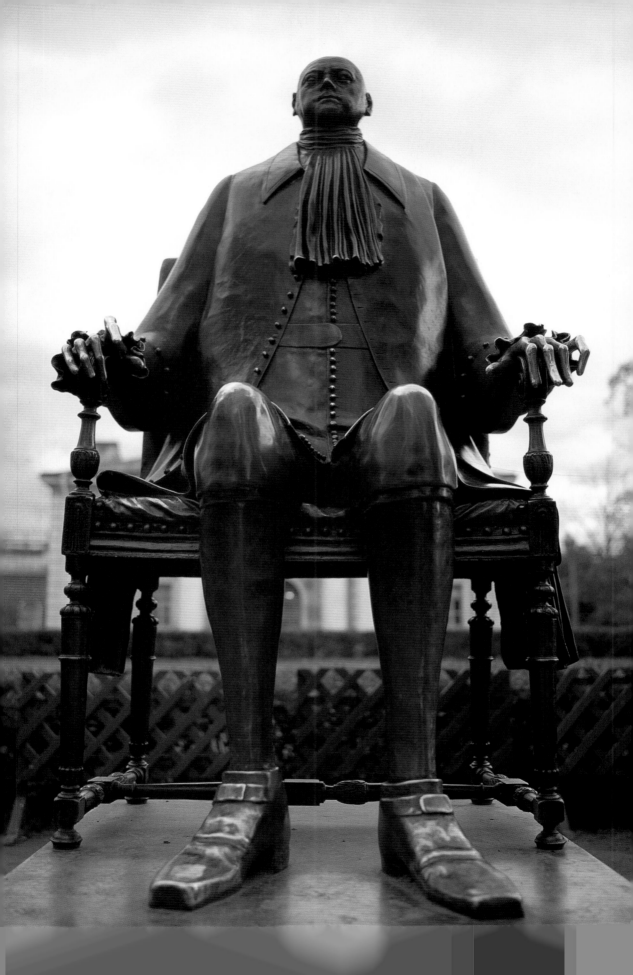

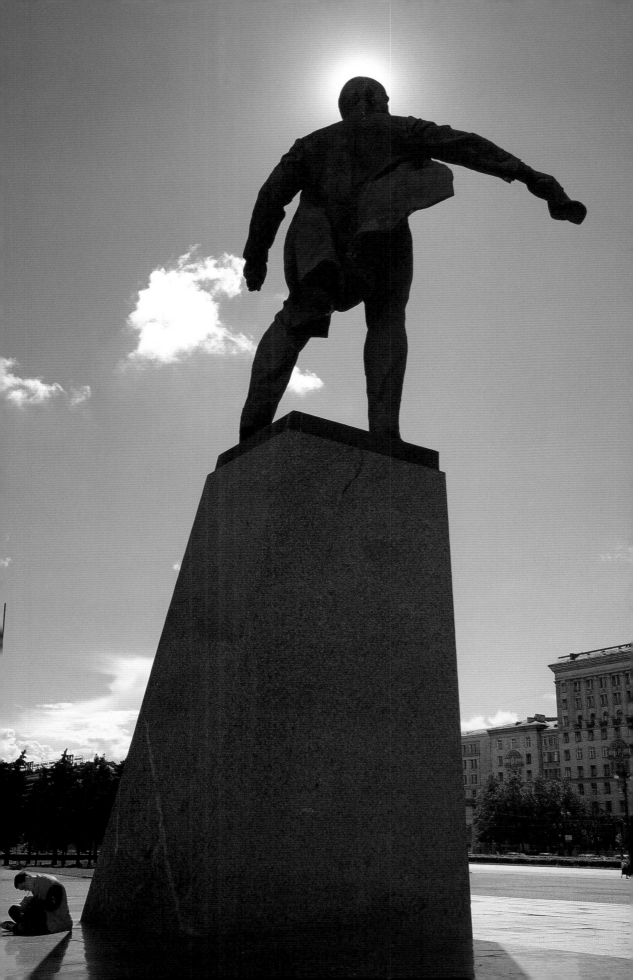

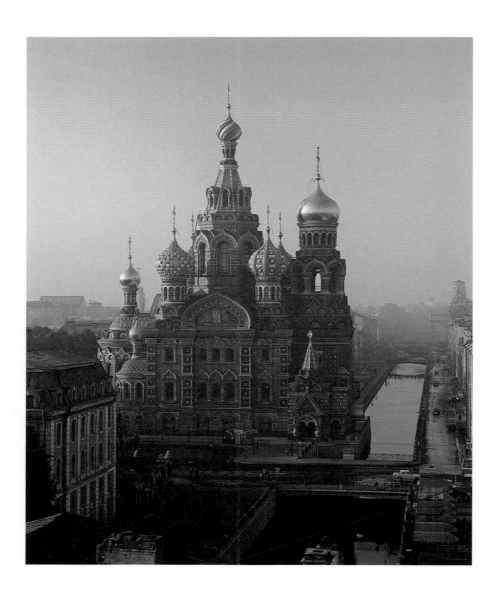

*The Cathedral of the Resurrection,
commonly known as 'The Saviour on the
Blood', was built in memory of Alexander II
near to the place (by the Griboedov Canal)
where the tsar was assassinated in 1881*

The Beautiful and the Damned
Preserving Peter the Great's Dream on the Neva

As cities go, St Petersburg is very much a Johnny-come-lately: when Peter the Great decided to found a city on marshlands at the mouth of the Neva River, New York City was already seventy-seven years old. The choice of location was an act of daring presumption – a flamboyant Petrine tweak of Charles XII's nose – for at the time the whole area still belonged to Sweden, and only became part of Russia at the conclusion of the war between the two countries in 1721. Not even a war, however (and one Peter came perilously close to losing) could deter this demiurge of a man from working simultaneously on a bevy of awesome schemes. In no other country in modern times, with the exception of China, could such a grandiose plan of construction have been put into motion and brought to such a speedy reality. When Peter conceived his new capital, building entire cities from scratch was most definitely the prerogative of Asian despots. Even Louis XIV in his heyday would have been hard-pressed to find the funds and mobilise such a Pharaonic work force.

And St Petersburg is a city of blood – lots of it. For Peter's dream was the serf's nightmare. When, on 16 May 1703, this Byzantine sovereign supposedly stuck his cane into the marshy ground on Zayachy Island and imperiously declared, 'The city will be here!',[1] he condemned at least a hundred thousand serfs to death. Historians still argue over the exact number, with some trying to mitigate the cost by saying *only* thirty thousand or so perished. Peter, one suspects, would have been unlikely to notice the difference, for monumental labour forces were never a problem for the Romanovs: when Alexander II emancipated the serfs in 1861 he freed somewhere between forty-five and fifty million human beings who had hitherto been either privately- or state-owned slaves.

Serfs and other workers were impressed into Peter's service from all over Russia, and thousands were to die under miserable conditions each year. The Museum of the History of St Petersburg, located, appropriately enough, in the Peter and Paul Fortress, shows how these labourers attempted to survive in open ditches, with nothing but branches for shelter. Recent archaeological research indicates that even those who built the Great Pyramid were essentially free citizens, and lived and worked under far better circumstances than the dispensable drudges who turned a tsar's whim into reality.

Peter the Great was not the first Russian ruler with a less than benevolent attitude towards his subjects; his heirs ensured he was not the last. On the night of 17 December 1837 a devastating fire broke out in the Winter Palace. It burned for thirty hours, destroying the interiors of the main and upper floors. Servants and soldiers managed to save the furnishings and works of art.

Nicholas I, the tsar who brutally suppressed the Decembrist uprising of 1825 and thereafter became the epitome of the watchdog policeman for all of Mother Russia, impatiently commanded a speedy reconstruction; within two years it was achieved. No one would have dared raise a cautionary, let alone dissenting, voice against this enforced labour. It was Nicholas I, after all, who declared to the Council of State upon ascending the throne: 'I cannot permit that any individual should dare defy my wishes, once he knows what they are.'[2]

During these eighteen months of reconstruction, some thirty thousand labourers died. They were forced to work in rooms that were heated to one hundred degrees Fahrenheit in order to speed up the drying of plaster and paint, and then go outside in temperatures as low as minus fifty to work on the façade. Astolphe, the Marquis de Custine, who spent just under three months in Russia in 1839 and had the opportunity of conversing with the tsar on various occasions, recorded his disgust: 'I was told that those who had to paint the interior of the most highly heated halls were obliged to place on their heads a kind of bonnet of ice, in order to preserve use of their senses under the burning temperature. Had there been a design to disgust the world with arts, elegance, luxury, and all the pomp of courts, could a more efficacious mode have been taken? And yet the sovereign was called father, by the men immolated before his eyes in prosecuting an object of pure imperial vanity.'[3] Nicholas I remained impervious to something as inconsequential as human suffering. Undoubtedly, Peter the Great would have applauded his descendant's sense of priorities.

If St Petersburg's foundation is blood, its superstructure is pure theatre: an excessive and often overbearing stage design for a cataclysmic imperial tragedy known as the House of Romanov. On a warm July evening in 1839, at a grand fête in the Winter Palace, Nicholas I observed to de Custine that 'Petersburg is Russian, but it is not Russia'.[4] Indeed, you only have to travel some fifty or so miles from St Petersburg to find yourself in real Russia. But the tsar was correct in his assessment that the metropolis is Russian: it is quintessentially Russian if by 'Russian' is understood a concept of grandeur that never attempted, nor even considered, a modicum of restraint in the megalomaniacal exuberance that is both its source of inspiration and its aesthetic prerogative. While many of the noble families who were ordered to move to St Petersburg and build residences there encountered financial difficulties in the process, lack of money was never a problem for the Romanovs. J. Beavington Atkinson, an English art critic who visited Russia in 1870, was astounded by the sheer size of the grandest buildings in St Petersburg. Speaking of imperial expenditures, Atkinson observed, 'the one impression left on my mind is that Russian Governments never count cost or economise material; that when they do not screw they squander; that where they do not starve they supply to satiety'.[5] This applies to every reign from Peter the Great to Nicholas II.

Once Peter had determined to build his 'New Rome' at the mouth of the Neva, haste was of the essence, as it was for subsequent rulers. Caught between their gargantuan ambitions and the constant threat of assassination, the Romanovs were unable to indulge in the virtue of patience. Their messianic conception of Russia's significance, and that of the tsar, required a backdrop that would impress both foreigners and the indigenous population. Like a stage set assembled over 200 years, St Petersburg was designed by a succession of architects to provide a theatrical suspension of belief on the grandest of scales, and a city that reflected in pomp and majesty the country of which it

The ten atlantes supporting the
portico over the entrance to the
New Hermitage were restored in 2000

was capital. De Custine, for all his misgivings, was genuinely impressed by the spiritual and intellectual impulse behind St Petersburg's creation: 'St Petersburg, in all its magnificence and immensity, is a trophy raised by the Russians to the greatness of the future. The hope which produces such efforts appears to me sublime. Never, since the construction of the Jewish temple, has the faith of a people in its own destinies raised up from the earth a greater wonder than St Petersburg.'[6] As truly wonderful as St Petersburg is, closer scrutiny is advisable.

In so many things, from cooking to friendship to animal training to military might, the Russians are magicians. They have an inbred ability to create fantastically memorable impressions that often prove to be more chimerical than real. At the opening of his book *An Art Tour To Russia*, Atkinson highlights the flimsy nature of St Petersburg's architecture: 'While Rome [was] built for eternity, Russia runs up some false construction, some showy façade which melts like snow in the sun, or crumbles as stucco in the frost.' He continues: 'Few cities are so pretentious in outside appearances as St Petersburg, and yet the show she makes is that of the whited sepulchre: fake construction and rottenness of material, façades of empty parade, and plaster which feigns to be stone, constitute an accumulative dishonesty which has few parallels in the history of architecture.'[7] Shrill in its harshness, Atkinson's condemnation nevertheless contains much truth.

In terms of 'façades of empty parade', anyone standing in Palace Square, with the Winter Palace behind them and facing Carlo Rossi's General Staff Building, cannot miss the immense triumphal arch that punctures the massive sweep of the indented façade. To the unsuspecting observer, such a majestic opening implies an entrance to a grand *via imperiali* beyond. Nothing could be further from the truth. Rossi's Triumphal Arch leads to a small street that abuts the arch at an angle and runs its short length to an intersection with Nevsky Prospect. What was important, however, was the effect. Whatever the aesthetics of the entire ensemble (de Custine, for one, was not impressed, dismissing the General Staff Building as 'temples erected to clerks'[8]), the desired impact – intended to dwarf people, to put them in their humble place before the residence of the tsar and the centre of imperial power – was more than achieved. Standing there today you can still experience the chill of the autocratic principle.

If the audacity of Peter's choice of location has to be admired, a heavy price of ongoing maintenance will always be exacted by his decision. Like Amsterdam and Venice, St Petersburg is more or less floating on a marsh. Nothing could be raised, whether a street or a building, until 'oaken piles sixteen feet long [were] driven their full length into the ground'.[9] One example will serve to highlight the problems and achievements of constructing massive buildings on sludge. Built between 1818 and 1858, St Isaac's Cathedral 'weighs about 300,000 tons; very strong stone foundations, made of hundreds of pilings, were needed to support it'.[10] If the difficulties caused by choosing a mammoth swamp for a building site were not enough, the mighty Neva River was there to add one further, potentially devastating, factor.

Despite the miles of pink Finnish granite ordered by Catherine the Great to face St Petersburg's quays, the Neva continued – and will always continue – to flood the city. Since St Petersburg's foundation the river has burst its banks some 260 times. De Custine rather ominously summed up the danger thus: 'The [Neva] will here, sooner or later, teach a lesson to human pride. The

granite itself is no security against the work of winters in the humid ice-house, where the foundations of rock and the ramparts of the famous citadel, built by Peter the Great, have already twice given way. They have been repaired, and will be yet again, in order to preserve this *chef-d'oeuvre* of human pride and will.'[11] The Hermitage basements are periodically inundated, as are the basements of all the buildings along the Neva embankments. Flooding will always present a serious problem for the preservation of the city.

Catherine the Great is rumoured to have privately criticised Peter's whimsical decision to site his capital not just at the mercy of floods, but also captive to a climate of extreme humidity in summer and freezing temperatures in winter. During the first phase of St Petersburg's evolution, only the most important buildings were constructed of brick covered with stucco. Most structures were made of wood, as they were in Moscow. As St Petersburg steadily grew, more and more buildings were built with bricks coated with plaster. From Catherine's reign on, increasing use was made of stone – both granite and marble – for the grandest edifices, such as Antonio Rinaldi's Marble Palace (1768–72) and de Montferrand's St Isaac's Cathedral (1818–58). Although stone was used more frequently from the late eighteenth century onwards, brick covered with stucco remained the most common form of building construction.

De Custine makes mention of the ravages caused each winter to St Petersburg's buildings:

> The ancients built with indestructible materials under a favourable sky; here, under a climate which destroys everything, they raise palaces of wood, houses of plank, and temples of plaster; and, consequently, the Russian workmen pass their lives in rebuilding, during the summer, what the winter has demolished. Nothing resists the effects of this climate; even the edifices that appear the most ancient have been reconstructed but yesterday; stone lasts here no better than lime and mortar elsewhere. That enormous piece of granite, which forms the shaft of the column of Alexander, is already worn by the frost. In St Petersburg it is necessary to use bronze in order to support granite; yet notwithstanding these warnings, they never tire of imitating the taste of southern climes.[12]

The damage done to buildings each year by severe weather is further compounded by the often sloppy workmanship of their hasty construction, built, as they were, more for the short-term aggrandisement of their Romanov creators than for long-term durability. No doubt the tsars could not imagine a day when they would be unable to restore and renew their capital at will. Maintenance of Peter's vision on the Neva is likely to remain a nightmare for the federal and municipal governments, owners of historic buildings, and anyone who cares about the city's preservation. As economic prosperity eventually filters down to the general populace, the class of artisans and craftsmen that has made such grand-scale renewals possible will diminish drastically: younger people will undoubtedly look for more profitable careers. This will only compound what is already an immense problem.

The effects of the harsh winters on St Petersburg's buildings are not hard to discern. Icicles, many of them thicker than a grown man and eight feet or more in length, hang from infirm cornices, posing a major structural threat to buildings and a potentially fatal danger to anyone walking below. Highly pitched roofs more suited to the climate would not be stylistically appropriate for buildings that have been constructed, as de Custine observed, in 'the taste

of southern climes'. St Petersburg's low sloping roofs become heavily laden with snow and ice which have to be removed to prevent them from collapsing. Pickaxes and other sharp tools are used to loosen the ice, with the result that roofs made from thin metal sheets are frequently riddled with holes. In a domino effect, these punctures then lead to internal water damage. The superb neo-classical frescoes on the ceiling and front wall in one of the rooms on the upper floor of the Laval Mansion, which now houses the Russian State Historical Archives, have suffered severely from years of water seepage caused by the problems of ice removal and roof maintenance. This is merely one of a myriad such examples. Ice also forms in the ubiquitous metal gutters and thick drainpipes that are signature elements of all St Petersburg buildings. The weight of the ice eventually causes the gutters and pipes to become detached from the cornice line and walls, and when the screws holding them in place by metal bands give way they extract large patches of brick and plaster.

A few years ago anyone walking down Palace Embankment in front of the Winter Palace could not have failed to notice how shabby the façade had become through years of neglect. In many places plaster had become detached, exposing the brick construction underneath, especially on the lower parts of the massive white columns that so invigorate Rastrelli's façade. Even the columns' stone pedestals showed obvious signs of major structural disintegration. While the Hermitage's administration was obviously deeply concerned about the situation, it was unable to undertake the necessary work due to a serious lack of funds. In 1993–4, as part of the UNESCO Dutch Fund-in-Trust Hermitage Project,[13] a British architectural firm was commissioned to carry out a survey of the entire museum. In their report, the architects addressed the problem of flaking plaster and crumbling stone pedestals caused by both the winter climate and the capillary attraction of ground water to stone, brick and plaster. Their recommended course of action would have entailed a major structural intervention intended to provide a definitive solution to the recurring problem; it would also have required a significant investment of funds that were not available, and probably never would be. Some time later, when the museum was able to locate funding sufficient to carry out traditional repairs to the façade and columns, one of the British architects expressed his dismay. He could not understand why the museum had chosen a temporary fix to an on-going problem when a supposedly permanent solution had been offered by his firm. A member of the Hermitage administration explained that this was the way these particular maintenance issues had been dealt with since the palace had been built, and that they would continue to be handled in this way since experience showed that the approach worked, even if it had to be repeated on a regular basis. Moreover, the Hermitage administration was sceptical as to the efficacy of the treatment proposed by the British architects. The museum made the correct decision: old buildings, like old people, get used to things being done in a certain way, and disaster frequently occurs when drastic changes of dubious or unproven merit are introduced.

After his exchange of views with the Hermitage regarding architectural restoration, the British architect might well have been inclined to agree with Atkinson's assessment of Russia as 'a nation of makeshifts, of piecings and patchings'.[14] What has always been of primary importance is the outward show. In the period immediately following the collapse of the Soviet regime, anyone with connections in the conservation world who visited Russia was invariably asked by Russian professionals in the field to bring along as much

Iced-up drainpipe on Nevsky Prospect

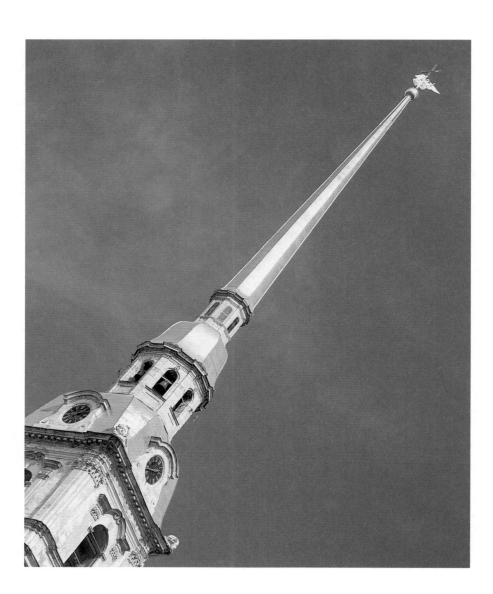

*Spire of the cathedral inside the Peter and
Paul Fortress, built by Domenico Trezzini
between 1712 and 1733*

gold leaf as possible. For many Russian restorers this was the highest priority. Why? It runs in the blood. Atkinson makes mention of this, contrasting his own preference for the subtleties in visual effect caused by the ageing process – what art historians and restorers refer to as *patina* – with the very different attitude of his Russian hosts: 'In the still barbaric state of Russian art, such delicate undulations may be accounted as loss of power. The multitudinous domes of the Kremlin in Moscow are mostly gilt; and I was surprised to find that no one would join in my admiration of the gold toned by time, oxidised and brought into broken yet rich harmonies with sky and cloud. Everybody deemed the span-new gilt pumpkin of a dome the nearest possible approach to the divine.'[15]

In St Petersburg many domes and spires have been re-gilded over the past ten years while the buildings supporting them still require major interventions to guarantee their long-term survival. The five domes on Chevakinsky's dazzling baroque Cathedral of St Nicholas (1753–62) were re-gilded before the structurally unsound four-tiered belfry that stands close to it on the Kryukov Canal had been covered with scaffolding. Both the cupola and spire of the Admiralty Tower have been re-gilded, even though much more serious work to the complex remains to be done. St Petersburg's most visible landmark – the spire on the Cathedral of Saints Peter and Paul – was re-gilded in 1994; to this day, the roof of the cathedral itself needs to be completely renewed. While non-Russian conservation specialists may question the Russians' sense of priorities, they should also remember that St Petersburg, despite its status as a UNESCO World Heritage City, belongs firstly, if not exclusively, to Russia. The spires and domes of the three buildings cited above are among the most famous landmarks in the city: they stand as potent symbols of the city's history and spirit. But just as important are the symbolic associations of gold itself, considered in Russia to be a pure metal. Churches of the Byzantine tradition use gold for their sacred vessels; it symbolises the divine. It is not surprising, therefore, that in the immediate post-Soviet period there was a rush to gild monuments, both religious and historic. Westerners schooled in an aesthetic of decay may question the logic of Russian priorities, and they may not approve of it; but it is the Russian way of doing things, for which they have their own rationale.

In a similar vein, western conservation professionals are often dismissive of the major reconstructions of Peterhof, Pavlovsk and Tsarskoe Selo. When the German *Wehrmacht* departed northern Russia in 1944 after the Siege of Leningrad, the Nazis' parting shot was the torching of these three bewitching palaces outside St Petersburg. Such senseless destruction of a nation's cultural heritage is a form of spiritual annihilation, since all artistic creations are tangible manifestations of their makers' intellect and soul. The Soviet regime decided to reconstruct the palaces despite their lasting association with Russia's imperial past. Whatever their exact motives, beyond national pride, it should be remembered that even communist leaders were Russians first and Bolsheviks second. Furthermore, the dedicated professionals who were in charge of these buildings managed to save most of the contents by shipping them to Siberia and elsewhere for safe keeping before the Germans arrived. Much of the original ambiance, therefore, was able to be convincingly re-created.

The reconstruction of the palaces was very much in the Russian tradition. Atkinson refers to Napoleon's destruction of much of Moscow in 1812 and notes that 'many streets and structures were speedily restored as near as might be to their original condition'.[16] Whether one can speak of restoration or

reconstruction depends, of course, on the extent of the damage. While the palaces at Peterhof, Pavlovsk and Tsarskoe Selo were not completely razed, the sheer extent of the devastation was such that three courses of action were possible: their charred shells could have been left as haunting reminders of the insanity of war; their remains could have been completely demolished and the places where they once stood returned to nature; or they could be completely reconstructed using photographs, original architectural plans, subsequent surveys and other documentary evidence at the disposal of the experts. The Russians chose a course consistent with their tradition: reconstruction. Russia has always been blessed with craftsmen and restorers capable of carrying out such work in a remarkably convincing manner: 'The Russian artisan has always been so perfect an imitator that, if he re-touch a wall-painting or restore a moulding, it is hard after the lapse of a twelvemonth to tell where the old work ends and the new work begins.'[17] This very Russian talent can, however, present problems for art and architectural historians.

Almost all of St Petersburg's greatest landmark buildings have undergone everything from minor changes to major alterations. Many were simply torn down to make way for new buildings as styles and tastes changed. A succession of imperial egos did little to ensure the longevity of many architects' creations. In this frenetic process of construction, alteration, demolition and reconstruction, a complicated archaeological legacy was rapidly achieved. Every period has its own style, its own way of seeing and creating, and the specialist with a well-trained eye can distinguish genuine eighteenth-century work from nineteenth- and twentieth-century imitations. Fakes, no matter how well done, will always reveal themselves eventually, but it is not always easy to differentiate immediately between the original and the counterfeit. The reconstructions at Pavlovsk, for example, are generally more convincing than those at Peterhof, but the work at both palaces is of an amazingly high calibre. This Russian tradition of complete renewal has meant that their architectural restoration work is often extremely rigorous. In October 2000 international conservation specialists met in Riga and drew up a charter entitled *On Authenticity and Historical Reconstruction in Relationship to Cultural Heritage* – a sensible document that allows for much leeway while at the same time making a strong case for keeping interventions to a minimum.[18] It is to be hoped that increasing dialogue on this issue will take place between foreign and Russian specialists. As prosperity continues to increase, so will the dangers to the preservation of the authenticity of historical property and cityscapes.

At an administrative and legislative level, too, the preservation of St Petersburg is beset by difficulties. At the heart of the problem lies the article in the 1993 Russian Constitution pertaining to the regulations for the restoration of monuments, which has yet to be ratified by the State Duma: the law still in force dates from Soviet days, when private property owners did not even exist!

The organisation nominally responsible for St Petersburg's historical built environment is GIOP, or the Committee of State Control, Management and Security of Historical Monuments. Nowadays GIOP is a far more effective organisation than it was under the Soviets, and even though conservation as it is understood and practised in Western Europe is still relatively foreign to GIOP, the approach to historical monuments is much stricter in St Petersburg than in other cities in Russia. No listed building can be restored unless its occupants consult with GIOP regarding a plan of action, and tenants who do not fulfil their obligations or who damage the monuments they occupy may be issued

with legal proceedings leading to a possible prison sentence. GIOP has also prepared regulations that determine whether or not new buildings can be constructed in the city's historic centre, but they have yet to be sanctioned by law.

GIOP, however, frequently finds itself in conflict with the Municipal Government and the City Architect, who support a policy of filling in gaps in the city centre with modern buildings. Their position on this sensitive issue is extremely favourable to developers who understand that cultural heritage means money. People who can afford it want to live in the historic city centre; to accommodate them the developers would like to put up modern apartment buildings in some of the most spectacular locations, such as the squares overlooking the Alexandrinsky Theatre and the Preobrazhensky Cathedral. Up to now activist specialists have been able to thwart these plans.

At the same time a policy of gentrification has led to inhabitants of communal flats being moved out of the city centre in droves, while the buildings thus vacated are transformed into offices or apartments for the rich. This has already led to a marked difference in day- and night-time populations, with parts of the centre of St Petersburg being completely deserted at night. City policy actively encourages this process, and as it gains momentum a major social crisis is being created.

And there is a further complication. Russia's Constitution places cities under the control of the Federal Government, so even where GIOP, the Municipal Government and the City Architect find themselves in agreement, they are not permitted to pass legislation. Hope exists that this situation will soon change, but until this legislative mess is untangled and local governments can pass their own laws, the present impasse will continue.

These are just some of the problems facing those involved in the preservation of Peter's dream on the Neva. What is remarkable, though, is how much of this copious legacy has come down to us, especially given what the city has undergone in just the last hundred years of its relatively brief history: the 1905 and 1917 Revolutions, the Russian Civil War, the Siege of Leningrad. Today fire is one of the principal threats (just as it was in the eighteenth century, despite Peter the Great's directive that only stone and brick were to be used for construction), mostly as a result of antiquated electrical wiring. In 1988 a fire in the Library of the Russian Academy of Sciences destroyed four hundred thousand books and severely damaged another three and a half million.[19] The library is still struggling with the aftermath of this disaster. More recently, in November 2001, a fire broke out in the belfry of the Cathedral of Saints Peter and Paul, but was fortunately extinguished before the entire church burned down.

One of the main reasons why so much has survived is the dedication of all those involved in various capacities in looking after the collections under their care, from directors to cleaners. You only have to hear Russians talking about their cultural heritage to appreciate the explosive mixture of fierce national pride and a passionate love of Russian history, art, literature and music. Of course, not every Russian embodies such high ideals. Slick developers, who are as likely to worry about maintaining historical cityscapes as to endow a chair in philosophy at the University of St Petersburg, will grasp any opportunity to make a buck, or rouble. Russian and foreign companies pollute the city with their ugly neon signage, thinking only in terms of getting their message out to the public. Politicians, who may privately be disturbed by some of the more negative aspects of St Petersburg's rapid development, are, like politicians everywhere, creatures of expediency. They cannot even pass basic

legislation that would regulate both the restoration of monuments and future development in the historic centre. Being masters of short-term thinking, they fail to understand that 'niche' tourists, who bring in eighty percent of tourist revenues, will be deterred from visiting St Petersburg if its streets start to resemble the kind of generic suburban shopping malls found in Düsseldorf or Chattanooga. In the case of Nevsky Prospect, St Petersburg's authorities and conservation specialists will have to reach an acceptable compromise that will maintain the historical atmosphere without mummifying what is, after all, the city's main commercial artery.

As the city moves with increasing momentum into its fourth century, more and more buildings are being restored, or at least their façades are being renovated and given a coat of paint. It would, of course, be impossible for all the monuments that desperately need attention to be completely restored, including new electrical wiring, new plumbing, new roofs – those essentials that help preserve buildings more than a lick of paint. But, when all is said and done, façadism is very much a part of St Petersburg's conception and tradition, and it will most probably remain so. The Federal Government has provided extra funds, but in the foreseeable future it will never be able to guarantee the level of funding required to tackle the colossal problems caused by some eighty years of neglect. And was the neglect really all that bad? The answer is both yes and no. Yes, because in so many instances the damage caused by neglect, or by turning grand buildings into communal flats with no thought for their architectural merits, was so extensive that major losses to the fabric of buildings were inevitable and will require drastic interventions to protect what is still left. Regular maintenance would have preserved so much more of the original, even though the original in St Petersburg has always been the product of renewal and reconstruction. And no, because the benign neglect of St Petersburg effectively saved the city for us. Had Stalin and his henchmen chosen St Petersburg for their capital, the city would have suffered as Moscow did: buildings would have been torn down to make way for the type of ulcerous architecture that, under communism, brought mediocrity to new heights.

Perhaps St Petersburg was both an embarrassment and a threat to Lenin and Stalin, and the viperous toadies who so slavishly served them. Too many imperial ghosts – foremost among them Peter the Great's – remained lurking in the shadows of St Petersburg for the communists ever to feel at home there. Anyone who loves the city can be thankful for that. Writing in 1848, John Ruskin, in his *Seven Lamps of Architecture*, ruminates upon the collected associations and values that accrue to buildings over the years: 'The greatest glory of a building... is in its Age, and in that deep sense of voicefulness, of stern watching, of mysterious sympathy, nay, even of approval or condemnation, which we feel in walls that have long been washed by the passing waves of humanity.'[20] St Petersburg is indeed filled to symphonic proportions with a voicefulness of the past. Sometimes it echoes with the groans and unheard prayers of the countless serfs who died in the realisation of Peter's dream; the explosion of the bomb that killed Alexander II in 1881; or the clatter of the Cossacks' horses across Palace Square as they lashed into the revolutionaries in 1905. Sometimes it is hushed, like the murderous soldiers entering Paul I's bedroom in Mikhailovsky Castle in 1801; the scratch of Alexander II's pen as he signed the document freeing the serfs in 1861; or Kerensky looking up on his way home early on Easter morning in 1905 and seeing Nicholas II standing alone on a balcony of the Winter Palace.

*The tower of the City Duma on Nevsky
Prospect; from 1786 to 1918 the Duma was
the centre of local government in the city*

In the early 1990s, before any restorations had begun and St Petersburg was still engulfed in a layer of ancient grime and dust, the past seemed somehow closer than it does today. It was almost as though the hands of a giant Futurist clock had been stopped somewhere between 1917 and 1960. The voicefulness of the past resonated so loudly because the present had yet to be articulated. Today St Petersburg is well on its way to assuming a new, but equally significant, role to the one it enjoyed under its Romanov creators. President Vladimir Putin, frequently accompanied by his Minister of Culture, regularly brings foreign leaders to St Petersburg to show off the city where he grew up. Peter's capital is again being used as a theatrical backdrop to the very serious business of Russian international politics. De Custine, who was so often critical of St Petersburg, understood its soul far better than he probably realised: 'This *chef-d'oeuvre*, not of architecture but of policy, is the New Byzantium, which, in the deep and secret aspirations of the Russian, is to be the future capital of Russia and the world.'[21] It could just be that President Putin will turn Peter's 'window to Europe' into a window to the world, and in the process turn it into the capital of the world. If history teaches us anything, it is that stranger things have happened.

1 Solomon Volkov, *St Petersburg: A Cultural History*, trans. Antonina W. Bouis, New York, 1996, p. 6.
2 Edward Crankshaw, *The Shadow of the Winter Palace*, New York, 1978, p. 40.
3 Marquis de Custine, *Empire of the Czar: A Journey Through Eternal Russia*, anon. translator, New York, 1989, p. 93.
4 Ibid., p. 160.
5 J. Beavington Atkinson, *An Art Tour to Russia*, London, 1986, p. 120.
6 de Custine, pp. 109–110.
7 Atkinson, p. 4 and p. 12.
8 de Custine, p. 152.
9 W. Bruce Lincoln, *Sunlight at Midnight: St Petersburg and the Rise of Modern Russia*, New York, 2000, p. 20.
10 Alexander Margolis, General Editor, *St Petersburg Traveller's Guide*, St Petersburg, 1995, p. 112.
11 de Custine, pp. 107–108.
12 Ibid., pp. 153–154.
13 Funding for this project was made available by the Ministry of Culture of The Netherlands.
14 Atkinson, p. 222.
15 Ibid., p. 186.
16 Ibid., p. 220.
17 Ibid., p. 221.
18 A copy of the Riga Charter can be requested from the Heritage Settlements Programme, ICCROM, Via di San Michele, 13, 00153 Rome.
19 As a result of this the St Petersburg International Center for Preservation was established. On this, see Jane Slate Siena and M. Kirby Talley, Jr, 'The St Petersburg International Center for Preservation', *Conservation: The Getty Conservation Institute Newsletter*, Vol. 11, No. 3, 1996, pp. 4–9.
20 John Ruskin, *The Seven Lamps of Architecture*, New York, 1961, no. X, p. 177.
21 de Custine, p. 154.

Acknowledgements
I wish to thank Dr Alexei Gibson, Project Director of the St Petersburg International Center for Preservation and a distinguished literary scholar of the Russian Silver Age, for reading this text and making many perceptive and helpful suggestions for changes and additions. Information in the section devoted to GIOP and the preservation of the built heritage was graciously provided by Dr Alexander Margolis, a distinguished architectural historian, General Director of the International Charitable Foundation for the Renaissance of Petersburg-Leningrad, and a member of the Academic Advisory Board of the St Petersburg International Center for Preservation.

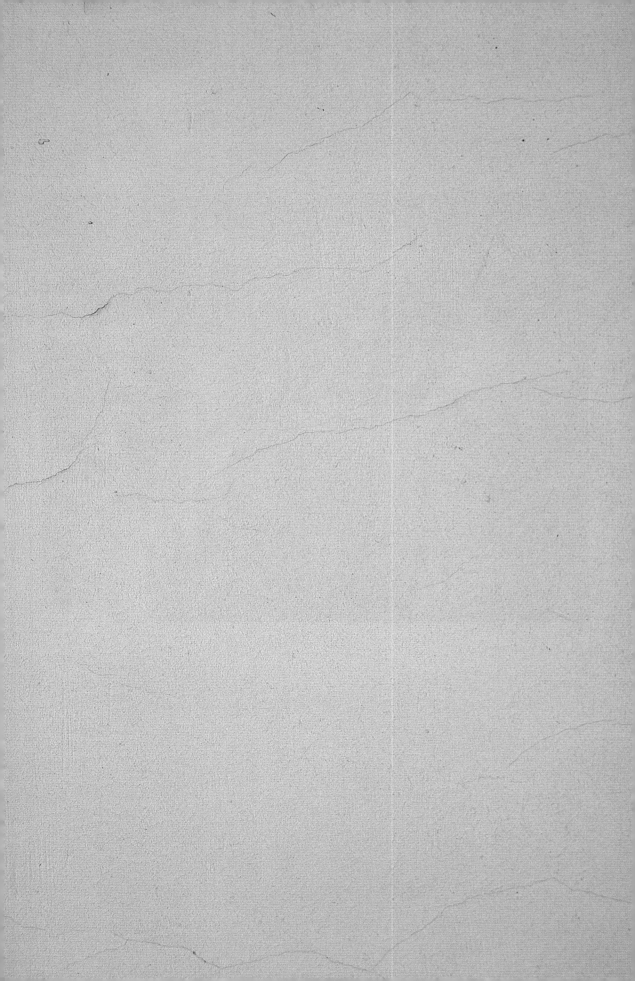

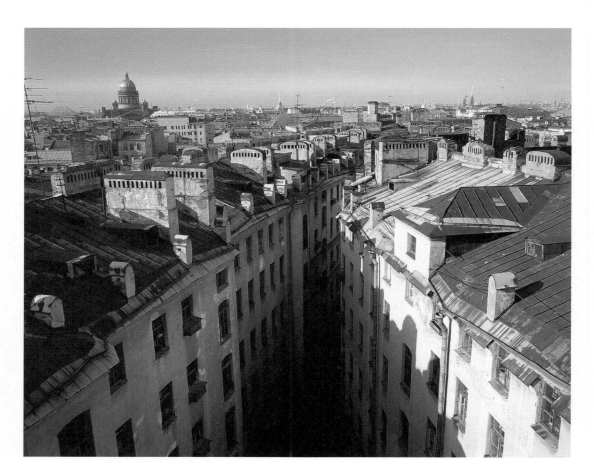

Courtyard behind Sennaya Square,
with St Isaac's Cathedral in the distance

Inside the Noah's Ark

'The house in which [the Petersburger] rents his flat is a genuine Noah's ark,
in which you can find a pair of every kind of animal.'
Vissarion Belinsky, 'Petersburg and Moscow', 1845

St Petersburg's architecture has always seemed strangely detached from the lives of those who inhabit it. Viewed from the outside, the city's buildings – for all their shabbiness – have an unchanging, geometrical perfection. But behind these rigid façades, life has evolved at its own pace: sometimes gradually; sometimes, at key moments in the city's history, in sudden great leaps. These changes are mostly invisible from the street. To understand the city more fully, we need to delve beneath its architectural skin – to take a look, for example, inside a typical apartment block in the centre of St Petersburg.

Built in 1909, our house stands on the embankment of the River Fontanka – so called because it supplied the fountains that used to play in the Summer Garden – in a spot which in the eighteenth century, before it fell under the magnetising influence of nearby Haymarket Square, looked out peacefully over unpolluted waters to country estates dotting the opposite bank. Previously on this site there stood a modest three-storey building, erected in 1736 as the *osobnyak*, or private house, of a merchant supplying goods to the market. The elongated territory extending far to the back of the main building was originally home to an untidy collection of sheds, servants' living quarters, trees, bushes, a sea of mud (dust in summer), seven pigs and a brood of hens. The merchant himself rarely bothered to glance at, let alone set foot in, his yard; yet when he did, was always comforted – the scene reminded him of his birthplace, a small town in central Russia. In 1835, however, this idyll of provincial life was wiped out. The merchant's descendant and heir, a young officer of the Guards, staked the property on the Queen of Spades one evening, and lost.

The new owner, an aristocrat who already had two palaces and three houses in St Petersburg to his name, showed no interest in his new acquisition. It was, frankly, in what was considered the wrong part of town, and so he turned it over to his steward, to be exploited at the latter's discretion. The

steward proceeded to make the most of the situation, moving his family and various relatives into the house. Then, by knocking down the sheds at the back and putting up a warren of hastily constructed barrack-like three-storey structures alongside the original servants' quarters, he created St Petersburg's first large concentration of commercially run slum accommodation. The barracks offered a cheap bed to the teeming thousands who made their living on and around the nearby Haymarket: seasonal workers, market traders, sailors, old soldiers, stonemasons, street hawkers, petty criminals, leather tanners, street musicians, prostitutes, beggars, fleas, cockroaches, rats. The oddly shaped plot became in effect an entire district, with its own bath-house, brothel, food stalls, drinking dens, small manufactories, even its own air. In fact, the air became so dense with the aromas of poverty and disease that the steward, after three years of living behind hermetically sealed windows, was forced to move out. By this time he could afford to do so: while generously surrendering ten percent of the income from the property to its owner, he had himself become a millionaire.

New public sanitation laws introduced in the 1880s forced the closure of these slums. For the next fifteen years the plot stood unoccupied, forgotten by its aristocratic owner until mounting debts required him to dispose of some of his assets. The new title-holder, a fast-moving entrepreneur, demolished everything that stood on the lot. The building he constructed in its place in 1909 provided the perfect solution to the challenge of how to collect the maximum rent from an awkwardly shaped territory situated in by no means the most fashionable area of town. This structure represented the last word in turn-of-the-century capitalist functionalism and construction technology: a towering seven-storey brick box clamped together with metal beams and ingeniously packed with apartments of varying sizes calculated to suit the needs and pockets of different categories of St Petersburg citizen. It divided into two unequal parts: a smart-looking front end facing the river, and a long, unprepossessing tail consisting of steep walls of apartments pulled together around narrow, light-starved courtyards that step back one after another – one, two, three – into the depths of the lot.

This typically Petersburg combination – an elegant façade disguising dingy back courtyards – reflects the conditions that prevailed in St Petersburg at the turn of the twentieth century. At this time major American and European cities were developing rapidly in a horizontal direction, as improvements in public transport made it possible to relieve some of the pressure on central districts by placing residential areas at a distance from manufacturing facilities. St Petersburg, however, had no underground railway, a limited and expensive tramway network, and very little private transport. Its workers were condemned to living within close distance of their place of work, and these workplaces (government departments, offices, markets, workshops, even factories) were concentrated in the centre. This meant that the city could not expand outwards, but was compelled to grow ever more compact within its existing boundaries. Increasing pressure drove residential buildings upwards (until they bumped against the ceiling set, out of respect for the imperial family, at the height of the cornice of the Winter Palace), and ballooned them outwards, towards the backs of the plots in which they stood, pulling them closer and closer around narrower and narrower spaces left for shaft-like courtyards.

The street-facing facade of our house is its public face. Dressed in handsome reconstituted stone, enlivened with a sprinkling of decorative elements

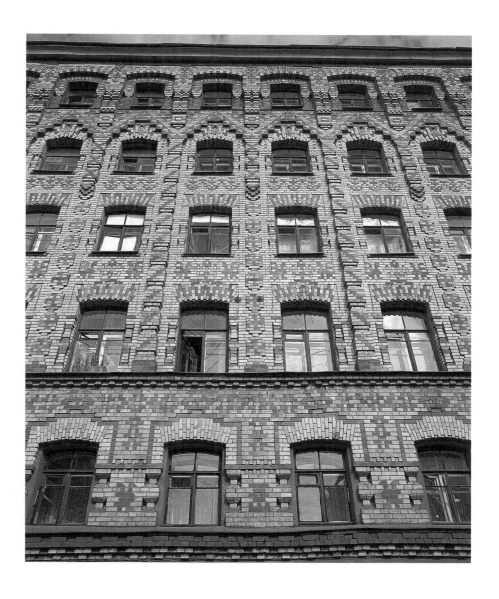

Early twentieth-century apartment block
on Moscow Prospect

selected from the architect's make-up box (mosaic tiles, stucco medallions, tiers of balconies), the front of the building salutes passers-by with a reserved dignity that puts it, at the very least, on equal terms with its neighbours. Equally dignified are the two front entrances. But this house was built at the beginning of the twentieth century, not the nineteenth: here you will find no superfluous grandeur or ostentatious wallowing in precious space; instead, the key words are comfort and convenience. The entrance-halls are generously sized, but not cavernous. The staircases, made of plain stone rather than marble, are wide, but not grand. Pride of place goes to the elevators, elegantly caged in Art Nouveau ironwork. This wonderfully democratic, radically levelling device opened the upper floors to habitation by the middle layers of society, wiping out the previously unbridgeable chasm that existed, up to almost the end of the nineteenth century, between the first three storeys and those above (where, because of the fatiguing climb needed to reach such altitudes, no self-respecting citizen, given the means to live elsewhere, would ever consider taking up residence).

Here, at the front end of the house, the apartments were made for living in comfort and a degree of style. Each had a minimum of six rooms, some (on the second and third floors) as many as ten. The main reception rooms – the study, drawing-room, library and dining-room – overlooked a quiet, tree-lined stretch of the Fontanka (the water cast agile reflections onto the ceilings). Some of these rooms still contain restrainedly ornate moulded ceilings, oak parquet floors, and brass door-handles and window fastenings. Overlooking the courtyard were the main bedrooms, a governess's room, a water-closet, and a bathroom with running hot water (an exciting novelty for the beginning of the twentieth century), while the kitchen and a small pantry or servant's room led off a dark, narrow corridor at the back of the apartment. A back door leading to a steep back staircase (without a lift) enabled the kitchen staff to come and go without being seen.

So much for the smart front end of the house. Walk through the archway into the first of the three internal courtyards and you will find a different story. Away from the street, out of the public eye, the building gives up all effort to impress, becomes undisguised function. The plain plastered walls with their unadorned windows have always been drab; now, after ninety years of confrontation with the St Petersburg climate, they're stained and tattered, the plaster peeling off to reveal scabs of dusty red brick. This narrow conduit (courtyards like this are so steeply sided, so dark, that citizens of St Petersburg call them 'wells') receives the back or so-called 'black' staircases of apartments whose main rooms are situated at the front end of the house. It also has its own 'main' staircase leading to apartments that give exclusively onto the courtyard. There is no lift here. The apartments have fewer and smaller rooms than those at the front of the house (a maximum of four rooms, while some have only one) and these rooms are more simply decorated (cheaper parquet; in some cases, floorboards; plainer ceiling mouldings). Worst of all, though, their windows admit from the courtyard a twilight that hardly ever varies in intensity.

The St Petersburg apartment block has always been a mixed box, a vessel carrying representatives of all social classes – what the philosopher and literary critic Vissarion Belinsky, writing in 1845, called 'a genuine Noah's ark'. In our house the front and back ends have from the very first been separate worlds populated by tenants drawn from sharply differing social and economic backgrounds.

The original occupants of the front part of the house were a cross-section of middle-class Russian society which, under the gathering winds of capitalism and liberalisation, was beginning to move in new directions at speed. On the upper three floors, where, despite the lift, the apartments were still less expensive to rent, lived people from various professions: middle-ranking government officials, two engineers, a private school headmaster, a tailor, and the architect who designed the house. The fourth floor was taken up by, among others, a widowed Baroness, a university professor, and a doctor. The doctor practised in his front rooms. The larger and relatively grand apartments on the third floor were occupied by an army general and the owner of a contracting firm. The general lived on his own in ten darkly furnished rooms, entertained lavishly, though rather stiffly, on every major church holiday, was otherwise rarely at home in the evenings, and was to be seen at fixed hours every day leaving for or arriving from the General Staff Building on Palace Square in a lacquered dark-blue carriage. The building contractor, the product of a long line of thickly-bearded merchants, was a man of modern outlook who realised that commercial success in today's conditions called for entirely new ways of thinking and doing business. The turn-of-the-century construction boom had thrown up opportunities for those capable of handling contracts for vast apartment blocks built to rigid deadlines, and he had taken them. He and his family lived in relative simplicity, without any of the excesses for which the merchant class were famous in earlier times: no gilded furniture, no swollen retinue of servants, no week-long carousing in dark and heavily panelled chambers. Knowing the value of a proper education, he had sent his sons to university to study law and languages. His daughters, elegant young women devoid of affectation, were accomplished musicians who looked set to marry officers, high-flying government officials, and other members of the nobility. This family was not to dally in our slightly trade-oriented district for long, however. In 1913 they would move to the highly fashionable Sergievskaya Street, where they would occupy an entire floor in a newly built mansion.

These were the first inhabitants of the front end of our house. Following the October Revolution, those who did not flee the country, die fighting or from famine during the civil war, and were not arrested by the communists, stayed put. Now, though, they were forced to share their apartments with crowds of new fellow-tenants in a process called *uplotnenie* ('compression'). The Baroness, for example, declared that at her age she was staying put. In 1919 she was ordered to move her essentials into her dining-room and hand over all other rooms in her apartment to various people at whom, prior to the Revolution, she would never have looked twice. Thus private residences were converted into nationalised communal flats, or *kommunalki*: within each

>
Block of flats on Nakhimov Street at the western end of Vasilevsky Island

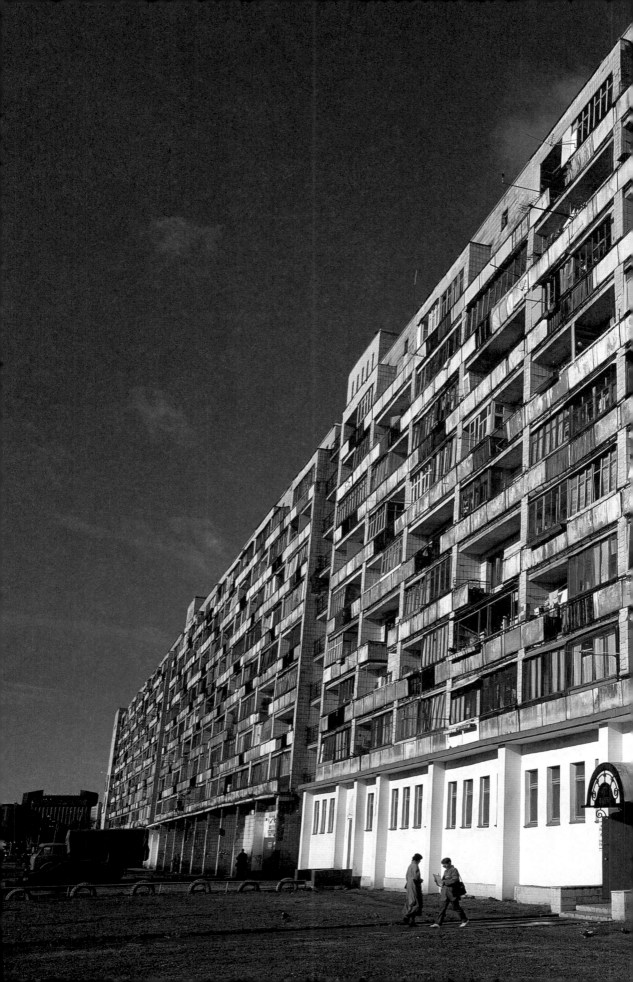

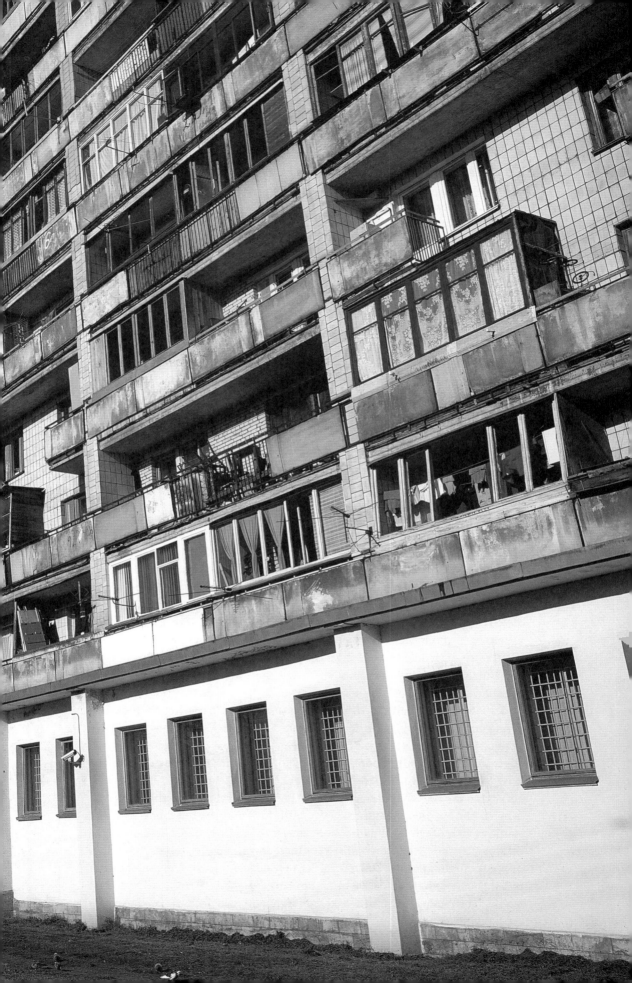

apartment space was divided up, re-parcelled into rooms of roughly equal size and identical purpose. Pantries became bachelor's pads. Society ballrooms were surgically cut into a number of sections, each accommodating an entire family. Toilets, bathrooms and kitchens became shared territories. Where a household of four or five had lived before, now there were twenty or thirty citizens all queuing up to use the same toilet and bathroom. In this way St Petersburg's once spacious apartments were transformed into intricate labyrinths with miles of cluttered corridors and uncountable populations.

The years went by. The state had planned to build accommodation of a new kind for a radically new communist way of life: indeed, a very small number of experimental 'commune houses' were built, in which the residents, while each having their own room, ate together in a communal dining-room, washed their clothes at a communal laundry, and spent their leisure hours reading in a communal library or sunning themselves at a communal solarium. But these were very rare exceptions; in general, it was left to the people themselves, ever adaptable, ever resourceful, to invent new structures to accommodate their lives. To create a measure of privacy, families subdivided their rooms into still smaller rooms: partition walls were improvised from bookcases, dining-room dressers and curtains, transforming single rooms into entire microcosms with separate zones for eating, sleeping and watching television. Others took advantage of their high ceilings to put in a second storey at the back of their rooms – a mezzanine that could be used as a sleeping area.

Then in the 1960s and 1970s the Soviet Union finally initiated mass construction programmes, building millions of square metres of low-quality residential housing on the outskirts of almost every town and city. Jaundiced by years of communal living, people abandoned themselves to the dream of acquiring their own separate flat, however small, however badly built, and however far from the city centre. Those who were intelligent, influential, industrious, pushy – or just plain lucky – moved out. The remainder were left to sit it out in their large communal apartments. Gradually, the city centre evolved into a forcing pit for hardship, discomfort, dirt and social problems.

Hope of change came with economic reform and the establishment of 'democracy' at the beginning of the 1990s. As the market economists had predicted, new money began to move people around. The communal apartments at the front of our house were gradually bought up by those with the means to do so, attracted by three things: the relative youth of the building (and in particular the fact that it had metal, rather than wooden, beams); the size of the apartments and spaciousness of the rooms (compared, that is, to flats built under Soviet rule); and the view. First to settle was a barrister. Then came a young trader working for a foreign bank, a builder, a publisher of science fiction, an estate-agent... The Russian wife of a Swiss businessman took a large apartment on the third floor. An artist who, riding on the wave of interest in Russian art provoked by perestroika, had successfully exhibited in Paris and London in the late 1980s, bought a space on the seventh. For six summers running the house trembled from dawn until dusk and the air shook with the sound of violence as apartments were banged, beaten, drilled, and hammered into new shapes. Partition walls were torn down, parquet floors ripped up, plaster brought crashing down from century-old ceilings, arches punched out of load-bearing walls, massive brick fireplaces erected where none had been before. The builder installed a swimming-pool-sized jacuzzi supported by specially reinforced beams. The barrister knocked together three rooms at the

front of his apartment to make a ninety-square-metre columned hall (a vast *trompe l'oeuil* of fauns in a Mediterranean landscape adorns the back wall, while classical statues stand idly between the columns). The artist spent three years building himself a penthouse studio in the attic above his apartment. Now, when you look up at the front of the house, you can see that the tasteful monotone grid of the original façade has been haphazardly renovated with new window frames of different colours (white, brown, grey), varying materials (wood, PVC, aluminium), and inconsistent design.

As the new rich moved in, so the old poor moved out, setting off on a long trek to much smaller apartments in the suburbs. They were not the only ones to move. Mice and rats who had lived side by side with the old tenants for years suddenly found their welfare cut off and upped and left in protest. Cockroaches moved camp *en masse*. On days when chemical warfare was being waged against them in one apartment, entire armoured battalions might be seen trooping down the outside walls of the house, pouring through windows they met on their way in the hope of finding another old-style *kommunalka* with its guarantee of plentiful dirt, moisture, and old-style Soviet cockroach comfort. Where they found it most often was in the courtyards at the back of the house.

The inhabitants of these back apartments have always been drawn from the darker depths of the ocean that is St Petersburg: people who for whatever reason have found themselves trapped in accommodation they could never conceivably have wanted to make their home, even though after a few years they grow accustomed to the gloom, settle back into their submarine recesses like fish each into its own protective cranny, develop habits of behaviour that enable them to survive, if not thrive, in the given conditions, and all in all begin to find it difficult to imagine living anywhere else. In the years before the Revolution the residents of this part of the house were minor government officials, qualified factory-workers, hard-up widows, traders at the nearby markets, schoolmasters, stage performers and musicians, pawnbrokers, students. Many tenants sublet some or most of their rooms – or even parts of rooms – to others even less well-off than themselves. Typically, a single room might have been sublet to four students or to the family of some minor clerk.

It is easy to see, then, that the advent of Soviet rule after the Revolution brought few changes to the back of the house: the light-starved, crowded rented apartments became light-starved, crowded communal apartments and embarked on seven decades of gentle, but persistent, decay. As the years passed, paint steadily thickened and curdled on woodwork as new coats were piled on top of old; ceiling mouldings gradually disappeared under accumulating layers of whitewash; window glass darkened and denatured; pipes burst, were patched up, and then burst again; siftings of dust and detritus fell through the cracks in floors, accumulating in the half-metre gaps between storeys, only to be exhaled in sudden puffs through floor grilles whenever a draught ran through the building. And generations of less mobile Soviet citizens (those who were not determined, skilful, or lucky enough to secure a separate flat in a new building on the outskirts of town) replaced one another, spinning out time with the help of cards, a fishing-rod, and vodka.

Today very few of these apartments have changed hands. Because of the lack of light and the low social attractiveness of the neighbours, property in this part of the house is almost unsellable. Renting out is a different matter. St Petersburg contains, and attracts, large numbers of people who cannot

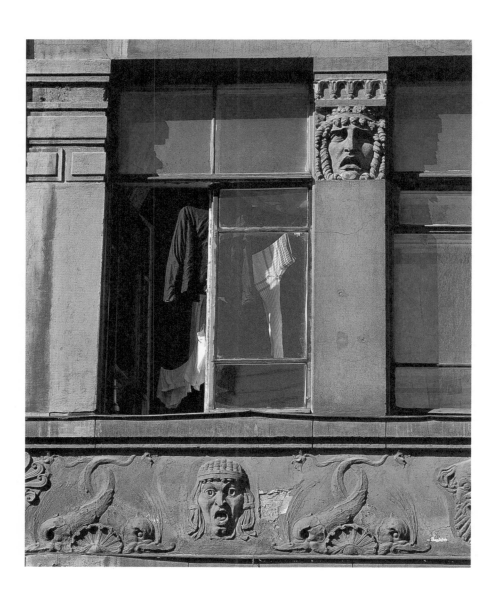

Window on Bolshaya Konyushennaya Street

afford to buy an apartment of their own, but desperately need a space in which to live. Thus the courtyards of our house are awash with an ever-changing tide of temporary tenants paying minimal rents. *Babushkas* supplement their pensions by renting out rooms cluttered with a lifetime's possessions to students. Young couples, drawn to St Petersburg by the hope of finding better-paid work, pay $100–150 a month to share a one- or two-room apartment with a battalion of cockroaches. Market traders from the Caucasus live ten to a room in a three-room apartment on the ground floor. In a two-room apartment above the archway between the first and second courtyards two ambitious young women, Masha and Kristina, have set up a cooperative providing sexual services to moneyed segments of the male population.

The lives of the people who live here have an improvised, makeshift quality: attempts to piece together an existence from discarded scraps. Nowhere is there a more convincing demonstration of the Russian ability to adapt and survive in conditions where the odds are minimal and where no help is to be expected from the state, no guidance provided by established patterns of behaviour. A team of prematurely aged drunkards daily tours the area's dustbins, gathering paper and cardboard which, carefully folded and attached with string to a heavy trolley, they wheel to a basement collection point at the end of the day and exchange for the monetary equivalent of two bottles of vodka. A jobless woman in her forties, desperate to support her teenage son and parents, starts selling macramé knitted by her homebound mother at a stall improvised on the side of the street, then realises that there is an untapped market for such handiwork and enlists all her mother's friends to knit for her as well. Young men fresh from university, unable to find employment on the strength of their university degrees, discover an unsuspected talent for plastering and plumbing and set up in business as interior decorators, transforming a series of battered communal flats into glossy, spacious apartments.

If you look up at the third floor in the second yard, you will see four windows lined with heavy velvet curtains and begonias. Here, in a three-room apartment, live some of the wealthiest residents of this part of the house: Olga Aleksandrovna, Olga Nikolaevna, and Vera Maksimovna, three women who between them are almost as old as St Petersburg itself (in fact, they total a mere 225 years against the city's 300, but they're catching up fast). Unlike many of their fellow-pensioners, who have nothing but their pensions to draw on, they live in luxury, denying themselves nothing. They think nothing of treating themselves to massage sessions, the best seats at the theatre and opera-house, days out at the Hermitage, summer boat trips along the city's rivers and canals, even the occasional fling at the casino. What is the secret of their wealth? Very simple. Three years ago Olga Aleksandrovna invited her friend Olga Nikolaevna, who lived all on her own in a four-room apartment in the front of the house, to move in with her at the back end. Not only did this provide mutual companionship (and they spent almost all their time in each other's company in any case), but it meant that Olga Nikolaevna's apartment with its wonderful view could then be rented out for a handsome sum, which would make living for the two of them easier still. The experiment was so successful that a little later they asked their friend Vera Maksimovna, who also had an apartment all to herself, to come and join them. Now, with the monthly income from renting out two apartments, they live the life of three wealthy young bachelors with not a care in the world.

Just beyond the arch connecting the second and third courtyards, in a tiny one-room apartment once occupied by the house's senior *dvornik* or court-yard attendant (before the Revolution there were no fewer than seven *dvorniki* serving this house) lives Yakov Leopoldovich. A retired rocket scientist, this courteous old man, deeply ingrained with the values of his city (not St Petersburg, but Leningrad – the city of terrible suffering heroically borne, and at the same time of a determined belief in a better, socialist future), has a pension of 800 roubles ($28) per month. Until recently, this was sufficient to take care of his bodily needs. After all, he does not need much: he has his radio, his books, a cheap season-ticket for the Philharmonia, and as for food, 'when you've lived through the Blockade, a bowl of porridge is a full meal, a loaf of bread is a feast, and two slices of meat is enough to give you indigestion'. But then he fell badly ill. Forced to spend his entire monthly pension on medicines, he had no choice but to supplement his diet with 'tastier morsels' selected from local dustbins. One day, as he was wheeling his pickings back home, he was given a hand by a young woman who happened to be standing outside the bread shop. In fact, the young woman was so kind and helpful that she accompanied him to his apartment, made him tea, took an interest in all his difficulties, and then made him a remarkable proposal: she offered to feed and look after Yakov Leopoldovich until the end of his days, asking in return only that he make her legal heir to his apartment. Since the old man had no family, it seemed he had nothing to lose. The following day they went to the notary to set their contract down in law. Yakov Leopoldovich now tells his neighbour that, for all these cruel and selfish times, the old Leningrad spirit of compassion lives on. His neighbour, watching the young woman's increasingly irregular visits, is less convinced.

Much has changed in St Petersburg since the early 1990s, and yet in many respects we have come full circle, back to the nineteenth century. Thousands of originally palatial apartments have been emptied of their heterogeneous populations, stripped of their clutter, and returned to states resembling and even exceeding their original splendour. The fabulous, picturesque contrasts between poverty and riches, health and illness, elegance and ugliness, have been lovingly restored. In the well-like back courtyards of St Petersburg's houses, now that the public-welfare system has effectively collapsed, many of the classic urban social problems all but eradicated by the Soviet system (poverty, disease, crime) are once again on the rise. Tuberculosis has made an unexpectedly big come-back. Today, perhaps more so than at any time in the last eighty years, St Petersburg's houses remain Noah's arks packed to the gunnels with every kind of life form. Miraculously still afloat, they have, in spite of frequent sightings, yet to reach firm land. The voyage continues.

Construction site on Ligovsky Prospect,
showing the outline of the building that
formerly stood here

Now half-asleep, Onegin takes
The bed-bound road from last night's ball.
While boisterous Petersburg awakes
To morning drum and merchant's call.
Along the roads the pedlars scurry;
And coachmen to the cabstand hurry;
A girl from Okhta bears her pitcher;
The crunch of morning snow beneath her.
With joyful sounds this morning's blessed!
As shutters open, chimney smoke
Curls upwards in a bluish cloak,
The German baker, smartly dressed
In cotton hat, with due dispatch
Has opened up his serving-hatch.

Alexander Pushkin, *Yevgeny Onegin*

>
Kiosks on Bolshaya Porokhovskaya Street

>>
*Snow clearing from the roof of the
New Hermitage*

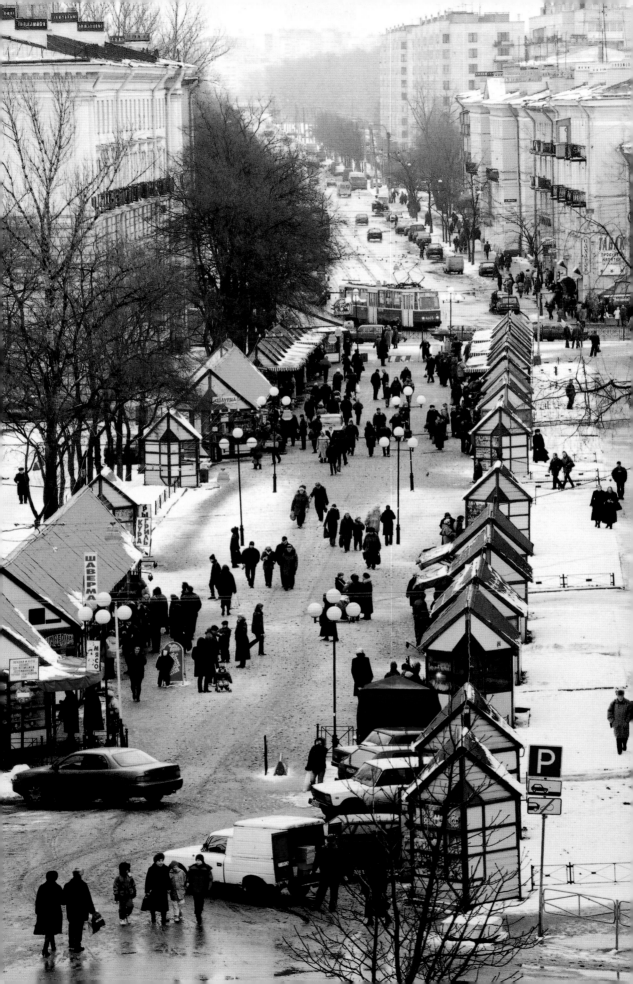

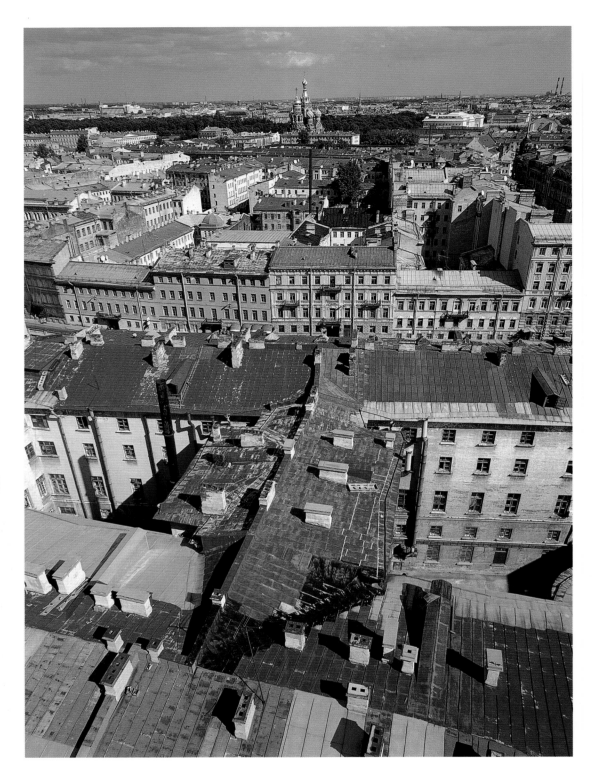

View from the roof of the Winter Palace towards
the Cathedral of the Saviour on the Blood

Courtyard on Kamennoostrovsky Prospect

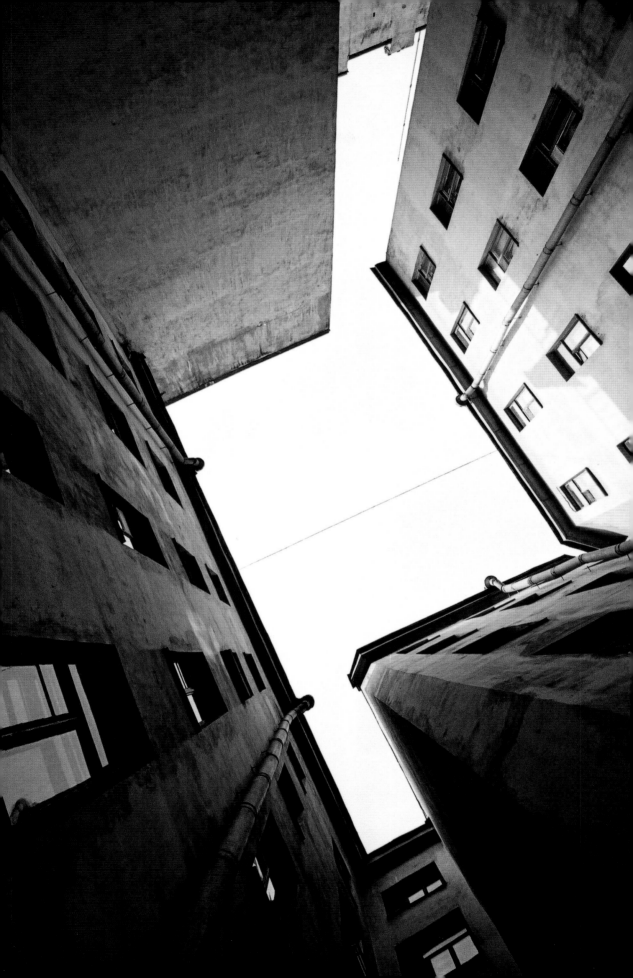

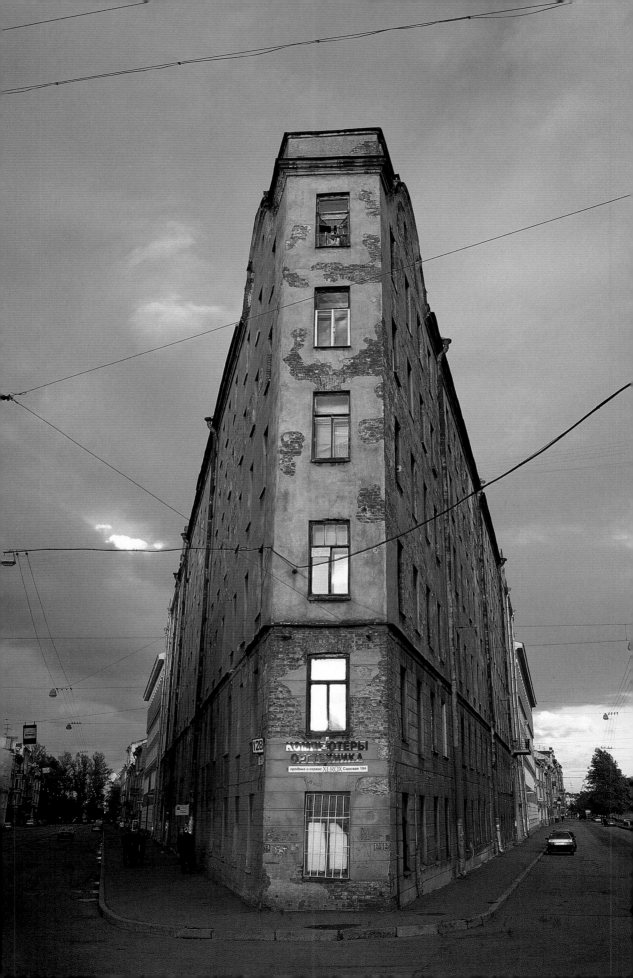

'Iron' House
This house, designed by Vasily Shaub, stands at the intersection of Sadovaya Street and the Fontanka Embankment. Such houses are popularly known as *doma utyugi* or 'iron houses', their tapering form reminiscent of old-fashioned clothes' irons.

Underground Women's Underwear Store in Apraksin Dvor
Gostiny Dvor stands on Nevsky Prospect and has always been St Petersburg's most glamorous shopping address. Five minutes' walk away, however, in a network of small streets behind Sadovaya Street, is Apraksin Dvor – an altogether less salubrious jumble of stall-holders selling everything from condoms to cardigans. This former cellar is one of the city's less enticing underwear stores.

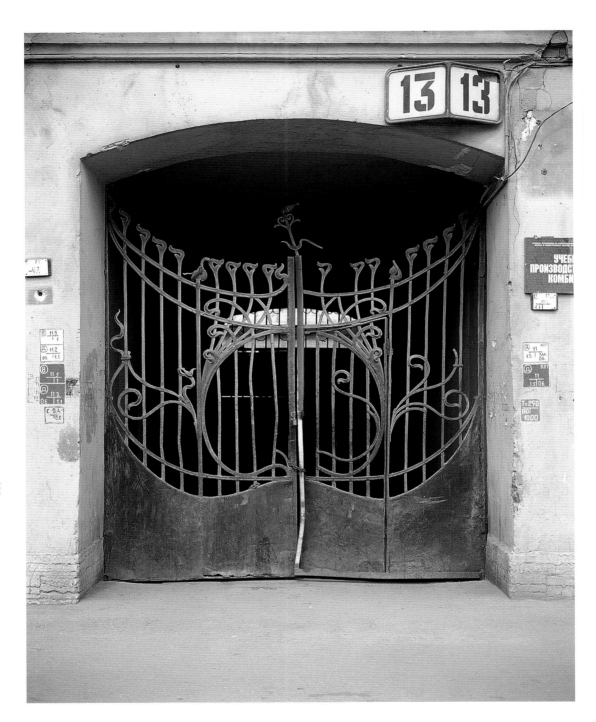

Gates on Dobrolyubova Street

Art Nouveau, or Style Moderne as it is known in Russia, was enthusiastically adopted by Petersburg's architects at the turn of the twentieth century. Sinuous lines and floral motifs began to adorn the façades of private houses as increasing prosperity created a building boom, particularly on the Petrogradskaya side. With the city's traditional attention to detail, even the wrought-iron entrance gates to internal courtyards followed the new style. The design of these gates on Dobrolyubova Street was directly inspired by the work of a German naturalist and craftsman, Hermann Obrist, who created a carpet in 1895 with a red cyclamen design. The line of the cyclamen's stem, resembling a lively flourish of the pen, was widely copied in graphic and decorative art, and adopted, as here, by architects working in Style Moderne.

Window Grille on Sadovaya Street

This grille is a variation of the 'sunray' grilles which are a common feature of windows throughout the city. The utilitarian lamp motif, dating from the 1970s, reflects the lettering at the top of the window 'СМУ' ('SMU'), which stands for 'stroitelno-montazhnoe upravlenie', the local government department responsible for installation of utilities.

Mayakovskaya Metro

After publication of the Futurist manifesto *A Slap in the Face of Public Taste*, Vladimir Mayakovsky was recognised as leader of the Futurist movement, although Gorky said of him: 'Strictly speaking there is no such thing as Futurism; there is only Mayakovsky. A great poet.' Politically active from the age of fourteen, Mayakovsky's enthusiasm for the Revolution was in part a reflection of the avant-gardists' belief that liberation for the arts could only come through destruction of the old social order. His reputation as communism's cheerleader-in-chief was posthumously confirmed when Stalin announced in 1935 that 'indifference to his memory and his work is a crime'.

Mayakovsky shot himself in Moscow in 1930 at the age of thirty-seven. In his suicide note he wrote: 'Forgive me – this is not the way (I don't recommend it to others) but I have no other choice.' The note included a short poem:

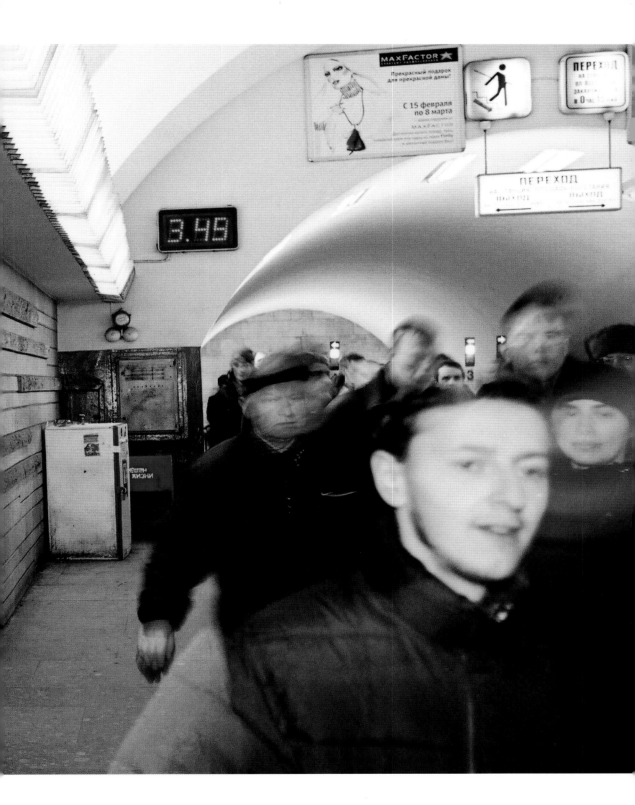

'The case is closed'
as the saying goes,
love's bark lies wrecked
 on the everyday.
Life and I have settled up –
no need to list
our mutual pain
 woes
 and dismay

Crowd of demonstrators on Palace Square

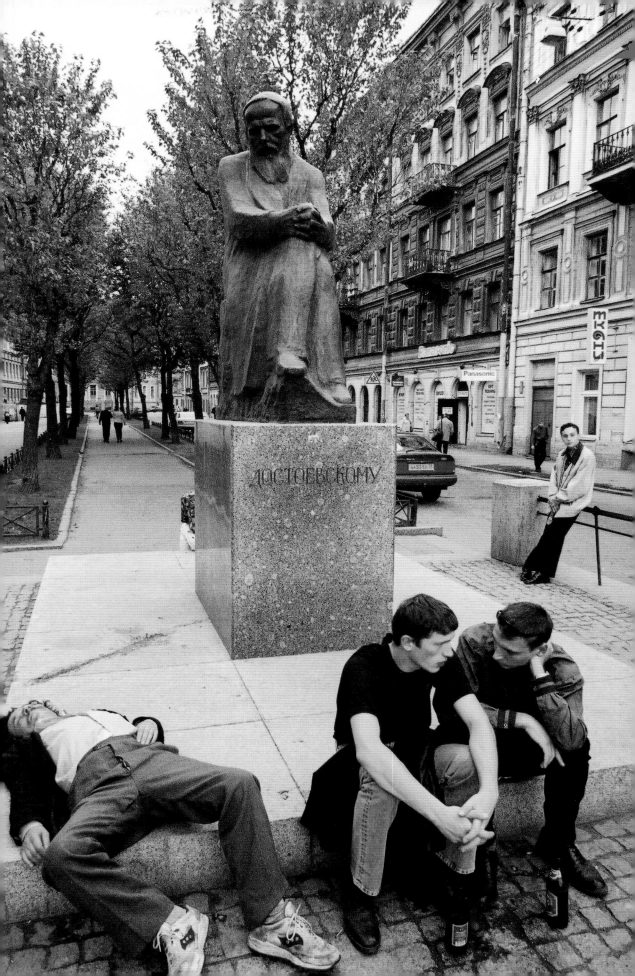

<

**Statue of Dostoevsky
on Bolshaya Moskovskaya Street**
'[Raskolnikov] had walked down this
lane many times before. It made a
bend, and led from the square to
Sadovaya Street. During his recent
weeks of wretchedness he had actually
felt a longing to loaf around in all
these places, "so as to get even more
wretched". Now he entered the lane,
thinking of nothing. There was a large
building here which was entirely
taken up with drinking dens and
other food-and-drink establishments...
A large group of women was gathered
outside the entrance; some of them
sat on the steps, others on the pave-
ment, and yet others stood talking
together. Beside them, in the roadway,
loudly swearing, a drunken soldier
was wandering aimlessly with a ciga-
rette in his hand, apparently looking
for some place he wanted to go to,
but unable to remember where it was.
One ragged man was exchanging
abuse with another ragged man, and
someone else who was dead drunk lay
sprawled across the street.'
Fyodor Dostoevsky, *Crime and
Punishment*

Shop front on Nevsky Prospect

НЕ ЖЕРТВЫ-ГЕРОИ
ЛЕЖАТ ПОД ЭТОЙ МОГИЛОЙ
НЕ ГОРЕ А ЗАВИСТЬ
РОЖДАЕТ СУДЬБА ВАША
В СЕРДЦАХ
ВСЕХ БЛАГОДАРНЫХ
ПОТОМКОВ
В КРАСНЫЕ СТРАШНЫЕ ДНИ
СЛАВНО ВЫ ЖИЛИ
И УМИРАЛИ ПРЕКРАСНО

**Monument to the Fighters
of the Revolution, Field of Mars**

Many of the soldiers and civilians who died during the February Revolution of 1917 were buried on the Field of Mars. A monument to those who died, by the sculptor Lev Rudnev, was completed in 1919. The inscription reads:

'Not victims, but heroes lie beneath this tomb. Your fate engenders not grief, but envy in the hearts of all your grateful descendants. In those terrible red days, you lived gloriously, and died magnificently.'

The graffiti on Akademichesky Pereulok
reads 'I love you madly'

Courtyard entrance on Mokhovaya Street

>
Fire Escapes in Apraksin Dvor

>>
*Children playing in the snow outside
Kazan Cathedral*

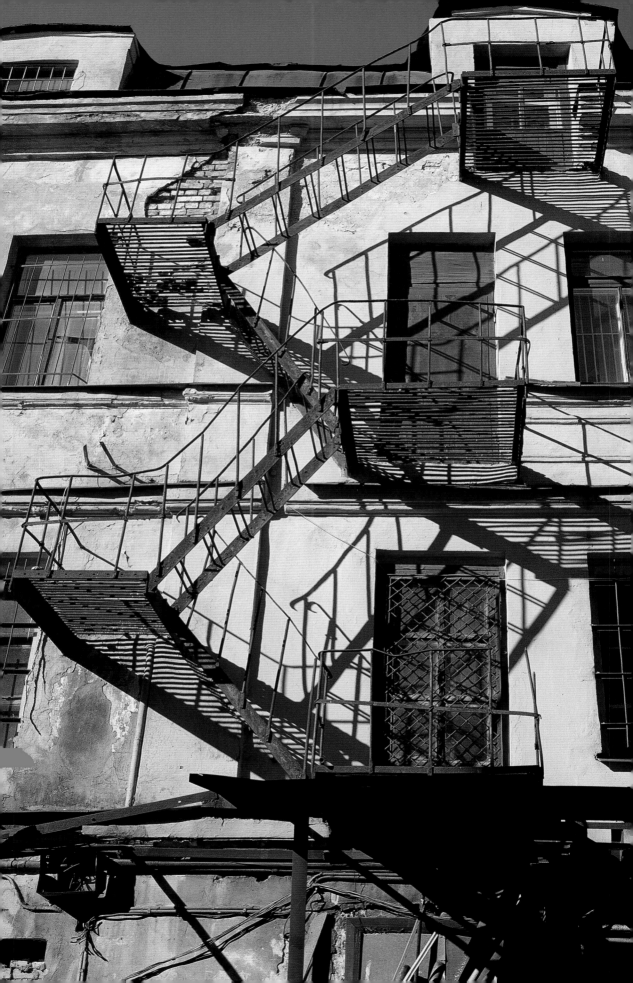

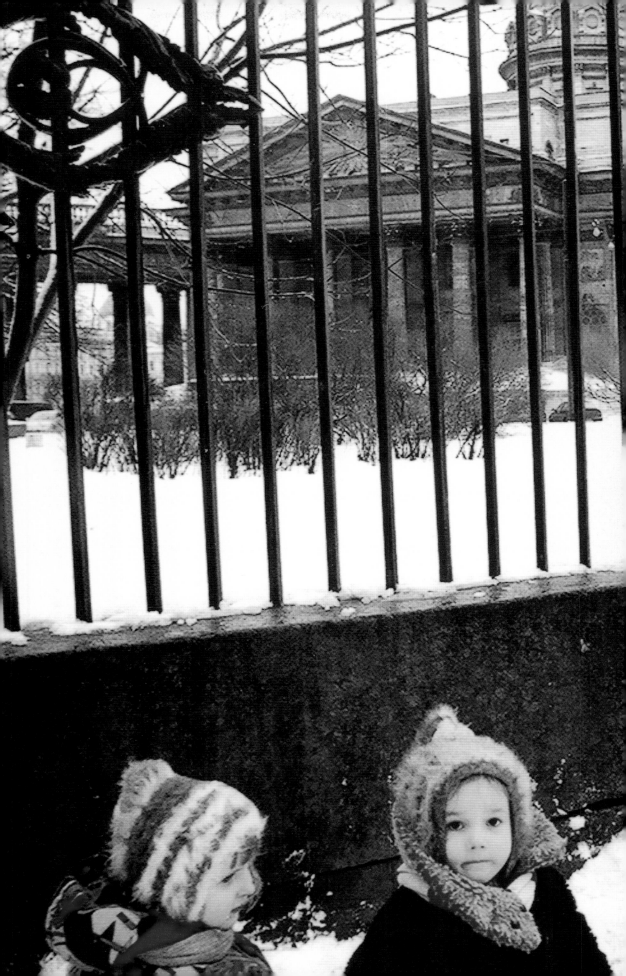

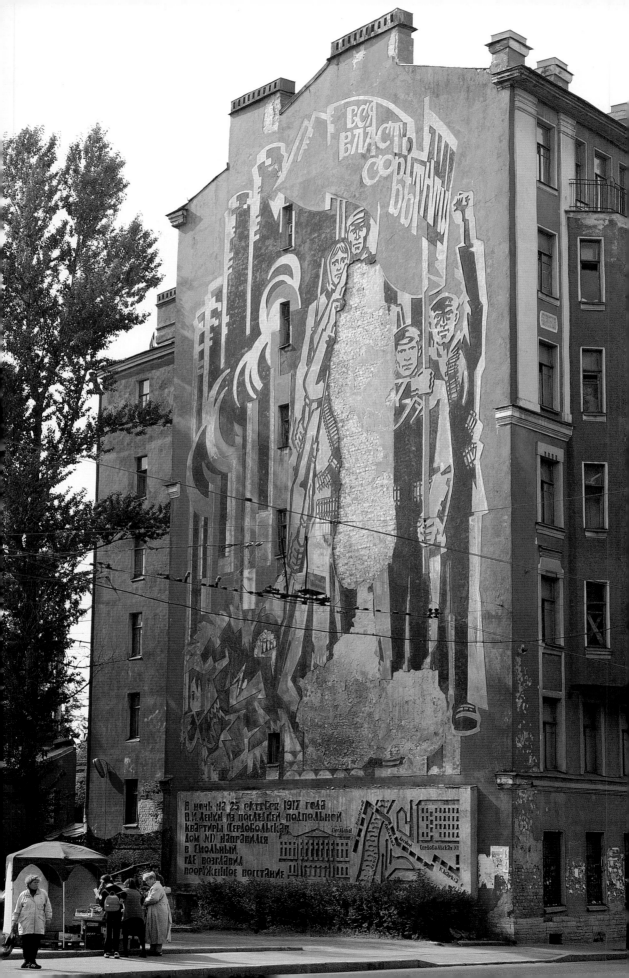

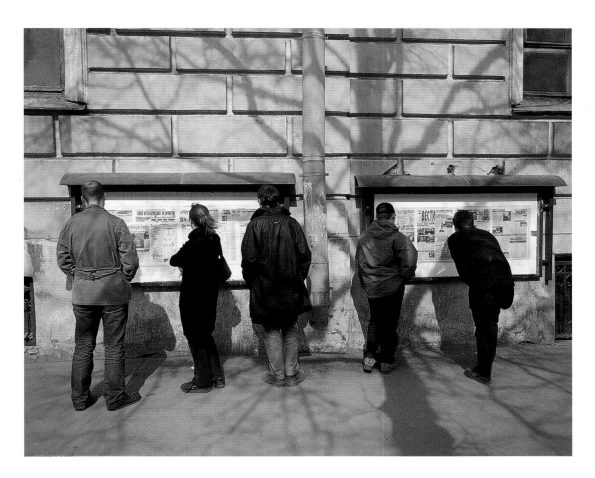

Newspaper readers on Pestel Street

<

Mural on Serdobolskaya Street
The mural commemorates Lenin's last
hiding-place before the Revolution.
The inscription at the base of the
mural reads: 'On the night of 25
October 1917 V.I. Lenin set off from his
last underground flat (Serdobolskaya
1) for Smolny, where he led the armed
uprising.' Alongside is a map plotting
Lenin's route. According to Soviet
history books, on the night he set out
Lenin left a note for the owner of the
flat, Margarita Fofanova: 'I have gone
where you did not want me to go.
Goodbye. Ilich.'

>

Moscow Square
Under Soviet plans for the develop-
ment of Leningrad drawn up in 1935,
the administrative centre of the city
was to be moved ten kilometres south
– to Moscow Square. The centrepiece
of the new ensemble was the enor-
mous Palace of Soviets, designed by
Noy Trotsky. Completed in 1941, the
building contained 700 offices, a
conference hall with a capacity of 3000
as well as ten other smaller meeting
chambers. It was also the first building
in the USSR to be air-conditioned.
Trotsky's building never fulfilled its
intended purpose. A guide to the city's
architecture published in 1976 by 'The
Principal Town-planning Management
of the Leningrad Soviet of Workers
Deputies Executive Committee' [*sic*]

notes dryly: 'Then this plan was
changed and after the Great Patriotic
War the idea of building a new admin-
istrative centre in the south was given
up altogether, so the square lost its
importance of being the city centre.
The result of it was that the architects
did not succeed in creating an architec-
tural ensemble of the square.'
Nevertheless, the Soviet authorities
did not turn their back on the square
altogether: in 1970 a statue of Lenin by
Mikhail Anikushin was erected to com-
memorate the hundredth anniversary
of the Bolshevik leader's birth.

>>

Apartment block entrance, Moscow Prospect

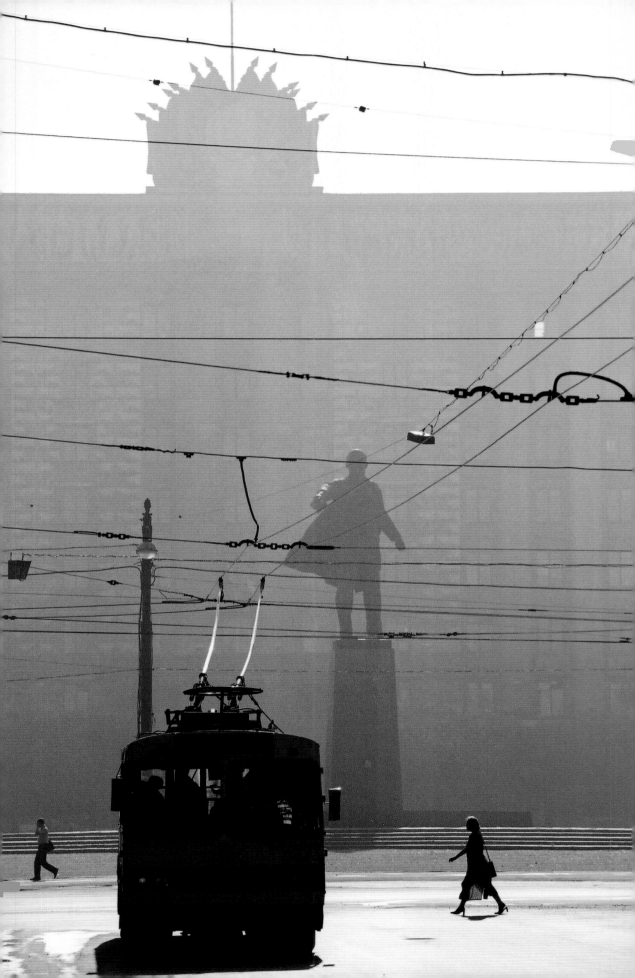

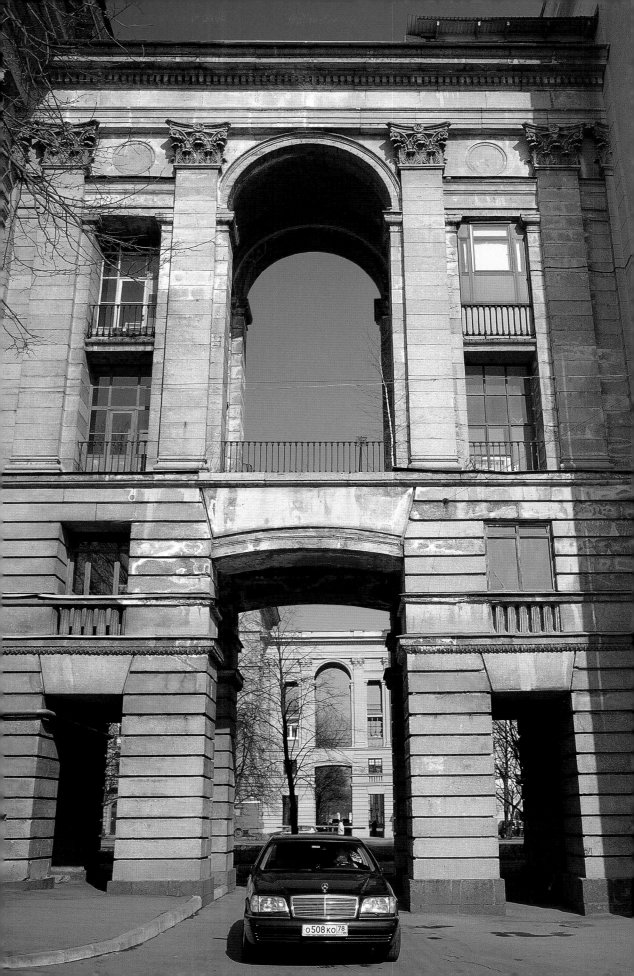

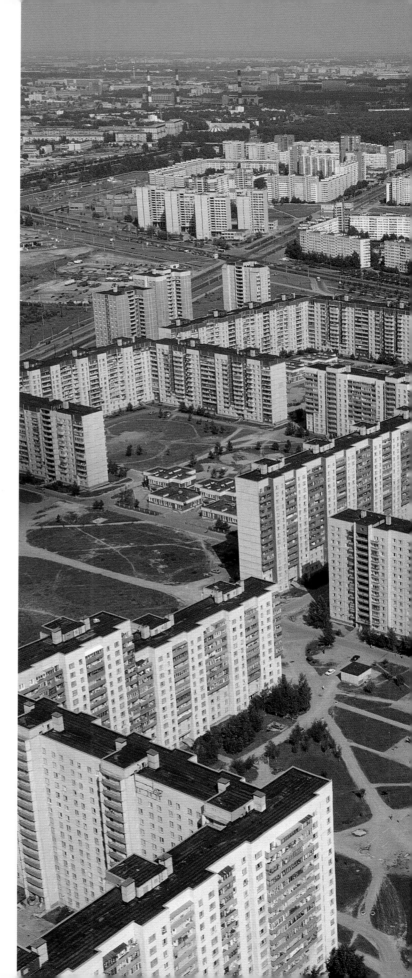

Grazhdanka

By the early 1960s the ever-increasing pressure on the centre of Leningrad, where a growing population was crammed into communal flats in dilapidated buildings, could no longer be ignored. Over the next ten years new accommodation was built to re-house almost one third of the city's population – some 940,000 people. The vast majority of them were re-located to new regions, such as Grazhdanka to the north of the city, and Leningrad achieved the distinction of building the greatest volume of such high-rise buildings in the country.

The geometric arrangement of these new regions – street upon street of identical blocks – was satirised in the film *Irony of Fate*, in which the central character, after a mighty drinking session in the *banya* with his friends, finds himself in Leningrad rather than his native Moscow, locates the ubiquitous Constructors Street, lets himself into what he believes to be his flat – and finds nothing different enough to alert him. This sense of geometrical order was not new to the city: describing St Petersburg in the 1840s, the poet and critic Apollon Grigoriev wrote: 'See how all its streets stretch out in amazing lines! How geometrically even are the outlines of its squares and parade grounds! And if somewhere on the far side of the Neva the buildings lean slightly to one side, still they lean in most regular fashion!'

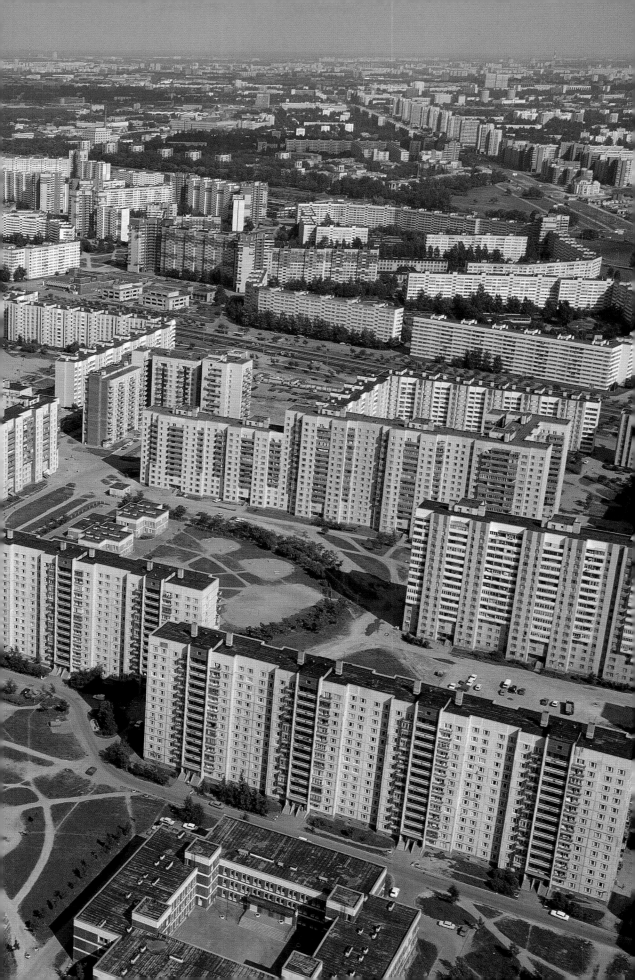

Пусть собака, помощница и друг человека с доисторических времен, приносится в жертву науке, но наше достоинство обязывает нас, чтобы это происходило непременно и всегда без ненужного мучительства.

И. Павлов

Statue of Pavlov's Dog

The bas-reliefs around the plinth of the statue to Pavlov's dog portray scenes from the famous scientist's work. The inscription reads: 'Let the dog, man's helper and friend from prehistoric times, be sacrificed to science, but our dignity requires us to ensure that this happens with certainty and always without unnecessary suffering.' Ivan Petrovich Pavlov first won fame (and a Nobel Prize) for his work on the digestive system in mammals. During his work, however, he noticed that dogs started to salivate at the sight of those who fed them, rather than at the sight of food itself. After further experiments Pavlov defined this kind of reaction as a 'conditioned reflex'.

Circus Billboard

Circus performances with acrobats, jugglers and horsemen have been a feature of St Petersburg since the eighteenth century. Wooden circus buildings began to appear at the beginning of the nineteenth century, and in 1877 Russia's first permanent circus opened on the banks of the Fontanka River.

> >

The Summer Garden

The bust of Agrippina, one of ninety statues still standing in the Summer Garden, is subtitled 'An Allegory of the Transience of Life'. It is the work of an unknown early eighteenth-century Italian sculptor.

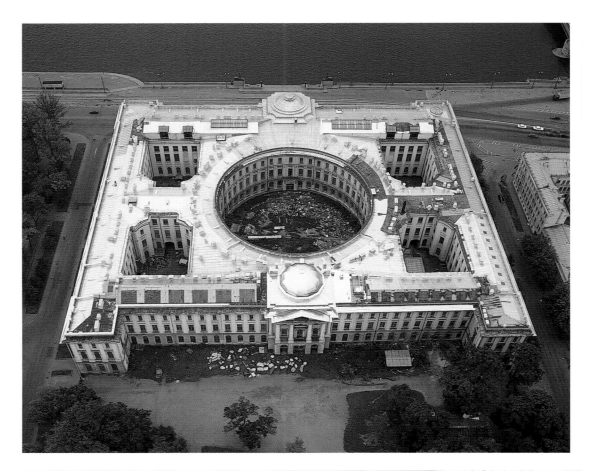

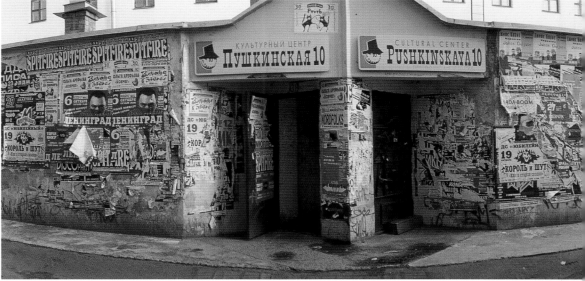

Academy of Arts and the New Academy of Fine Arts

Culturally, St Petersburg has often veered between innovation and reaction, but its artistic endeavours continue to be influenced by a strong sense of the classical traditions which played such an important role in the city's development. The Academy of Arts on University Embankment has long been the spiritual home of

Russian classicism. Its unusual design – a large circular courtyard surrounded by four smaller square ones – was apparently dictated by its founder Catherine the Great, who announced that the circular courtyard was necessary 'so that all the children who study here should have something the size of the dome of St Peter's in Rome before them'.

In 1990 the artist Timur Novikov

founded a movement known as Neo-academism, and the Museum of the New Academy of Fine Arts was established at Pushkinskaya 10 – the city's unofficial centre of non-conformist art. Novikov died in 2002 aged forty-three, his work described as 'a surreal, digitally created marriage between gilded-marble classical splendour and the destitute, street, refuse art of Petersburg dandies'.

Entrance to the Mitki Workshops
One of the most influential group
of artists and writers in the late Soviet
era were the *Mitki*, founded by, and
named after, Dmitry Shagin in 1984.
The group's well-known symbol is here
seen on the door leading into flat 20
on 16 Pravda Street.

In his tongue-in-cheek manifesto
for the movement, published in 1990,
Vladimir Shinkaryov described the
Mitki as 'a new mass youth movement
in the style of hippies or punks'.
Shinkaryov goes on to interpret a typi-
cal conversation between two *mitki*:
'Humph!' – 'Nah, Fiddlesticks!' –
'Humph!' – 'Fiddlesticks!'
'This conversation can mean all sorts
of things. For example, it might mean
the first *mityok* is asking the second
what time it is. And the second replies
that it's already past nine and isn't it
a bit late to dash off to the shops, to
which the first suggests heading for
a restaurant, while the second com-
plains that he's out of money. More
likely, however, the conversation
doesn't mean anything at all, but is
simply a way for *mitki* to pass the time
of day and confirm their existence.'

>
Façade on Vladimirskaya Square
The original building that stood
behind this façade has been demol-
ished. In a typical example of the
city's approach to reconstruction, the
façade now conceals a vast concrete
box – the 'Vladimirsky Passazh Hotel
and Shopping Complex'.

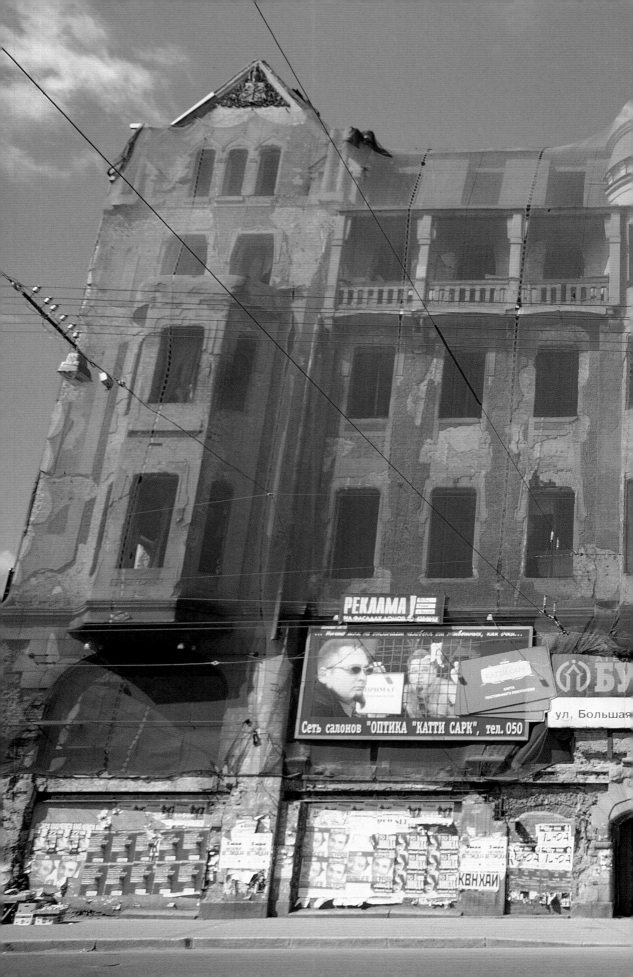

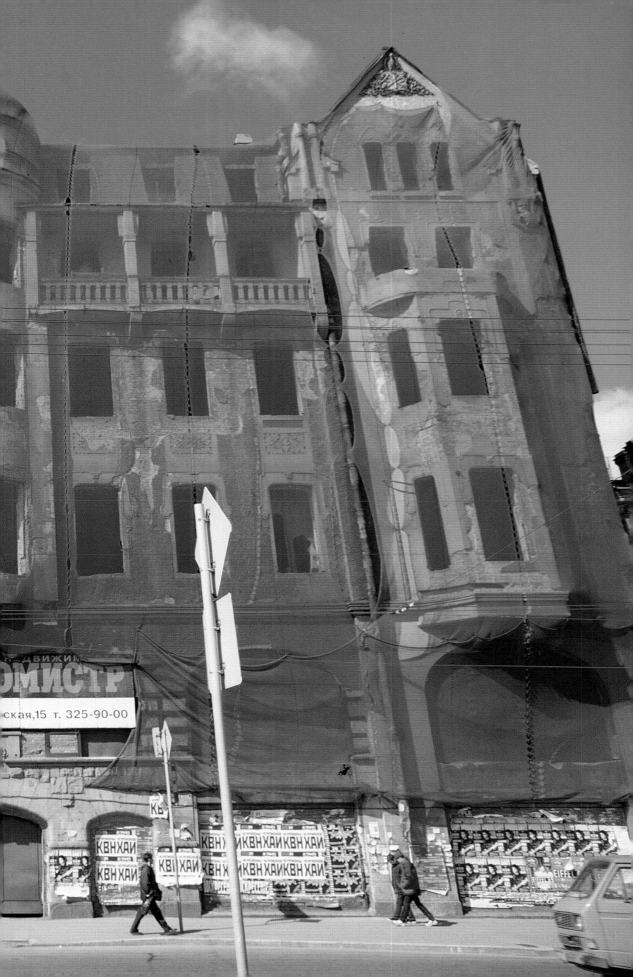

The Flat

Rogozin peered into his glass and blew.

'Look – not here, okay?' said Vasily, uneasily.

Rogozin looked round in amazement. 'Oh come on! Don't be such a worm!'

Something banged against the door; a screech of wheels, loud laughter. Vasily gestured angrily towards the corridor.

'What was that?' asked Rogozin.

'Next door's kids on a trike.'

'So what?'

'It... it gets in the way.'

Rogozin breathed into the glass and wiped it dry with his finger: 'Gets in the way? I think it's rather sweet. What you need is a drink. Get tanked up, you know, give them something to remember you by. I suppose you've always just sat quietly in here?'

'Like a mouse.'

'So let's hear the mouse give one last roar.'

Vasily looked even more uneasy. Yes, it was farewell to this room, the most squalid in the whole communal flat, goodbye to his personal hell. Hot and damp – he'd remember it like a chronic illness, an interminable melancholy. So why not let go at the last? Why not have one last bite back at them? But then, if Rogozin was threatening to make himself heard before he'd even poured his first drink – well, the chances were they'd end up down the police station.

Vasily owed a lot to Rogozin. It was Rogozin who had brought along that torn-off flake of paper with a phone number on it, and quickly, as if in a dream, without agents or exchange offices, Vasily had bought a one-room flat on Truth Street for sixteen thousand dollars. Sixteen thousand North American notes; at the agency it would have cost him an unattainable twenty.

'All right, all right,' said Rogozin. 'We'll just drink this bottle and then move on. What's got into you? Am I running this bloody race on my own?'

Vasily looked gloomily round in response, wondering where he could get a second glass. Everything he owned was already packed up in cardboard boxes, pictures of oranges and dry white wine down the sides. His books, his most valuable possession in Soviet times (though they'd all been reprinted often enough now, and the second-hand stores weren't interested), his non-matching chairs, the dismantled cupboard, the couch, the desk. Junk, the lot of it – not even worth the cost of removal. He found some ornamental metal goblets in the desk drawer.

'I'll be moving in a few days; you'll help me with my things? That'll be it then, the end. I'll sit down before I unpack and then I'll get tanked up for you,' said Vasily, downing his vodka unenthusiastically from the dirty goblet. 'But for now I've still got some matters to attend to. I can't relax yet. Not here anyway.'

'You know what they say: there's no such thing as an easy voyage or a difficult voyage for a true sailor – just the voyage to glory. Who's making that racket all the time?'

'Next door on the phone. Sounds like an impersonation of one of her beloved neighbours. Yes – probably me. The thing is, when you sell a room in a communal flat you need the agreement of all the other inhabitants; so you're faced with having to drag them all off to the notary to renounce their preferential rights of purchase, or whatever. But this lot just laughed in my face…'

'Yeah, yeah – I get the message. You wouldn't have got me to the notary's either. But you sold it, didn't you? The room?'

'Drew up a deed of settlement. Forged it, of course. Cost me two hundred dollars.'

Rogozin wasn't really following the conversation and, bored, looked round at the adverts and reminders pinned to the walls: 'Sign up at your local military office!' 'Buy PPS for pre-sale security!'

'Listen,' he said firmly. 'You've done it now. So hold your head up and give us your glass. Where did you get that kind of money from anyway? Loaded, are you?'

'Loaded? Me?' Vasily was offended. 'After the divorce I put aside every last rouble. And whenever I had five thousand roubles I'd go out and buy myself a dollar.'

'And you're telling me it only took you three years to stack up sixteen thousand bucks? That's a joke. Don't play the mystic miracle-worker with me.'

'You forget that I sold the room for seven thousand.'

'Fine. So you only needed to save up nine thousand. It's still a joke.'

Vasily had never been much good with money, and it really did seem as though the cash had piled itself up, sucked in by his desperate desire to get a flat.

'I sold everything. Got a thousand for *The Car*.'

'What car was that?'

'A story I wrote. A story called *The Car*. It was a take on Gogol's *Overcoat*. A civil servant is embarrassed by his Lada; he dreams of exchanging it for a Volvo. Even a BMW in his more ambitious moments. Eventually he does it. He's overjoyed, his whole life changes. He spends his time sitting in his Volvo, dozing off, can't bear to get out – he's like a baby in the womb. Petersburg all around, the bleak northern fortress with its climate on the edge of human endurance, and the Neva distended over its banks.' Vasily pointed at his glass where the vodka's meniscus bulged up over the rim. 'And he sits warming himself in his car and smiles. Well, naturally the car soon gets nicked and that's that. "And Petersburg lived on without Akaky Akakievich, as if he'd never been there in the first place."'

Rogozin bent down over Vasily's glass and slurped the vodka to stop it spilling. Suddenly he grew wiser and more lively: the medicine had taken its effect.

'No great tragedy there,' said Rogozin. 'What kind of a loser dies for a car? You don't even have one, do you?'

'And what if I don't?'

'Overcoats, cars – they're not Petersburg themes. But what about living space?'

'You mean I should start writing about myself? You're saying I'm like Akaky Akakievich, are you?'

'One and the same.' Rogozin poured out more vodka in triumph. His own glass he filled to the brim, Vasily's halfway. 'You never get out. Akaky Akakievich sat around copying things out, while you waste your time playing on that computer. You've sold it, have you?'

'Oh yes. I've sold it all right. Televisions... You hear them? Until every last one of my neighbours is tucked up it's impossible to concentrate on anything.'

Rogozin listened hard for a few seconds:

Put the gun down! Don't do it, Jack!

'You see? The televisions howl at each other, just like the adults and children who own them. They're high on sensory deprivation, you know – not a moment's silence. Their TVs howl them to sleep.'

'You should just turn yours on loudest of the lot.'

Vasily was silent.

'Look, Rogozin, that's good vodka I've staked on you, and not a drop of sympathy in return. Why are you always trying to upset me? I tell you, this flat business... I'm a nervous wreck.'

'Come on, don't be stupid – calm down. I'm just saying that if I were you I'd get my own back: I'd make that lot shit themselves all the way to Timbuktu... You're too thin-skinned, you are... you're a mollusc without a shell.'

'All right, so I sat around playing on my computer. So what would you suggest? Get wasted like you?'

Rogozin smiled. 'There's no comparison. Playing on the computer is no better than playing with yourself. You don't know how to drink, that's all.'

'So that's it, is it? I don't know how to drink. And there's you: you live all right, you're not in a communal flat. You've got a family. So what do you drink for? Sober bad, drunk good – is that the bottom line?'

'Yeah, right: a fat lot of good sobriety has done you!' cried Rogozin maliciously. He jumped up and started running between the cardboard boxes full of books. 'I've had enough. Let's make tracks, it's getting hot in here...' he said irritably. 'You know, you call yourself a writer, and you don't even know life. Look at me: my wife's a whore, my son's a sniffer...'

'What do you mean a sniffer?'

'Oh, there speaks the writer. You mean you've never heard of sticking a bit of glue into a plastic bag and giving it a good snort?'

Rogozin tried to force the stopper back into the almost empty bottle. Then sharply he tipped it out into his glass and downed it.

Vasily was already in his coat, listening hard at the door. He opened it a touch: a podgy boy slid slowly away down the dark corridor on his tricycle. The boy looked round and smirked knowingly: doesn't even know what a sniffer is!

<

Wall detail showing makeshift adverts for, amongst other things, flat rentals, parquet floors, miracle diets and insect extermination

Vasily didn't want to go anywhere, he was just waiting until he could go home – which is to say until Rogozin had drunk enough wherever it was they were going not to notice him leave. Go home – not to his old room, but to the one-room flat on Truth Street, where there was nothing apart from useless boxes and cases. The flat was triumphantly empty ('Tao is empty, but its applications are endless,' recalled Vasily).

But for the moment he had to keep going, and drag himself along to see Rogozin's friend Yemelyanov.

Along the way Rogozin was compelled to drop into a bar for a glass of vodka, in order to feel the full effect of their dissipated wandering and, most importantly, 'not to lose altitude'. They spent ages waiting for a taxi minibus and then travelled gloomily, tightly packed. Rogozin felt sick from the shaking and began to cause trouble. When one of the other passengers asked him to pass their money to the driver he made a show of turning his back, and when the passenger asked again he shouted, for no reason, 'You mutant!' There was an unpleasant exchange, excuses, malicious sneers. They got off near Haymarket Square ('why should I have to put up with that?' muttered Rogozin); Yemelyanov lived round the corner, they could get there on foot. It was a good thing they hadn't walked the whole way, because no doubt Rogozin, encouraged by the damp air of an autumn evening, would have looked for other excitements. And found them.

By now it was completely dark, and a blind invalid played ferociously on his accordion. Old women stood by the metro selling nails and pornography.

When they got to Yemelyanov's door Rogozin performed his latest trick: he leant his forehead against the bell and stood there as if dozing. Yemelyanov soon opened the door and Rogozin wrenched his forehead from the bell, shook himself down like a sparrow and cried out exultantly: 'I've brought you an intellectual. Allow me to introduce Vasily Kazakov, the literary man.'

But it didn't have the desired effect: Vasily's nervous energy was too spent for him to feel embarrassment.

Yemelyanov muttered something like, 'Yes... uh-uh...'

'So you've read him?' Rogozin was even more excited. 'You see, Vasily, people admire you, they read you. Do you read much contemporary fiction? I'm buggered if I can, but then what's the point?'

Yemelyanov, whom Vasily hardly knew, looked at him apathetically through swollen, bloodshot eyes. He was in slippers, track-suit bottoms and a dressing-gown, and had obviously just got up. He led his guests into a room piled so high with books that none of the walls were visible.

'Coffee, tea?' he asked wearily.

With slow ceremony Rogozin produced two bottles of vodka. Yemelyanov turned silently and shuffled off into the kitchen.

Vasily cast a single sweeping look along the shelves of books. They were like fortress walls, protection against the world outside in all its madness. Vasily had dreamed of a room like this since childhood, and immediately he started thinking about how he would arrange the books differently in his flat on Truth Street. And despite this sudden rush of sympathy towards his host, he wanted to get back there as quickly as possible to dream.

'Happy are you?' asked Rogozin, apparently to Yemelyanov, but looking sideways at Vasily.

Yemelyanov brought in a tray with glasses and some simple but carefully prepared snacks, and put it down on the coffee table. He grinned contentedly.

'Yes,' he began, settling down. 'You can ruin your health quite quickly, turn family life into hell and even achieve some remarkable creative failures. But these are little more than skirmishes along the front. Total and utter defeat of the self can only be achieved through alcohol.'

'Don't discombobulate me!' Rogozin blustered, realising what Yemelyanov meant. 'If you don't want a drink then pour yourself a cup of tea!'

'No, why should I?' said Yemelyanov, pouring out the vodka. 'Vasily, I hope you're not an alcoholic? Like us?'

'Oh go to Timbuktu and take your alcoholism with you!' shouted Rogozin. 'The lad's celebrating, he's finally sorted his life out, but you just bang on: Alcoholism! Alcoholism! Fucking parrot. Fine, I admit it, maybe I have got a certain weakness, even if I... well, anyway...'

'Alcohol provides the perfect adjustment to reality,' announced Vasily, wanting to shine in front of the clever Yemelyanov.

'A rather Procrustean adjustment,' remarked Yemelyanov gently, raising his glass. 'So what is it you're celebrating, Vasily?'

'Watch out or he'll piss on your parade,' grumbled Rogozin.

'Tomorrow I'm getting the documents for my own flat,' Vasily began shyly. 'Not far from here... Truth Street. I got divorced, had to move into a room in a communal flat. It was a nightmare – indescribable. I spent three years there, not living, just hiding from the neighbours. It was absolutely impossible...'

'...to write books,' blurted out Rogozin.

'It was absolutely impossible to concentrate.'

Yemelyanov had waited for the end of this artless monologue; now he raised his glass in congratulation and tipped it into his mouth.

'Good for you,' he spluttered hoarsely, freezing over before their eyes. 'Excellent vodka. Where did you get it?'

'By the Technological Institute – on the other side of the street in the corner,' Rogozin explained eagerly.

Yemelyanov thought for a moment and then nodded his head in comprehension. Without getting up he started rummaging around in a pile of papers on the floor, pulled out a sheet and began to read:

'"Tu-Keizhi, who lived in the Qin Dynasty, built himself a tall tower in which to practise the art of painting. For otherwise his inspiration could find no outlet; it would perish without bringing forth fruit. How then could the artist reveal the essence of things in his paintings? But if a common man were suddenly to enter and spoil the artist's thoughts or feelings, all would be lost" – isn't that right?'

Vasily choked on the vodka he was downing in tiny little sips. 'Brilliant,' he thought with feeling. 'A piece of paper with a quotation right to hand.'

'Tu-Keizhi didn't know the half of it!' he declared. 'These days the common man is a greater threat than ever. All my energy goes on patience – patience from dawn till dusk...'

Rogozin took the bottle and poured himself and Yemelyanov a drink: 'Lest we lose kinetic speed!'

Yemelyanov went on: '"I live in isolation in order to achieve my aims. I have heard these words, says Confucius, but I have never met such a man."'

'Hold on... You say Confucius never met such a man? A man who wanted to achieve his aims?' Rogozin had roused himself. 'How so? What was stopping him?'

'What was stopping him? Well, you'll recall that when you were a child you wanted to build a skyscraper.' (Vasily was amazed: so they've known each other since childhood?) 'Well, what stopped you?'

'I still want to build a skyscraper,' Rogozin acknowledged gloomily.

Vasily reckoned that Yemelyanov had got it all mixed up: Confucius wasn't talking about some kind of existential *ennui*. He simply meant that it wasn't right for man to be alone.

'But some people must achieve their aims,' said Vasily. 'Of course solitude is... man needs solitude to get things done. For example, for a crystal to grow, even when it's in a saturated solution, you mustn't shake it up, you mustn't add anything. You need to leave it alone.'

'Oh. So you're a crystallographer now, are you?'

'Just leave it out, Rogozin,' replied Vasily rudely.

'Ugh! Writers!' exclaimed Rogozin. 'Any minute now my brain'll explode from the extraordinary amount of knowledge I'm picking up from these conversations. Writers can teach you all sorts of things. Take Limonov – he taught me that sauerkraut soup needs to be eaten cold. What are you whinging on for? Whinge, whinge, whinge. It used to be your old woman, and the only problems you had were of the urino-genital kind. Now you're all packed up, bought your flat...'

'Whinge? What do you mean?' Vasily was amazed. 'On the contrary...'

'Forget it; look – this conversation. We've gone off the rails,' Rogozin interrupted decisively. 'Let's drink. What are your problems to me? A legion of passing ants.'

They drank in silence. Yemelyanov put on a jazz record and rolled his eyes up towards the ceiling. Rogozin looked down with gloomy hostility. He seemed to be nodding off.

'Yes,' as if summing up his thoughts. 'Morals won't help you get through to a woman. Only the lash will do.'

'Which particular woman are you talking about?' inquired Yemelyanov.

Rogozin did not answer. His eyes had closed.

'Given that he was referring just now to my former wife...' began Vasily.

Rogozin started to mumble a warning and then laid his head on the back of the armchair.

'Now he'll go to sleep and miss the last metro,' Yemelyanov stated impassively.

'Yes, it really is late. I must be going.'

'But you only got here twenty minutes ago! Look how much vodka's left.'

'I don't drink much, and anyway we had a few before we got here.'

'Well don't drink then. What about coffee? God, it didn't take him long to drop off today... He wanted to come round yesterday to pick up his... what is it he calls them? His aphorisms?'

'Rogozin writes aphorisms?' asked Vasily without any particular surprise, and thought bitterly: 'well why shouldn't Rogozin write? I suppose Yemelyanov writes as well. Look at all the papers...'

'Not exactly aphorisms, no – and not a diary either. It's a sort of ship's log. I think he was in the navy.'

'Yes, he was. He was posted up in the arctic. They put Rogozin on watch and he fell off the gangway onto the ice.'

'Something like that, anyway. Here – have a look through this, it's not confidential. I'll make some coffee.'

Yemelyanov went out. Without opening the exercise book in his hand Vasily stared dully at the book shelves. A complete edition of Brockhaus's *Encyclopaedia* sparkled gold at him, all eighty-six volumes of it – even today they'd cost a fair bit. And the valuable little blocks of a first edition of *Fallen Leaves*: they must have cost a good month's wages. Yes, to turn that many planks into shelves he must have spent... oh, God knows. It's nice the way the shelves go all the way to the ceiling. And no TV, of course. Perhaps there's one in the kitchen. And suppose the neighbours made a racket behind the doors of a room like this? Sounds of aggressive squalor, day and night. Although the noise itself isn't really the point: it's the fetid stench of poisonous misery and malice... Vasily shuddered and opened the exercise-book:

I'll sell my coat and go to Sevastopol.

They carried the suicide out of the Banya. 'Don't do that,' my brother said to me.

The only thing that keeps Vasily occupied is worrying about his own fate. You shouldn't worry about your own fate like that. He said it himself: what we may lose is nothing compared to what we have lost already. There you go: even the clever ones are more interested in sparkling witticisms. (Vasily worked out that this was about him, was mightily offended and read on with a certain ill-disposition.)

I feel sorry for my wife – what is there to do with her apart from lie there in the darkness? We decided to go out of town, and when we got to the bottom of the escalator I asked, so where are we going? 'Oh f- off!' she shouted and ran back upstairs. It turned out she went to the Taurida Gardens to go skating. Which reminds me – Florensky once said that he had been to Trafalgar Square more often than he'd been to the Taurida Gardens.

Further on were some pasted-in newspaper cuttings:

At the evening show in the Moskovsky Cinema an unidentified youth got up on stage and slashed the screen. He escaped after breaking a window. The showing of 'Jack Vosmerkin is an American' was interrupted for 10 minutes.

Last night S. Osipov, A. Mukhachev, I. Cherednichenko and A. Smirnov, four men employed by local businesses, broke into the Stepan Razin Brewery where they tried to steal 166 bottles of beer and 267 empty bottles. Members of the local police force apprehended the thieves at the scene of the crime.

Late last night at the Electrosila Factory employee R drank some liquid (How delicately put. R for Rogozin perhaps?) *and a few hours later died in hospital.* (So not Rogozin then.)

Last night in Kolpino an unidentified criminal stole 1,200 Christmas crackers from a local warehouse. The value of the stolen goods is being calculated.

An employee of the Red Triangle Factory, N. Dubrovsky, broke into a flat at No 3 Menshikov Prospect through an open window on the first floor, where he attempted to steal some works of literature. On leaving the flat he was arrested by members of the local police.

A. Sokolov, a student at the Petersburg Technical College, and M. Ivanov, a fourteen year-old pupil at Tikhvin High School, walked out of the Tikhvin Museum in the middle of the day carrying two bayonets, a medallion and an ornamental axe. Shortly afterwards they were arrested by members of the local police.

Yemelyanov came in with a cup of coffee.

'Like them?'

'I don't get the cuttings,' said Vasily. 'A chronicle of life's petty squalor? Are they supposed to be funny? A record of Perestroika, I suppose. No, they can't be – the cuttings are all old. Look, here's someone going around stealing books...'

'There's nothing malicious about it – of course there isn't. Just sorrow and poetry...' Yemelyanov solemnly poured himself some vodka and switched

the scratchy music back on. 'Don't go looking for any conceptualism. Though I suppose it's true that Rogozin lives the life of a conceptualist. He pissed down the back of my TV. Never smelt a TV like it.'

Vasily laughed: 'You're right – a most conceptual course of action.'

'Ah yes, but it was even better than a conceptual piss, because he did it subconsciously. Not quite a Zen Buddhist *koan* – a little too symbolic for that, too easy to interpret – but close.'

'I tell you what was a true case of Zen Buddhism: when he expressed his disappointment in Perestroika through swallowing three packs of Hungarian contraceptive pills. They were truly remarkable pills – the list of side effects included "vomiting frequently observed during sexual intercourse".'

Yemelyanov fell silent. As if he found Vasily's words offensive.

'Swallowed the lot of them,' Vasily repeated, ignoring him. 'They had to give him a stomach pump. Much as I love Zen Buddhism and Rogozin...'

'...and Perestroika and Hungarian contraceptives...'

Vasily, relieved, burst out laughing:

'Yes... but my point is that much as I love him, our friend is often a source of complete drivel, in word and deed... He's a clever man, mind you, talented; after all, it was Rogozin who set me up with my flat... yes, really! A nice cheap flat. And while I was waiting for it, nearly four years, I hardly wrote a word. I was in a kind of panic, looking for some guiding light to help me concentrate and start living.'

'That can't be right.'

'What do you mean?'

'Waiting four years to start living. You're a writer, aren't you? You should be your own guiding light. In order to live – well, neighbours don't stop you, even the weirdest ones. You know what Chesterton said: "They are not yahoos, they are those for whom Christ did not disdain to die."'

Vasily was silent, not knowing how to trump that. It was all very well, but what did Yemelyanov know about everyday life? It was easy for him to preach, sitting in his fifty-square-metres flat. I mean, it must have cost him...

Rogozin started and muttered in his sleep: 'Popped round behind the kiosk and pissed in the bread racks. And when I got back the old cow's forehead was already cracked. Turned out it was her birthday.'

Vasily got up and smiled gratefully.

'You're absolutely right.'

'What?'

'I am my own guiding light. You know the song: "I'm my own sky, my own moon". I must go; forgive me for leaving Rogozin with you like that.'

'Just the usual Rogozin. He's spoken, soon he'll wake up and we'll have something to eat. You must come again.'

'I will,' Vasily stopped on the staircase. 'I'll sort everything out with the flat, and then I'll come. As soon as I walked into your flat I knew that I would keep coming here. Sometimes I get that – a memory of something to come: I see something in a shop, and then I remember quite clearly that one day it will

>
Doorbells to a communal flat
(formerly occupied by the writers Dmitry
Merezhkovsky and Zinaida Gippius):
the bells bear the names of the occupants
of each room of the flat

belong to me. Sometimes I'm even sorry about it – what use could it possibly be to me? – but I still have to buy it. And when I walked into your flat I remembered.'

Despite the draught coming up the stairwell, Yemelyanov stood happily in the doorway without the slightest sign of impatience.

'Another alcoholic,' thought Vasily, hurrying downstairs. 'Not completely saturated yet, still holding out.'

He seemed to have lots of alcoholic friends again these days; only recently they'd all been dying out. But new ones were popping up: Rogozin, Yemelyanov. The woman on the stairs...

The previous winter the lift in Vasily's building had been broken, and when he was going down the stairs from his room on the top floor, a woman from the floor below had come out holding her year-old baby – perhaps she'd been waiting for him? She carried the pushchair down and Vasily took the baby – and he was afraid in the darkness, afraid of stumbling. The baby was breathing heavily through its nose – it was so tiny, but as it looked straight ahead its breathing was as heavy as a grown man's. And Vasily had almost wept from tenderness and self-pity.

How wonderful it would be to push a child around the park in the warm weather, with little dogs running by, and your baby breathing. Almost makes you want to marry a woman like that, a drunkard...

Vasily spent five minutes wandering around his still unfamiliar flat, his mind whirring with imaginings of how the book shelves would look, and then he collapsed. He flattened some cardboard boxes, spread his overcoat on them and lay down, looking through the window at the street-lamp outside. The Food Worker's Cultural Centre was off to the left, but for some reason its red neon letters weren't lit. Perhaps it had shut down altogether. Truth Street was quite quiet despite being in the centre of the city. Once it had been one of the gateways to the city, the 'Lice Exchange' they called it, where they checked new arrivals for lice before letting them in.

'The dream has come true, the idiot's dream has come true,' thought Vasily gloomily. 'Tomorrow I'll take the documents off to the Registration Bureau and then I'll move in as quickly as possible. Move in, lie down and just stay here until the fever passes. For four years I prayed God to force me out onto the road of a normal life. And here it is... Soon there'll be a desk here, inviting me to lay out my papers, some books, a lamp. I'll wrap myself up in my books, in the quiet of the flat – no shrieking television, none of the aggressive din of others' lives. Their children are just like their televisions, that's why they love one as much as the other. Or I suppose they made television in the image of their children. Tantrums and showing off, yelling and screaming... They're not "yahoos"; perhaps I am worse and weaker than they? After all, they put up with me: I was the one who had to move out so I didn't destroy myself with hatred. I've had enough of destroying my eternal soul... I mustn't even attempt to describe all that in a book. I must leave it all behind, or else what I write will start to come true. No, let me spend the rest of my life writing only of happy, radiant things. Like: "He stood at the window of his luxurious apartment... and embraced the waist of his quiet young wife." Oh forget it – I'll stick to idiots and misfortune. What kind of quiet young wife will I ever get... if I get a wife at all?'

Vasily stood up, turned on the light and walked towards the window. And delicately he fingered his thoughts of the future.

The window rapped gently against the dirty window-pane. It was as if an angel whispered over his shoulder: 'Don't worry. She is there. And even if she isn't, what does it matter?'

The trees rocked rhythmically in the wind, and the yellow street-light flickered on the grey leaves.

'My nerves have gone,' thought Vasily. 'I spend my whole time either in a rage or in raptures.'

No point in churning over his 'urino-genital problems', as Rogozin had so pleasantly termed his former wife. Yes, he'd had a wife – and a young, quiet one, too. And it had been worse than the communal flat – fused every circuit in his brain.

At first it had been overwhelming happiness – such happiness that we didn't know what to do. Joy would cut me like a knife and I would cry out. And at night our conversations were whispered, sated, contented. Then came the 'explanations of our relationship', the dismantling. No doubt these explanations were inevitable; they were the exchange of experience, which means the experience of evil. And it turned out we didn't fit each other's contours, didn't flow around each other, pressing gently; instead we ossified, and grated and grated. What are happiness and love but the ability to wound deeply?

My wife had a certain elegant dazzle, a sort of superficial electricity. But within she was a shrivelled udder: for years she had squeezed herself dry of all tenderness. When a woman falls out of love, 'morals won't help you get through to her'. Not even when she's in love. But for a long time we stayed together, and she put up with me for the money. How she used to demand money and take it – and then for a moment she would chew on it contentedly, like a dog gnawing a scrap fallen by the wayside.

'What's wrong with my nerves?' Vasily shuddered again. 'I'm angry. Why am I always thinking about money? When we were at Yemelyanov's it was "how much do those shelves cost?", with Rogozin "how much did you pay for the vodka?", and now it's my wife...'

'I need to get a book or something, start reading quietly. I'll move, soon I'll move and then I'll calm down. Rogozin will help me. My nerves – it's all Rogozin's fault: sometimes his grossness goes too far. "Urino-genital problems" – he can speak for himself... I'll write a grotesque, biting novel, and call it "Rogozin": "Rogozin sat at his table and greedily read an article entitled 'Onanism: a proper form of sexual conduct'"... I know how it'll begin: "The only time he knew the tender caress of a woman's hand was when he went to the hairdresser's." Forget it – it's stupid... I'll describe a character who's constantly infuriated by other people's stupidity, who spends his whole time smirking sarcastically. Although in fact he's the one always being made a fool of, he's the loser. And he has ridiculous problems. Perhaps Rogozin has haemorrhoids from drinking too much? Yes, haemorrhoids – that's excellent. He has to stuff suppositories up himself, walks around in a foul mood, his arse damp and dirty. Then he goes and has a shit; squints suspiciously into the bowl, but there's only crap down there.'

Vasily smiled to himself. He lay down on his coat and tried to go to sleep.

He could hear the never-ending drip of water in the kitchen – enough to drink without turning the tap. But there was no sound of cars on Truth Street... no doubt there would be some during the day. Vasily got up with a jerk and began to walk around the dark room; then he went and switched on the kitchen light.

A terrible thought which had been wandering along the edge of his consciousness all day began to rap painfully: 'I haven't the slightest sense that I am actually going to live here. And will I? It's tangential – someone else's flat. What could I expect from Rogozin? Ridiculous notions, absurd adventures – that's all he's good for. And now they're starting again – with this flat, the one he set me up with. Rogozin is a crazy conceptualist, a Zen Buddhist teacher, a subconscious conductor of teleological causality... And when they cut me off from this flat it'll all be a lesson in Zen Buddhism. Because that's what's going to happen: there's too much cheating these days, too many false documents... Each of us falls into a trap for what we want most. For what is most important to us is what will cause us to perish. For some it is a woman. For Rogozin it is alcohol. And for me...?'

For a moment Vasily was soaked with fear. Standing in the doorway to the kitchen he fixed his gaze on the chipped ceiling and the dusty hob: 'this will not be mine!'

'Stop it! Enough – calm down! What's the panic? What's changed? Tomorrow at two o'clock I shall go to the Registration Bureau, they'll give me the documents and that'll be that: *my flat*... But will they give me the documents? They'll say: get out of here! Some bespectacled girl will come out, and in a quiet voice warning against hysterics will say: "your right of ownership in the property cannot be registered, since the right of ownership in the said property is already registered in the name of Mr Sidorov."'

And the words of this yet unspoken utterance branded themselves on Vasily's crazed imagination.

Why hadn't he gone to an estate agent, why hadn't he talked to the woman he knew in the trade? Why had he trusted a piece of paper? Because he was clever, and it was cheap. But it's the clever ones who fall for the cheapest tricks.

Why hadn't he bought something affordable in the outskirts? Because it was too far to get to the theatre? But he never went anyway. No, fuck it – he needed to feed on the aura of Petersburg, he needed its restless ghosts, its Queens of Spades, its Bronze Horsemen. Well, he'd got his Bronze Horseman now: 'Yevgeny shuddered. Terrible thoughts arose in him.'

Vasily tried to distract himself as best he could. He took a bath, cold and dirty, and then, teeth chattering, he dried himself. Then he ran out onto the street, up to Nevsky and along to Moscow Station. There was a crowd there, a big gloomy crowd of mankind at its most simple and kind-hearted.

A few crooks wandered around, policemen, old women chewing on cold chicken, alcoholics exhausted in noxious perspiration. The girls behind the cages of the night-time stalls were reading romantic novels, 'being got through to morally'. The figures on the electronic clock grew larger and larger: four o'clock, one minute past four, two minutes past four... Vasily ran further, back to the empty flat, looked at the flattened cardboard, and turned back onto the street again to mix with the crowd and dissolve in their uncomplicated thoughts.

At midday Vasily, having found salvation in torpor, bought some tokens at Vladimirskaya Metro and called his friend the estate agent from a telephone box. She had once refused to exchange his room for a flat – at least, she hadn't refused, but smiling pleasantly had said 'My services don't come cheap'. Vasily had taken offence and hadn't called back.

'Tanya?'

'Yeah?'

'It's me, Vasily. Have I woken you up? Have you got a couple of minutes?'

'Hi Vasenka! How are you?'

'Tanechka, I've bought a flat.'

'Well done you. So you're not as much of a mug in everyday affairs as most singers and artists. Come and have some breakfast.'

'What do you mean breakfast, Tanya? I've got to go and get my documents from the Bureau of Registration.'

'They're open until seven.'

'I'm sorry, no. But I do have a question – purely theoretical. Can they tell me that my rights of ownership can't be registered because they've already been registered to someone else?'

'Of course they can.'

'But how does that happen?'

'These days anyone can get hold of a good colour photocopy. You can print ten lots of documents and sell them ten times over.'

'But they gave me the key! I've already spent the night there!'

'And what's to stop them making ten sets of keys?'

'No, wait. I know the name and address of the man who sold me the flat...'

'He might have spent a couple of hundred dollars registering himself at some address in Kolpino – but where he is now is anyone's guess, and as for what's happened to your money... that's a purely rhetorical question.'

'So what can I do?'

'Go to court, make a private claim: I wish the court to recognise my right to the accommodation. They'll say, fine. Your claim is the hundred thousandth we've received this month, so come back in five years' time and we'll have a look at it.'

'Does that often happen?'

'When you're at the Registration Bureau, have a look in the toilets: there aren't any locks on the doors.'

'So what?'

'The head of the Bureau told me they took away the locks because it was too much trouble to remove the doors.'

'I don't get it...'

'People lock the doors in the toilets and hang themselves. So it was to stop them locking the doors.'

'Come on, Tanya, what do you mean?'

'Life is full of unseen tears. Did you buy the flat at an agency?'

'No. Are agencies safe?'

'Agencies sell their services, not unconditional security. Have you heard of 'Inter-Occidental'?'

'Yeah.'

'They were rated sixth in the whole of Russia. Then their boss Dale Corcoran, no doubt with an entirely justified sense of moral satisfaction, took all the money from the tills and went to live in Hawaii. Come and have breakfast and I'll tell you some even more amusing stories.'

'No thanks Tanya, not now – I'm out of tokens.'

Vasily hung up and looked dully at the tokens stuck to his palm. He shook his hand and set off.

The Municipal Bureau of Registration of Rights to Real Estate can't be reached by public transport. The road's not bad, and there's a car park for three hundred, but most ordinary people walk in terror along the edge of the road or on the swollen earth. It sets the mood.

There's a big black anchor lying by the entrance. The sea isn't far off, behind a scattering of barrack buildings and a black pond. A lot of people always hang around the anchor smoking, and Vasily stood among them.

He spent ten minutes knocking around in the hall, and then got into line. It was like Moscow Station, only cleaner. A stone floor, electric daylight, silent people. Pure Buchenwald. A big notice board saying 'Information' and a scattering of signs that read 'Xerox'. Xerox: it sounded like the slash of metal; would have been a good name for the guillotine.

The autumn sunshine was setting on the polluted shore, and a mournful metallic clanging wafted across from the gulf. The children of people registering their rights in real estate were playing on the huge slimy anchor, climbing up onto it and then banging it with their spades. Vasily clenched the key in his pocket and smiled dreamily. 'The flat is still mine,' he thought. 'And while the flat was mine, happiness was mine.'

He remembered an amazing TV programme he had watched, about an eight-year-old Australian girl with AIDS. She was a thin little thing with crutches, and it was clear she wasn't long for this world: there were already some tubes on her face, some kind of permanent drip. Her father took her to the ballet – she had dreamed of becoming a ballerina, but had never even been to the ballet. And here she was with her father, happy, sitting in the empty auditorium, while up on stage they were performing some wonderful ballet, especially for her. Then they took her off to the make-up room and dressed her up like a princess, and she came out on to the stage, stooping over her crutches, as one of the soloists began to dance with her.

The most hardened misanthrope would have shed a tear for that girl, so carefully decked out. 'But what about me? – even my own eyes are dry. What an utterly unremarkable story mine is – from first lines to the moment it gets chucked out with the garbage: I just didn't fit the times. And why should I? These times didn't deserve me. It's the end of history and it stinks... when even murder's only worth doing if there's money involved.'

Vasily squinted in the sunlight.

'...The end of history is round the corner – and I've only got ten minutes left. No, less: in five minutes "the wolf will break free from the enchanted trap and will devour the sun, while across the seas will sail a ship made of the fingernails of the gods."... I wonder where that wolf came from. "The Song of the Nibelung"? So beautiful, and I can't even remember it...'

He went back inside. There was only one person left between him and the little window. Vasily stood behind him in tense concentration.

'It can't be "The Song of the Nibelung" – it's nothing like it. Something modern perhaps – a parody? I hope not... I know: it's from "Edda Saemundar"! That's it!'

The back turned and Vasily found himself face to face with window 22, Inspector Liudmila Ivanovna Plugatyreva.

'Oh Lord, do not judge me. My kingdom come,' thought Vasily.

'First name, patronymic, surname?' asked the woman, adjusting her glasses.

Briefly Vasily thought again: 'No; Thy will be done, not mine.'

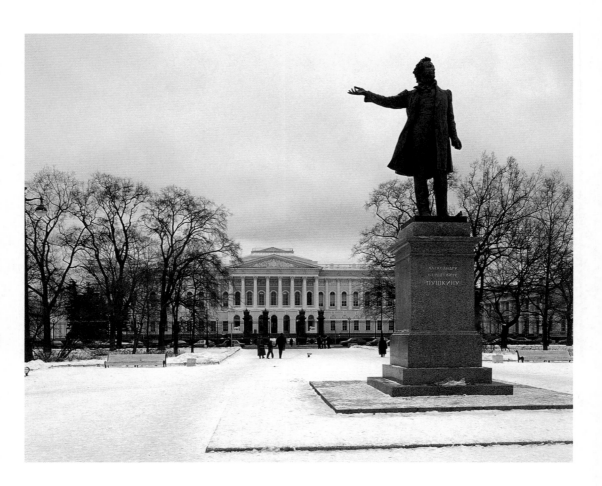

Mikhail Anikushin's statue of
Pushkin stands on Arts Square
in front of the Russian Museum

Pushkin's Letter

'Farewell, friends'
(A. S. Pushkin's words on his deathbed to the books in his study)

It was already dark, and the roar from Nevsky Prospect was muffled by the wind thudding at the windows. On the third floor of the National Library of Russia, amidst the shadowy stacks of books, only a few pools of light still shone on the desks of St Petersburg's scholars of the humanities. Now even these were extinguished one by one, with sighs and rustling of paper. The limping historian, the art critic whose frailty belied a fierce will, and the huge, soft, sad-faced linguist – all in some way marked physically by their career of intellectual exploration – slowly packed up and went home, without enthusiasm.

By eight o'clock only one lamp was still lit. Yevgeny Polyakov, the eminent bibliographer and author of a number of works on printing and binding in nineteenth-century Russia, nodded to his colleagues as they left. Then, humming tunelessly, he picked up a volume bound in green leather. He ran his fingers over the inlaid medallion in the centre of the front cover. Holding the book up under the light, he inspected the gilt spine. The back cover, with its gilt border, caused him some anxiety: was there slight rubbing to the corners? Polyakov examined it, turning it this way and that under the light. At length, however, he harrumphed and took up his pen.

'Pushkin, Aleksandr Sergeevich,' he wrote. 'Collected Poems, 1837. Includes the first complete publication of "The Bronze Horseman". A magnificent copy re-bound in a presentation binding by the owner, Pushkin's friend A. N. Vulf, in olive-green morocco, with a gilt and enamel portrait medallion of the author inlaid in the upper cover. Gilt borders, gilt spine. Marbled endpapers, with, pasted to the inside front cover, a letter dated 10 December 1833 from Pushkin to Vulf, soon after he finished writing "The Bronze Horseman". Very fine condition.'

A more tender bibliographical homage could barely be imagined. Polyakov was a big, battered-looking figure; in his youth his great forearm had wrestled many another student's to the table. But physical exertion did not interest him. He had devoted his life to the study of books, towards which he felt a reverence that made the young library assistants giggle. To see this huge slab of a man bending delicately over a pamphlet, brushing it with fingers like pork chops and murmuring 'What a delight!', sent them scuttling into the stack with their hands over their mouths. But Polyakov, who was pleased to see

people laugh even if he didn't quite know why, would call them back and in his gentle way point out its beauty.

Lately, however, something had changed in dear Yevgeny Gavrilovich. His colleagues whispered anxiously about him as they smoked in the stairwell. It was understandable, of course, that the exhibition he was organising would agitate him a little. Years ago, under Brezhnev, a display of the Library's treasures for a group of international scholars had been Polyakov's dream, and even in the decade since perestroika began he had not received more than a handful of foreign visitors.

'You remember how emotional he used to be when he received a letter from the scholar working in the British Library?' the head of the Manuscript Department said to her assistant as she lit up an American Express cigarette.

'The whole Library knew about it,' the assistant agreed. 'But now he looks haggard. That's not the exhibition.'

'No.'

They knew why it was that Polyakov these days was losing weight, why the frown lines cut deeper into his forehead and he did not linger to chat by the card catalogue as he used to. Yet a sort of superstitious horror stopped them from naming it. Even the cloakroom attendant, furious at Polyakov's long hours, only hinted at it. She waddled forward with his coat and scarf and hissed, 'Too late! Nine o'clock, and your poor wife at home – '

All the ride home on the trolley bus, Polyakov peered out at the dark, shabby buildings, the Soviet-style signs with letters missing, and the occasional brand-new shop front, spilling its sterile light onto the streets. He thought about his catalogue, the visitors arriving from all over the world to see the exhibition, the sensation very close to love of discovering others who understood his work, who loved books, the loneliness of the pre-perestroika years of his youth, of those times spent reading catalogues of libraries he would never be able to visit, and the slow disillusionment of the post-Soviet years, the decaying city around him, the creeping sense of being stranded, cut off, irrelevant, useless. And at the same time in some other part of his brain he thought about his wife, his beloved Galya, who at this moment lay at home like a literary heroine, coughing tubercular phlegm into a handkerchief.

From the door of his apartment, Polyakov could hear Andrusha's booming tones.

'Yes, I spoke out at the committee meeting, I told them: we are doing the Lord's work. No effort is wasted that magnifies the Lord. They agreed with me – '

Polyakov exchanged his shoes for slippers in the dusty hallway and wondered when his son had started to speak like a minor bureaucrat. Only a year ago, Andrusha's voice was not fully broken and he'd laugh shyly when he managed a whole gruff sentence. Now he sat in the kitchen, spooning soup into his mouth and talking about God. Galya was lying on the narrow divan by the window where she rested during the day.

'Hello, darling,' she said as he entered. 'I'm hearing about Andrusha's difficulties with the church committee.' And as he bent over to kiss her she gave him a quick, complicitous smile. They both struggled to sympathise with their son's new-found Orthodoxy.

'It's dangerous on the streets these days, you know, Papa,' Andrusha reproached him. 'You shouldn't come home so late and alone.'

'I'm sorry, I was finishing the text for the exhibition catalogue, it needs to go to the printers' tomorrow – '

'Well, thank God you're safe!' Andrusha crossed himself. 'I've told you before, you must ring me from the library and I will accompany you home.'

Polyakov suppressed a rush of irritation. 'Thank you, Andrusha, but I think I can manage. How was the hospital today?' He turned to Galina. 'Did they have the results?'

'Yes.' Galina hesitated. 'Come and sit down. I'm afraid it wasn't entirely good news – '

'But, Mama, you didn't tell me!'

'I thought I'd wait until your father was here too.' She looked exhausted. 'Apparently there's a strain of tuberculosis that has developed a resistance to the medicine I've been taking. The doctor tells me it evolved because of the shortages. Doctors don't want to send their patients away with nothing, you see. They always try to give their patients some drugs, even if they don't have the full course ... that's what makes the germs resistant. There's something quite touching about it, don't you think?'

'And you've got it?' Polyakov ignored her last remark.

'There are other antibiotics they can give me, but they are so expensive – '

'Oh, Mama.' Andrusha had gone pale. He flung himself onto his knees. 'Let's say a prayer. Almighty God, who with unfailing mercy heals the sick, hear us now ...'

Polyakov, kneeling awkwardly, tried to think about what his wife had just told him.

'... we, your children, trust in Thee,' Andrusha was saying. 'Thy will be done. In the name of the Father, the Son and the Holy Ghost, Amen.'

'This isn't about God,' muttered Polyakov. 'This is about money, that's all. It's about this damp flat and no holidays and bad food, don't you see?'

Andrusha did not answer.

'Forgive me,' Polyakov said. He went out into the corridor and pounded the coats hanging on the wall, silently. After a while Galina's voice, the pale remains of Galina's voice, reached him.

'Are there beautiful things in your exhibition?'

Polyakov breathed deeply and unclenched his fists. Then he returned to the kitchen and sat down beside his wife, taking her thin little hand in his. 'Beautiful,' he replied. 'We've got the Book of Hours, we'll have that open at "December" – do you remember?'

'Of course – '

'... and a couple more manuscripts, and some spectacular maps.'

Galina and he had always preferred to talk about ideas, the whirring world of the mind that they had inhabited together for almost thirty years. As Polyakov set off on his description, he was aware that his eyes were filling with tears, but after a time both he and his wife were too involved in their conversation to cry.

The clinic was full of the patients and their relations, who sat, as did the Polyakovs, in dazed silence. They looked like the survivors of a flood: some in dressing-gowns, some in coats, clutching whatever they had grabbed when the disaster had driven them from their homes and into this cold and dangerous place. Polyakov held a copy of the exhibition catalogue, just back from the printers'. At home, Andrusha was helping a Swiss bookseller pack up the contents of his father's bookcases. The collection of Leskov that he had begun as a student. The first edition of Turgenev that he had discovered in Yalta and had given to Galya on their first wedding anniversary. Even his reference books were going: he would have to use the library copies. Empty shelves, thought Polyakov, how I used to long for just one or two ... In the inner pocket of his coat was a lump that pressed against his chest: three thousand dollars. The Swiss bookseller, a shark who happened to be on a short trip to St Petersburg, would sell them on for triple the price – yet what else could he do in such a hurry? He didn't regret it at all. But he was a little alarmed at how light he felt, how hollow, scoured out. The catalogue was his anchor: it would keep him from being swept away.

'I hope Andrusha is handling them carefully,' Polyakov turned to Galina. 'He is sometimes rather rough with books.'

'Of course he's taking the greatest care,' murmured Galina.

'He isn't always very gentle with the spines when he is reading. I've seen him lean on an open book and crack the spine completely.'

Her faint smile shamed him. 'Of course, it's not important.'

At last they were called in to see the doctor. He was writing notes and flapped his hand at them to sit. Greyish-black damp bloomed on the wall above his head and along the skirting board. Polyakov noticed that the furniture stood a metre away from the walls; probably the floor was rotten around the edges as well.

'This room was repainted only six months ago,' said the doctor, following Polyakov's eyes. 'The mould has eaten right into the fabric of the building. It's impossible to get rid of it.'

'But isn't it unhealthy?'

The doctor sighed. 'We do the best we can. It's the same all over the city. We're living on a swamp in St Petersburg, as you know. Now, Galina Aleksandrovna, here is the prescription for the drugs you will need. It is a two-year course, and I must tell you that these antibiotics can cause serious side effects, rather like chemotherapy. Therefore we have to monitor you closely. These drugs, as you know, cost in the region of six thousand dollars. I believe you have brought an initial payment?'

Polyakov showed no sign of hearing. His eyes were still fixed on the mould. 'Can't mould spores cause all sorts of infections?' he interrupted, leaning forward.

'Excuse me, I'm just – '

'Listen, I've raised three thousand dollars. You realise that this is not easy for a librarian. Now we have to conjure up another three. Do you think I am a magician?'

'I understand.' The doctor's voice softened. 'It's hard. But you were told the price already, weren't you?'

'Yes, we were told,' Polyakov said bitterly. 'But how are we to pay it?' He stood up and yanked Galya's arm, fury exaggerating his movements. 'Come on, Galya. Let's go home. This place isn't healthy.'

Outside the clinic they collapsed on a bench. Galya was grey-faced and sweat stood out on her forehead: Polyakov had dragged her along the corridor almost at a run. Now her thick, painful cough possessed her, like an engine struggling into life. Polyakov put his arm around her and waited. The wind was whipping the last leaves off the rowan trees and piling them in soggy drifts. Not far from their bench a silver Mercedes drew up and a woman stepped out of the back seat. Wrapping her coat around her, she picked her way through the mud in a pair of stiletto-heeled boots, just the colour, Polyakov noticed, of a green morocco binding.

'With profound sentiment I received the letter from your organisation suggesting a visit to our National Library here in St Petersburg. It is an honour and a pleasure to receive experts on the Book from so many different countries ...' The Director hesitated. He was losing his audience. The bibliophiles had noticed the exhibition laid out in glass cabinets and, almost without taking their serious, attentive eyes from him, were drifting towards them.

The Director took a breath and spoke more loudly. 'Our Library holds a total of three million volumes, including those in our stores outside the city. We are a copyright library ...' The visitors were on the whole elderly, but determined; as they spotted objects of interest in the heaped and piled shelves, they tottered into the stack and disappeared.

'Please! Wait here your guided tour!' hissed the assistant librarian. But they waved her aside, pretending they didn't understand. As the Director's oration rolled on, Polyakov watched, faintly amused, as a professor vanished, followed by pair of women in tweed suits and a gentleman walking with two sticks.

At last the Director gave in to *force majeure*. 'In conclusion, we hope that our exhibition will please you. Welcome to our Library!' he finished. The remnants of his audience gave a perfunctory round of applause and fell upon the exhibition.

Polyakov wandered from case to case, avoiding eye-contact with the visitors. Everything seemed brightly and minutely lit; he could view the world in vivid detail, he could even hear the people's conversations, their laughter, although it was a little muffled and hard to understand. But he was apart from them, in a place with little colour, a place that was possibly even hidden from their sight. They were craning at the books in his exhibition, consulting his catalogue and letting out exclamations of delight and surprise. But Polyakov did not respond.

He had slept little lately. It was a month since Galina had begun the treatment and Polyakov could not have imagined such fierce medicine. She was thinner than ever, nauseous, with great bags under her eyes. During the night he listened to her cough and thought about the strange power of money. As the grey-yellow dawn lit up their bedroom he ran through his friends and acquaintances in his mind. None of them would have that amount to lend.

'Yevgeny Gavrilovich!' The Head of the Manuscript Department rushed up behind him. 'Oh – excuse me, I didn't mean to disturb you – ' She was shocked by his expression, he saw. 'It's just that one of our guests is very keen to meet you.'

A short, red-faced man with tightly curled fair hair pushed forward. 'My

name is Andreas de Hartmann, I am delighted to make your acquaintance. Probably you have heard of my collection? It is one of the finest of nineteenth-century Russian and East European literature; I have recently finished building an extension to my library in Hamburg to house my manuscripts alone – '

Everything about Andreas de Hartmann was small and bursting with vitality: his face glowed, he was constantly waving his little arms and jumping from foot to foot. As Polyakov led him to the beginning of the exhibition, he felt the collector suck away his last, shallow reserves of energy.

'I have many of these!' he cried at the sight of the illuminated manuscripts. He had many maps as well, and many examples of early printing. Polyakov was running out of patience when they arrived at *The Bronze Horseman*, and de Hartmann fell silent. He stared at the book through the glass and his rosy cheeks became slack. After a minute he turned to Polyakov.

'Can you get it out of the case? I'd like to handle it.'

'Of course.'

Polyakov laid it on top of the glass and watched as de Hartmann ran his fingers gently over the binding.

'What a beautiful thing,' he breathed. 'And how fascinating.' De Hartmann looked at the letter pasted to the inside front cover. 'Would you mind reading it to me?' he asked, suddenly diffident. 'I find this handwriting difficult.'

'Yes, indeed.' It was a letter to Pushkin's old friend, Vulf: 'I am applying for permission to publish my ode to the Imperial city, which I am afraid will have problems with the censorship. If it were not quite the best thing I have written, I would be depressed, for money, as usual, torments me ... I long to spit on St Petersburg, retire, scamper off to Boldino and live there like a lord...' He hesitated; he had a lump in his throat.

'What a marvellous thing.' De Hartmann took the book back and began to leaf through the pages. After some minutes he handed it back and Polyakov caught the expression in his eyes. There was something lustful and single-minded there that Polyakov thought he recognised. He could not, however, be sure.

The guests did not stay long at the exhibition. They were led away to the University Library, and Polyakov went back to work, fingering Andreas De Hartmann's card in his pocket. The sensation of hollowness inside him had grown until he seemed to be only a paper shell, as light as leaves. Three thousand dollars would be enough for Galya, and then he would work out how to live with what he had done.

That evening, when the wind boomed at the windows and his colleagues slowly packed up their papers, Polyakov stayed on, writing up a report of the exhibition. Beside him were a few of the exhibits which he referred to from time to time.

'I see you keep the valuable ones beside you,' said the art historian, shuffling past.

'That's right, wouldn't want any harm to come to them,' replied Polyakov. 'Goodnight.'

When he was alone, Polyakov took the copy of *The Bronze Horseman* from the pile. He stared hard at the medallion with its portrait of the author: this

young man with too much curly hair, plump cheeks and liquid eyes. 'Would he understand?' thought Polyakov and instantly, scornfully, dismissed the question.

He opened the front cover. The letter was pasted onto the inside cover with crumbling, ancient glue. A corner was already loose. Polyakov took a small knife from his pocket. He tested the blade against his thumb. The Library was quiet. The knife sliced through the glue with a cracking noise that he would not forget.

Polyakov laid the letter between several pages of blotting paper and placed it in the lining of his jacket. Then he returned the Pushkin to its place in the stack. With a little luck, it would be several months, perhaps years, before it was consulted again. And by then, nothing would matter.

Before he left the building, Polyakov made a call from the public telephone. 'Mr de Hartmann, I so enjoyed meeting you today. I wondered, could I come and pay you a quick visit?'

'Indeed!' de Hartmann was effusive. 'It would be a pleasure – you would definitely enjoy the catalogue of my library that I have with me – '

'And I, too, have something that may interest you.'

'I look forward to it! Shall we meet in the hotel bar at nine o'clock?'

'No, no, I may be a little late. I would prefer to collect you from your room.'

De Hartmann was still agreeing enthusiastically as Polyakov pushed the disconnect button. He dialled his home telephone number.

'Oh, Papa, thank God. We've been waiting,' said Andrusha. He sounded scared.

'How are you both?'

'You must come home. Mama's not well, the doctor says her liver has collapsed – '

'Get the doctor. Get whatever she needs. Don't worry about money. I'll be back soon, do you understand?'

The street was full of black, ice-edged wind that sliced around the corners. Polyakov hurried up Nevsky Prospect, past the mausoleum columns of the Kazan Cathedral. People were gazing in the new, glittering shops with their backs to the weather. Polyakov, despite his bulk, slipped between them as though he were invisible.

In the lift of the Astoria Hotel his hand was shaking so much that he could barely press the fourth-floor button. It was possible, of course, that de Hartmann would simply call the police.

The collector beamed as he opened the door. 'Come in! A glass of whisky? Or vodka? And something to eat – '

'I have the thing you wanted,' Polyakov blurted as the door clicked shut.

'Wanted? What did I want?'

Polyakov laid the folder on the desk. 'Open it.'

De Hartmann turned back the blotting paper. His plump shoulders gave an involuntary shudder when he saw the letter. 'I never asked you for this!'

'I could not take the whole book out.'

'I never asked you for any of it! And now you have cut out the letter! Defaced an object of great beauty!' De Hartmann was lit up with rage, quivering all over. 'How can you have thought that I – '

'The letter itself is undamaged,' muttered Polyakov, eyes lowered.

'But you have removed it from its proper place. That's destruction

enough,' spat De Hartmann. 'You fool. You must take it away instantly.'

'But listen, I'm desperate. My wife – '

'It's no excuse!'

They sat in silence for a long moment. Then de Hartmann nodded and turned to Polyakov with a look of settled contempt. For the first time, the little German was absolutely still. 'On second thoughts, perhaps you had better tell me why you have committed this crime.'

De Hartmann's expression did not alter as Polyakov told him; all his energy seemed suddenly to have evaporated. Treading heavily, he left the room, patting his jacket pocket to check for his wallet. Fifteen minutes later he returned with a roll of dollars that he thrust roughly into Yevgeny's hand.

'Take them, go, before I change my mind,' he muttered. 'I wish your wife well.' He folded the letter back into the blotting paper and handed it back to Polyakov. 'And, because I have respected you for so long, I will trust you to return this to its proper place. Only never contact me again, do you understand? I want nothing more to do with you.'

In the toilets of the Astoria Hotel, Polyakov locked himself into a cubicle and counted the money: two thousand dollars. Almost enough. He ran to catch the bus, and ran from his stop all the way to his apartment. He stood in the hall, gasping for breath, while the doctor hurried towards him.

'Zhenya,' said the doctor, and the pity in his voice made Polyakov suddenly nauseous. 'I'm glad you've arrived. You must go in and see her. But it's bad news. I'm afraid the drugs have caused liver failure. I'm so sorry. It is always a possibility when the treatment is so toxic, but we considered the risk was justified – '

'But – ' Polyakov interrupted. 'I've got the money now, for almost the whole course.'

'Oh, Zhenya.' The doctor paused, then led Polyakov into the bedroom. Galina seemed to be sleeping. Her face was flushed and now and again a cough, beginning deep in her chest, shook her whole body. She did not wake.

'Surely you can do something!'

'They can't,' said Andrusha. 'Papa, we've been waiting for you.'

In the small hours of the morning, Galina seemed to be struggling to say something. They caught a murmur: 'Both of you ...' Soon afterwards she sank into a deep coma that lasted four days. On the fifth day, she died.

In the National Library, they clubbed together to buy flowers for Yevgeny Polyakov's wife. A number of his colleagues came to the funeral and laid the huge spray of white carnations on the coffin. Polyakov had not yet been back into the Library, but the Head of the Manuscript Department reported to her assistant on his stark pallor, his dignity. He had great courage, they agreed. He was the sort of person who would behave well even in a situation like that. The Director of the Library had given him more or less indefinite leave, but they were sure he'd be back at his desk soon. In this, however, they were wrong. The weeks went past and Polyakov did not reappear.

He remained in his apartment. In the early hours of the morning he would be driven out of bed by his thoughts; visions of De Hartmann, the doctor's mouldy walls, and lines from *The Bronze Horseman* chased him from hall to bedroom to kitchen:

> Alas! His mind was so hard pressed
> It could not stand the awful rigour
> Of all these shocks ...

Andrusha was scared. 'Papa,' he pleaded with him as the weeks passed. 'Come with me to church?'

Polyakov did not answer. At last, one night in March, he drank down a bottle of vodka and went out onto the streets. His big, muscly body was slack and his arms swung loose. He wandered until he found a bar, where he drank more vodka. Later he found himself on the street with a bloody nose. It was drizzling and dark, and he had no idea where he was. He searched for a place that he could recognise, but the whole city was strange to him. He began to cry. Then he slid against a doorway and fell asleep.

When he woke, the streets were already busy. He began to walk, still only half-conscious. He was near the centre; in a few minutes he turned onto Nevsky Prospect and made his way through the hurrying commuters. After a hundred yards or so he turned left again, into a courtyard. The entrance of the National Library of Russia was ahead of him. It took all his strength to push open the door; he stopped to regain his breath. Then he climbed the stairs to the third floor.

It was early; he was the only one there. Slowly he found his way through the stack, with its teetering, dusty shelves, its pieces of occasional furniture piled high with books, its files of pamphlets bursting open, crushed against one another. In the Pushkin section he passed the long drab shelves of *Collected Works*, the commentaries and translations. Finally he found the 1839 edition of *The Bronze Horseman*.

Looking about him, Polyakov took Pushkin's letter from a notebook in his jacket. He laid it back inside the front cover and turned the book over to examine the binding. The olive green leather glowed in the dusty sunlight, and Polyakov, with a sense of unutterable relief, breathed in the crumbling, leathery smell of the library, unchanged, indifferent, and welcoming. All around him the shelves creaked and sighed, as though the three million volumes in the National Library of Russia's possession were jostling to be read. Polyakov slid *The Bronze Horseman* back into its place, sat down and leant his head very carefully against the books behind him. For the first time since Galya's death, he was not alone. He closed his eyes and slept.

>
Crosses in the Smolensk Orthodox Cemetery
on Vasilevsky Island

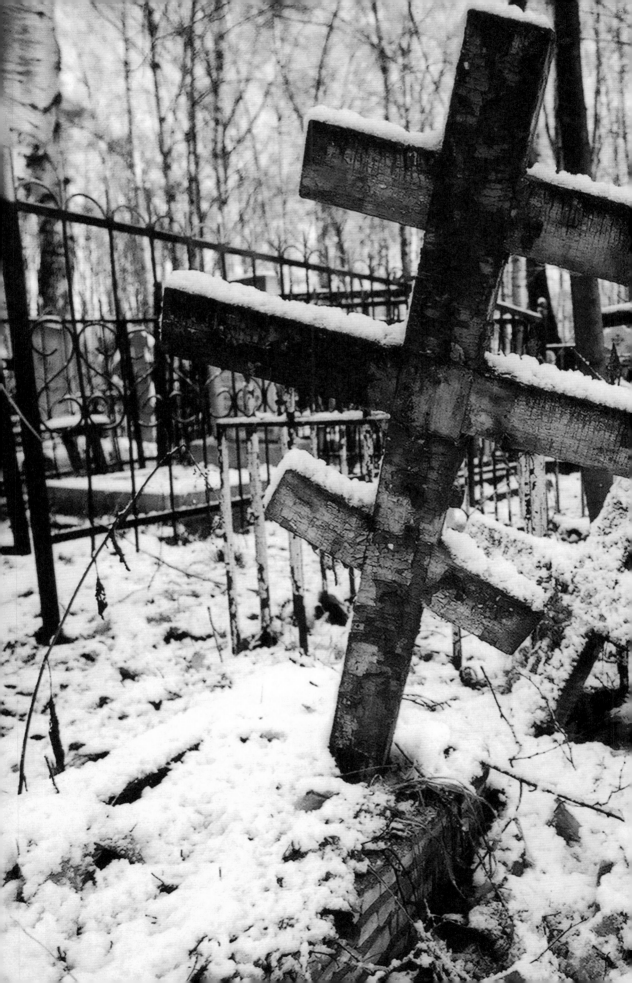

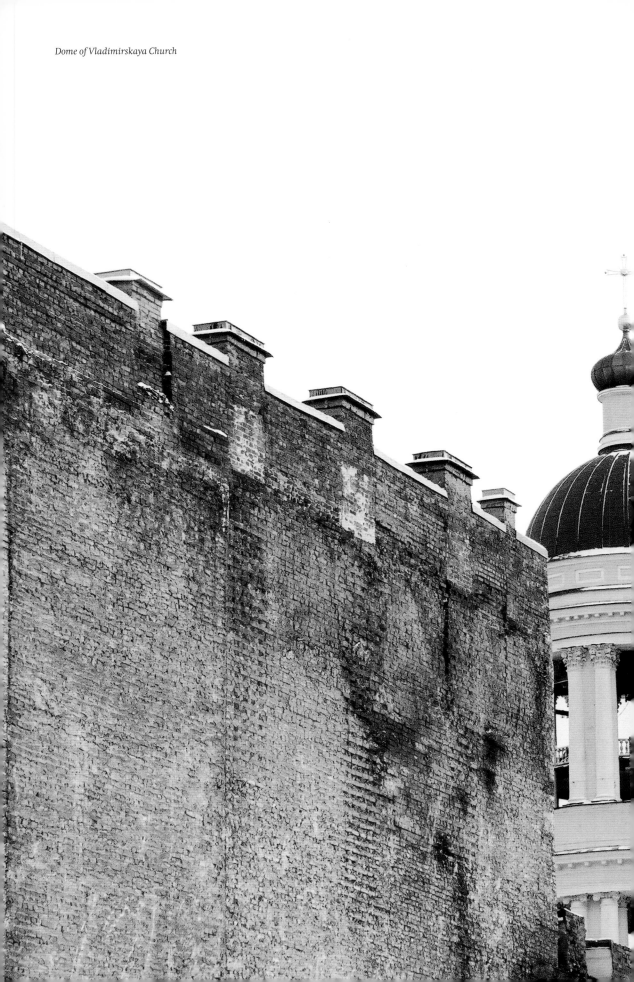

Dome of Vladimirskaya Church

And never more shall we recall,
In this wild citadel confined,
The lakes, the steppes, the cityscapes
And dawns of our great motherland.

From day to night in bloody circle
A brutal listlessness consumes us...
And no one wanted help to come
To those of us who stayed at home;

Who loved our native city more
Than winged liberty's temptation;
Who chose to safeguard for ourselves
Its palaces, its fire and water.

Another time is drawing near,
Our hearts now blown by death's lament,
But Peter's sacred town will be,
Unwittingly, our monument.

Anna Akhmatova, 'Petrograd 1919'

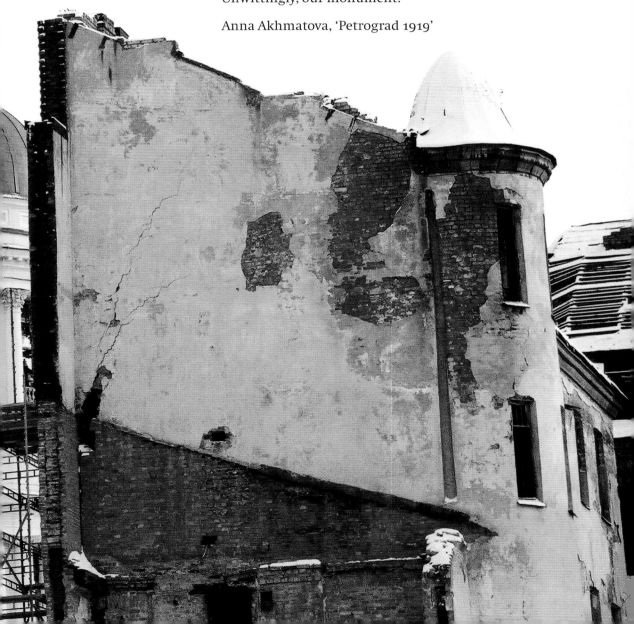

Headstone of Andrei Voronikhin,
architect of Kazan Cathedral

Kazan Cathedral

In October 1800 a number of foreign architects, including Charles Cameron and Pietro di Gonzago, entered the competition to design a new cathedral near Nevsky Prospect. Its inspiration – St Peter's in Rome – would suggest that it was indeed designed by one of Petersburg's favoured foreigners. In fact, the commission for the Kazan Cathedral went to Andrei Voronikhin, who only ten years before had lived as a serf of Count Stroganov. Completed in 1811 and dedicated to the icon of Our Lady of Kazan, which it once housed, the cathedral quickly acquired a central role in Russia's ceremonial life. A *Te Deum* marking the deliverance of Moscow from the

French in 1812 was followed the next year by the state funeral of the man behind Napoleon's defeat, Marshal Kutuzov, and just over a decade later that of the victorious emperor himself, Alexander I.

For all its imperial connections, however, the Kazan Cathedral owes its construction to humbler origins. In the words of a visiting foreigner, it was built by 'simple *muzhiks* in torn sheep-skin coats who did not need to rely on instruments of measurement'. The Corinthian columns of the cathedral's north-facing colonnade were the work of Samson Sukhanov, a peasant from Vologda province, whose parents were so poor they were forced to seek alms.

Sukhanov fashioned the columns from Pudost stone, quarried from the village of Pudost not far from Gatchina. The Decembrist Nikolai Bestuzhev wrote of Sukhanov: 'We seek wonders in foreign climes... and yet we walk past these miraculous columns with just an idle display of curiosity'. Such praise, however, did not last long. As tastes changed and the neo-classical style went out of fashion, so Sukhanov's commissions began to peter out, and his life ended as it had begun: in penury.

>
Colonnade of Kazan Cathedral

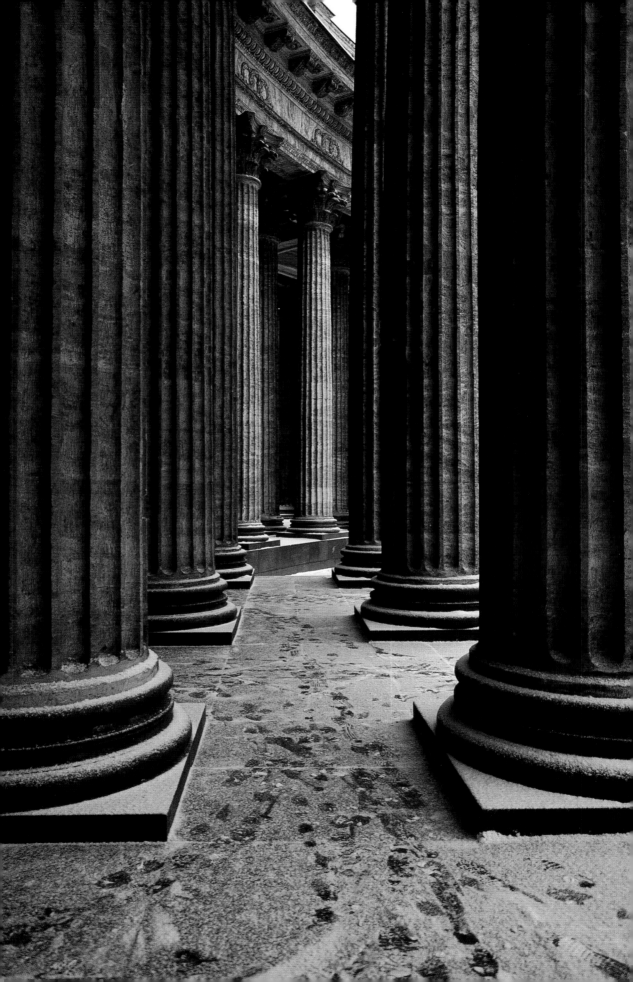

Monument to the
Heroic Defenders of Leningrad

Germany declared war on the Soviet
Union on 22 June 1941, and within
two and a half months the German
army had occupied the southern
approaches to Leningrad. By early
September, with nearly three million
people still inside the city, Leningrad
was completely surrounded, and the

siege (or *blokada*, as it is known in
Russian) had begun. During the siege
the only link to the outside world was
along the so-called 'Road of Life', a
supply route which ran across the
frozen waters of Lake Ladoga during
the winter months. Hunger and cold
were the truly implacable killers: the

first winter was particularly severe,
and in January and February 1942
alone 200,000 people died. The siege
was first broken in January 1943, but
only lifted completely on 27 January
1944. Almost 900 days of unimagin-
able horror and hardship had left at
least 641,000 people dead (with some

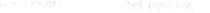

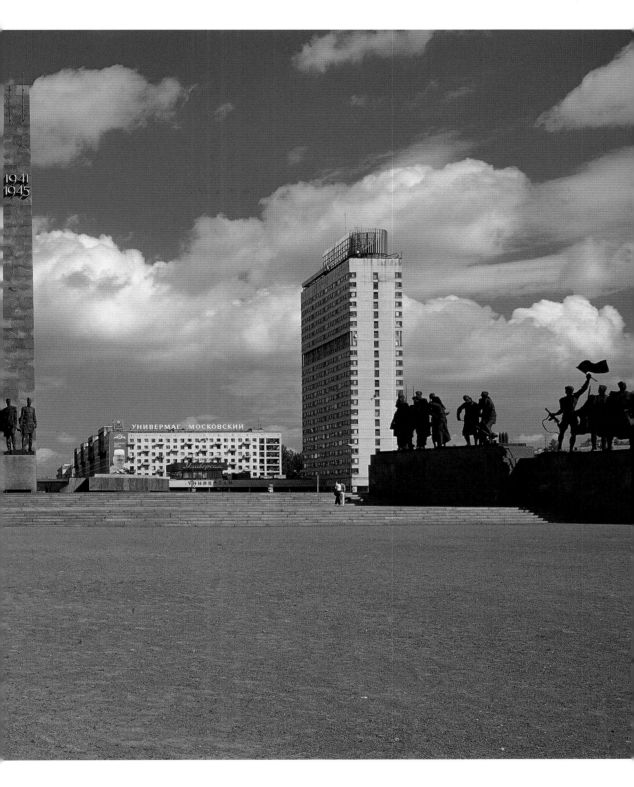

estimates putting this figure as high
as 800,000).

The Monument to the Heroic
Defenders of Leningrad on Victory
Square was designed by Sergei
Speransky and Valentin Kamensky
and unveiled in 1975 on the thirtieth
anniversary of the end of the war.

Mikhail Anikushin's heroic sculp-
tures of soldiers, sailors and grieving
mothers surround a huge circular
enclosure representing the besieged
city, while in the memorial hall
beneath, the beat of a metronome –
the wartime radio signal – symbolises
the city's defiant heartbeat.

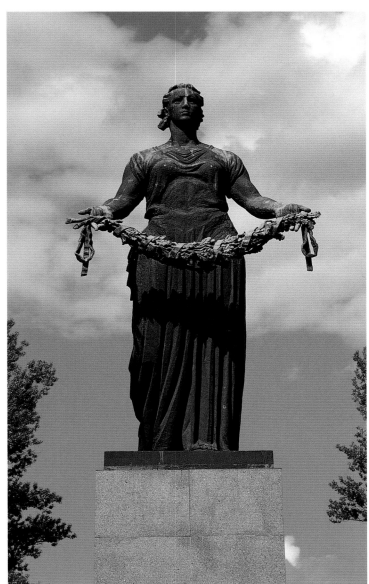

Sculptural group on the Monument to the Heroic Defenders of Leningrad

Statue of Mother Russia, Piskaryovskoe Cemetery

The grieving statue of Mother Russia towers above the city's largest memorial cemetery, where around 470,000 citizens and 100,000 soldiers were buried in communal graves (in Russian *bratskie*, literally 'fraternal', graves). The raised mounds are marked only by year, a bleak reminder of the sheer scale of mortality. Almost every family in Leningrad lost at least one of its members. Relatives and visitors to the city come to honour the dead year-round, but especially on three days: 8 September, the day the siege began; 27 January, the day it was lifted; and 9 May, Victory Day.

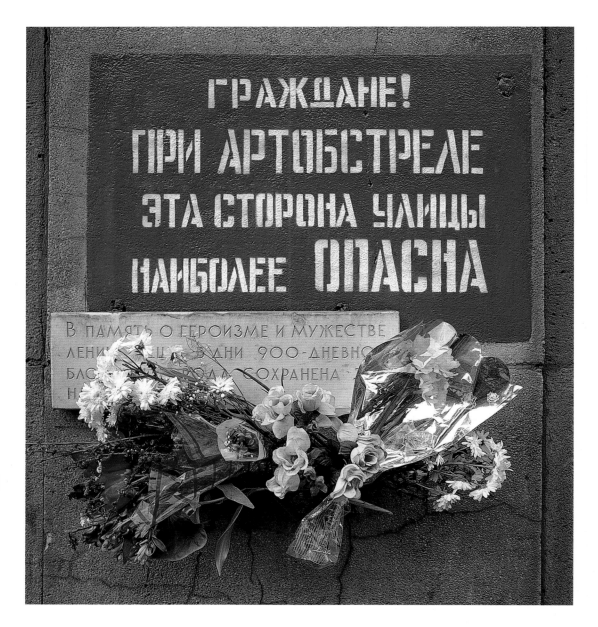

Memorial Plaque
to the Siege of Leningrad

Some 17,000 people were killed by aerial bombardment during the siege. The plaque, on the north side of Nevsky Prospect, reads: 'Citizens! During artillery bombardment this is the most dangerous side of the street.' Through those months and years of endless suffering, encouragement often came from unexpected quarters. Olga Berggolts was a young Leningrad poet who spent the blockade living in Radio House on Rakova street, from where she broadcast almost daily on Leningrad radio. Fyodor Abramov, a fellow-writer, described the effect of hearing her read her poetry over the loud-speakers positioned around the city: 'And then in those hours of terrible solitude, above the head of the *blokadnik* the sound of a live, human voice would suddenly resound from the frozen loudspeakers, shaggy with hoarfrost. And then a miracle happened: through the strength of her words the hopelessly sick, the exhausted and the dying would be resurrected to life. Her verses helped us to die with dignity.'

Cathedral of the Assumption
of the Blessed Virgin Mary
on Malaya Okhta

The Cathedral of the Assumption stands on the site of the old Petersburg Cemetery in Malaya Okhta, where mass burials took place during the siege of Leningrad. It was consecrated on 8 September 2001, the sixtieth anniversary of the beginning of the siege. The cathedral was built without state funding, and its 8,000 bricks are inscribed with the names of private donors, many of them descendants of victims of the siege.

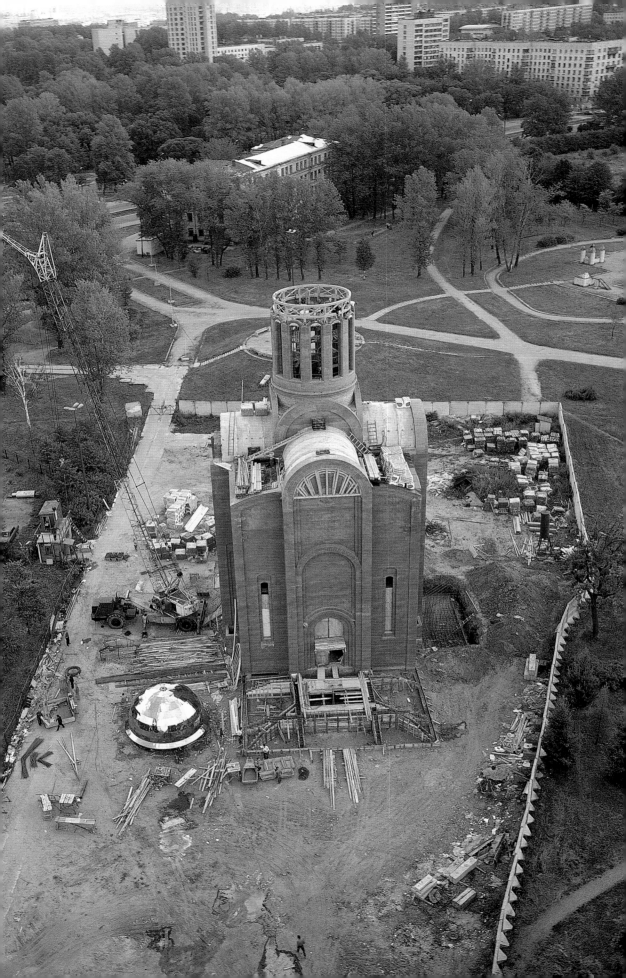

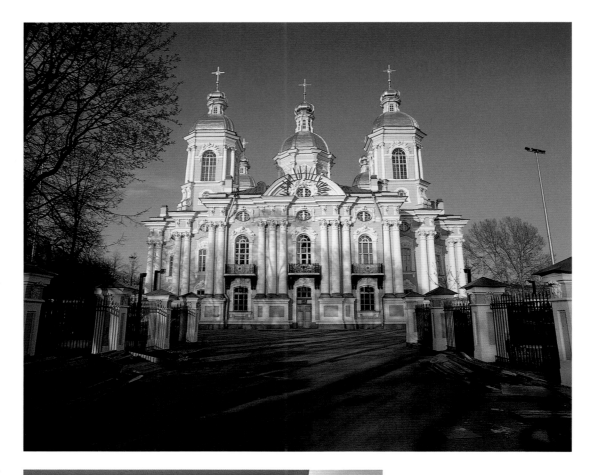

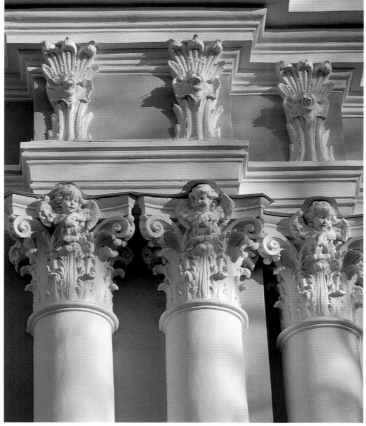

Cathedral of St Nicholas

The Cathedral of St Nicholas was built between 1753 and 1762; it was named after the patron saint of sailors, many of whom used to live in the area near the Kryukov and Griboedov canals where the cathedral stands. It was designed by Savva Chevakinsky according to the classic Greek cruciform plan, with a central cupola and a turret at each corner surmounted by onion domes. Inside there are two churches: the lower 'winter' church lit by icon lamps, candles and chandeliers for daily worship, and the naturally lit, typically baroque upper church which is used on Sundays and for festivals. The cathedral was one of the few places of worship not to be closed during the Soviet era.

**Detail from the Church
of the Holy Mother of Kazan,
the Convent of the Resurrection**

The original Convent of the
Resurrection was founded by the
Empress Elizabeth for her retirement.
The empress commissioned her
favourite architect, Bartolomeo
Rastrelli, to design the ensemble,
which came to be known as Smolny.
Elizabeth did not live to see Smolny
completed (nor, indeed, did Rastrelli),
and in 1830 the Convent of the
Resurrection moved to Vasilevsky
Island. In 1845, by order of Nicholas I,
a new site was found to the south of
the city on Zabalkansky Prospect (now
Moscow Prospect). Construction of the
new convent buildings began in 1848
under the architect Dmitry Yefimov,
and various additions were made over

the next half-century,
culminating in a gold-domed bell-
tower erected in 1908. Today the
monastery façade presents a rather
dour sight: the bell-tower has gone
and the original entrance church, its
five gold cupolas lopped off, is flanked
by anonymous walls. Inside the
grounds, however, the Church of the
Holy Mother of Kazan, richly deco-
rated with majolica, intricate carvings
and ceramic tiles, recalls the convent's
more prosperous past.

>

Preobrazhensky Cathedral

The neo-classical Preobrazhensky
Cathedral (named after the regiment
of Guards who supported the future
Empress Elizabeth in her bid for power
in 1741) was re-built after a fire by
Vasily Stasov in the late 1820s. As a
regimental church it contains many
trophies of war, including Turkish
standards, the sword Alexander II
wore on the day he was assassinated,
and various imperial uniforms. The
perimeter fence designed by Stasov
comprises 102 Turkish cannon barrels
seized by Russian troops during the
Russo-Turkish War of 1828–9. The
coat-of-arms of the Ottoman Empire
can still be seen on some of the bar-
rels, as well as inscriptions that read:
'The Wrath of Allah', 'Holy Crescent'
and 'I offer only death'.

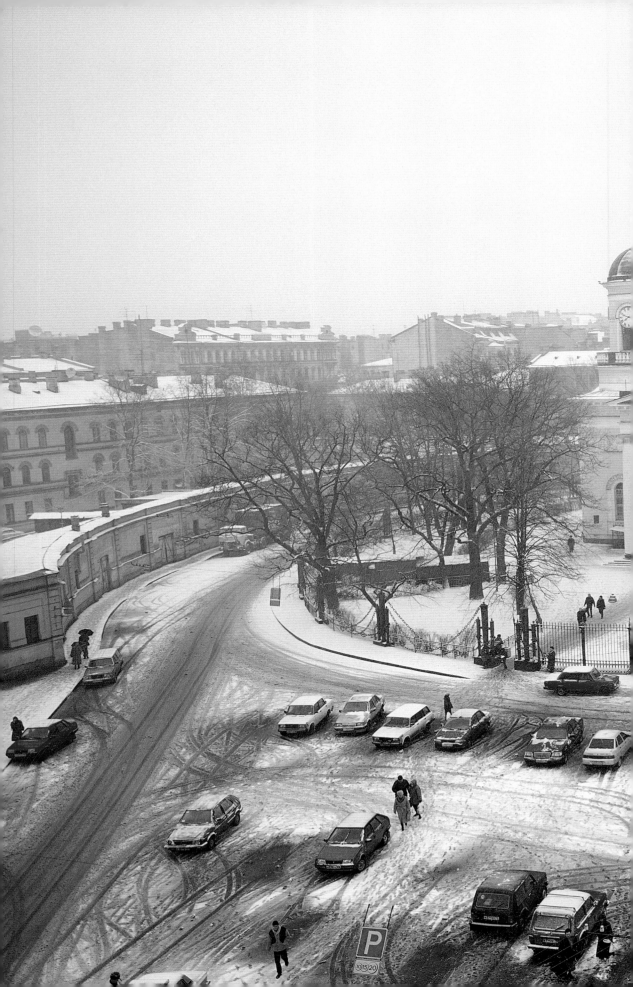

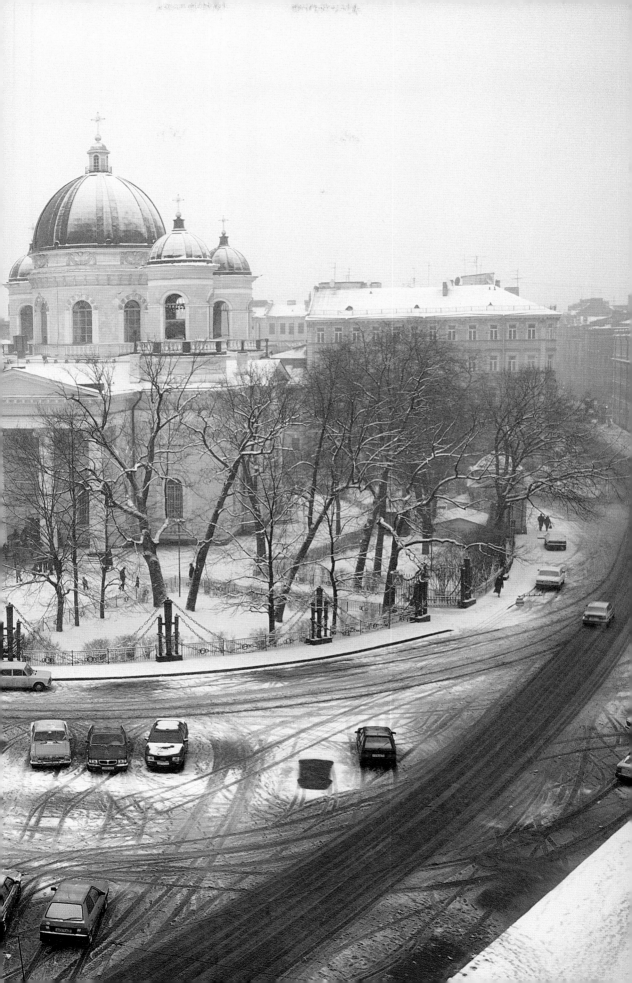

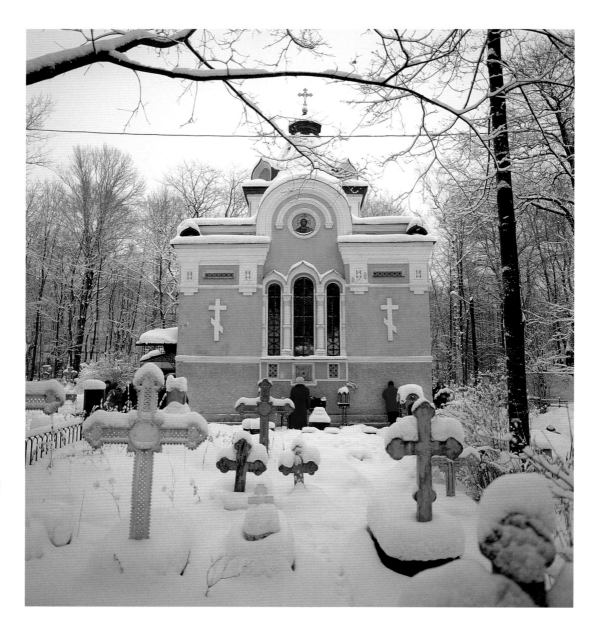

Chapel of Ksenia Peterburgskaya the Blessed

Ksenia Grigorevna Petrova was married to a chorister at the court of Empress Elizabeth in the middle of the eighteenth century. Ksenia's husband died when she was twenty-six, whereupon she gave up all her earthly possessions and began the life of a wanderer. After forty-five years of poverty, living off the charity of others and offering blessings in return, Ksenia died around the turn of the nineteenth century. Petersburg adopted Ksenia as its patron saint and she became known as 'Ksenia Peterburgskaya'. The inscription on her grave read: 'Whoever has known me, let him pray to my soul to save his own.'

The Chapel of Ksenia Peterburgskaya the Blessed is situated in the Smolensk Orthodox Cemetery on Vasilevsky Island. It is one of the city's most holy sites: visitors come to press their palms against the walls, praying and giving thanks for help and protection to their loved ones.

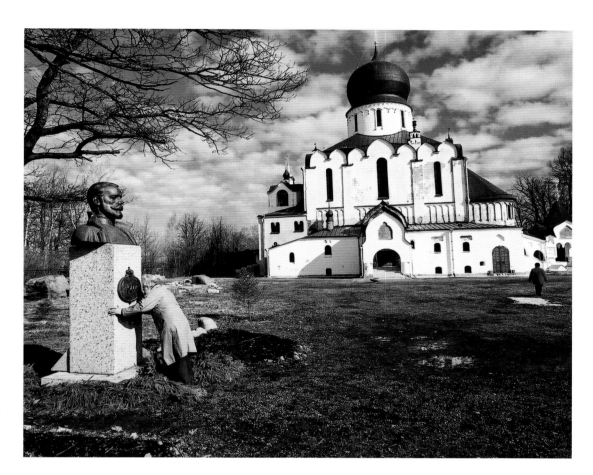

Fyodorovsky Cathedral, Tsarskoe Selo

The Fyodorovsky Cathedral at Tsarskoe Selo was commissioned by Nicholas II as the regimental church of His Imperial Majesty's Combined Infantry Regiment (formed to guard the imperial family in the wake of Alexander II's assassination). Modelled on the Cathedral of the Annunciation in the Moscow Kremlin, it was consecrated on 20 August 1912 in the presence of Nicholas II and his family, who worshipped there whenever they were at Tsarskoe Selo. The tsar's wife, Alexandra, had her own private chapel in the crypt, which contained a shrine with some of the relics of St Seraphim of Sarov.

The monument to Nicholas II by the sculptor Viktor Zaiko was unveiled in 1993 on the anniversary of the family's murder; it has since become a place of pilgrimage for nostalgic monarchists.

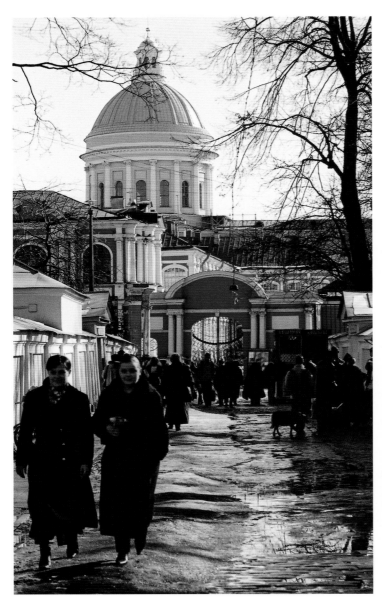

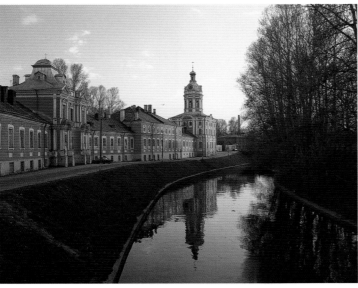

Alexander Nevsky Monastery
The Alexander Nevsky Monastery
contains two churches: the Trinity
Cathedral, whose dome towers over
the rest of the complex (*above left*),
and the earlier Church of the
Annunciation which overlooks
the Monastyrka River (*left*).

Grave of Anatoly Sobchak, Alexander Nevsky Monastery

The two best known cemeteries at the Alexander Nevsky Monastery, the Lazarus and Tikhvin, contain the graves of many of St Petersburg's most illustrious names: Dostoevsky, Rimsky-Korsakov, Tchaikovsky, Glinka, Lomonosov, Quarenghi, Rossi and many others (*see overleaf*). At the back of the monastery a third cemetery, the Nikolskoe, contains the graves of the city's more recently departed. The grave of Anatoly Sobchak is a poignant reminder of St Petersburg's first decade after the break-up of the Soviet Union. Sobchak was elected mayor of Leningrad in June 1991, and enjoyed enormous popularity in the early years of post-Perestroika Russia; his political career in many ways reflects the roller-coaster ride of that time. An early supporter of Gorbachev, Sobchak subsequently switched allegiance to Yeltsin and his programme of radical, market-led reforms. As one of the most high profile advocates of these reforms, the mayor's personal and political fortunes were tied to their success. His name will forever be linked with the decision, in 1991, to change the city's name back to St Petersburg. But as public disillusionment with the pace and direction of reform set in, so Sobchak's star began to fade. In July 1996 he lost the mayoral election to his former deputy, Vladimir Yakovlev. The following year he was forced to testify to the public prosecutor about possible abuse of office during his tenure; taken ill, he received treatment in France where he remained in voluntary exile until July 1999. On his return Sobchak attempted to re-enter the political fray, this time as the supporter and confidant of his fellow Petersburger and former deputy, Vladimir Putin, whom he saw as a leader who would restore to the country a sense of order and national pride. He died in 2000, the same year his protegé was elected president of Russia.

Ivan Shishkin, landscape painter

Nikolai Rimsky-Korsakov, composer

Vladimir Stasov, art critic

Fyodor Dostoevsky, author

Pyotr Tchaikovsky, composer

Mikhail Lomonosov, academic and founder of Moscow State University

Lev Gumilyov, historian, son of Anna Akhmatova and Nikolai Gumilyov

Mili Balakirev, composer

Headstones and Memorial Plaques
While many of St Petersburg's most famous dead lie buried in the cemeteries of the Alexander Nevsky Monastery, it has also long been a Petersburg tradition to link their names with the buildings they once inhabited (or, in the case of Lenin, even briefly visited). These memorial plaques (*right*), especially popular in the Soviet era, provide not just an insight into prevailing iconographic styles, but also into the city's political and cultural history.

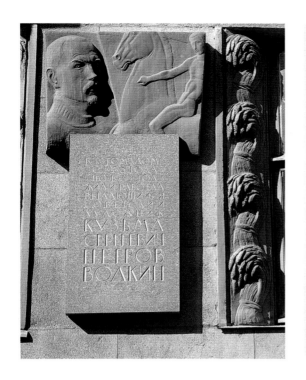

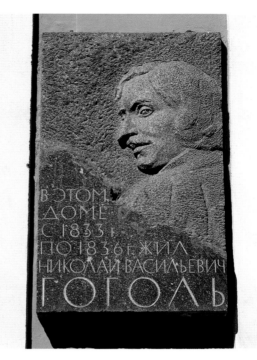

'The eminent Soviet artist Kuzma
Sergeyevich Petrov-Vodkin lived in this
building from 1936 to 1939.'
14 Kamennoostrovsky Prospect

'Nikolai Vasilevich Gogol lived in this house
from 1833 to 1836.' 17 Malaya Morskaya Street

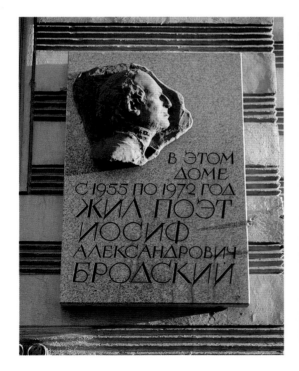

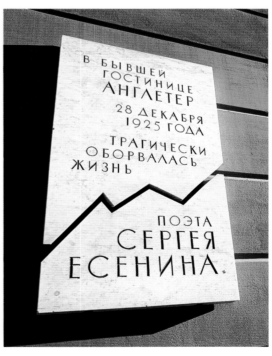

'The poet Joseph Alexandrovich Brodsky
lived in this building from 1955 to 1972.'
24 Liteiny Prospect

'On 28 December 1925 in the former Hotel
Angleterre the life of the poet Sergei Yesenin
came to a tragic and abrupt end.'
24-6 Malaya Morskaya Street

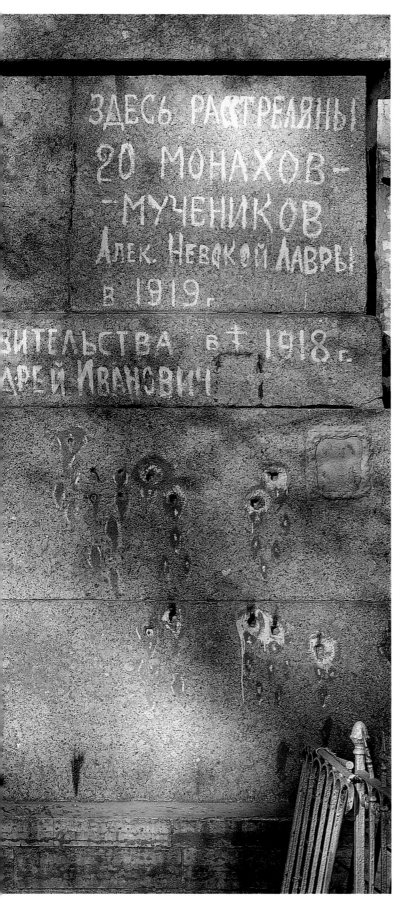

Memorial Wall in the Alexander Nevsky Monastery

This unofficial memorial was created in the early 1980s in the Nikolskoe Cemetery of the Alexander Nevsky Monastery. It commemorated the supposed execution of twenty of the monastery's monks during the Bolshevik Terror that followed the Russian Revolution. The main inscription, outlined in red, read 'Holy martyr-monks pray to God for us', while the inscription on the right recorded the event: '20 Martyr-monks of the Alexander Nevsky Monastery were shot here in 1919.' At the bottom right of the wall 'blood' was painted on to the wall, dripping from the bullet holes. An addition to the main inscription read: 'and two holy martyrs, ministers in the Provisional Government, Fyodor Fyodorovich Kokoshkin, Andrei Ivanovich Shingaryov in 1918.'

In fact there is no evidence that any monks were ever executed in the monastery. Furthermore, although Kokoshkin and Shingaryov are both buried in the cemetery, it is known that they were brutally murdered by a group of Baltic sailors on 6 January 1919 at the Mariinskaya Hospital on Liteiny Prospect (some distance from the Alexander Nevsky Monastery).

In 2001, in an attempt to prevent an historical inaccuracy from becoming a place of pilgrimage, the Church authorities ordered that the memorial be painted over. The 'bullet holes' were filled in, and a new, more general memorial was erected in front of the wall. It reads: 'Lord God in your kingdom pray for monks of the Alexander Nevsky Monastery, pious holders of the faith, who were arrested in 1918 (20 monks) and 1932 (more than 32 monks), and later suffered and were killed in the camps.'

>

Skulls on a Headstone

These skulls are on the gravestone of a father and son called Pukhalov, in the Tikhvin cemetery at the Alexander Nevsky Monastery. Skulls were a popular motif for a brief period in the 1820s and 1830s, when classicism borrowed from earlier architectural and artistic styles (the skull motif is thought originally to date from the Middle Ages). A butterfly, symbolising the spirit of the deceased, is normally shown flying upwards and away from the skull.

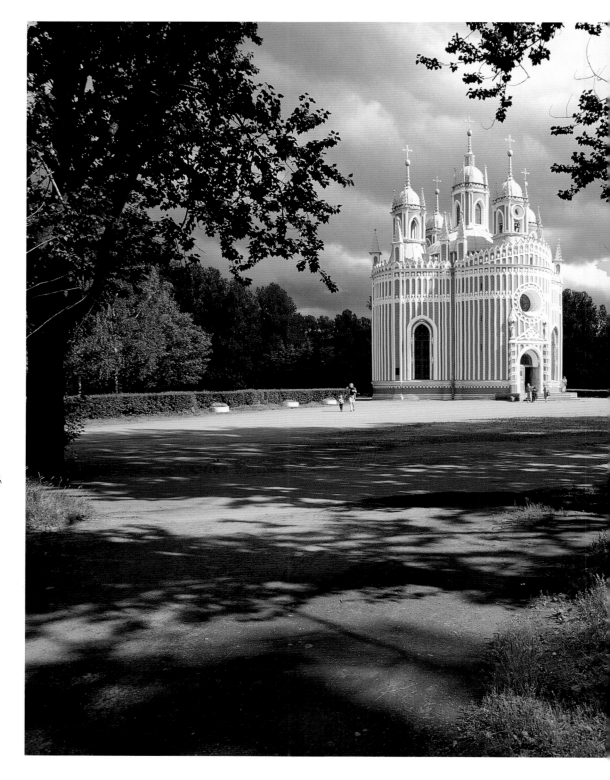

Chesme Church

The Church of John the Baptist which adjoins the Chesme Palace (not far from Moscow Square) was built between 1777 and 1780 by Yury Felten. Commissioned to mark the Russian naval victory over the Turks at Chesme Bay in the Aegean in 1770, the palace was only ever intended as a *putevoi*, or 'stop-over', residence for the court's annual exodus to Tsarskoe Selo. No tsar ever stayed at the Chesme Palace (at least alive: Alexander I's mortal remains supposedly rested there on their return from the emperor's fateful expedition to Taganrog in 1825), but Rasputin's body lay in state there after his murder in 1916. The palace was converted into a hospital in the 1830s and its original appearance greatly altered. The church, however, remains virtually unchanged. Its exuberant pseudo-Gothic exoticism was designed by Felten to recall the kiosks and pavilions of the Bosphorus; today, surrounded as it is by modern housing developments, the church looks more exotic than ever.

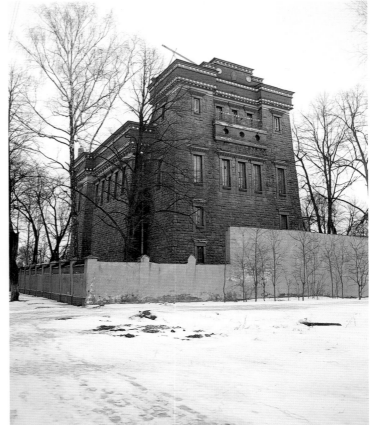

Mosque and Buddhist Temple

The mosque off Kamennoostrovsky Prospect, clearly visible from Troitsky Bridge, was built between 1910 and 1914, when the Russian empire's Moslem population was around eighteen million. Modelled on the Mausoleum of Tamerlane in Samarkand, it is the world's most northerly situated mosque.

The Buddhist Temple of Kalachakra in Novaya Derevnya was built between 1909 and 1913 on the initiative of the Dalai Lama. For much of the Soviet period both mosque and temple were either closed or used for non-religious purposes, and the temple was only finally returned to the city's Buddhist community in the early 1990s.

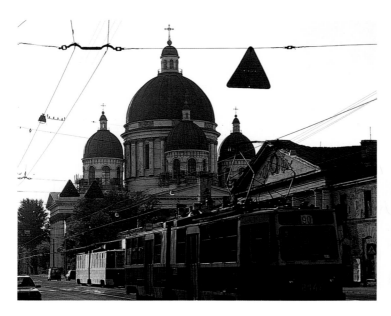

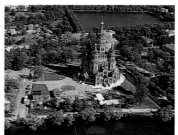

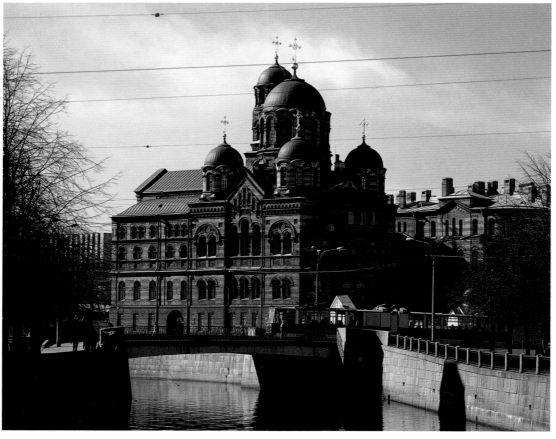

Troitsky Cathedral

Aerial view of Peter and Paul Cathedral, Peterhof

St John's Convent, Karpovka Embankment

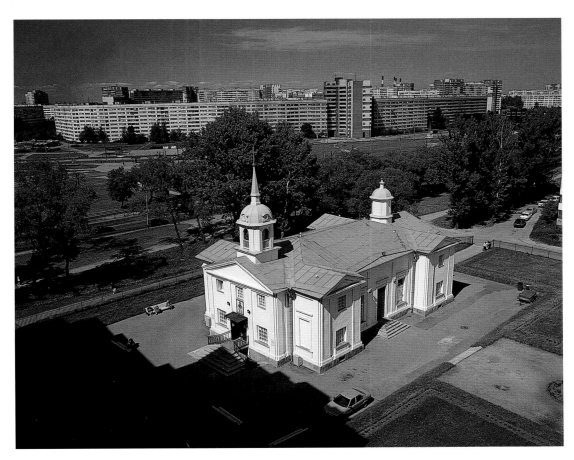

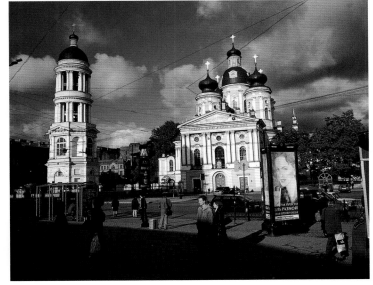

Church of Sts Vera, Nadezhda and Lyubov,
Prospect Stachek

Konyushenny Church

Church of the Annunciation,
Primorsky Prospect *Vladimirskaya Church*

ПАМЯТНИК
АРХИТЕКТУРЫ
XVIII
ВЕКА
ЗДАНИЕ БЫВШЕЙ
ЗНАМЕНСКОЙ
ЦЕРКВИ
ПОСТРОЕНО
В 1734-1747 гг.
АРХИТЕКТОРЫ
М.Г.ЗЕМЦОВ
И.БЛАНК

ОХРАНЯЕТСЯ
ГОСУДАРСТВОМ

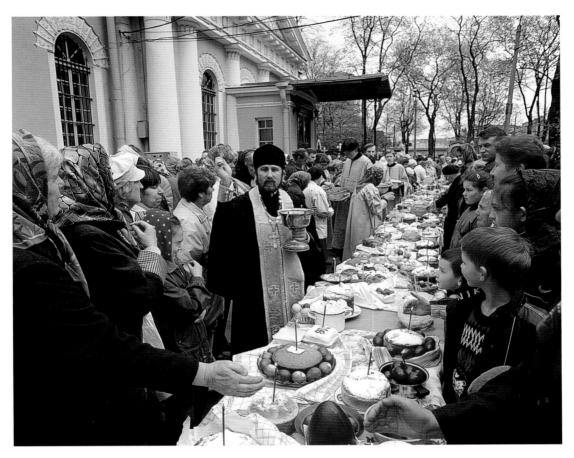

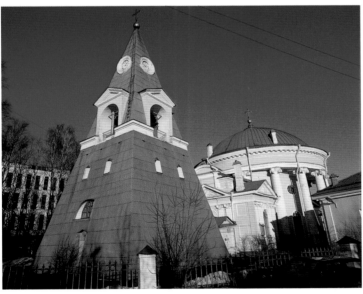

Church of the Holy Trinity ('Kulich i Paskha')

The Church of the Holy Trinity is more popularly known as 'Kulich i Paskha'. The name derives from the unusual shape of the church and its bell tower. *Kulich* is a special kind of sweetened bread in the form of a tall cylinder, while *paskha* is a dessert of curds in the shape of a pyramid. Both dishes are made and served as part of the Easter celebrations ('Paskha' is the Russian word for Easter). On Easter Saturday the congregation brings *kulich* and *paskha* to church, where the priest blesses the food and sprinkles it with holy water (*above*). This is taken as the symbolic end of the Lenten fast.

The Church of the Holy Trinity was built in 1785 by the architect Nikolai Lvov. It formed part of the estate belonging to Count Vyazamsky, Procurator-General under Catherine the Great.

<

Plaque on Znamenskaya Church, Tsarskoe Selo

The Soviet origin of this plaque on Znamenskaya Church is clear from its wording: 'The building of the *former* Znamenskaya Church was erected in 1734–47 by the architects M.G. Zemtsov and I. Blank'. The word *byvshei* ('former') has been semi-erased – symbolic, perhaps, of religion's greater powers of endurance over political doctrine. Znamenskaya Church was the first stone building in Tsarskoe Selo, and was named after the icon with which the dying Peter the Great is said to have blessed his daughter Elizabeth.

St Isaac's Cathedral

On 19 February 1712 Peter the Great married Catherine I in the wooden church of St Isaac of Dalmatia (St Isaac's day was 30 May, also the birthday of Petersburg's founder). The church stood on the banks of the Neva near the Admiralty, approximately on the site where the Bronze Horseman stands today. In 1717 the wooden church was replaced with a stone structure, which was in turn demolished to make way for the first St Isaac's Cathedral, designed by Antonio Rinaldi and Vincenzo Brenna and built between 1768 and 1802.

When Alexander I came to the throne, he decided to organise a competition for the design of a new cathedral; it was felt that the original building ill suited its surroundings. The competition was won by a young French architect, Auguste de Montferrand, and construction on the new building began in 1818.

St Isaac's Cathedral took forty years to complete – a remarkable feat of engineering and transportation of materials (even before the foundations could be laid, more than ten thousand pine-tree piles were driven into the ground). The cathedral was finally consecrated on 30 May 1858; the effort expended on its construction may have been too much for Montferrand, who died thirty days later.

In 1930 St Isaac's was designated the State Anti-Religious Museum (not to be confused with the State Museum of Religion, then situated in the Kazan Cathedral). According to a Soviet guidebook published in 1933, the museum 'unveils and explains the counter-revolutionary role of religion and religious organisations of all types both in the USSR and abroad, and arms the working masses with the theory and practice of militant atheism, using all the achievements of socialist construction, science and technology as well as the monuments of the former St Isaac's Cathedral'.

304

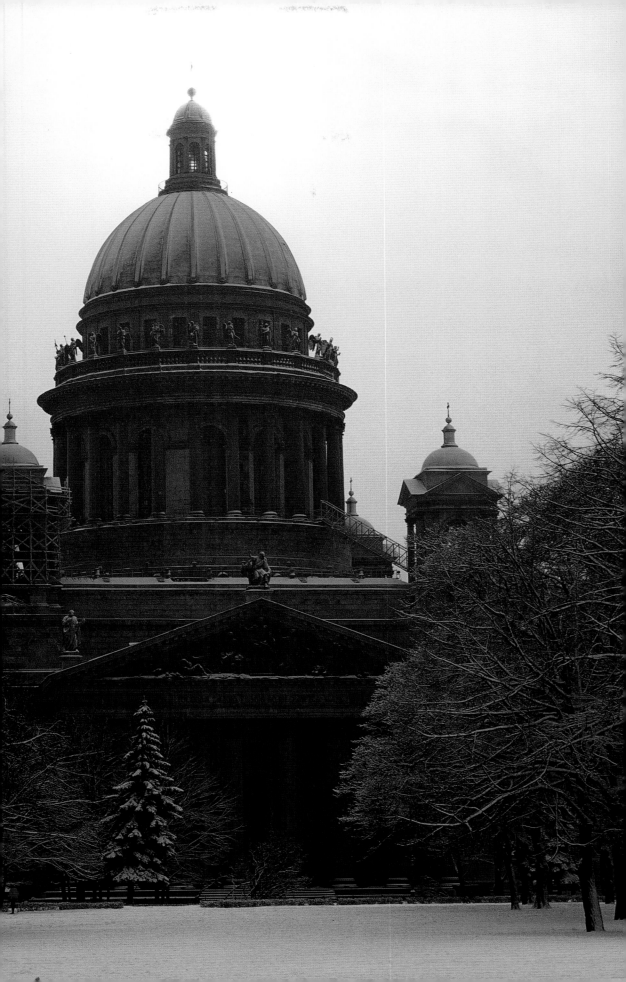

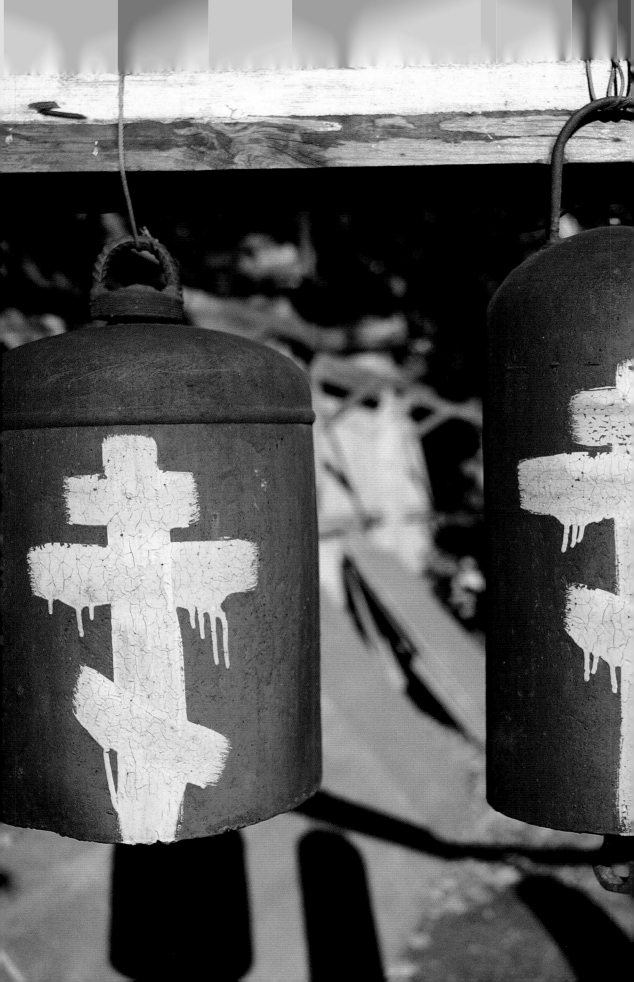

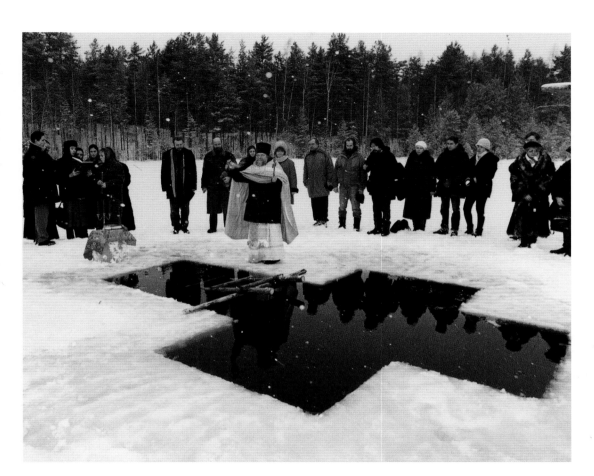

> **Smolny Cathedral**

The exuberant baroque exterior of Smolny Cathedral, commissioned by Empress Elizabeth in 1748 and designed by her favourite architect Bartolomeo Rastrelli, is entirely at odds with the cathedral's plain white-washed interior, which was completed only in 1835 by the architect Vasily Stasov. The cathedral was the centre-piece of the convent which Elizabeth founded to educate the city's young noblewomen. By the early nineteenth century the convent needed to expand, and so Giacomo Quarenghi was commissioned to build the neo-classical Smolny Institute within its grounds. It was from here that Lenin orchestrated the October Revolution of 1917, and the Smolny Institute became his seat of government until it moved to Moscow in March 1918.

Baptism Ceremony, Sosnovo

Baptism in the lake at Sosnovo, sixty kilometres north of St Petersburg on the shore of Lake Ladoga, is only for the most hardy: although the Russian Orthodox Church does not require total immersion for all baptisms, the practice is still adhered to by some Orthodox believers.

Church Bells at Oranienbaum

These bells with their painted Orthodox crosses, which hang outside the Church of St Panteleimon at Oranienbaum, have been improvised from sawn-off gas canisters.

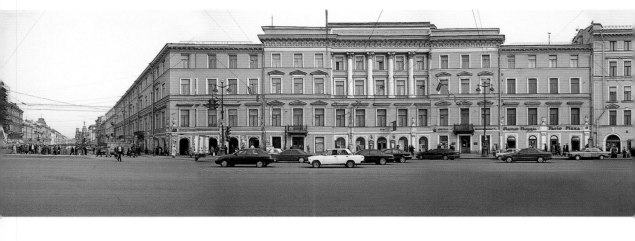

Panorama of Nevsky Prospect

Nevsky Prospect, St Petersburg's central artery, has been immortalised in numerous works of fiction, most famously Gogol's short story of the same name, but the street has also long held a fascination for artists. In the 1830s and 1840s lithographers started to make detailed engravings of Nevsky Prospect and one artist in particular, the former serf Vasily Sadovnikov, caught the public's imagination with his *Panorama of the Nevsky Prospect*, which depicted both sides of the street 'with not a single sign omitted'. Viewed through an aperture as the enormous lithograph was rolled from one reel to another, all the buildings from the Admiralty end of Nevsky Prospect up to Anichkov Bridge passed before people's eyes, including (in this stretch) the Roman Catholic Church of St Catherine, the Grand Hotel Europe, the Armenian Church designed by Felten and the tall art nouveau building which, since the beginning of the twentieth century, has housed the famous Yeliseyevsky food store.

Index

Page numbers in *italic* refer to photographs

Abramov, Fyodor, 282
Academy of Arts, 31, *100*, 236, *236*
Academy of Sciences, 151
 wall detail, *185*
Admiralty, 36, 58, *58*, 92, *93*, 109, 114, 179, 223
Admiralty Canal, 71, 163
Admiralty Embankment, *4–5*, 20, *59*
Aesop, 140
Akademichesky Pereulok, *220–1*
Akhmatova, Anna, 20, 22, 25, 63, 102–3, 105, 151, 164, 292
Alexander I, Tsar, 42, 127, 157, 163, 276, 298, 304
Alexander II, Tsar, 67, 170, 171, 182, 285, 289
Alexander III, Tsar, 101, 148, 160–1
Alexander the Great, 140
Alexander Column, *126*, 127
Alexander Mikhailovich, Grand Duke, 67
Alexander Nevsky Monastery, 113, *290–1*, *290–2*, *294–7*, 295
Alexander Park, Tsarskoe Selo, 153, *153*
Alexandra, Tsarina, 289
Alexandrinsky Theatre, 114, *115*, 151, *151*, 181
Alexandrovsky Garden, 114
Alexei, Tsarevich, 54
Alexei Alexandrovich, Grand Duke, *47*
Amenhotep III, Pharaoh, *31*
Amundsen, Roald, 34
Andreyev, Daniil, 42
Anichkov Bridge, 28, *67–9*, 312
Anichkov Palace, 68
Anikushin, Mikhail, 167, 227, 260, 279
Anna Akhmatova Museum, 164
Anna Ioannovna, Empress, 113
Antsiferov, Nikolai, 120
apartment blocks, 187–98
Apraksin Dvor, 114, *209*, 224
Architect Rossi Street, 114, *115*
Arctic Sailors' College, 165
Arkhangelsk, 71
Armenian Church, *314*
Art Nouveau, 210
Arts Square, *260*
Arzamas, 63
Atkinson, J. Beavington, 172, 174, 176, 179

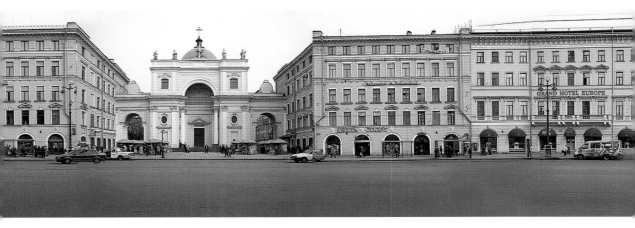

atlantes, *130*, 131, *173*
Aurora, 76

Balakirev, Mili, 101, *292*
Ballets Russes, 101, 102
Baltic Sea, 91
baptism, *307*
Batignolle, 83
Belinsky, Vissarion, 41, 187, 191
Beloselsky-Belozersky Palace, *66, 67*
Bely, Andrei, 30, 97, 142
Bennigsen, General, 154
Benois, Alexander, 92, 101
Benois, Leonty, 116
Berggolts, Olga, 282
Berlin, Isaiah, 103
Bestuzhev, Nikolai, 276
Blank, I., 303
Blok, Alexander, 30, 62, 94, 103
Bobrinsky Palace, 163
Bobrinsky Palace Garden, *162*
Bolshaya Konyushennaya, *196*
Bolshaya Moskovskaya Street, *215*
Bolshaya Neva, 138
Bolshaya Nevka, *76*
Bolshaya Porokhovskaya Street, *203*
Bolsheokhtinsky Bridge, *71*
Bolsheviks, 19, 116, 161, 179, 295
Bolshoi Prospect, 20-2, 24-5, 34
Borodin, Alexander, 101
Brenna, Vincenzo, 154, 157, 304
Brezhnev, Leonid, 37
Brodsky, Joseph, 41, 53, 76, 105, *293*
Bronze Horseman, 42, 94-6, *95*, 304
Bryullov, Karl, 97
Buddhist Temple of Kalachakra, *299*
Bukharin, Nikolai, 33
Bulgakov, Konstantin, 84
Byzantium, 179

Café Nord, 41
Cameron, Charles, 153, 157, 276
Cathedral of the Assumption of the Blessed Virgin Mary, *283*
Cathedral of the Resurrection of Christ ('Saviour on the Blood'), *10-11*, *170*, *206*
Cathedral of St Nicholas, 116, *117*, 179, 284, *284*
 wall detail, *49*
Cathedral of Saints Peter and Paul, 42, 113, *178*, 179, 181
Catherine I, Empress, 139, 145, 153, 304

Catherine II the Great, Empress, 101, 154, 174
 Academy of Arts, 100, 236
 Bronze Horseman, 95
 Gatchina Palace, 160
 Hermitage Museum, 129
 Hermitage Theatre, 85
 monument to, *150-1*, 151
 Oranienbaum, 145
 Peter and Paul Fortress, 54, *112*, 113
 Pavlovsk, 157
 Taurida Palace, 149
 Tsarskoe Selo, 153
Catherine Canal *see* Griboedov Canal
Catherine Palace, *152*
Chapel of Ksenia Peterburgskaya the Blessed, *288*
Charles XII, King of Sweden, 171
Chekhov, Anton, 151
Chernaya Rechka, 25, 46
Chesme Church, *298-9*
 wall detail, *273*
Chesme Palace, 298
Chevakinsky, Savva, 164, 179, 284
Chinese Palace, Oranienbaum, 145, *145*, *147*
Cholera Uprising (1831), 158
Church of the Annunciation,
 Alexander Nevsky Monastery, 290
Church of the Annunciation, Primorsky Prospect, *301*
Church of the Holy Mother of Kazan, *285*
Church of the Holy Trinity ('Kulich i Paskha'), *303*
Church of St Catherine, *313*
Church of St Panteleimon, Oranienbaum, *306*, 307
Church of Sts Vera, Nadezhda and Lyubov, *301*
Church of St Vladimir, 120
circus, *233*
 wall detail, *201*
City Duma, *183*
Commission for the Masonry Construction
 of St Petersburg, 92
Communist Party, 67
Constructors Street, 237
Convent of the Resurrection, *285*
Cossacks, 94, 161, 182
Crimean War, 42
Cross Bridge, Alexander Park, Tsarskoe Selo, 153, *153*
Custine, Astolphe, Marquis de, 20, 172, 174-6, 184

Dalai Lama, 299
Dashkova, Princess Yekaterina, 151
Decembrist Uprising (1825), 54, 172

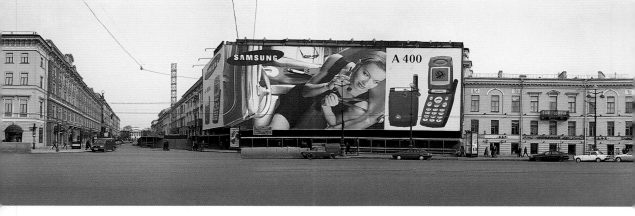

Derzhavin, Gavrila, *150*, 151
Diaghilev, Sergei, 101, 102, 149
Dobrolyubova Street, *210*
Dobuzhinsky, Mstislav, 28, 101
Dostoevsky, Fyodor, 20, 30, 62, 65, 79, 94, 96–7, 103, 105, 108, 215, 291, *292*
Dukhobors, 62

Eiffel, Gustave, 83
Elizabeth, Empress, 54, 64, 151, 288, 303
 Convent of the Resurrection, 285
 Oranienbaum, 145
 Smolny Cathedral, 307
 Summer Palace, 154
 Tsarskoe Selo, 153
 Winter Palace, 129
Engels, Friedrich, 161
Engineer's Castle *see* Mikhailovsky Castle
English Embankment, *60–1*, 76

Falconet, Etienne, 94, 95, 96
February Revolution (1917) *see* Russian Revolution
Felten, Yury, 129, 298, 312
Field of Mars, 114, *218–19*
Filonov, Pavel, *104*
Filosofov, Dmitry, 101
Finland, Gulf of, 37, 53, 83, *110–11*, 165
Finland Station, 42
Flavitsky, Konstantin, 54
Fofanova, Margarita, 227
Follenveider Mansion, *163*
Fontana, Giovanni Maria, 138, 145
Fontanka Embankment, *62–5*, 67, *78–9*, 209
Fontanka River, 25, 28, 37, *67*, *78*, 114, 154, 187, 190, 232
Futurism, 212
Fyodorovsky Cathedral, Tsarskoe Selo, *289*

Gatchina Palace, 48, 160–1, *160–1*, 276
General Staff Building, *122–3*, 127, 129, 174, 191
Georgi, Johann Gottlieb, 113
Germany, 179, 278
Gerstner, Anton Ritter von, 157
GIOP (Committee of State Control of Historical Monuments), 180–1
Gippius, Zinaida, 251
Gladkov, Alexander, 33
Glazunov, Alexander, 157
Glinka, Mikhail, 102, 157, 291
Gogol, Nikolai, 30, 40, 41, 76, 94, 96, 97, 103, 151, 243, *293*, 312

Goncharova, Natalya, 148
Gonzago, Pietro di, 157, 276
Gorbachev, Mikhail, 30, 148, 291
Gorky, Maxim, 212
Gorokhovaya Street, 58, *58* , 92, 114
Gostiny Dvor, 209
Gotzkowski, Johann, 129
Grand Hotel Europe, *313*
Grand Palace, Oranienbaum, *144*, 145, *146*
Grazhdanka, 119, 230, *230–1*
Griboedov Canal, 25, *80–81*, 114, 116, 170, 284
Grigoriev, Apollon, 230
Grigorovich, Viktor, 131
Grimm, Friedrich Melchior, 149
Gumilyov, Lev, *292*
Gumilyov, Nikolai, 292

Hanging Garden, 129
Helsinki, 20
Hermitage Bridge, *85*
Hermitage Church, *132–3*
Hermitage Museum *see also* Winter Palace, *128–9*, 129, 131, 138, 175, 176, *204–5*
Hermitage Theatre, *85*, 129
Herzen, Alexander, 92, 97
Hitler, Adolf, 41, 103
Hoare, Sir Samuel, 127
Hotel Angleterre, *293*
House of the Soviets, 119
House of Writers, 33

Ilin, Lev, 119
Institutes of Artistic Culture, 148
'Iron' House, *208*

Kamennoostrovsky Prospect, 38, 46, *207*, *293*, 299
Kamenny Island, 39
Kamensky, Valentin, 279
Kandinsky, Vasily, 148
Karamzin, Nikolai, 65
Karpovka Embankment, *300*
Kazan Cathedral, 28, *29*, 276, *276–7*
Kerensky, Alexander, 76, 149, 161, 182
KGB, 33, 40
Kirov, Sergei, 33
'Kirov Affair' (1935), 32
Kitezh, 102, 105
Klenze, Leo von, 129
Klodt, Pyotr, 68–9, 158

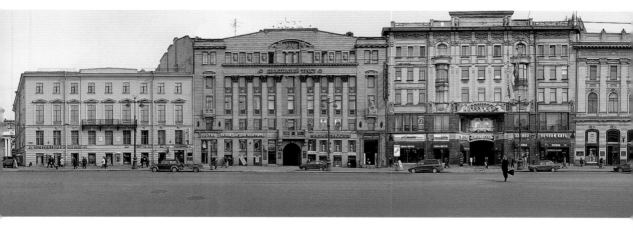

Kokorinov, Alexander, 100
Kokoshkin, Fyodor, 295
Kolomna, 79, 84, 108
Konstantin, Grand Duke, 163, 165
Konstantinovsky Palace, *164–5*, 165
Konyushenny Church, *301*
 wall detail, *35*
Kovensky Lane, *301*
Kozlovsky, Mikhail, 135
Krasnov, General, 161
Krestovsky Island, 163
Kron, Alexander, 105
Kronwerk, 54
Krylov, Ivan, 140
Kryukov Canal, 25, 71, 116, *117*, 179, 284
Ksenia Peterburgskaya the Blessed, 288
Kshesinskaya, Matilda, 33
'Kulich i Paskha', *303*
Kunstkamera, *118*
 wall detail, *169*
Kupchino, 119
Kutuzov, Marshal, 276

Ladoga, Lake, 24, 83, *90*, 278–9, 307
Lanceray, Eugène, 101
Large Hermitage, 129
Larionov, Mikhail, 148
Laval Mansion, 176
Lazarus Cemetery, Alexander Nevsky Monastery, 291, *292*
Leblond, Jean, 91
Lenfilm, 37
Lenin, Vladimir, 38–40, 42, 76, 103, 105, *167*,
 182, 227, 292, 307
Leningrad Philharmonic Orchestra, 103
Leningrad State University, 163
Lermontov, Mikhail, 151
Ligovsky Prospect, *199*
limitchiks, 40
Liteiny Prospect, 33, 293, 295
Literatorov Street, *8–9*, *104*
Lomonosov, Mikhail, 291, *292*
Lomonosov Bridge, 78
Lopukhina, Anna, 154
Louis xiv, King of France, 171
Lourié, Artur, 63
Lvov, Nikolai, 303

Maclean, Fitzroy, 67
Malaya Morskaya Street, *293*

Malaya Neva, 138
Malaya Okhta, 71, *283*
Malevich, Kasimir, 148
Mandelshtam, Osip, 25, 34, 102
Marble Palace, *163*, 175
Maria Fyodorovna, Tsarina, 157, 163
Mariinskaya Hospital, 295
Mariinsky Theatre, 116
 wall detail, *107*
Marinali, Orazio, 141
Marine Canal, 135
Marx, Karl, 161
Matisse, Henri, 148
Mattarnovi, Georg, 91–2
Mayakovskaya Metro, *212–13*
Mayakovsky, Vladimir, 212–13
Meltzer, Roman, 163
Menshikov, Alexander, 138, 139, 145
Menshikov Palace, 138, *138–9*, 145
 wall detail, *2*
Merezhkovsky, Dmitry, 30, 251
Meyerhold, Vsevolod, 33, 151
Michetti, Niccolò, 165
Mikeshin, Mikhail, 151
Mikhailovsky Castle, *26–7*, 28, 62, 63, 154, *154–5*, 182
 wall detail (pavilion), *259*
Minikh, Field Marshal Burkhard Khristofor, 58, 113, 114
Mint, 113
Mir iskusstva see World of Art group
Mitki Workshops, *237*
Moika River, 20, 25, 28, 37, 84, 114, 154
Mokhovaya Street, *222–3*
Monastyrka River, 290
Montferrand, Auguste de, 158, 175, 304
Monument to the Fighters of the Revolution, *218–19*
Monument to the Heroic Defenders of Leningrad, *278–81*
Moscow, 19, 37, 38, 40, 41, 42, 43, 48, 91, 101, 102,
 113, 114, 179
Moscow Prospect, *189*, 227, 229, 285
Moscow River, 48
Moscow Square, *167*, 227, *228*
Moscow Station, 37
Mosque, *299*
Mother Russia, Statue of, *281*
Muravyov, Alexander, 54
Museum of the History of St Petersburg, 171
Museum of Musical Instruments, 164
Museum of the New Academy of Fine Arts, 236
Mussorgsky, Modest, 101

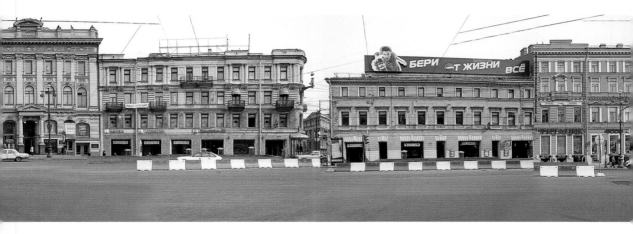

Nabokov, Vladimir, 62, 122
Nakhimov Naval Academy, 76
Nakhimov Street, *192–3*
Nansen, Fridtjof, 34
Napoleon I, Emperor, 33, 42, 127, 179, 276
Narva Gate, 68
Naval Museum, *74–5*
Navy Day, 77
Nazis, 179
Nekrasov, Nikolai, 20
Neo-academism, 236
Neptune, Statue of, *74–5*
Neva River, 25, 28, 32, 34, 42, 46, 48, *52–3*, 53, 71, 83, 91, 94,
 96–7, *98–9*, 108–9, *110–11*
 floods, *84*, 96, 97, 108–9, 174–5
Nevsky Prospect, 19, 20, *36*, 37, 58, *58*, 92, 96, 114, 116, 119,
 120, 151, 174, *177*, 182, *183*, *216–17*, 282, 312, *312-19*
New Academy of Fine Arts, 236, *236*
New Admiralty Canal, 163
New Hermitage, 129, 131, *173*, *204–5*
 wall detail, *17*
New Holland, *72–3*
Neyelov, Vasily, 153
Nicholas I, Tsar, 42, 157
 Convent of the Resurrection, 285
 Gatchina Palace, 160
 Hermitage Museum, 129
 monument to, 68
 Statue of, 158, *158–9*
 Winter Palace, 172
Nicholas II, Tsar, 71, 114–16, 182, 289
Nienshants, 119
Nike, Statue of, *122–3*
Nikolaev family, 24
Nikolskoe Cemetery, 291, *294–5*, 295
Northern War (1700–21), 109, 135, 171
Novaya Derevnya, 299
Novgorodians, 108–9
Novikov, Timur, 236

Obrist, Hermann, 210
Obvodny Canal, 25, 116
October Revolution (1917) *see* Russian Revolution
Odessa, 48
Odoevsky, Prince, 94, 97
Old Believers, 94
Oranienbaum, 76, *144–7*, 145, 165, *306*, 307
Orbeli, Iosif, 157
Orlov, Count Alexei, 145

Orlov, Count Grigory, 54, 145, 160
Orlovsky, Boris, 127
Ostrovsky Square, 151
Ottoman Empire, 285
Ovid, 33
Ozerki, 119

Palace Embankment, 176
Palace of Grand Duke Alexei Alexandrovich, *47*
Palace of Soviets, 227
Palace Square, *23*, 76, 122, *124–5*, 127, *127*, 129, 174, 182, *214*
Paris, 114
Pasternak, Boris, 25, 33, 91
Paul I, Tsar, 42, 63, 182
 Gatchina Palace, 48, 160
 Mikhailovsky Palace, 154
 murder of, 63
 Pavlovsk, 157
Pavlova, Anna, 157
Pavlov's Dog, Statue of, *232*
Pavlovsk, 30, *156–7*, 157, 179–80
Peretyatkovich, Marian, 116
Pestel Street, *227*
Peter the Great, Tsar, 97, 105, 145, 151, 172, 181
 battle of Poltava, 71
 foundation of St Petersburg, 91–2, 94, 108, 109, 171, 175
 ghost of, 42
 Konstantinovsky Palace, 165
 Kunstkamera, 118
 Menshikov Palace, 138
 Naval Museum, 74
 Peter and Paul Fortress, 54, 113
 Peterhof, 135
 St Isaac of Dalmatia, 304
 Sheremetev Palace, 164
 Statue of, *166*
 Summer Garden, 140
 Summer Palace, 139
 Winter Palace, 129
 Znamenskaya Church, 303
Peter II, Tsar, 113, 145
Peter III, Tsar, 145
Peter and Paul Cathedral, Peterhof, *300*
Peter and Paul Fortress, 25, 38, 42–3, *44–5*, 46, 54, *54–7*, 76,
 91, 109, *112*, 113, 165, 171
Peterhof, *134–7*, 135, 145, 165, 179–80, *300*
'Petersburg *moderne*' style, 22
Petrograd Soviet of Workers' and Soldiers' Deputies, 149
Petrov-Vodkin, Kuzma *293*

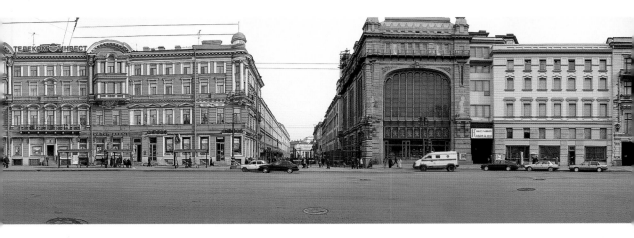

Petrova, Ksenia Grigorevna
 see Ksenia Peterburgskaya the Blessed
Picasso, Pablo, 148
Piskaryovskoe Cemetery, *281*
Polonsky, Yakov, 65
Poltava, battle of (1709), 135
Porokhovye, 119
Potseluev Bridge, 116
Potyomkin, Prince Grigory, 149, 151
Pravda, 165
Preobrazhensky Cathedral, 181, 285, *286–7*
Primorsky Prospect, *301*
Prokofiev, Sergei, 102, 157
Pryazhka River, 25
Pukhalov, 295
Pushkin, Alexander, 20, 25, 33, 40, 62, 91, 102, 103,
 105, 108, 109
 Arzamas, 63
 The Bronze Horseman, 28–30, 84, 94–6, 97, 101,
 261, 266–7, 268–9
 death, 46
 on Karamzin, 65
 The Queen of Spades, 85
 Statue of, *260*
Putin, Vladimir, 48, 165, 184, 291
Pylyaev, Mikhail, 64

Quarenghi, Giacomo, 85, 129, 291, 307

Radio House, 282
Radio Orchestra, 103–5
Raphael Loggias, 129
Rasputin, Grigory, 298
Rastrelli, Bartolomeo, 28, 129, 152–3, *153*, 165, 176, 285, 307
Repin, Ilya, 148
Rimsky-Korsakov, Nikolai, 101, 291, *292*
Rinaldi, Antonio, 145, 160, 163, 175, 304
Romanov dynasty, 129, 172, 175
Romanov, Grigory, 30, 40
Rossi, Carlo, 28, 114, 127, 151, *151*, *163*, 174, 291
Rudnev, Lev, 218
Rumyantsev Palace, *60–1*
Rusca, Luigi, 163
Ruskin, John, 182
Russian Academy of Sciences, 181
Russian Civil War, 181
Russian Museum, 148, *148*, *260*
Russian Orthodox Church, 113, 135, *307*
Russian Revolution (1905), 76, 181

Russian Revolution (1917), 24, 76, 149, 161, 181, 191,
 218, 227, 295, 307
Russian State Historical Archives, 176
Russo-Turkish War (1828–9), 285

Sadovaya Street, 209, *211*, 216
Sadovnikov, Vasily, 312
St Isaac's Cathedral, 42, *93*, 122, 158, 174, 175, *186*, 304, *304–5*
St Isaac's Square, 68, 158
St John's Convent, *300*
St Petersburg Construction Commission, 58, 113
Samson, Statue of, 135, *136*
'Saviour on the Blood'
 see Cathedral of the Resurrection of Christ
Schädel, Gottfried, 138, 145
Second World War, 24, 32, 68, 103–5, 119, 135, 157, 165, 278–82
Ségur, Comte de, 85
Seneca, 140, *141*
Sennaya Square, 158, *186*, 187
Seraphim of Sarov, St, 289
Serdobolskaya Street, *226*
Sergei Alexandrovich, Grand Duke, 67
Shagin, Dmitry, 237
Shalyapin, Fyodor, 157
Shaub, Vasily, 208
Shemyakin, Mikhail, 165
Sheremetev, Field Marshal Boris, 164
Sheremetev family, 40, 164
Sheremetev Palace, 103, 164, *164*
Shingaryov, Andrei, 295
Shinkaryov, Vladimir, 237
Shishkin, Ivan, *292*
Shostakovich, Dmitry, 102, 103–5
Shtakenshneider, Andrei, 67, 157, 165
Siberian Bridge, Tsarskoe Selo, 153, *153*
Siege of Leningrad (1941–4), 76, 103, 135, 179, 181, 278–9,
 278–82, 281, 282
Small Hermitage, 129
Smolenka River, 25
Smolensk Orthodox Cemetery, *270–1*, 288
Smolny, 285
Smolny Cathedral, *308–9*
Smolny Institute, 71, 307
Sobchak, Anatoly, 291, *291*
Socialist Realism, 148
Sosnovo, *307*
Spasskoe, 108–9
Speransky, Sergei, 279
sphinxes, *31*, *39*

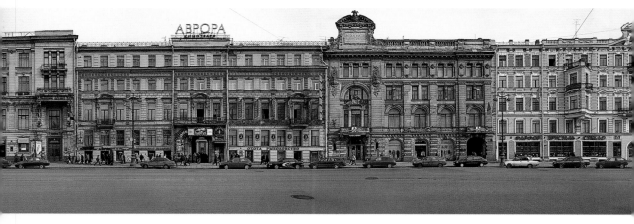

Stalin, Joseph, 32, 41, 102, 103, 105, 182, 212
Staro-Kalinkin Bridge, 78
Starov, Ivan, 149
Stasov, Vasily, 129, 285, 307
Stasov, Vladimir, 101, *292*
State Anti-Religious Museum, 304
State Duma, 102, 149, 180
Stock Exchange, 19, 74
Stolyarny Lane, 105
Strauss, Johann, 157
Stravinsky, Igor, 102
Strelka, *18*, 74
Strelna, 165
Stroganov, Count, 276
Style Moderne, 210
Sudeikina, Olga, 63
Sukhanov, Samson, 276
Summer Garden, 28, 40, 67, 84, 114, 140, *140–3*, 142, 187, *234–5*
Summer Palace, 84, 139, *139*
Surikov, Vasily, 148
Sweden, 109, 135, 171
Symbolists, 97

Tarakanova, Countess, 54
Tatlin, Vladimir, 148
Taurida Palace, 102, 149, *149*
Tchaikovsky, Pyotr, 85, 101–2, 291, *292*
Terebenev, Alexander, 130–1
Thomon, Thomas de, 18–19, 74
Tikhonov, Nikolai 33
Tikhvin Cemetery, Alexander Nevsky Monastery, 291, *292*, *296–7*
Tolstoy, Lev, 24, 42, 62, 105
Tosna River, 91
Trezzini, Domenico, 91, 139, 178
Trinity Cathedral, Alexander Nevsky Monastery, 290
Triumphal Arch, General Staff Building, *122–3*, 174
Troitsky Bridge, *82–3*, 299
Troitsky Cathedral, *300*
 wall detail, *241*
Trotsky, Leon, 33
Trotsky, Noy, 227
Tsarskoe Selo, *152*, 153, 157, 179–80, *289*, 298, *302*
Tsimbalinsky railway viaduct, 119
Tsushima Bay, battle of (1905), 76
Turgenev, Alexander, 63
Turgenev, Ivan, 65
Turgenev, Nikolai, 63

Ulyanov, Alexander, 54
underwear store, underground, *209*
UNESCO, 179
UNESCO Dutch Fund-in-Trust Hermitage Project, 176
University Embankment, 34, *50–1*, *100*, *118*, 138, 236
University of St Petersburg, 181

Vallin de la Mothe, Jean-Baptiste, 100, 129
Vasilevsky Island, *18*, 19, *50–1*, 74, 109, 114, 138, 145, *192–3*, *270–1*, 285, 288
Vauxhall, Pavlovsk, 157
Venice, 92, 119–20
Vienna, 114
Vihtula, 113
Vladimir Monomachus, Prince, 67
Vladimirskaya Square, *238–9*
Vladimirskaya Church, 120, *274–5*, *301*
Voltaire, François Marie Arouet de, 153
Voronikhin, Andrei, 29, 165, 276, 276
Voznesensky Prospect, 58, *58*, 92, 114
Vyazamsky, Count, 303

white nights, 43, 120
Winter Canal, *85–7*, 129
Winter Palace, *6–7*, 42, *52–3*, 76, *93*, 94, 113, 127, *127*, 129, *131*, 161, 171–2, 174, 176, 182, 188, *206*
 wall detail, *121*
Winter Stadium (wall detail), *89*
World of Art group, 101–2

Yakovlev, Vladimir, 120, 291
Yefimov, Dmitry, 285
Yefimov, Nikolai, 129
Yekateringofka River, 20
Yelagin Palace, *163*
Yeliseyevsky food store, 312
Yeltsin, Boris, 291
Yenakiev, Fyodor, 116
Yesenin, Sergei, *293*

Zabalkansky Prospect, 285
Zabolotsky, Nikolai, 33
Zaiko, Viktor, 289
Zayachy Island, 54, *56–7*, 109, 171
Zemtsov, Mikhail, 303
Zhdanov, Andrei, 22, 148
Znamenskaya Church, Tsarskoe Selo, *302*
Zoshchenko, Mikhail, 22

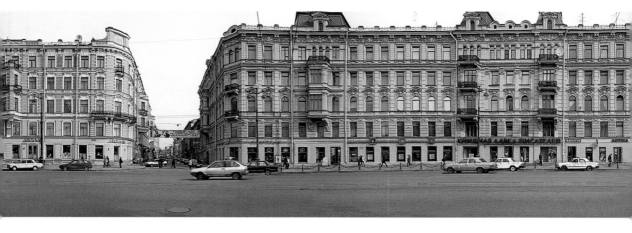

Authors' Biographies

Yury Arabov is head of the department of scriptwriting at the Russian State Institute of Cinematography. Arabov has published three volumes of poetry, a collection of essays and a novel, but is best known for his twenty-year collaboration with the film director Alexander Sokurov: his screenplay for Sokurov's *Molokh* won the Palme d'Or at Cannes in 1999.

Orlando Figes is Professor of History at Birkbeck College, University of London. He is the author of *Peasant Russia, Civil War* (1989) and *A People's Tragedy* (1997) which, among other awards, won the Wolfson History Prize, the WH Smith Literary Award and the *Los Angeles Times* Book Prize. His latest book *Natasha's Dance* (2002) is a highly evocative exploration of Russia's culture and people.

Charlotte Hobson read Russian at Edinburgh University and went on to spend much of the 1990s in Russia. Her first book, *Black Earth City* (2001), won a Somerset Maugham Award and was shortlisted for the Duff Cooper Prize and the Thomas Cook Travel Book prize. Charlotte Hobson now lives in Cornwall and is working on her first novel, set amongst the avant-garde artists of early twentieth-century Russia.

Alexander Kushner has been described by Joseph Brodsky as one of the best lyric poets of the twentieth century. In the 1960s he belonged to a circle of young Leningrad poets, including Brodsky, whose mentor was Anna Akhmatova. Besides numerous collections of poems, including a selection published in English, *Apollo in the Snow* (1991), he has published essays, children's verse and translations, notably of Philip Larkin's poems.

John Nicolson, writer and long-term resident of St Petersburg, is known in the city for his wry, sidelong look at Petersburg life – in particular in his book *The Other St Petersburg*, published in 1994. Having recently converted one floor of a town house behind Nevsky Prospect into a small hotel, he is well placed to comment on the changes taking place to the architectural fabric of present-day St Petersburg.

Yury Piryutko is Curator of the State Museum of City Sculpture in St Petersburg (part of the Alexander Nevsky Monastery). His publications include a survey of Gatchina (1977); *Historical Cemeteries of Petersburg* (1993); and *A Different Petersburg*, published in 1998 under the pseudonym K.K. Rotikov.

Vladimir Shinkaryov is a writer and artist. Born in Leningrad in 1954, Shinkaryov was a founder member of the 'Mitki', the most significant group of underground artists to emerge in Leningrad in the late Soviet era. Shinkaryov's manifesto defined the group, and his novel *Maksim & Fyodor* inspired a youth movement throughout communist Russia. Shinkaryov's paintings have been exhibited all over the world, while *Maksim & Fyodor* was published in English for the first time in 2002.

M. Kirby Talley, Jr, art historian and author, is an Executive Counsellor to the Dutch Ministry of Culture. In 1993 he was instrumental in the creation of the UNESCO Dutch Fund-in-Trust Hermitage Project, and in 1995 he joined the Board of the St Petersburg International Center for Preservation, an initiative of the Getty Conservation Institute, the Russian Academy of Sciences and the Municipal Government of St Petersburg. He served as the Center's Director in St Petersburg from 1998 to 2001.

Yury Molodkovets has been one of
the principal photographers at the
Hermitage Museum in St Petersburg
for the past eight years, contributing
to more than eighty publications on
the museum's collections and on the
city's history and architecture. He also
works as a freelance photographer
for the newspapers *Argumenty i Fakty*,
Kommersant and *Moskovskie Novosti*, as
well as for a number of art and design
magazines. His recent exhibitions
include *All Petersburg* (1999–2002) and
a one-man show entitled *Christmas
2001* at the Borei Art Centre. He has
published a number of art-related
projects, including *The Mitki-papers*,
as well as a series of books under his
own imprints, Mitkilibris and Red
Sailor. Fascinated by the concept of art
disseminated by post, he has curated
four exhibitions of 'mail art' at the
Post Museum of St Petersburg.